HEART OF SPAIN

ROBERT CAPA'S PHOTOGRAPHS OF
THE SPANISH CIVIL WAR

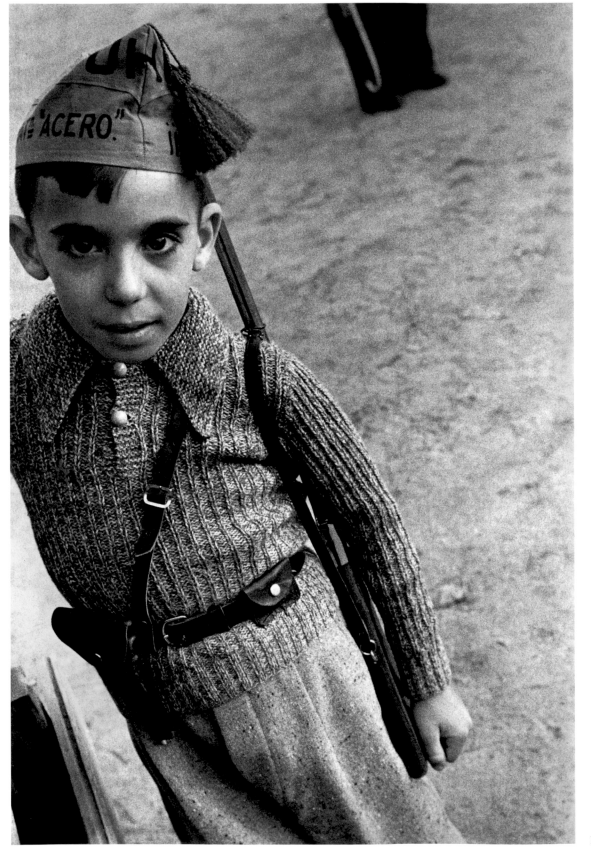

Barcelona, August–September 1936

HEART OF SPAIN
ROBERT CAPA'S PHOTOGRAPHS OF
THE SPANISH CIVIL WAR

FROM THE COLLECTION OF THE
MUSEO NACIONAL CENTRO DE ARTE REINA SOFÍA

DEDICATIONS BY ESPERANZA AGUIRRE GIL DE BIEDMA,
JOSÉ GUIRAO CABRERA, AND CORNELL CAPA

HISTORICAL ESSAYS BY JUAN P. FUSI AIZPÚRUA,
RICHARD WHELAN, AND CATHERINE COLEMAN

APERTURE

MUSEO NACIONAL CENTRO DE ARTE REINA SOFÍA, MINISTERIO DE EDUCATIÓN Y CULTURA

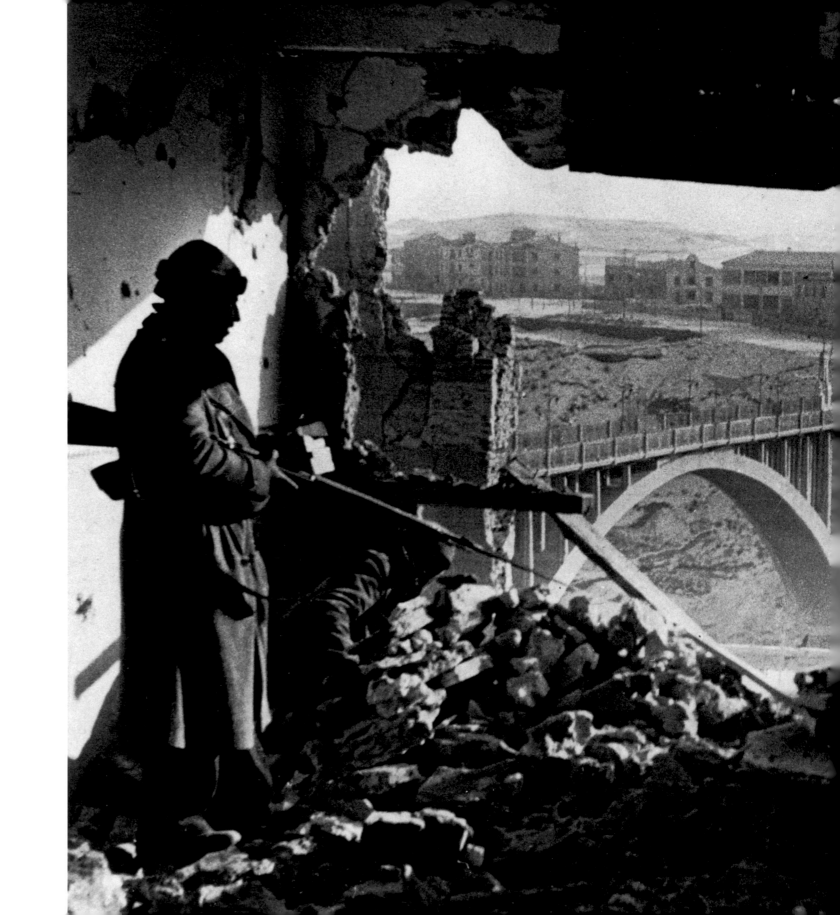

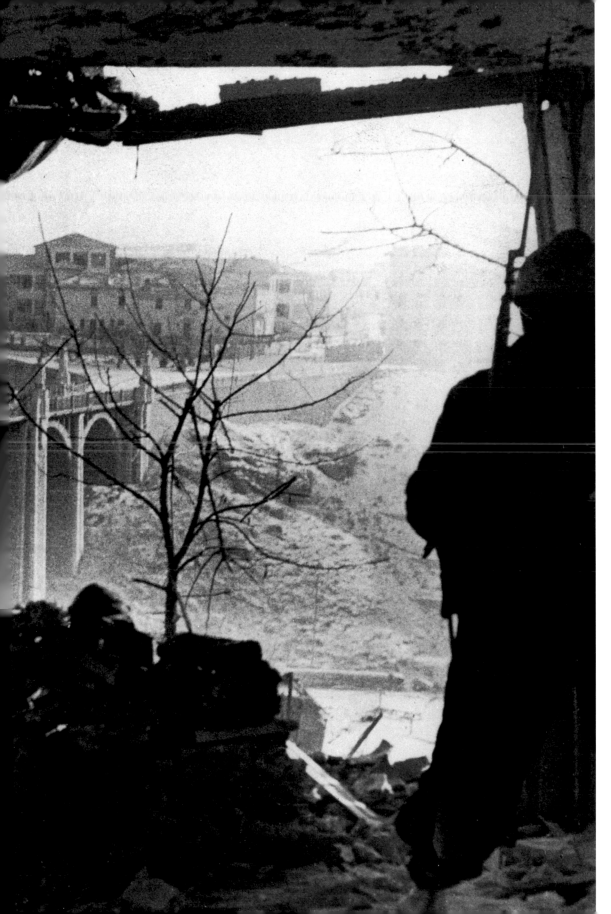

Teruel, Aragon front, January 3, 1938

CONTENTS

The cover of one of Robert Capa's notebooks, from the Archives Nationales, Paris.

We are most grateful to Mr. Cornell Capa, who has generously donated to the MNCARS the most significant photographs taken during the Spanish Civil War by his brother, the world-renowned photojournalist, Robert Capa.

Photography, which, in addition to cinema, is one of the great forms of artistic expression most clearly identified with our century, has become one of the fundamental tools of recording history and of preserving our collective memory. Photography has changed modern man's perception of the world. Robert Capa did not limit himself to documenting the great battles; he also captured the effects of this uniquely human invention—war—on the civilian population. Capa's photographs have come to symbolize the ravages that the civil war had on all Spaniards. The universal icon of his *Falling Soldier*, Cerro Muriano, September 1936, is an image of such visual potency that it is on a par with Picasso's *Guernica*.

We gratefully welcome the Capa donation because its presence in Spanish state collections means that this living legacy, through future exhibitions and publications, will be a constant reminder and a stimulus for younger generations to reflect upon events that occurred over fifty years ago. Those events should not be consigned to oblivion, having been overcome by means of our Constitution, that instrument of concord, and by the vigorous Spanish reality of our time, based on the peaceful coexistence of all Spaniards and our mutual confidence in our future.

ESPERANZA AGUIRRE GIL DE BIEDMA
Minister of Education and Culture, Spain

Robert Capa in Spain, 1936. Attributed to Gerda Taro.

Robert Capa's photographs of the Spanish Civil War possess an undeniable beauty. They depict human relationships, capturing joyful, tragic, and noble moments, on the front and behind the lines. However, Cornell Capa's donation to the Museo Nacional Centro de Arte Reina Sofía (MNCARS) is important for additional reasons: he has endowed the museum with a corpus of photographs from the 1930s, which will constitute the basis for future research and analysis.

The decade of the thirties is of particular concern to the Museum's Permanent Collection: Picasso's *Guernica* and its preparatory drawings are not only the axis around which is based the rest of the oeuvre that make up the Spanish avant-garde previous to the civil war, but also the complete works of the Permanent Collection; this emblematic canvas serves as the hinge, the element of union, between the aforementioned avant-garde and the creations which arose after the end of the conflict. Capa's black-and-white photographs depict the destruction caused by the Nationalist bombings of Republican urban areas and the suffering of the civilian population which caused and inspired the genesis of Picasso's great painting of 1937. Both artists capture the lost hope of a people in the human figure. A great part of Capa's oeuvre is dedicated to war journalism; Picasso carried out the same accusation in *Guernica*. Hence our warm welcome of Robert Capa's 205 photographs, which make up a significant contribution to our constantly growing collection.

Included in the exhibit are Capa's photographs belonging to the National Historic Archive, Civil War Section, in Salamanca, probably given by Capa himself to Dr. Juan Negrín during the Spanish Civil War. Some of those images are unique, having never been published, and their negatives lost or destroyed.

MNCARS has exhibited the great photographers of the Twentieth Century—Brassaï, Paul Strand, Manuel Álvarez Bravo, and László Moholy-Nagy, among them—and, now, Robert Capa. His brother Cornell Capa announced that he would like Spain to have the complete history of Robert Capa in Spain. Consequently, we would like to express our most sincere gratitude for his wonderful donation, which completes a gap in the museum's photographic collection.

JOSÉ GUIRAO CABRERA
Director

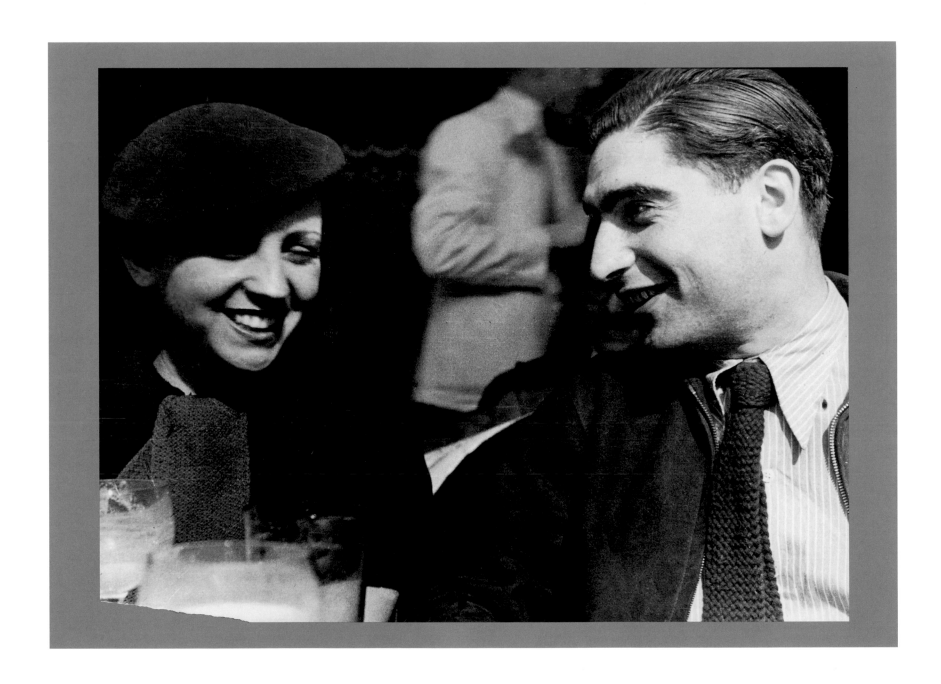

Gerda Taro and Robert Capa, Paris, autumn 1935. Photograph by Fred Stein.

My brother Bob went to Spain for the same reason that volunteers from all over the world went there to fight for the Republic. They all knew it was their fight, not just that of the Spanish people. They believed and hoped that a Republican victory might bring about the collapse of fascism throughout Europe, thereby averting the world war that seemed more and more inevitable with each passing day. Alas, those noble reasons were to be shattered, at least temporarily.

Bob went to Spain with a German refugee named Gerda Taro. They were young, in love with each other, and idealistic. Their weapons were their cameras, which they used to win international support for the Republican cause. Tragically, Gerda was killed at Brunete in July 1937, and Bob never fully recovered from his grief. Although at first he could not bear to return to the war that had killed the woman he loved, his great love for the Spanish people soon drew him back to document their struggle to the end.

It gives me immense pleasure and satisfaction to donate, in loving memory of my brother, 205 of his finest Spanish Civil War photographs to the Museo Nacional Centro de Arte Reina Sofía, and thus to the Spanish people. It has long been my wish to give to Spain this extraordinary visual document of one of the most painful chapters in that nation's history. I hope that this powerful testimony of tragedy may help to heal old wounds and to prevent future strife.

CORNELL CAPA

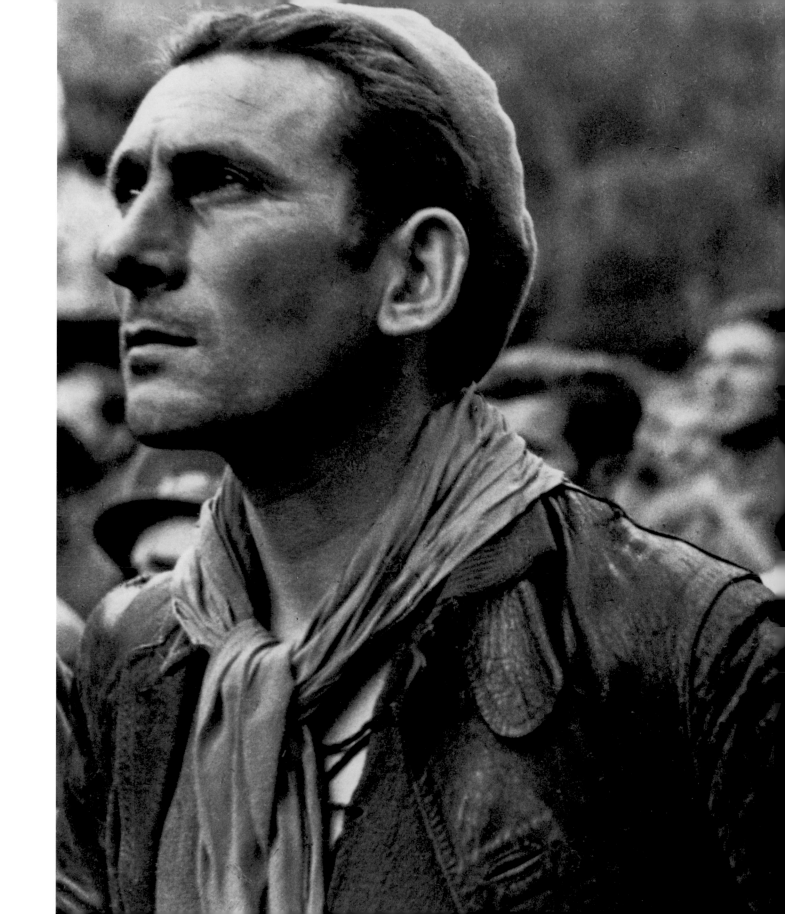

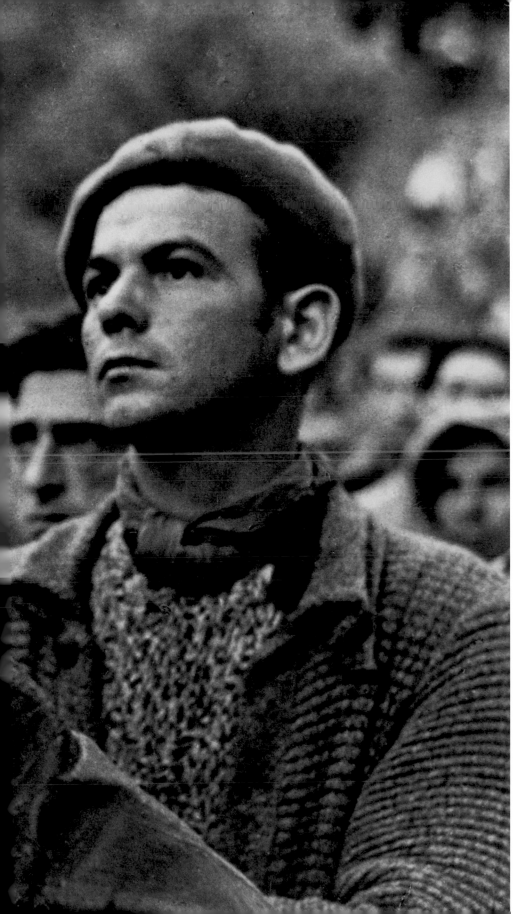

*I remember that in Spain during the civil war
I had a revelation of "the other man" and of
another kind of solitude: not closed, not
mechanical, but open to the transcendent.
No doubt the nearness of death and the
brotherhood of men-at-arms, at whatever
time and in whatever country, always pro-
duce an atmosphere favorable to the extra-
ordinary, to all that rises above the human
condition and breaks the circle of solitude
that surrounds each one of us. But in those
faces—obtuse and obstinate, gross and brutal,
like those the great Spanish painters, without
the least touch of complacency and with
an almost flesh-and-blood realism, have left
us—there was something like a desperate
hopefulness, something very concrete and at
the same time universal. Since then I have
never seen the same expression on any face.*

OCTAVIO PAZ
from *The Labyrinth of Solitude*

Montblanch (near Barcelona),
October 25, 1938

Frontiers that divide the people,
Soon we'll tear apart.
The masses speak a thousand tongues—
But have one heart.

For the workers no boasting Fatherlands,
Only freedom and peace,
So that through peace and freedom
All may find release.

The men sing as they work.
The women sing at their tasks.
All the World is singing
When the people are free at last.

But silent now the guitar
And the jota aragones.
First comes the International,
Then the Marseillaise.

Red with the people's blood
From the bombs of the enemy's raids,
Our flags are blooming like flowers
On freedom's barricades.

Girl of the People's Army,
Do not be jealous of me
If to my heart I take
Both you and liberty.

ANON
"Spanish Folk Song of the War"
(Translated from the Spanish by Langston Hughes)

Barcelona, August 1936

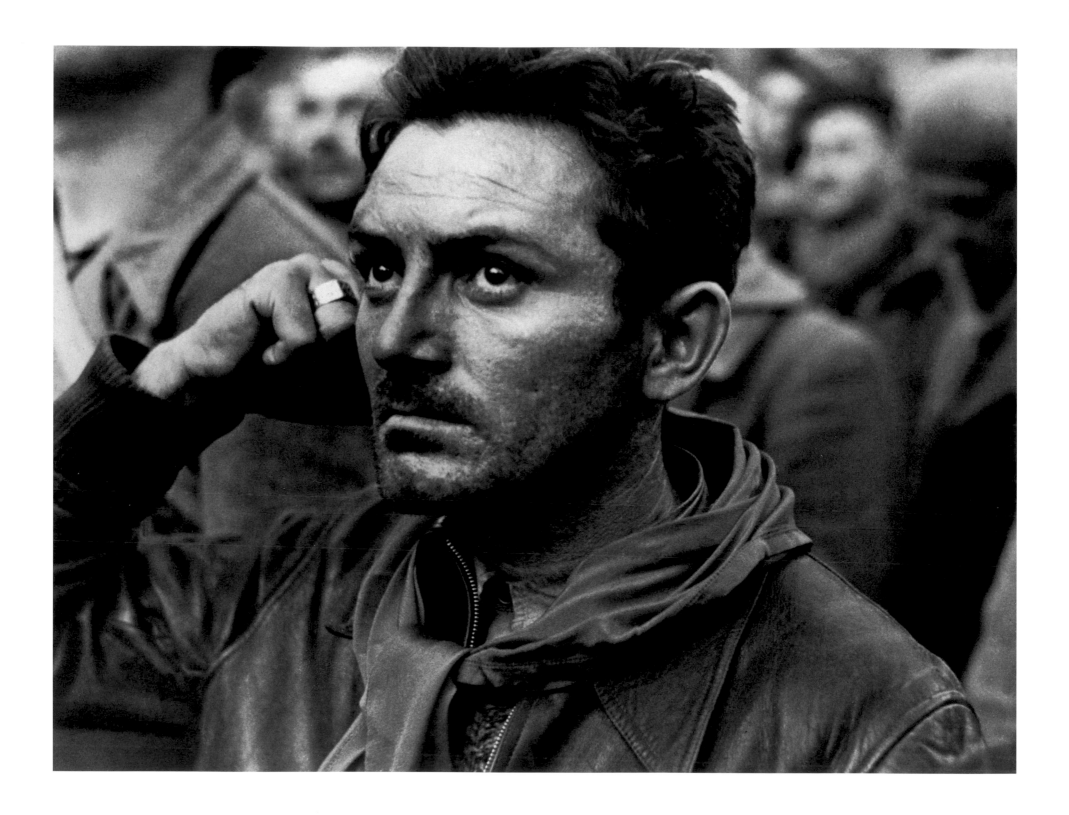

Montblanch (near Barcelona), October 25, 1938

THE CULTURE OF ANTIFASCISM

JUAN P. FUSI AIZPÚRUA

Antifascism was the great moral cause of the European left in the 1930s. As the British poet Stephen Spender said, "the 1930s was the decade in which young writers became involved in politics." He added that "this generation's politics was almost exclusively those of the Left."[1]

Spender was mainly referring to the so-called Auden generation, that is, to poets W. H. Auden, C. Day Lewis, Louis MacNiece, and novelist Christopher Isherwood (and himself). All of them approached the left, sympathized with the Communist Party, tried to write literature that was politically committed, and supported the Republic in the Spanish Civil War. Intellectuals, even more than poets, turned to the left in this era. Even in the universities of Oxford and Cambridge, interest in Marxism was evident. One of the most successful books of the decade was *The Coming Struggle for Power*, a pro-communist tract written by aristocrat John Strachey and published in 1932. The Left Book Club is another example of interest in the left during this period. Created in 1936 by the editor Victor Gollancz, it had an extraordinary impact. In a short time, it had signed up sixty thousand members and some of its publications sold up to 750,000 copies. Two young writers, John Cornford and Julian Bell, militant Communists educated at Cambridge and members of the British intellectual haute bourgeoisie, would die during the war in Spain while fighting for the Republicans. George Orwell would be seriously wounded.[2]

In the United States even, a country without a great socialist or leftist political tradition, a majority of intellectuals (most notably Eugene O'Neill, John Dos Passos, John Steinbeck, Edmund Wilson, Dashiell Hammett, Lillian Hellman, Richard Wright, Clifford Odets) identified themselves with the left in the 1930s, and tried to give their works explicit political content. Journals such as *The New Masses* and *Partisan Review*, as well as centers of debate like the John Reed clubs, which were created in various American cities after October 1929,[3] discussed, analyzed, and spread leftist ideas and thought. The Spanish Civil War would have a great impact on the country (among other reasons, because of Robert Capa's photographs, which appeared in *Life*). John Dos Passos, Ernest Hemingway, Martha Gellhorn and Waldo Frank openly defended the Republican cause. Close to three thousand American volunteers enlisted in the Lincoln Brigade of the International Brigades.[4]

In France, some of the most important writers associated with surrealism—André Breton, Louis Aragon, Paul Eluard, Georges Pérec, Pierre Unik—joined the French Communist Party in 1927. This was the last step in a process of politicization triggered by their opposition to the French army's increasing involvement in Morocco's war against the anticolonial rebellion in the Riff. Until 1933, when Surrealist intellecturals were expelled from the French Communist Party, surrealism considered itself in the service of revolution, to quote the title of one of their publications, *Le surrealisme au service de la revolution*. Many other French writers—André Malraux, André Gide, Romain Rolland, Henri Barbusse, Julien Benda, Tristen Tzara, Jean Guéhenno, Paul Nizan, Jean Cassou and many others—joined the Association of Revolutionary Writers and Artists, created in 1932, and participated in initiatives such as the Amsterdam-Pleyel movement (1932–33), the Human Rights League, and the antifascist Intellectual Vigilance Committee (1934). Many also took part in international congresses of Writers for the Defense of Culture, held first in Paris in 1935 and later in Spain in 1937 in the midst of the Civil War. This last conference was held in Valencia, which was at that moment the capital of the Spanish Republic, as was an obvious act of support.[5]

In Germany, Bertolt Brecht's theater, along with Erwin Piscator's, evolved towards Marxism in the 1920s. Films such as *The Blue Angel* (1930) by Sternberg and *The Underworld* (1931) by Jutzi, the cruel and distorted paintings of Otto Dix and Georg Grosz, the more allegorical of Max Beckmann's work, Erich Remarque's *All's Quiet on the Western Front* (1928), and Döblin's *Berlin Alexanderplatz* (1929) reflected the pessimism of intellectuals and artists about the new Weimar Republic. Established in 1918 after German defeat in

World War I, the regime was unstable due to its lack of support among large parts of the population, on both the right and the left. In the end, the growth of right-wing forces and especially National Socialism caused its demise. Christopher Isherwood would reflect this atmosphere very well in his novels *Mr. Norris Changes Trains* (1935) and *Goodbye to Berlin* (1939). Bauhaus, the school of design, arts, and crafts created in 1919 in which Walter Gropius, Mies van der Rohe, Wassily Kandinsky, Paul Klee and László Moholy-Nagy, among others, collaborated, was formed with the ultimate goal of applying the principles of avant-garde art to the daily life of the working classes. They designed factories and workers' housing to be revolutionary environments of great simplicity and beauty. The Frankfurt School—a group of philosophers and social theorists associated with the Institute for Social Research at University of Frankfurt consisting of Max Horkheimer, Theodor Adorno, and Walter Benjamin—was devoted to the elaboration of Marxist social criticism. Hitler's accession to power in 1933 put an end to all that: almost all of the above mentioned names, and hundreds of German intellectuals, had to go into exile. German intellectual life was thus disassembled and dispersed. The German exile and the Spanish war were sinisterly connected, in part due to the 1940 suicide of Walter Benjamin, who had found refuge in Paris since 1933. He had then fled from the Nazis to Port Bou, on the Franco-Spanish border, and his suicide acquired the value of a tragic metaphor when the new Spanish regime denied him permission to enter.[6]

Certainly, there was no dearth of right-wing intellectuals. Some of the more noteworthy were Oswald Spengler and Martin Heidegger, Ezra Pound, T. S. Eliot, and Evelyn Waugh. Among the less noteworthy in Germany was Ernst Jünger, the author of *Storms of Steel* (1920), a best-selling exaltation of the chivalrous ideals of honor, risk, and courage. In France, there were Céline and Drieu La Rochelle, whose great novel *Gilles* (1939) contrasted the virility and authenticity of life on the front with the mediocrity and hypocrisy of life at the rear. In Italy, Mario Sironi and many others were active fascists.

In Spain most intellectuals had supported the Republic in 1931 and would continue to support it in 1936. Federico García Lorca would be shot. Miguel Hernández would die in prison. Rafael Alberti, Jorge Guillén, José Bergamín, Luis Cernuda, Pedro Salinas, Pablo Casals, Gabriel Miró Ferrer, Luis Buñuel, Juan Ramón Jiménez, Salvador de Madariaga, and many others would be exiled after the Republic's final defeat. Others, however, were on the right. Ramiro de Maeztu, Manuel Bueno, Pedro Muñoz Seca (all three shot in the war), D'Ors, Pemán, José Maria Salaverría, Foxá, Sainz Rodríguez, the Fascist and Falangist intellectuals (Giménez Caballero, Ledesma Ramos, Sánchez Mazas, Ridruejo, Eugenio Montes, Luis Rosales, Panero, etc.), and many others supported the military uprising of 1936.[7]

Still, Spender was correct: the left, even communism was the great temptation of 1930s intellectuals. This had a price. The most serious was the silence of the majority of intellectuals regarding Stalinism and their aggressive criticism of those few who dared to denounce the Soviet regime and Communist politics. For example, Gide, when he published *Return from the USSR* in 1936 and Orwell, when he published his story of his experience in the Spanish Civil War, *Homage to Catalonia,* both met with hostility and denunciations. The intellectuals' left-wing politics led them to support popular and progressive causes, the most glamorous of which was the Republican cause in the Spanish Civil War. The Spanish Civil War broke out on July 18, 1936 when part of the Spanish army rebelled against the Second Republic, the democratic government elected by popular vote in April 1931. It became a beacon and a symbol: it galvanized the democratic and revolutionary hopes of international opinion.

THE CIVIL WAR: THE MILITARY UPRISING

Between July 18, 1936 and April 1, 1939, Spain was involved in a long and fierce civil war.[8] The right saw that war as a crusade against communism: the left idealized it as the romantic resistance of the people and the proletariat against fascism. Manuel Azaña (1880–

1940), the Republican leader and head of government between 1931 and 1933, as well as president of the Republic after the spring of 1936, saw it another way: as a "collective hallucination," where heroism coexisted with atrocities, intolerance, fanaticism, hate, and fear.[9]

The Spanish Civil War gained international dimensions when Germany and Italy, the Fascist powers, began openly supporting the military uprising with weapons and soldiers. The USSR helped the Republic, and a significant contingent of volunteers, mostly communists, joined the International Brigades and fought for it Republic. Nevertheless, the civil war was a Spanish affair. Azaña himself argued that the religious and social divisions within the middle and upper classes were the true origin of the war.

He was correct. The fall of the monarchy and the proclamation of the Republic in April of 1931 signaled not only a change of regime but the beginning of a social revolution. The Republican-Socialist coalition under Azaña's leadership governed from 1931 to 1933 and initiated an ambitious program to reform what they considered to be Spain's great problems. The government wanted to expropriate the great estates and divide the land among the peasants; he also wanted to create a professional army that would be neutral in politics. The coalition sought to limit the influence of the Catholic church, secularize social life, promote a liberal lay education, and decentralize the state by granting autonomy to those regions in which large nationalist movements had appeared since the late nineteenth century (Catalonia, the Basque Provinces, and Galicia).

The government's plans polarized political and social life. The reforms were opposed by Catholics, the Church, landowners, and many members of the military. Some of the government's initiatives, such as agrarian reform, were technically poorly conceived; in other cases, like the dissolution of the Jesuits and the prohibition of teaching by religious orders, the Republic acted with excessive and unnecessary sectarianism. Important bases of support in the urban and rural middle classes were alienated. On the other hand, the measures were not sufficient to satisfy the rising expectations that the change of regime had caused in broad sectors of the working class and peasantry. Some did not give it enough time: the anarcho-syndicalist trade union, the Confederación Nacional del Trabajo (CNT), set loose a truly revolutionary offensive against the government practically from the summer of 1931.

All this made democratic stability impossible. The elections of 1933 marked a significant turn to the right. The Confederación Española de Derechas Autónomas (CEDA), a Catholic party opposed to the spirit of the Republic, became the key to power in the years of 1934 and 1935, and used its position to get legislation passed that partly reversed the measures of 1931–33. Facing the threat of Spanish-style fascism, the Partido Socialista Obrero Español (PSOE), the main leftist party, opted for insurrection. The socialist revolution in October 1934, which failed and caused hundreds of deaths and left thousands in jail, seriously hurt the legitimacy of the Republic. For that reason, in February 1936, when the left, united in a Popular Front under Azaña, won the elections, a group of right-wing military officers started to conspire and plan. A military rebellion broke out all over Spain on July 18, 1936, though some officers had already rebelled in North Africa the day before.

Only part of the army rebelled. The part of the military directed by generals Francisco Franco, José Sanjurjo, Emilio Mola Vidal, and Gonzalo Queipo de Llano, rebelled for various reasons. They claimed that the Republic lacked political legitimacy. They thought that the concession of autonomy to the regions (in fact, in July 1936, autonomy had only been granted to Catalonia) was a threat to the unity of Spain. They thought the strikes and riots revealed democracy's lack of authority. They felt that Republican legislation attacked the Catholic essence of Spain. The rebellious military thought the coup d'état would triumph immediately. They were wrong: they triggered a devastating civil war that lasted three years.

The military uprising triumphed only in certain parts of Spain: Galicia, Navarre, Álava, Old Castile, the capital cities of Aragon, some Andalusian cities, the Canary and Balearic Islands (except

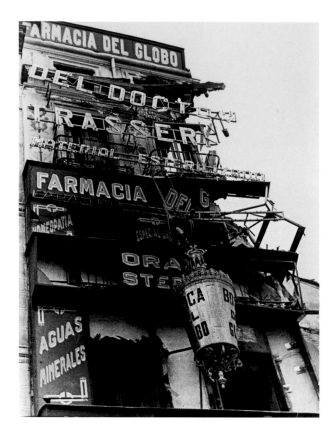

The Globo Pharmacy,
Madrid, 1937.
Courtesy of Archivo His–
tórico Nacional, Sección
Guerra Civil, Salamanca.
In the late 1970s, a small
suitcase, containing ninety-
seven Robert Capa photo-
graphs and miscellaneous
papers, which had belonged
to Prime Minister Juan
Negrín of the Spanish
Republic, was discovered in
the archives of the Swedish
foreign ministry. All of the
documents and photographs
from the suitcase are now
housed in the Civil War
Section of the Archivo
Histórico Nacional, located
in Salamanca. The photo-
graph above is one of the
ninety seven.

Minorca), and the colonies in North Africa. It failed in Madrid, Catalonia, the east, the coastal provinces of the north, the south-center of the country, and in most of Andalusia and Aragon. Of the 31,000 officers in the Spanish army in 1935, some 14,000 rebelled; about 8,500 remained loyal to the Republic; the rest had different fates. The Republic theo-retically counted on some 160,000 sol-diers, plus the majority of the air force and the navy; the rebels, who adopted the name of "Nacionales" (Nationals), retained some 150,000 soldiers. Among these were the Spanish Army's elite corps, the Army of Africa, some 47,000 men. Franco was able to airlift them to the peninsula thanks to German and Italian aid.

The apparent balance of forces hid a fundamental fact: the Repub-lic suffered from a lack of unity which lasted several months in the political and military management of the war. This was due to the very nature of the popular response to the coup d'état—the mili-tary uprising triggered a revolutionary process in the working class, directed by workers' parties and trade unions, which broke the very structure of the Republican state. It was that which gave the Span-ish Civil War the significance which moved the romantic imagina-tion of the European left, which turned it into the idealized epic of popular and proletarian resistance to fascist aggression. From a mil-itary point of view, the result was disastrous. The revolution undid the Republican army, and substituted it with irregular and undis-ciplined forces based on party and union militias and commanded by improvised officers. The militias' enthusiasm certainly prevent-ed the triumph of the rebellion. But until the spring of 1937, the Republic did not have a truly operative army. This was the first rea-son for their defeat.

THE ADVANCE ON MADRID

Initially, the objective of the rebel troops was Madrid. By the end of September 1936, the troops of the Army of Africa, under Fran-co's command, were at the southern gates of the capital. They had advanced some five hundred kilometers and occupied a large part of the south and west of Spain, as well as some important cities like Badajoz and Toledo. At the same time in the north, Mola's troops had conquered San Sebástian and the Basque-French border and were threatening Madrid from the mountains to the north (Somo-sierra, Los Leones).

It was still a "minor" war. It was a war of columns. Both sides used few resources. Infantry was the main weapon, while the air force, artillery, and the navy were secondary. However, the war had already shown one of its most cruel and sinister faces. From the first moment, both sides began campaigns of wide-scale repression behind their lines. The rebel forces shot members of leftist parties and trade unions, hundreds of teachers (who were considered sym-bols of Republican secularism), some Republican intellectuals (the most well-known is Federico García Lorca), and even sixteen priests who sympathized with Basque Nationalism. Republicans—almost always simple patrols of uncontrolled murderers and not Repub-lican authorities—executed people known for their conservative, Catholic opinions. They killed militant members of right-wing par-ties, suspicious military officers, and a great number of priests and members of religious orders (a total of 6,500 by the end of the war). Badajoz, where the Nationalists shot two to four thousand people in August 1936, became a symbol of Francoist violence. The attacks on the prisons of Madrid and Bilbao, and the shootings in Paracuel-los del Jarama, a village near Madrid, were the expressions of Repub-lican terror. In total, during the war some sixty thousand persons were executed in Franco's area and a minimum of thirty thousand in Republican territory.

The offensive on Madrid began in earnest in November of 1936 and lasted until February of 1937, when the Nationalist troops were contained in a battle near the Jarama River. It involved some

of the heaviest fighting of the war. Madrid's resistance, led by a Board of Defense chaired by General José Miaja, reinforced the legend of Spanish antifascism. It also proved two other things: the Republic was beginning to organize its armies and the war was becoming international. The former became possible in September with the formation of a coalition government headed by the Socialist Francisco Largo Caballero (1869–1946) which consisted of Socialists, Communists (two ministers), and, shortly thereafter, Anarchists (four ministers). In the defense of Madrid, Miaja had eight newly created brigades among his forces, two of which were made up of members of the International Brigades; he also had Soviet airplanes and vehicles. Franco employed German and Italian tanks and airplanes.

The inconsistent efforts of the European democracies—Great Britain and France primarily—to prevent any country from intervening in Spain had failed. Germany and Italy recognized Franco in November of 1936. That same month, Germany sent its Condor Legion, a group of a hundred airplanes with German pilots commanded by German officers. Germany would also send 5,000 advisors over the course of the war. Italy sent some 70,000 soldiers, who entered combat after January 1937. The USSR sent two thousand advisors to the Republic (instructors, aviators, artillery experts, etc); the total number of people enlisted in the International Brigades was about 60,000. Franco received about 1,200 German and Italian airplanes and some 350 tanks; the Republic got 1,300 airplanes—though because of the distance between the airports and the front, they were not always used to their full potential—and 900 tanks, almost all of which were from the Soviet Union. The war of columns in the summer of 1936 became a total war between increasingly better-equipped and larger armies (about 500,000 soldiers on each side by spring 1937), using artillery and aviation. The war also widened to include civilians. Bombing of civilian populations would become as important as the infantry on some fronts.

FRANCO'S ADVANCE

After one last (failed) offensive on Madrid in March 1937, which was led mostly by Italian troops (35,000 men, airplanes, tanks, etc), Franco took the war to the north. On March 31, after massive bombing by air and artillery, he began an attack on the Basque Provinces, which had become an autonomous region in October 1936 and was governed by the Partido Nacionalista Vasco. On April 26, German airplanes destroyed Guernica, the spiritual capital of the Basques, an event which stirred international outrage; Bilbao, the region's main city, the center of the Spanish steel and shipbuilding industries and the most important port in the country, surrendered on June 19 after fierce fighting. Days later, Franco achieved another victory, this time moral and psychological. On July 1, forty-eight bishops made public a document supporting the military uprising. They justified the war as a crusade in defense of religion. The Republican chief of staff, General Vicente Rojo (1894–1966), designed a brilliant counterattack in Brunete, near Madrid, but Franco was able to react in time and repel it. He conquered Santander in August and Asturias in October, which meant that he dominated the entire northern coast and the main mining, iron, and steel centers of the country, which is an important factor in explaining his final victory.

On October 1, 1936, the leaders of the uprising had named General Franco head of Government and State of Nationalist Spain, and commander-in-chief (Generalísimo) of the armed forces. Franco intended to found a new state based on a mélange of Catholic social doctrine, fascism, authoritarianism, and a host of political parties and free labor unions. In April of 1937, he ordered all the political forces that had supported the July 18, 1936 uprising, Falangists, Catholics, monarchists, and traditionalists, to become united in a single movement or party, the Falange Española Tradicionalista y de las JONS (the initials of some small Fascist parties). In January 1938, he nominated his first government, and in April he passed the Fuero del Trabajo, or Workers' Doctrine, a sort of charter for the new state, which was defined as a nationalist-syndicalist regime, with both Catholic and fascist inspiration.

Franco had maintained complete control in his area, which was a deciding factor in the outcome of the war. The contrast with the political evolution in Republican territory is revealing. Since the beginning of the war in July 1936, an Anarchist council had governed in Aragon. Catalonia had two governing bodies. On the one hand, there was the Generalitat, the regional autonomous government made up of leftist Catalanists, Anarchists, and Communists; on the other, there was the powerful Central Committee of Antifascist Militias of Catalonia, under the leadership of the CNT, an Anarchist labor union, which controlled factories, supplies, and armed militias. The central Republican government's authority was almost nonexistent. In May 1937, a civil war broke out within the civil war when militias of the CNT and the POUM (Partido Obrero de Unificación Marxista, a small Trotskyite party) confronted the Generalitat's forces of public order over the control of certain enclaves in Barcelona. The insurrection was controlled, but at a very high political and moral price. The head of the central government, the Socialist Largo Caballero, resigned because he did not want to accede to the Communists' and Soviets' demand that he declare the POUM illegal. He was replaced by another Socialist, Dr. Juan Negrín (1892–1952). He formed a new government in which the Communists were the most influential part, perhaps because they understood most clearly that the logic of war demanded that Republican territory be unified both politically and militarily. The central government's authority was reaffirmed in Catalonia, and, shortly thereafter, in Aragon. Beneath the romantic vision of antifascist resistance in Republican Spain, there arose another reality: the Communists' increasing domination of the Republic's political and military organizations.[10] For those, like George Orwell and other volunteers in the militias controlled by the POUM who had idealized the proletarian aspect of the Spanish struggle, the revolution had been betrayed. Members of the POUM, were accused of being agents provocateurs of fascism and were persecuted by the police, which was controlled by the Communist party. Andrés Nin, leader of the POUM died after being arrested and tortured. Orwell and other members of the POUM had to flee.

THE FINAL VICTORY

A new army counteroffensive initiated in December 1937 allowed the Republic to recover Teruel, one of the Aragonese capitals, in January 1938. But the Nationalists recaptured the city on February 22 after prolonged and fierce combat. In March, the Nationalists launched an offensive down the Ebro valley towards the Mediterranean, which they reached on April 15. They had cut the Republican territory into two. Franco then committed the strategic error of sending his army south, towards Valencia, through the Maestrazgo mountain range, an exceptionally difficult terrain. This made it easier for the Republic to defend its territory and could have had serious military consequences but did not. By the spring–summer of 1938, the Nationalists had achieved superiority over their enemies in the air and on the water. The Republican fleet had been forced to remain in its harbors; the supply of weapons and war material from the USSR, which came through the Mediterranean, had been seriously constricted.

But the Republic was not beaten yet. The government, led by the energetic Negrín, had reinforced discipline in the People's Army and had efficiently reorganized its military resources. Rojo again surprised Franco strategically. On July 25, 1938, the Republican army crossed the Ebro River at various points and threatened to break the Nationalist line. Again, however, Franco was able to react in time by shifting his forces to halt the Republican advance. The battle of the Ebro, which lasted into November, was the roughest and most devastating in the war: some 20,000 soldiers died, and total casualties on each side were around 60,000. Even though the Republic still had Catalonia, Madrid, most of La Mancha, Valencia, and the southeast, and had armed forces made up of four corps, a total of forty-nine divisions (eight less than Franco), the outcome of the war had been decided: the battle of the Ebro destroyed the People's Army's morale and operating ability.

On December 10, Franco initiated an offensive on Catalonia, which on paper was one of the best-designed operations in the entire war. The outcome was determined less by Franco than the Catalonians. Catalonia surrendered without offering much resis-

tance. President Azaña was indignant, since he had always thought that Catalonia had not contributed enough to the war effort. He was partly correct and partly unfair: Barcelona suffered over 500 air raids during the conflict. Barcelona fell on January 26, 1939, and, days later, Franco's troops arrived at the French border. Five hundred thousand people went sadly into exile, either temporarily or permanently. Among them were the president of the Republic, Azaña, and General Vicente Rojo.

Only Negrín and his Communist advisors thought it possible to prolong resistance; this, given the state of the two armies and the desire of the Western democracies to appease Hitler and Mussolini (Franco's main supporters), was probably impossible. On March 4, 1939, Lieutenant Colonel Casado, head of the central army and representative of the non-Communist and pro-surrender sector of the Republic, revolted against Negrín and formed a National Defense Council to negotiate a peace. For several days, Madrid was the scene of violent clashes between Casado's troops and Negrín's, in which some 2,000 people died. Moreover, Franco did not negotiate at all. He demanded unconditional surrender. His troops entered Madrid on March 28, 1939; two days later, they occupied Alicante, the last free Republican city. In its harbor, some 15,000 persons were waiting futilely to escape by sea. On April 1, Franco proclaimed victory. The war was over.

Some 300,000 people had died. 140,000 deaths occurred at the front and the rest behind the lines on each side. Another 300,000 went into exile, never to return, and a similar number (300,000) were imprisoned between 1939 and 1945 (the figures for executions in this period range from 28,000, which Franco's regime admitted to, to a maximum of 200,000, the figure brandished by the opposition, which is probably inflated). The destruction of buildings, bridges, railways, highways, ships, crops, and cattle was incalculable. The years from 1939 to 1942 were years of hunger in Spain.

From a democratic perspective, the Republic of 1931 was the most serious effort up to that time to modernize the country. Franco (1892–1975), a conservative, Catholic officer, short in stature, prudent and inexpressive, believed that liberalism and political par-

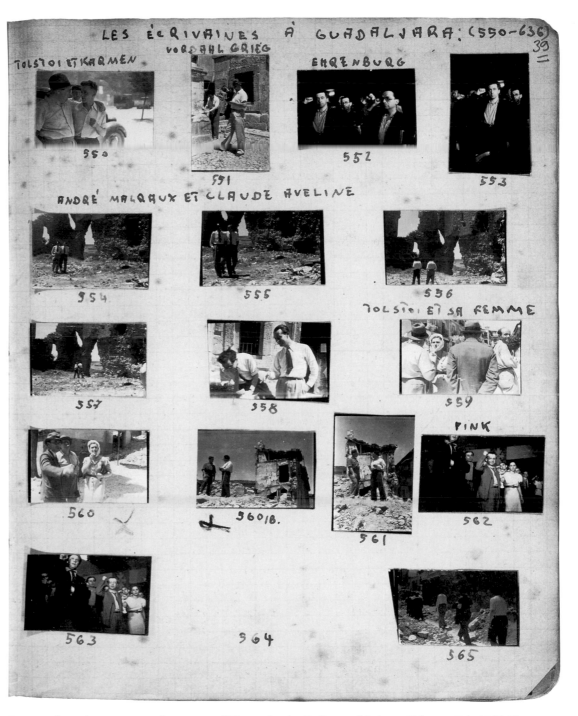

Portraits from the international congress of Writers for the Defense of Culture, Valencia, July 1937. From Robert Capa's notebooks. Photographs by Gerda Taro.

ties were to blame for Spain's troubles and created an authoritarian regime based on personal power that lasted until his death in 1975.[11] Three influences defined the new regime: the Falange's fascist ideas, the conservative social theory of the Catholic church, and the military's principles of order, national unity, and authority. Franco's regime was at first totalitarian, and clearly aligned with Hitler's Germany and Mussolini's Italy, although Spain remained neutral in the war. After 1945, it was defined as a social and Catholic monarchy, even though the king was never restored. During the years 1957 to 1961, after two decades of Nationalist economics that almost brought the country to bankruptcy, Franco's regime began to liberalize the economy. Only then did Spain's transition to an urban, industrial, and modern country begin.

Exactly because it was a great moment for humanity (to paraphrase what Charles Péguy said about the Dreyfus affair), the Spanish Civil War left an indelible mark on historical memory. The memory of the war and its terrible consequences, and the desire to avoid repeating a similar collective failure were some of the factors that favored the spirit of consensus and reconciliation that made Spain's transition to democracy after Franco's death possible. The war produced thousands of books, essays, and articles, hundreds of novels, numerous films, plays, and works of art, many of which became immediate classics: Capa's photograph *Falling Soldier* (taken in Cerro Muriano, Córdoba in September 1936) and Pablo Picasso's *Guernica*; personal testimonies, like Arthur Koestler's *Spanish Testament*, Orwell's *Homage to Catalonia*, and Bernanos' *The Great Cemeteries under the Moon*; novels like Hemingway's *For Whom the Bell Tolls*, Malraux's *Espoir* (Hope), Max Aub's cycle of novels entitled *The Magical Labyrinth*, and *The Evening in Benicarló*, the novel/dialogue written by Azaña, president of the Republic in 1937.

Some memories of the war inevitably reinforced the vision of Spain as a tragic, romantic, violent, yet generous and idealistic country. As writer Jorge Semprún would make the main character say in his work *La Guerre est finie* (1965), the war would end up becoming a myth for former combatants and would take a hallowed place in the history of the international left. Other memories, those contained, for example, in the many good books written about the conflict by historians such as Hugh Thomas, Gabriel Jackson, Raymond Carr and Edward Malefakis, make it possible to understand it in its true perspective. They make clear at least two salient points: first, that the war had profound political and ideological connotations (in other words, that it was not primarily a class conflict) and that the ultimate cause of this civil war, as is the case in other civil wars, was the moral division of the country; and second, that the process triggering the civil war (the military conspiracy and uprising) was caused by ultimately individual decisions which, because of the mere fact that they were individual, could have been otherwise.

Because of its characteristics, its national and international implications, the moral climate existing when it broke out, and the final result (Franco's triumph, executions, dictatorship), the Spanish Civil War did not, unlike the American Civil War, leave an epic and admirable memory. The memory of the Spanish Civil War was to be a tragic one, the reminder of an incomprehensible, and most likely unnecessary and useless horror. Jover Zamora, a historian, defined it as a true crisis of civilization. Thinking of Spain, Orwell commented to Koestler one day that "history stopped in 1936."[12]

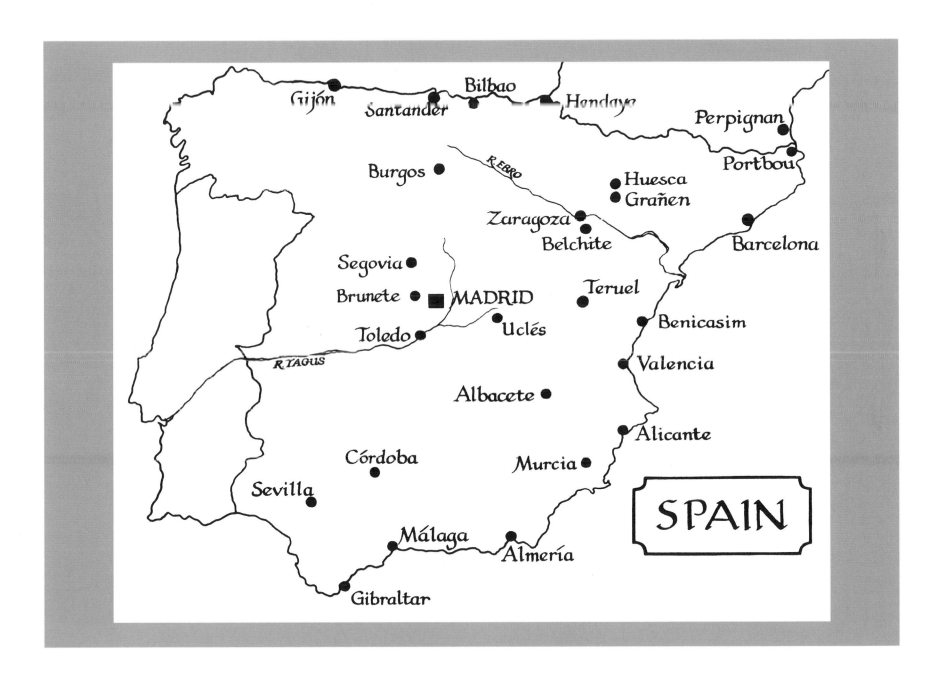

Gijón Bilbao Hendaye Perpignan

Santander Portbou

Burgos R. EBRO Huesca Grañen

Zaragoza Barcelona

Belchite

Segovia Teruel

Brunete MADRID Benicasim

Toledo Uclés

R. TAGUS Valencia

Albacete

Alicante

Córdoba Murcia

Sevilla

Málaga Almería

SPAIN

Gibraltar

25

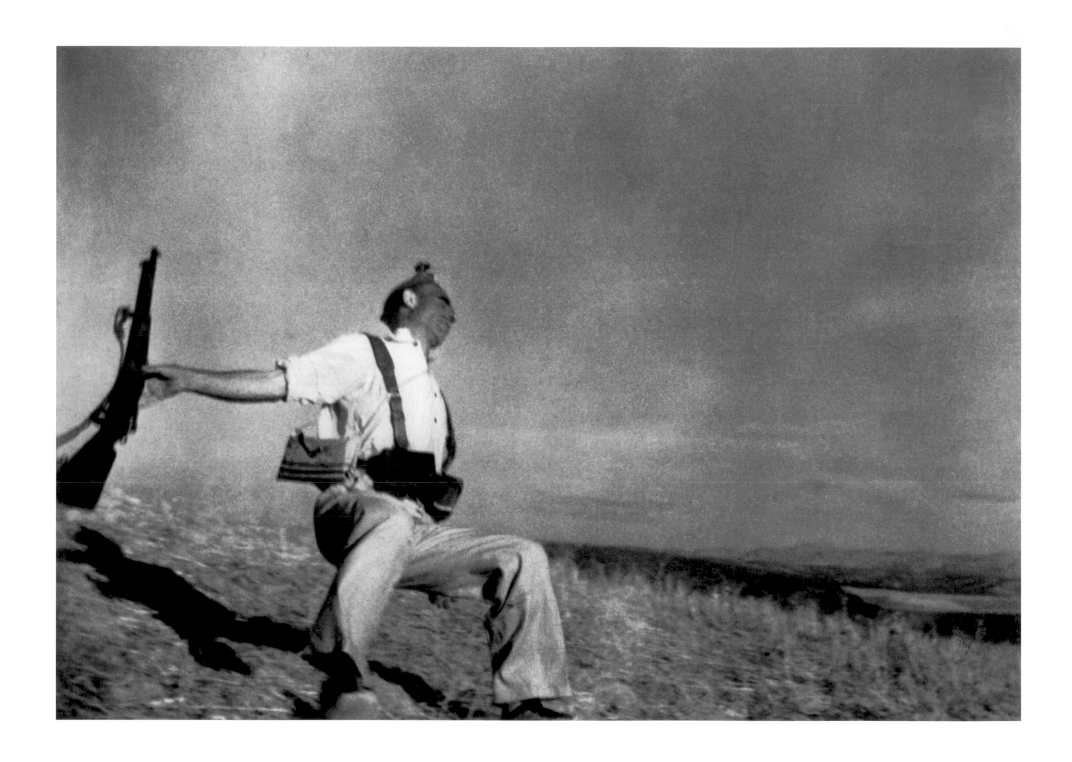

26 *Falling Soldier*, Cerro Muriano (Córdoba front), September 5, 1936

ROBERT CAPA IN SPAIN

RICHARD WHELAN

In December 1938, the prestigious British magazine *Picture Post* published eleven pages of Spanish Civil War photographs by twenty-five-year-old Robert Capa and proclaimed him "The Greatest War-Photographer in the World."[1] More than forty years after his death, Capa's extraordinarily powerful and moving coverage of war remains unsurpassed.

Besides documenting the Spanish Civil War, Capa spent six months in China during 1938 to photograph resistance to the Japanese invasion and went on to cover the European theater of World War II (1941–45), the first Arab-Israeli War (1948), and the French Indochina War (1954). On May 25, 1954, while photographing French maneuvers in the Red River delta, Capa stepped on an anti-personnel mine and was killed. He was forty years old.

Capa was born André Friedmann in 1913 in Budapest, where his parents owned a fashionable dressmaking salon. As a teenager, he had a precocious interest in social and political reform. His mentor, poet and painter Lajos Kassák, was the head of a group dedicated to socialism and avant-garde art. Among the works published in the group's magazine, entitled *Munka* (Work), were photographs by the great American reformers Jacob Riis and Lewis W. Hine, whose compassionate images of immigration, poverty, and child labor surely echo in Capa's photographs of refugees, life amid ruins, and children enduring the hardships and horrors of war.

As a high-school student, André had not yet thought of becoming a photographer. He was hoping to be a reporter, a profession that would enable him to combine his loves of politics and literature. Bright as he was, however, his prospects of attending a university in Hungary were not good, for the protofascist, anti-Semitic dictatorship severely limited the number of Jewish students. As a result of his participation in demonstrations and protests against that repressive regime, André was exiled from Hungary in July 1931, at the age of seventeen.

He went to Berlin to study journalism at the Deutsche Hochschule für Politik. In Berlin, he attended some of the popular discussion groups and lectures of Karl Korsch, who had risen to a high position in the German Communist Party before being expelled for his criticism of Stalin. Korsch favored an idealistically anarchistic society, and he believed that Spain was the nation in which such a society might be created.

On April 12, 1931, the people of Spain had gone to the polls and elected a republican government. Two days later King Alfonso XIII abdicated, and Spain was proclaimed a republic. In June of that year, Korsch was invited to Madrid to attend the congress of the Confederación Nacional del Trabajo (CNT), a powerful organization of anarchist trade unions (anarcho-syndicalists). He was very excited by what he saw and, upon his return to Berlin, published an enthusiastic article about the possibility that Spain could develop a non-Stalinist form of Communism.

When Capa first went to Spain to photograph the civil war in 1936, he made a point of seeking out the anarcho-syndicalist divisions that were fighting around Córdoba. The man in his famous picture of a militiaman who has just been shot was wearing a cap embroidered with the initials "CNT."

In Berlin, the rise of the Nazi party intensified André Friedmann's political engagement. His parents' Budapest business was badly hurt by the worldwide economic depression, and when they could no longer afford to send him money, he left school and got a job as an errand boy and darkroom assistant for the outstanding photographic agency, Dephot. There he was initiated into photojournalism. It is appropriate that for his first major assignment, late in 1932, this young man who admired Trotsky was sent to Copenhagen to cover a lecture given by the exiled Russian revolutionary.

Hitler's rise to power early in 1933 forced André to move on to Paris, where for nearly two years he had great difficulty in finding work. He fell in love with a young German refugee named Gerda Pohorylle, to whom he taught the basics of photography. She in

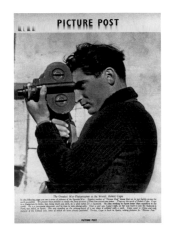

Picture Post, December 3, 1938. The page that deemed Capa "The Greatest War-Photographer in the World." The text reads "Regular readers of 'Picture Post' know that we do not lightly praise the work we publish. We present these pictures as simply the finest pictures of front-line action ever taken. They are the work of Robert Capa. . . . He likes working in Spain better than anywhere in the world. He is a passionate democrat and lives to take photographs."

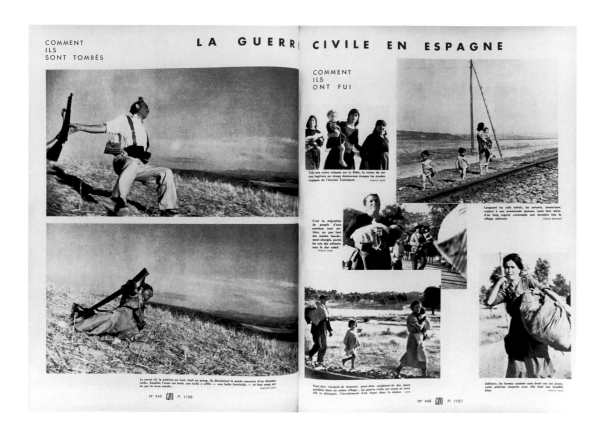

Vu, September 23, 1936. "La Guerre Civile en Espagne: Comment Ils Sont Tombés, Comment Ils Ont Fui" (The Spanish Civil War: how they fell, how they fled). The first publication of the *Falling Soldier* photograph.

turn hatched the idea of selling André's photographs as the work of an imaginary American named Robert Capa, who (so Gerda claimed) was extremely successful in the States. The plan worked, but the ruse was soon discovered, and André had no choice but to become Robert Capa. Gerda then changed her own name to Gerda Taro, taking her new surname from a Japanese sculptor, Taro Okamoto, with whom she and Capa were friendly in Paris.

In the spring of 1935, André/Capa's former boss at Dephot arranged for him to go to Spain to work on several assignments for German magazines. He went first to San Sebastián, where he did a story on the daily life of boxer Paolino Uzcudun, whose third fight with the German champion Max Schmeling was scheduled to take place in Berlin on July 7. Then Capa went on to Madrid to photograph Juan de la Cierva, who, in 1923, had invented a forerunner of the helicopter. Unfortunately, he refused to show Capa his machine, saying that he was now interested only in linguistics—a subject with little photographic appeal. While in Madrid, however, Capa did manage to photograph Lt. Col. Emilio Herrera, one of

Spain's most famous pilots, who was preparing for what he hoped would be a record-breaking balloon ascent to an altitude of 25,000 meters.[2] Having covered the great parade in Madrid on April 14 to celebrate the fourth anniversary of the Spanish Republic, Capa proceeded to Seville for Holy Week and the annual *feria.*[3]

He felt a great affinity with the warmth, the exuberance, and the generosity of the Spanish people, and his letters to his family, filled with accounts of his misadventures, read like a picaresque Spanish novel. Indeed, Spain and Hungary have much in common: both are sheep-raising, paprika-loving nations with a strong Gypsy tradition, and both endured long periods of domination by Islam and rule by the Hapsburgs.

In Paris, during the spring of 1936, Capa photographed the tumultuous parades and rallies before and after the election of the anti-fascist and pro-Soviet coalition of liberals, socialists, and communists known as the Popular Front, headed by socialist Léon Blum. Although the Soviet Union was at last taking a firm stand against Hitler and Mussolini, the League of Nations embraced a policy of appeasement, and the United States held itself aloof in isolationist neutrality.

The outbreak of the Spanish Civil War, in July 1936, finally gave anti-fascists an opportunity to confront fascism militarily. Capa and Taro both believed that it was absolutely vital for them to use their cameras to win worldwide support for the Spanish Republic and the anti-fascist cause.

They got their opportunity slightly more than two weeks after the outbreak of the war. Because Capa recently had several very strong *reportages* published in the outstanding French photographic magazine, *Vu,* the owner of the magazine, Lucien Vogel, invited him and Taro to join a group of journalists he was flying to Barcelona.[4]

Arriving in the Catalonian capital on August 5, Capa found the city radically changed since he had been there in the spring of 1935. After the swift suppression of the local military uprising, this comfortably bourgeois city had undergone a proletarian revolution.

Factories, stores, and restaurants had been taken over by their employees, and thousands of workers swelled the ranks of hastily organized militia groups.

At the Barcelona railroad station, Capa and Taro photographed soldiers bound for the Aragón front bidding a last farewell to their wives and sweethearts. Then, after a week or ten days in the city, they drove out to that front, where by mid-August the situation had become stalemated, as it would remain for more than a year. The fighting amounted to little more than occasional skirmishes—most of them at night, which, of course, was no good for photographers.

On the nearby Huesca front, Capa and Taro photographed militiamen camping in improvised shelters, manning machine-gun and artillery posts, and even helping farmers on nearby collectivized farms to harvest and thresh their wheat. Then the photographers drove southwestward, and for an excellent reason: the language in which they both were most comfortable was German, and there were many German émigrés serving in the militias between Huesca and Saragossa. Many of them had been in Barcelona to participate in the leftist Workers' Olympiad, organized to counterbalance the official Olympics held in Hitler's Berlin that summer.

Capa and Taro visited the village of Tardienta, headquarters of the German Communist Thälmann Centuria, but they spent most of their time with the column of the semi-Trotskyites of the Partido Obrero de Unificación Marxista (POUM) that had its headquarters in Leciñena, about twelve miles northeast of Saragossa. (It was with this POUM militia that George Orwell would serve that winter.) Like the anarcho-syndicalists, POUM supported the government in the civil war only because a Republican victory was a prerequisite for revolution.

Capa and Taro found the situation at Leciñena stalemated—as they would soon also find the Madrid, Guadarrama, and Toledo fronts. There was, however, one front from which the news sounded highly encouraging. During the second half of August, the Madrid government had begun an offensive to recover Córdoba. Day after day the government reported new advances, even emptily boasting that its troops had entered the city. If one wanted to photograph Republican victories, the Córdoba front was apparently the place to be. It was also there that one could see the most idealistic of the anarcho-syndicalist CNT militias in action.

II.

It was on the Córdoba front that Capa made the most famous of all his photographs, perhaps the greatest war photograph ever made—that of a Spanish Republican militiaman who has just been shot. It has been Capa's most controversial photograph, for during the 1970s questions were raised not only about the location at which the picture was taken but also about its reliability as an unposed document. Recently, however, the controversy has been definitively settled in Capa's favor by the discovery of the identity of the man in the photograph—Federico Borrell García, who was killed at Cerro Muriano, eight miles north of Córdoba, on September 5, 1936.

It is through circumstantial evidence, which I pieced together while working on my biography of Capa, that we know for certain that Capa and Taro were in Cerro Muriano on that day. In his book *The Spanish Cockpit* (1937) Swiss journalist Franz Borkenau tells that he witnessed a battle in Cerro Muriano that afternoon with two photographers from *Vu*.[5] They were Hans Namuth, who had known Capa in Paris before the outbreak of the Spanish Civil War, and his friend Georg Reisner. Namuth and Reisner photographed the terror-stricken inhabitants of the village as they were fleeing a fascist air raid. When I interviewed Namuth, he told me that he had not seen Capa and Taro in Cerro Muriano. But, a few weeks later, when he saw the issue of *Vu* dated September 23, 1936, which published (on the page facing Capa's *Falling Soldier*) Capa's photographs of some of the same people whom Namuth and Reisner had photographed along the same road outside Cerro Muriano, Namuth realized that Capa had indeed been there that day.[6]

That fact provided the essential clue for pinpointing where Capa made his *Falling Soldier* photograph. On the vintage prints pre-

served in the files of Capa's estate with their original chronological numbering, the numbers on the sequence of pictures to which the *Falling Soldier* belongs immediately precede those of the Cerro Muriano refugee series. (Unfortunately, most of Capa's film from Spain was cut into individual frames by his darkroom man in Paris, and many of the original negatives of the *Falling Soldier* sequence have been lost, including that of the famous photograph itself.) The numbering on the vintage prints clearly suggests that Capa made his *Falling Soldier* picture at Cerro Muriano, on September 5, 1936. Capa repeatedly confirmed during his lifetime that he had made his photograph on the Córdoba front.

The controversy over whether or not Capa posed this photograph was begun in the mid 1970s by the elderly British journalist O'Dowd Gallagher, who claimed to have been sharing a hotel room with Capa at the western end of Spain's border with France at the time the famous picture was made. But, nearly forty years later, Gallagher's memory had clearly played a trick on him. No doubt in perfectly good faith he confused Capa with someone else with whom he had shared a hotel room there in 1936. I believe that Gallagher and Capa did not meet until January 1939, when they were both staying in the same hotel in Barcelona. That such a lapse of memory is possible was dramatically demonstrated to me while I was conducting interviews for my biography of Capa. When I interviewed cartoonist Bill Mauldin, who inspired my confidence in his perfect recall, he told me that he had been with Capa on the Roer River front in the spring of 1945. I was surprised, for I was quite certain that Capa had been somewhere else at that time. But Mauldin assured me that he remembered very clearly being with Capa and, to prove his point, described the resulting photographs that had been published in *Life*. His descriptions were so precise that I recognized the photographs instantly when I looked them up in the magazine. They had, however, been made by George Silk, not by Capa, who was then covering the paratroopers who jumped east of the Rhine.

Gallagher told his story to three different interviewers over a period of a few years, and the glaring inconsistencies in his three accounts effectively discredited his testimony. Gallagher began by telling Phillip Knightley—a British writer who published the story in his book *The First Casualty: From the Crimea to Vietnam; The War Correspondent as Hero, Propagandist, and Myth Maker* (1975)—that "there had been little action for several days, and Capa and others complained to the Republican officers that he could not get any pictures. Finally . . . a Republican officer told them he would detail some troops to go with Capa to some trenches nearby, and they would stage some maneuvers for them to photograph."[7]

In 1978, Jorge Lewinski published in his book *The Camera at War* his interview with Gallagher, in which the journalist claimed that Franco's troops, not Republican ones, had staged the maneuvers:

> I began in Spain with [i.e., in] Hendaye in France, on the Spanish border by San Sebastián. Most of us reporters and photographers were there in a small shabby hotel. We went into Franco's Spain across the Irun River, when allowed by Franco's press officers in Burgos. . . . Once only the photographers were invited. . . . Capa told me of this occasion. They were given simulated battle scenes. Franco's troops were dressed in 'uniforms' and armed and they simulated attacks and defence. Smoke bombs were used to give atmosphere.[8]

Capa, however, would *never* have had anything to do with Franco's troops. The photographer, who was Jewish and a passionate anti-fascist, covered the Spanish Civil War as a profoundly committed partisan for the Republican side. Moreover, as a photographer who was by the summer of 1936 well known for his affiliation with several French leftist publications, he would never have been welcome in Franco-held territory except to be arrested.

In any case, it is possible to document Capa's travels in Spain between the outbreak of the civil war and the first publication of

his photograph; he was never anywhere within several hundred miles of San Sebastián.

As mentioned above, a dramatic revelation has recently removed all questions about the photograph's authenticity. The man in the photograph has been conclusively identified as Federico Borrell García, who was a twenty-four-year-old militiaman from Alcoy, near the city of Alicante, in southeastern Spain. His identity was tracked down by a Spaniard named Mario Brotóns Jordá, who has since died in Alicante. Born in Alcoy, Brotóns had himself joined the local Republican militia at the age of fourteen—and was present at the battle that took place at Cerro Muriano on September 5, 1936.[9]

When Brotóns's friend Ricard Bañó, a young Alcoy historian, mentioned to him that he had read in my biography that Capa's photograph might have been made at Cerro Muriano on September 5, 1936, Brotóns began his research. He knew that the man in the photograph must have belonged to the militia regiment from Alcoy, for the distinctive cartridge cases the man is wearing had been specially designed by the commander of the Alcoy garrison and made by the local leather craftsmen.

Brotóns then discovered in the Spanish government archives in Salamanca and Madrid that only one member of the Alcoy militia had been killed at Cerro Muriano on September 5, 1936—Federico Borell García. Brotóns then returned to Alcoy with a reproduction of the famous photograph and showed it to Federico's younger brother, Everisto, who had also been at Cerro Muriano on the fatal day. Everisto had not actually witnessed his brother's death, but he stated that the photograph conformed precisely to the verbal description he had been given of the circumstances, and that the man in the photograph was indeed his brother. The identification was confirmed by examination of family photographs of Federico.

The image of the *Falling Soldier* belongs to a sequence that shows the man in question among a group of soldiers jumping across a

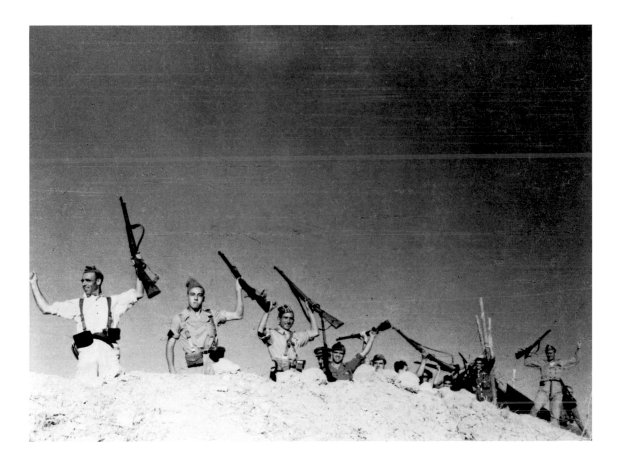

Cerro Muriano, Córdoba front, September 5, 1936

gully and firing over its far edge. When *Falling Soldier* was published in *Vu*, another photograph, showing a man in a further state of collapse on the same spot, was reproduced directly below it on the page. Although some writers have claimed that both photographs show the same man, careful examination leaves no doubt that they show two different men. One photograph in the series shows the two men lined up with some of their comrades and waving their rifles. Federico, who was to become the subject of *Falling Soldier* appears at the far left; the other man is third from the left. The latter is wearing cartridge cases with straps that cross to form an X over his chest, in contrast to the parallel vertical straps of the Alcoy design.

Capa's series of photographs shows that when the soldiers began their attack by jumping across a gully, the photographer was running beside them. After lying flat to fire a few shots, the soldiers then began their charge down an exposed hillside, where at least

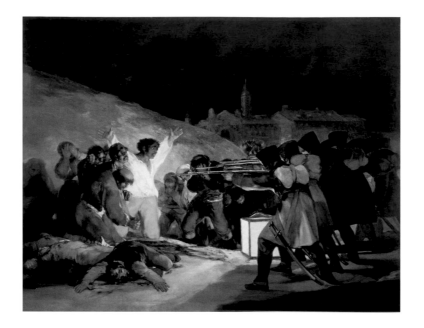

Francisco José de Goya y Lucientes, *Execution of the Defenders of Madrid, 3rd May, 1808,* 1814

two men were shot as they came into the range of enemy guns. It is obvious that Capa was close to the ground, pointing his camera upward, when he photographed *Falling Soldier*, and he remained in that position of relative safety at least long enough to photograph the other man's collapse.

Federico Borrell García was apparently the first to be shot. We do not see his body on the ground in the other photograph, for presumably momentum threw him some yards forward, beyond the frame of Capa's second photograph, before he collapsed completely. In the other photograph, the man has already collapsed so far that it seems likely that his body would have remained on the spot.

In 1938, Capa published a book of his (and Gerda Taro's) Spanish Civil War photographs, which he entitled *Death in the Making.*[10] A few years ago, one critic wrote that the fact that Capa didn't reproduce his most famous picture in the book reinforced doubts about its authenticity. The critic, however, had obviously never seen a copy of the book with its dust jacket, for that was where Capa reproduced *Falling Soldier*. Far from omitting the picture, he had given it maximum prominence.

When Capa's photograph was first published, in September 1936, viewers were astonished, for no one had ever seen such a picture. Earlier photographs of war had necessarily been rather static and distanced. Even as recently as World War I, the standard camera

had been the medium-sized Speed Graphic, with a bellows, using 4-by-5-inch plates. Not only did it call attention to itself, making candid shots nearly impossible, but it was also a burden with which the photographer could not easily maneuver in dangerous situations. By contrast, Capa's little 35 mm Leica was inconspicuous and gave him maximum mobility. With it he threw himself into the maelstrom of war, as no one had ever dared to do before.

When he was asked about his by-then-famous photograph in 1937, Capa replied, "No tricks are necessary to take pictures in Spain. You don't have to pose your camera [i.e., pose your subjects]. The pictures are there, and you just take them. The truth is the best picture, the best propaganda."[11]

The greatness of Capa's picture ultimately lies in its symbolic implications, not in its literal accuracy as a report on the death of a particular man. The photograph may be said to compress into a single figure all the drama of Goya's great painting of the execution of Spanish patriots by Napoleon's troops. Furthermore, the militiaman's position is reminiscent of depictions of the crucifixion of Christ. The photograph is an overwhelmingly powerful statement of the human existential dilemma, as the solitary man is struck down by an unseen enemy, as if by Fate itself.

Ultimately, even now that we know the identity of the subject of *Falling Soldier*, the photograph is a haunting symbol of all the Republican soldiers who died in the war, and of Republican Spain itself, flinging itself bravely forward and being struck down.

III.

By November 6, 1936, Franco's army had finally reached the outskirts of Madrid. Few preparations had been made for defense, and the Republican garrison was small and poorly equipped; the city's fall seemed inevitable. When the fighting began on November 7, Republican soldiers and civilians alike answered the fire of the most advanced German machine guns with the blasts of crude shotguns.

However, the next morning—almost miraculously, as it seemed to the beleaguered Madrileños—the first of the International

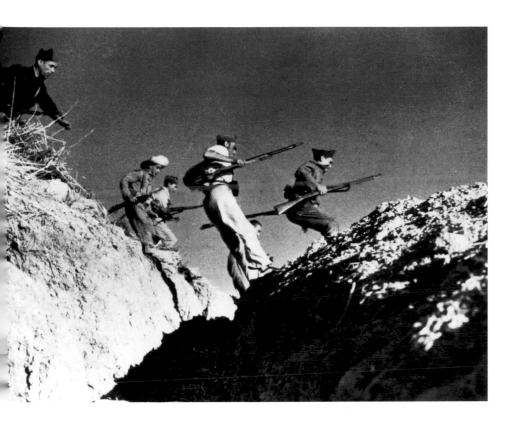

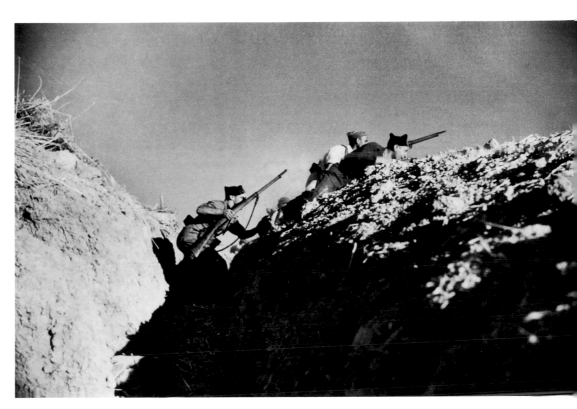

Cerro Muriano, Córdoba
front, September 5, 1936

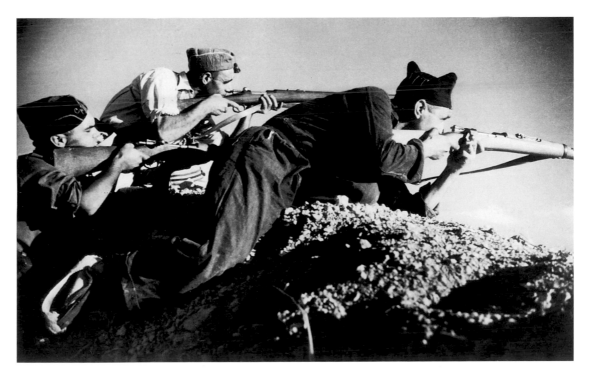

Brigades appeared, consisting of volunteers from nearly every country in Europe (very few Americans having yet arrived). Because Franco received aid from Germany and Italy, many young men and women in Europe and America felt that if they volunteered to aid the Republican side, they would at last have an opportunity to fight fascism and to inflict a defeat so decisive that the international fascist movement would be universally discredited, thus preventing a world war that otherwise increasingly seemed inevitable. These partisans defiantly proclaimed, "Madrid will be the tomb of fascism!"

They had been in the midst of training at Albacete but rushed to the aid of the Republican troops when it became clear that every available man and woman, no matter how poorly trained or equipped, was needed to defend Madrid. The arrival of this force of about two thousand gave an incalculably great boost to morale and enabled the Republicans to halt the Nationalist advance in the University City district, in the northwestern part of Madrid, where the battle soon became stalemated.

Capa arrived in Madrid on November 18. He spent a good deal of time his first week with the Twelfth International Brigade, whose commander, a lively and charming man who used the *nom de guerre* General Lukács, was Hungarian, and whose political commissar, Gustav Regler, Capa had encountered at meetings of an association of German émigré writers in Paris.[12]

During an ensuing battle in the farm buildings around the fortified manor house known as the Palacete de la Moncloa and in the neighboring model farms of the university's agricultural school, Capa attached himself to the Twelfth Brigade's Thälmann Battalion, the nucleus of which was formed by the German Communists of the Thälmann Centuria, which he and Gerda had visited on the Aragón front in August. He also went out by the slaughterhouses, which lay farther to the west in the no-man's-land between the lines, where he photographed Asturian *dinamiteros* as they used a small catapult to hurl their grenades across the old animal enclosures into enemy lines. The idea that former slaughterhouses for

animals were now slaughterhouses for men appealed greatly to Capa's sense of war's grotesque irony.

It was probably not until about a week after his arrival in Madrid that Capa paid an extended visit to the University City proper, where he found the Eleventh International Brigade engaged in a holding action. He spent most of his time with a company of the Commune de Paris Battalion in the Medical School, an immense, rambling building situated on high ground in the eastern section of the campus. Some of the very worst fighting had taken place there, and skirmishes continued, but most of Capa's photographs show only the watchfulness, the camaraderie, and the pluckiness of the French and Belgian volunteers who had settled in to defend the building.

Capa's pictures of Madrid make it clear that he was beginning to understand that the truth about war was to be found not only in the heat of battle, in the official show, but also at the edge of things, in the faces of soldiers enduring cold, fatigue, and tedium behind the lines and of civilians ravaged by fear, suffering, and loss. Throughout his entire career, Capa was always primarily a photographer of people, and many of his pictures of war are not so much chronicles of events as extraordinarily sympathetic and compassionate studies of people under extreme stress. He rarely photographed the dead or the grievously injured; instead, he focused on the survivors going on with life despite numbing losses and staggering destruction—the triumph of the indomitable human spirit.

Whether Capa's photographs show soldiers or civilians, the pictures are characterized by intimacy and immediacy, by compassion and empathy. The horrific tendency of modern warfare is to depersonalize. Soldiers can use their terrible weapons of mass destruction only because they have learned to conceptualize their victims not as individuals but as a category—the enemy. Capa's strategy was to *re*personalize war—to emphasize that those who suffer the effects of war are individuals with whom the viewer of the photographs cannot help but identify. Confronted with overviews of a battle or of vast movements of refugees, one may feel simply

overwhelmed and paralyzed. But the natural impulse of anyone who sees a photograph of an individual in pain or in need is to reach out and help.

Capa spent much time in the heavily bombed working-class district of Vallecas, where he photographed black-clad women with haggard faces who managed to laugh among themselves as they stood in line among the ruins for their daily food rations. But the homeless who took refuge on the platforms of the Madrid subway could not bring themselves to laugh. Capa's photographs of them lying on mattresses or sitting on benches in the Gran Vía station show only fear, sadness, resignation, and boredom.

There was, however, cause for rejoicing, for by the time Capa left Madrid on December 5 it seemed certain that the city would not fall. When he returned to Paris, his photographs created a sensation. *Regards* devoted much of its next four issues to them.[13] Although French publications at that time often gave no credit at all to photographers, the cover of the December 10 issue of *Regards* bore the following headline:

THE CRUCIFIED CAPITAL:
the prodigious photos
of
CAPA
OUR SPECIAL ENVOY TO MADRID.

Inside, the editors said, "*Regards*, wanting to give its readers a faithful, irrefutable image of the tragic life of the inhabitants of Madrid, bombarded by the fascists, sent one of its most qualified and audacious photographers to the Spanish capital."

In the middle of February 1937, Capa and Taro set out again for southern Spain. They went first to Almería, a whitewashed town on the Andalusian coast to which many thousands of refugees from Málaga had fled. Most of them had made the grueling one hundred-fifty mile, five-day trek on foot, and they had been repeatedly attacked by Nationalist planes. In Almería itself, as well as in Murcia, to which some of the refugees had been transported, Capa

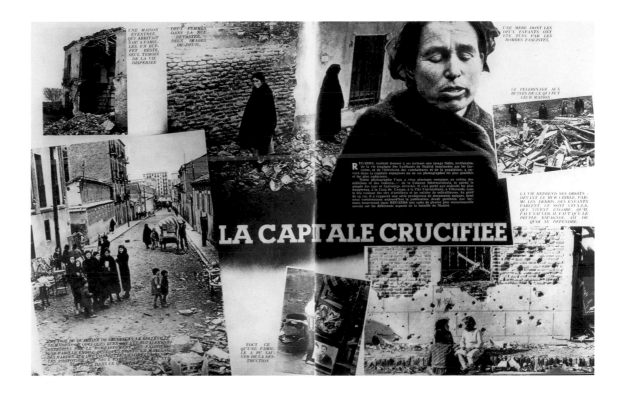

and Taro concentrated on scenes very similar to those in the Madrid subway stations, though even more wrenching. Here people were camping on the pavement, completely without shelter. Old women and children were huddled together on piles of sacks and blankets. The heads and feet of many were wrapped in bandages. The faces of even the youngest children, usually oblivious to tragedy, registered despair.

After a week in the hills between Almería and Málaga, where they saw no fighting, the photographers proceeded to the Jarama front, where the Nationalists were trying to cut the vital Madrid-Valencia highway. By the time Capa and Taro arrived, however, the Republicans safely held the highway, at least for the time being. Nor did they see any fighting when they returned to Madrid and visited the elaborate system of trenches, tunnels, and caves that the Republicans had dug around the Nationalist-held Clinical Hospital in the University City.

Early in March, Capa accepted a job as a staff photographer for *Ce Soir*, a newly founded Popular Front newspaper whose editor in chief, Louis Aragon, was a well-known Communist. The paper

Regards, December 10, 1936. "La Capitale Crucifiée" (The crucified capital).

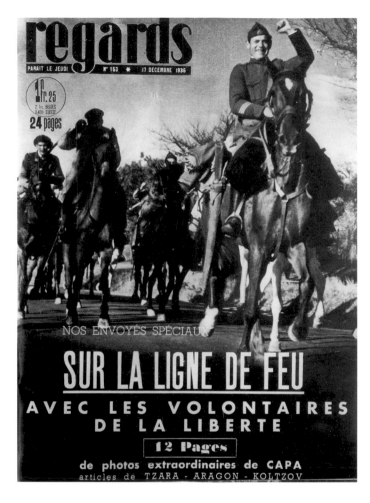

Regards, December 17, 1936. "Nos Envoyés Spéci-aux sur la Ligne de Feu avec les Volontaires de la Liberté" (Our special envoys at the front line with the volunteers for liberty).

would publish many of Capa's most important photographic stories from Spain.

After about a week of visiting the once again stalemated fronts outside the city, it became clear to Capa that the really exciting news was going to come not out of Madrid but out of Bilbao. After the National-ist setback on the Guadalajara front northeast of Madrid, Franco—eager to gain control of the iron ore, coal, and industry of the north—had decided to move the bulk of his forces from around the capital and send them against the Basque Country.

By the time Capa arrived in early May, Nationalist troops were ap-proaching the city from the east along a broad front. Having taken the defenseless towns of Durango and Guernica after merciless bomb-ings, they had come to the range of low mountains that served as Bilbao's last natural line of defense. On May 7, they attacked Mount Sollube, one of the most strategically important of those mountains. Capa covered the battle from the Basque trenches.[14]

He spent the next ten days documenting life in the beleaguered city itself, where the air raid sirens often sounded fifteen or twen-ty times in a single morning. As the populace ran frantically for shelter, Capa calmly remained above ground photographing until the streets were empty. The greatest of his pictures from this time shows a mother and daughter holding hands and running; in her panic the girl has misbuttoned her coat. Capa had a genius for cap-turing such poignant and revealing details.

Late in May, Capa and Taro returned to Madrid, where they stayed at the Hotel Florida, favored by journalists because of its proxim-ity to the press office in the Telefónica, then the tallest building in the city. That proximity also had an unpleasant drawback, how-ever, for occasionally a Nationalist shell aimed at the Telefónica would land on the hotel, doing little damage besides breaking win-dows and blowing out the water-heating system, but nevertheless shaking up the residents.

Among the journalists staying at the Florida was Ernest Hem-ingway, who had arrived in Madrid late in March to collaborate with John Dos Passos and Dutch documentary filmmaker Joris Ivens on a film eventually entitled *The Spanish Earth*. Capa and Taro became friendly with all of these men.

On May 31, Capa and Taro were at the Navacerrada Pass, near Segovia, to cover the abortive Republican offensive that Heming-way described in *For Whom the Bell Tolls*. On the first day of the battle, the two photographers took turns using an Eyemo movie camera to shoot footage for the Time Inc. newsreel series *The March of Time*. The other would make still photographs with a Leica. Hemingway was not present, and much of the description in his novel was based on the photographs and on Capa's eyewit-ness accounts.

Back in Madrid, which was enduring some of the heaviest shelling of the entire siege, Capa and Taro photographed and filmed *dina-miteros* using guerrilla tactics in house-to-house fighting in the southwestern suburb of Carabanchel, and they covered the state funeral of General Lukács, who had been killed in an attack on Huesca on June 12, when his car was hit by an enemy shell.[15]

More important than anything happening in or near Madrid was the Republican resistance to a Nationalist drive toward the rich mining region around Peñarroya, Pozoblanco, and Almadén. Accord-ingly, the photographers headed south, arriving on June 24 at the Chapaiev Battalion's headquarters near Peñarroya. On their first day, Capa and Taro filmed and photographed the victorious bat-talion's own reenactment of their successful attack on the village of La Granjuela, which had taken place on April 5.[16]

Capa then returned to Paris, but Taro remained in Spain to cover the congress of the International Association of Writers for the Defense of Culture. Soon, however, she decided that it was much more important for her to cover the major Republican offensive that had just been launched toward Brunete, west of Madrid. Day after day she drove out from Madrid to document the battle, which was far bloodier than any previous one in the civil war.[17]

Late in the afternoon of Sunday, July 25, during a confused retreat, Taro jumped onto the running board of a general's car to be carried to safety. Alas, the car was sideswiped by an out-of-control tank, and Taro was badly crushed. She died early the following morning. She was widely revered as the first female photographer ever to die in combat, and she became a heroine to thousands of young women.

When he learned the terrible news, Capa was inconsolable. After the splendid funeral that the French Communist Party gave Taro, and after her burial in Père-Lachaise cemetery, Capa went to New York, where his mother and brother had settled. Unable to bear the thought of returning to Spain, he then made plans to accompany Joris Ivens to China to make a documentary film about Chinese resistance to the Japanese invasion that had begun the previous year. Because Japan was allied with Germany, China was widely regarded as the eastern front of the anti-fascist war in Spain.

Shortly before his departure for China, Capa was drawn back to Spain to cover a battle too important for him to ignore, despite his personal pain. On the morning of December 15, 1937, the Republicans began a massive assault on the walled town of Teruel, a Nationalist stronghold in the bleak mountains of southern Aragón. The Nationalists clearly planned to use Teruel as the jumping-off point for their campaign to drive a corridor through to the Mediterranean, thereby separating Barcelona from Valencia and Madrid. The Republicans hoped that their offensive would not only stop the Nationalist push to the sea but also provide the psychologically decisive victory that the Brunete offensive had failed to yield.

Capa arrived at Teruel on the twenty-first and accompanied a detachment of *dinamiteros* as they spearheaded a direct attack on the town, finally blasting their way in with grenades. Having accompanied the first Republican troops to enter the town, and feeling certain of a Republican victory, Capa rushed back to Valencia that evening to send off his scoop.

On each of the next three days he drove with Hemingway and two other journalists to Teruel to witness the continuing battle, returning every evening to the relative comforts of Valencia.

Then, on New Year's Day, Nationalist newspapers and radio stations claimed that their side had retaken Teruel. Because communication lines around Teruel had been knocked down, not even military officials in Barcelona could deny the claims with certainty, Capa and *New York Herald Tribune* reporter Herbert Matthews set out to investigate. After an arduous journey over snow-choked roads, they found that although the Nationalists had gained a great deal of ground, most of Teruel was still in Republican hands. Capa and Matthews then covered a Republican attack on the largest concentration of Nationalists, in the charred ruins of the Civil Governor's palace; after blasting away the façade, the Republicans swarmed over the rubble and into the building, where ensued (wrote Capa, who scrambled after them) "a grenade battle without mercy."[18]

By the time Capa left Teruel that evening to return to Paris, the Republicans held the palace, and by the end of the week they again held the entire town, but they would not hold it for long. By the end of February, the Nationalists would retake Teruel, and on Good Friday, Franco would reach the sea.

Capa spent most of the first nine months of 1938 in China. When he finally returned to Spain, in October, the news was bad. In an attempt to win Hitler's friendship, Stalin had ordered the International Brigades to disband, thereby more or less guaranteeing victory to Hitler's ally Franco. On October 16, in the hills near Falset, a few miles east of the Ebro River, Capa photographed the men of the brigades as they marched in their final review.

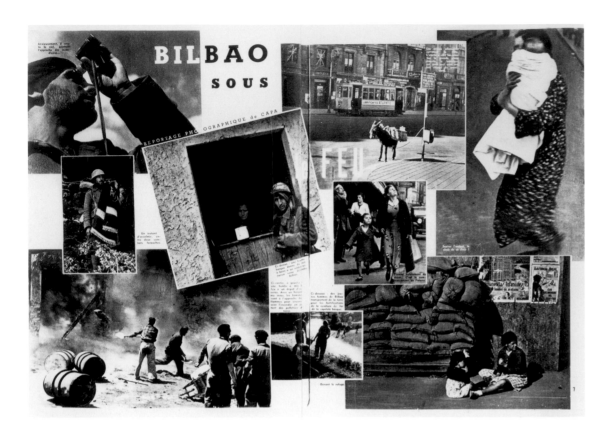

southwest of Urida, near the town of Fraga, where the fighting was especially heavy. In this barren, rocky, hilly terrain, as thousands of men made a last, futile attempt to thwart the imminent Nationalist victory on the Ebro, Capa made some of the most dramatic front-line battle photographs of his entire career. Looking at them, we can almost believe that we can smell the acrid fumes of gunpowder and feel the earth shaking as shells explode nearby.[21]

Life gave the story two pages; *Regards* gave it five pages and the back cover; and Stefan Lorant's new British magazine, *Picture Post*, devoted eleven pages to the photographs, calling one of them (of several men taking refuge under a rock overhang as shells explode close by) "the most amazing war picture ever taken." The magazine prefaced the story with a nearly full-page photograph of Capa (reproduced on p. 27).

When Capa returned to Spain, around January 10, 1939, he went to the Catalonian front to photograph General Lister and his men, but there was a lull in the fighting, and thereafter he remained in Barcelona.

Although some hoped that the city might follow Madrid's heroic example in defending itself, the realists correctly surmised that the hungry, exhausted, poorly armed city, which was now being heavily bombed, could offer little resistance.

During the night of January 12, Barcelona was plastered with posters announcing the general mobilization of all men up to the age of fifty for the defense of Catalonia, and by noon on the thirteenth the mobilization centers were filled to overflowing. That afternoon Capa went to one such center, a stadium on the outskirts of town. In his poignant series of photographs of the men with their families, he captured the fear, the gravity, and the resignation of the farewells.

Two days later, on January 15, Capa was out on the coastal road south of Barcelona photographing the refugees who had waited until the last minute to abandon Tarragona. Some had piled so many possessions onto their carts that they had to help the ema-

On October 25, Capa, in the company of fellow photographer and close friend David Seymour (also known as Chim), drove out to Montblanch, where government and military leaders were to bid farewell to a large delegation of volunteers of all nationalities. Capa focused on the men's strong faces, whose sadness reflected their certainty that the departure of the brigades would mean the Republic's defeat. Four days later he and Chim covered Barcelona's exuberant but bittersweet farewell parade for the volunteers.[19]

On November 5, Capa and Hemingway drove out to Mora de Ebro and crossed the treacherous Ebro River in a small boat to spend a day with General Lister and his fifth Army Corps, which was barely holding out against a major Nationalist offensive.[20]

The next night, in an effort to divert the Nationalists from the battle at Mora de Ebro, Republican troops waded across the Segre River, a tributary of the Ebro, some forty miles to the north. When word of the offensive reached Barcelona early on the morning of the seventh, Capa headed straight for the front. He found it

ciated mules by pushing from behind. Suddenly, planes swooped down over the road to machine-gun the helpless refugees. Among the most harrowing of the photographs Capa took that day was a series that show an old woman who miraculously survived unscathed an attack that killed everyone else in her group as well as her dog and her two mules. Capa found her circling her cart endlessly in a state of uncomprehending shock.[22]

To accompany his reportage, Capa wrote:

I have seen hundreds of thousands flee thus, in two countries, Spain and China. And I am afraid to think that hundreds of thousands of others who are yet living in undisturbed peace in other countries will one day meet with the same fate. For during these last three years that is the direction in which the world we wanted to live has been going.[23]

A few days later, after describing a beautiful, dark-eyed young girl he had photographed as she sat despondently on a pile of sacks in front of a Barcelona refugee center, he wrote, "It is not always easy to stand aside and be unable to do anything except record the sufferings around one."[24]

By January 21, Heinkel bombers had become an even more familiar and dreaded sight than ever in the skies over Barcelona. Often a respite of no more than fifteen minutes separated the raids, day and night. Then, at about one o'clock on the morning of Wednesday, January 25, arrived the alarming news that the Nationalists had already crossed the Llobregat River, less than ten miles to the west. Capa and several other correspondents piled into their car and drove north on the coastal road to Figueras, the last major town before the French border. One of Capa's companions wrote that they "overtook thousands and thousands of refugees, in carts, on mules, afoot, begging rides in trucks and cars, and always wearily struggling forward to that inhospitable frontier which still remained grimly closed to them," for the French had not yet agreed to allow the refugees to enter France.[25]

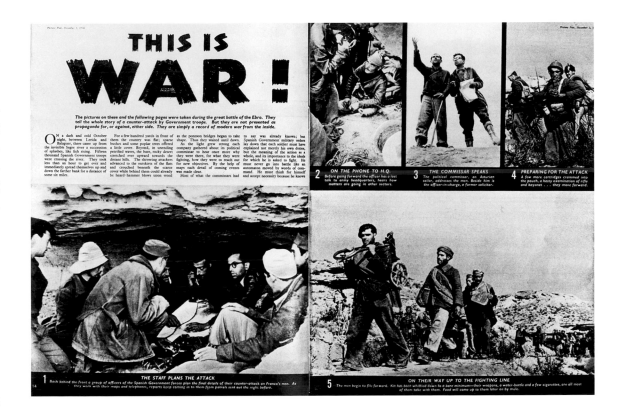

Capa spent the next several days in Figueras, photographing refugees in the town and on the nearby roads. On January 28, Capa crossed the border along with some of the first of the four hundred thousand men, women, and children who were eventually to leave Spain.

While he was in London in February, word came through that the French government (which until then had admitted only Spanish civilians) had finally decided to allow the retreating army of two hundred thousand Republican soldiers to cross the border, though they would be held in internment camps near Perpignan. Lorant immediately assigned Capa to do a story for *Picture Post* about the camps, but the photographer could not yet bear to face the humiliation that his Spanish comrades were having to endure at the hands of the French, who, he later wrote, "received the exhausted Spanish refugees with the cruel indifference of people who are warm and well fed."

It wasn't until mid-March that he made the journey to the huge camp on the beach at Argelès-sur-Mer where some seventy-five

"This is War!" *Picture Post*, December 3, 1938.

thousand men were interned. The camp, surrounded by barbed wire and patrolled by mounted Senegalese soldiers who were uncomfortably reminiscent of Franco's Moors, was, as Capa wrote, "a hell on the sand." Most of the men still were living in improvised tents and straw huts, which gave little protection against the abrasive, wind-driven sand. To make matters worse, there was no running water, only brackish water from holes dug in the sand.[26]

By the time Capa arrived, a slightly more comfortable camp had been built at Le Barcarès, twenty miles to the north. One great series of photographs shows a seemingly endless line of men, led by gendarmes, walking up the coast to the new camp.

During the first week of May, Capa went to Biarritz to photograph the comfortable orphanages that had been established on five nearby estates by the Foster Parents' Plan for Spanish Children. Each child corresponded with his or her sponsor—among them Eleanor Roosevelt, Helen Hayes, Tallulah Bankhead, Archibald MacLeish, Rockwell Kent, and the cast of the Broadway hit *The American Way*—and those who had been "adopted" by a famous person took special pride in that fact. Capa took several photographs of twelve-year-old Lorenzo Murias, who was nicknamed "Rooseveltito" in honor of his "foster mother."[27]

IV.

Early in November 1944, Capa drove from liberated Paris down to Toulouse for a three-day meeting of the Union Nacional Española. Toulouse, which had become the center of Spanish Republican activities in France, was filled with Spaniards who believed that since they had helped to liberate France, the Allies now had a responsibility to help them liberate Spain. Indeed, the Allies had secretly considered such a plan but abandoned it.

During October, however, several groups of Spanish exiles had tried to take matters into their own hands. On the twenty-second, a group of about one hundred fifty of them (Spanish government reports of thousands were wildly exaggerated) crossed the border southeast of Bagnères-de-Luchon and briefly gained control of a few frontier villages in the Aran valley. Government troops moved in quickly, killing, wounding, or capturing many and sending the rest fleeing back across the mountains. From Toulouse, Capa went up into the mountains to see where they crossed the border, and then he went to a hospital to visit some of the survivors, most of whom had light wounds and frostbitten feet. His photographs of their faces reveal that even after years of exile and struggle these men retained the courage, determination, and warm humor that had appealed to him so greatly during the Spanish Civil War.[28]

Capa never returned to Spain.

TECHNICAL NOTE

Between 1990 and 1992, Cornell Capa and I reexamined all of Robert Capa's contact sheets. From the approximately seventy thousand negative frames that he exposed during his lifetime, we chose 937 images to constitute an in-depth—though certainly not exhaustive—survey of his finest work. Of those 937 images, many of which have never before been published or exhibited, 205 were of the Spanish Civil War. Under our close supervision, an edition strictly limited to three identical sets of 937 prints on 16-by-20-inch paper was produced by master printers Igor Bakht and Teresa Engle Moreno. This project was made possible by the generous support of the Tokyo Fuji Art Museum, which acquired the first set. The second set has been donated by Cornell Capa to the permanent collection of the International Center of Photography in New York. Because of Robert Capa's European heritage, the third set is intended for an as of yet undetermined European museum.

For his donation to the Museo Nacional Centro de Arte Reina Sofía, Cornell Capa has now had Teresa Engle Moreno produce a new set of 205 prints of the Spanish Civil War photographs on paper trimmed to 15½-by-19½ inches in order to prevent any pos-

sible confusion between these prints and those of the three master sets of 937.

To assemble anything that might be called a truly definitive set of Capa's finest photographs of the Spanish Civil War would be impossible, for caches of previously unknown images turn up from time to time, and many of them are very fine indeed.

One of the most exciting discoveries in recent years was a small suitcase, containing ninety-seven photographs and miscellaneous papers, which had belonged to Prime Minister Juan Negrín of the Spanish Republic. Most of the photographs are by Capa, though a few are by Taro or their friend Chim. Some of the strongest Capa pictures in the collection are unique prints of images whose negatives were lost in the early 1940s. Capa, who was quite friendly with Negrín, had evidently given these ninety-seven prints to the Prime Minister, who took them with him into his French exile. When the outbreak of World War II subsequently forced him to flee France incognito, he gave the suitcase to the Swedish consul in Vichy for safekeeping, as Negrín knew that if he were apprehended with such evidence of his former position he would be in grave danger. The suitcase was eventually sent to Stockholm, where it was placed in the archives of the Swedish foreign ministry. In the late 1970s, an employee of that ministry came upon the suitcase, opened it, and realized that it should be returned to the Spanish government. The Swedish ambassador delivered it to Madrid in March 1979. A catalog of all ninety-seven prints was published by the Ministry of Foreign Affairs in 1990, and the photographs now form part of the collection of the Archiva Histórico Nacional, Sección Guerra

Civil, located in Salamanca. That archive owns prints or microfilm of some eighteen thousand other photographs of the Spanish Civil War, some of them probably by Capa. The archives of the Spanish Communist Party, in Madrid, also contain thousands of civil war photographs, some of which are undoubtedly Capa's.

In terms of the number of previously unknown Capa images of the Spanish Civil War, the notebooks rediscovered during the 1980s in the Archives Nationales, in Paris, are even more important than the Negrín collection. These eight notebooks contain about twenty-five hundred contact prints of Capa's 35 mm film, many of them cut into individual frames, pasted onto the pages, and labeled by subject. There are at least several dozen first-rate pictures for which no negatives are known to exist. With recently developed laser scanning techniques, these tiny contact prints may be used, as if they were negatives, to produce high-quality enlargements, which will considerably expand our knowledge of Capa's coverage of the Spanish Civil War.

These notebooks were apparently confiscated from Capa's Paris studio in the fall of 1939, shortly after the outbreak of World War II, by the section of the French Ministry of the Interior charged with investigating foreigners. As an Eastern European who had published extensively in left-wing periodicals, Capa was automatically placed under suspicion. Fortunately, he was able to leave France for New York, in October 1939. In 1952, Capa's notebooks were included in a mass transfer from the Ministry of the Interior to the Archives Nationales. They remained there, unnoticed, until a researcher stumbled upon them more than thirty years later. Some of these pages are reproduced in this volume.

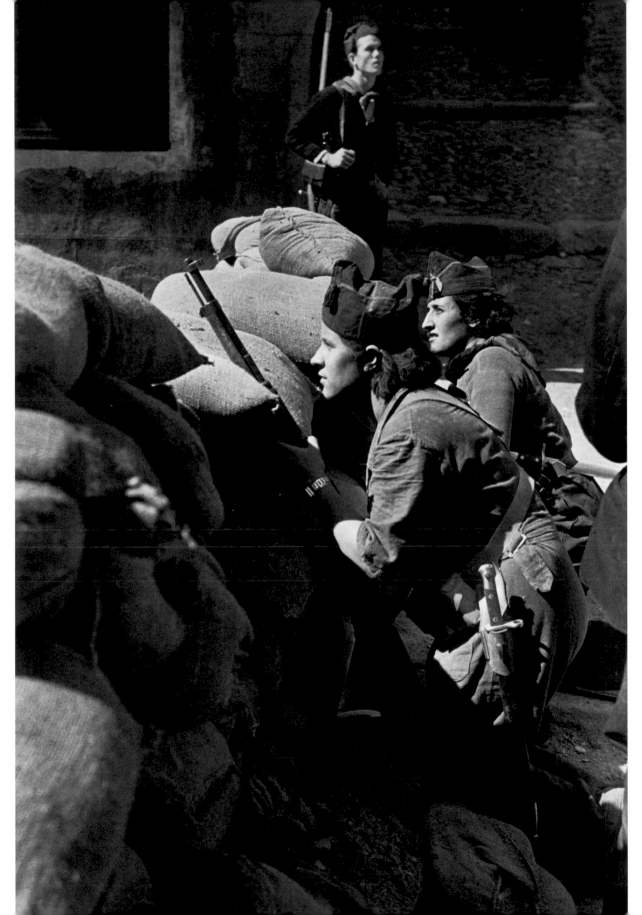

Barcelona, August 1936

WOMEN IN THE CIVIL WAR

CATHERINE COLEMAN

It is widely accepted that the Spanish Civil War was a harbinger of the global fight against fascism. It is now clear, however, that there were other social battles also being fought—battles which were then considered less urgent and, consequentially, are less evident in many of the histories of that time. Among them was the struggle for gender equality. It is from this perspective that we reexamine Robert Capa's photographs. Capa not only captured the pro-democratic, Republican fight, but also the flash of freedom Spanish women experienced in the 1930s. Between August 1937 and January 1939, Capa reported on the Spanish Civil War in many assignments for *Vu*, *Ce Soir*, *Regards*, *Life* and other publications. Many of his photographs depict women as protagonists on the Republican frontlines in the first stages of the war. (Capa did not photograph on the Nationalist side, and anyway, women had no involvement in the military on the fascist side.) Throughout the entire war, Capa photographed civilians as well as frontline combatants; at the end of the war he documented the Republican exile. Capa staunchly defended his leftist and antifascist beliefs, although he was never formally a member of any political party. As detailed in Richard Whelan's biography,[1] Capa was exiled for political reasons twice (from Hungary in 1931 and Germany in 1933) and castigated for being Jewish. His photographs defiantly tell the story of the side of the civil war with which he sympathized: the Republican fight against fascism and for democracy—for both men and women.

The anarchist Federica Montseny, a member of the Republican government,[2] argues that women who participated in the war have been silenced, their stories ignored, and their roles in the fight underreported. Perhaps the explanation for this gap lies in the old saw that winners write history and that the fascists were not fellow travelers in the fight for gender equity. Whatever the cause of this lack of attention, it is now being rectified by historians employing research tools such as oral history, which are better able to capture and record the voices and roles of women in this fight. Capa's photographs are an important part of this effort at historical rehabilitation.

WOMEN'S ACTIVISM AND THE GROWTH OF THE WOMAN'S MOVEMENT

The all too brief (1873–74) First Spanish Republic advocated the secularization of the state, the overthrow of the monarchy, and the end of the Catholic Church's control over education. It even went so far as to acknowledge, albeit with reservations, the potential of the female mind at a time when the literacy rate for women was only 9.6 percent (1870) and women who had completed the sixth grade were considered well-educated.

Miguel Primo de Rivera's dictatorship (1923–30) flirted with the idea of woman's suffrage; the decree of April 24, 1924, gave the vote to those unmarried or widowed women who were not subject to *patria potestad*—the authority of a husband or guardian. Despite these restrictions, at the very least women's suffrage was debated under Rivera's dictatorship. Thanks to increased awareness, the Second Republic could not ignore the 1924 decree. Moreover, one of the Republic's goals was to emulate western democracies based on one person/one vote. It could hardly offer fewer rights than the oppressive regime it supplanted had. Women's suffrage became an issue of crucial importance not only as an issue of individual democratic rights but also one of the well being of the entire republic. After the elections of April 1931, the Second Republic took immediate action to pass legislation to modernize the country's political structures.

The majority of Spanish women at that time were uneducated: the literacy rate for women in 1931 was 60 percent in Andalusia and 25–30 percent in the Basque country. The general consensus was that women, although different from men, were not inferior. Nevertheless, it was assumed that they were still in need of and

dependent on men to chaperone and protect them. A woman's duty was to the family, and her biological function was her destiny. Women had never been allowed to participate in the public sphere or to have a voice in the country's governance. (An exception should be noted, however, in that a minority of women in aristocratic circles were influential and contributed to political intrigues through the salons that they themselves created.) Work outside the home was frowned upon. Of those who did work, 40 percent of their jobs were in domestic service. Marriage frequently offered the only means to economic security.

Between 1931–33, issues influencing women's lives began to be addressed and progressive legislation was enacted, including the promotion of public coeducation through secondary school, night school for all adults, civil marriage and divorce. All were a result of the separation of Church and State. Under these reforms, education and the family fell under the jurisdiction of the State, not the Church. "Equal pay for equal work" was accepted in theory if not in practice. However, despite legal equality the patriarchal system remained intact and discrimination continued. For the most part, legislation on the status of women came before popular acceptance or demand. Nevertheless, in both actual and philosophical terms, these initial reforms opened new horizons of possibility.

While the Spanish constitution of 1931 had been inspired by such revolutionary constitutions as Mexico's of 1917, Russia's of 1918, and particularly by the 1919 German Weimar constitution, all of which recognized equal rights for both sexes, including suffrage, it did not mimic them. The feminist movement in Spain was neither revolutionary nor widespread; rather, it was a product of the equal rights agenda of the liberal bourgeoisie and did not have the backing of the mass of Spanish women. The issue of women's suffrage arose not because of popular pressure but because of the views and power of two conflicting sections of the country's elite.

In 1931 the issue of women's vote in Spain was still unresolved. The Republican cabinet must not have been entirely of one mind when, on May 8, 1931, it declared women eligible to run for and hold electoral office, but not eligible to vote.

The pros and cons of women's suffrage were debated by two of the three female parliamentarians who were elected to the 476-seat Constituent Assembly on June 28, 1931: Victoria Kent of the Radical Socialist Party and the socialist Clara Campoamor.[3] The debate took place during the month of September 1931, in the Parliament and the press. Granting women the right to vote meant incorporating approximately 7.9 million new votes (1933 census) to create of total pool of about 15 million. Much was at stake and, obviously, all political parties actively attempted to woo these potential voters.

Victoria Kent and numerous leftist intellectuals were against granting women the right to vote at that particular moment in history. Contending that women were still not sufficiently prepared to think independently, and fearing that husbands and confessors would dictate women's votes, they supported the delay in extending the vote to women, fearing that two years of republican reform would not be sufficient to reverse centuries of tradition and illiteracy. In the words of Gabriel y Galàn,

The Spanish woman deserves all the respect in the world as a housewife inside the Spanish home; the Spanish woman, as educator of her children, also deserves the praise of a poet; but the Spanish woman as a politician is handicapped, she is reactionary, and she still has not separated herself from the influences of charity and confession; thus, giving women the right to vote is like handing them a political arm that would kill the Republic. Woman's clericalism is what impedes equal electoral rights.[4]

Regardless of whether this diagnosis of women's political leanings was correct, it was not politically convenient for the Republic's immediate future to have female voters in the upcoming 1933 municipal elections. The Republic was threatened from within by two opposing factions: landed interests, the Church, and conservatives of various stripes on one hand, and workers of the proletarian anarchistic left on the other. In fact, the Socialists knew that they would lose if either faction gained strength: democratic prin-

ciple would be thwarted if women were not granted the vote; but, if granted, that vote would most likely work against them, thus endangering the Republic.

The Church and conservative Catholics shared these expectations of the likely voting behavior of women. Though they opposed the new social reforms, seeing in them the specter of communism and atheism, they supported women's suffrage. While every parish and pulpit served as an active forum for anti-republican propaganda, conservatives promoted women's right to vote, confident that confessional politics would bear fruit. The anarchists also supported women's right to vote, believing that they would gain a disproportionate share of women's votes, even though, on principle, the anarchists would not participate in any formal government.

On October 1, 1931, parliament voted to grant women's suffrage, 161 votes for and 121 against (approximately 40 percent abstained or were absent). The Radical, Radical Socialist, and Republican Action parties rejected granting the vote; in favor were the Socialists, Agrarians, and conservative republicans. As predicted, the conservatives won in the 1933 municipal election, confirming the republican fear that feminine conservatism and clericalism would kill the Republic from within.

THE BLACK BIENNIAL 1934–35

The conservative electoral victory initiated the so-called Black Biennial (1934–35): progressive legislation was repealed and workers' organizations eliminated, though both were reinstated after the Popular Front victory in 1936.[5] The National Association of Women against War and Fascism (Agrupacion de Mujeres Antifascistas), founded in 1933 by the Communist party and led by Dolores Ibárruri, was declared illegal and reorganized into Pro-Childhood Working Women (Pro-Infancia Obrera), headed by Clara Campoamor. The new organization sought to raise funds, obtain clothing for refugees and soldiers, and secure urban services and jobs. (They were also among the first in Spain to denounce Nazism and German concentration camps.) In the ensuing period, there was a surge in strikes and social agitation.

Of particular importance was the Asturian Revolution in October of 1934. A national uprising of workers protesting the conservative government took place October 5–18. The head of the Radical Party sent the young Franco, accompanied by mercenary North African legionnaires, to quell the revolt. A two-week rampage of murder and rape ensued and an estimated thirty or forty thousand prisoners were taken. With the young communist Aida Lafuente—who died with machinegun in hand—as a role model, this minor revolution served as a training ground for women's activism and military participation. Even in less dramatic ways, this incident increased the political awareness of the typical Spanish woman. The Foreign Minister Julio Álvarez del Vayo later wrote: "But it was the Spanish woman who proved her worth during the war. An absurd tradition had kept her on the fringe of national life and had confined her to the limited fringe of domestic work. But by 1936 a change had begun to take place. The women had been deeply shocked by the savage reprisals following the October 1934 movement and they registered their protest by voting for the Popular Front on February 16, 1936."[6]

The establishment of women's vote meant that political parties from the left, right, and middle all intensified their efforts to persuade half of the Spanish adult population of the validity of their ideologies and political programs. The change in women's voting behavior between 1933, when they voted conservative, and 1936, when they voted for the Left, must be understood in part as a result of those efforts. Women's exposure to political doctrine and the real life experience during those twenty-nine months, however limited—not to mention their awareness of their gains from progressive legislation—drastically affected their personal and public lives.

Political parties formed internal organizations to recruit and train women, timidly providing them with access to the public sphere—an action that would prove to be invaluable experience in the civil war. Women's political rights had been won, but there was hostility to the implementation of those rights from all political fronts. Although umbrella women's organizations were created within

each party, they were dependent upon the central party ideology and were not directly integrated into political life. The separate but equal philosophy continued to be preached but not practiced.

Since 1931, Catholic falangist and fascist groups had mushroomed and grown just as quickly as membership in the anarchist CNT (Confederación Nacional del Trabajo) labor union, the socialist UGT (Unión General de Trabajadores), and the Communist Party. The conservative Catholic Feminine Falangist Section (Seccion Femenina de Falange) was founded in 1934, promoting the traditionally submissive and docile image of women. The Antifascist Women's Association (Agrupacion de Mujeres Antifascistas) was created in 1933, winning the support of middle-class female Republicans and Socialists. The communist-dominated Women against War and Fascism (Mujeres contra la Guerra y el Fascismo) was founded in 1934. The latter two groups strived to make women aware of the need for social, cultural, and political education. Primarily created to capture votes, these women's organizations were also active throughout the civil war—organizing women's efforts on the front in Republican zones and in rearguard activities on both sides.

The 1936 Popular Front victory showed that Spain was evenly divided between two opposing sides: the coalition of Catholics, Fascists, and Monarchists on the right, and the center/left Popular Front composed of Socialists, Republicans, anarchists, Communists, and the Catalonian left. The enumeration of these parties demonstrates the bewildering array of political options available. The Popular Front won 257 out of 473 Parliament seats, although the popular vote showed a much narrower result, with the Popular Front gaining close to 4.7 million votes, against the right's 4.5 million.[7]

The five months from February to July of 1936 were marked by intense antagonism between the "two Spains." The close Popular Front victory had opened an even greater breach between them, which Manuel Azaña would later cite as the true cause of the civil war. It provoked the July 18 military rebellion against the elected government.

WOMEN ON THE HOME FRONT

General Franco became head of the rebel/Nationalist coalition in October of 1936 and, in November, he declared the war a "crusade," blessed by the Catholic church, against Marxist atheists to recuperate traditional Spanish Catholic values in the "reconquered" Badajóz, Malaga, Mérida, Seville, and Córdoba. He swiftly imposed an authoritarian regime. Regression to pre-1931 legislation[8] and reprisals[9] were the order of the day in the Fascist-controlled zones. For women it meant a giant step backwards—the loss of public identity and a return to submissiveness, to the traditional domestic role of mother and educator of children. Women were very active in the "re-Catholicization" of the newly conquered National territory and instrumental in providing and organizing health care.

The opposite occurred in the Republican zones, particularly those dominated by anarchists.[10] In the first few months of the war, anarchist-dominated areas in Aragon and Catalonia initiated a revolutionary social experiment modeled on the Soviet one. Women were protagonists in the public arena and were in legal control of their private lives until April of 1939. Radical proletarians saw the civil war as an opportunity for social revolution—an opportunity not only to move away from the Second Republic's bourgeois reformism and democratic liberalism, but towards wholesale collectivization and full equality. Anarchists considered the war and the social revolution equally urgent means to the end of a free society. Federica Montseny defended the position that women had identities and social functions independent of their status as procreators. She promoted the newly current idea that women should be treated as people and not just as mothers. The anarchist Minister of Justice retroactively legalized the free unions of militiamen who had died as a means of authorizing their sons and widows to get survivors pensions. In the Generalitat of Catalonia, anarchist Andrés Nin legalized abortion.

The CNT-supported Free Women movement was born in Madrid in the spring of 1936 and died with the war. An exclusively female organization within the anarcho-syndicalist CNT, it was considered necessary because the union demonstrated a general disin-

Madrid, November–December 1936

Militiawoman, n.d.
Another of the " Negrín
suitcase" prints. Courtesy of
Archivo Histórico Nacional,
Sección Guerra Civil,
Salamanca.

terest in women's issues. The anarchist Free Women organization had 150 branches and 20,000 members. The organization had three objectives: to campaign for women's issues (such as coeducational training schools, sexual education and freedom, abortion, birth control, and the education of prostitutes), to combat illiteracy, and to obtain equality between men and women in a social system based on libertarian communism.

Independent, emancipated women who had previously existed only in theory were now needed to join in the war effort as caretakers and occupants of the job positions their male companions had abandoned for the front. Women were called upon to substitute in these positions in order to maintain production, urban services, and industry. They organized around the anarchist, communist, and antifascist groups that had arisen in the early thirties with the objective of winning their votes. For the first time in their lives, and for a span of almost three years, women were gaining experience in the spheres of work and politics and helping to manage their country. Even so, gender discrimination did continue in job positions, occupations, and salaries.

LAS MILICIANAS

Mary Nash[11] has described what it must have been like on July 18, 1936, when the spontaneous female participation in the war effort first occurred. It was mid-summer. Children and teenagers were on school vacation, full of holiday spirit and summer freedom. Girls wearing espadrilles and light summer dresses, moved by utopian idealism, romantic summer nights, and the thrill of adventure, bicycled off to join the boys and men at the front. They became *milicianas* (militiawomen), a small but highly visible group in the early

months of the war. But the situation changed drastically with the cold weather in the fall of 1936. Euphoria dissipated and the exigencies of war asserted themselves. The undisciplined militia columns made up of average citizens without military training were reorganized into the Popular Front army in 1937.

The *miliciana* phenomenon has never been adequately addressed.[12] The first masculine sphere to which women had access was the military one. This was due, primarily, to the initial troop disorganization and, second, to the fact that the Republican army was formed of militia columns organized by trade unions and political parties without any military hierarchy. Few statistics exist on who actually fought. There were probably fewer than a thousand armed women at the front.[13] There were, however, the several thousand armed girls and women in each city who staffed the rearguard. Thousands of women under arms and in female battalions, for example, took part in the defense of Madrid in November of 1936. The communist-oriented Girl's Union (Union de Muchachas) alone consisted of two thousand girls aged fourteen to twenty-five who labored in workshops while receiving an education at the same time. These same women also set up shooting ranges and target practice in Madrid. In general, women had difficulty obtaining arms; yet despite this, they fully participated in repelling the Fascists, fighting in the Segovia Bridge area and on the southern front of the capital, near Getafe, where the Union Girls were the last to retreat.

As members of the working class and advocates of women's liberation, female anarchists were engaged in both a social and a political fight that included their participation on the frontlines. Under the conviction of total liberty, the CNT Free Women actively supported military participation throughout the war. Wearing their own uniforms, they were the most active female battalions at the front. Even after the government decree to remove women from the frontlines, a few women remained as military officers or as political commissars: Pepita Urda (sergeant), Mika Etchebéhère (captain), Anotonia Portero (political commissar).

The journalist H. E. Kaminski offers a profile of the militiawomen, who fought against the enemy close up and wore pants

just like men. "Vanity serves no purpose and women do not use lipstick or powder and wear short hair. The truth is women carry out their duties with the same devotion."[14]

The *milicianas* soon drew criticism and disapproval. Republican soldiers were uncomfortable with the *miliciana*. For the most part, men expected *milicianas* to do kitchen and laundry duties and to act as nurses. A former *miliciana* described wanting to abandon the Fifth Regiment and join Mika Etchebéhère's POUM (Partido Obrero de Unificación Marxista) column to avoid washing clothes and cooking: "I didn't come to the front to die for the revolution with a dishtowel in my hand."[15] After the first months of enthusiastic and equal participation, even the people on the left began to denigrate the work of the militiawomen.

Despite the creation of their own *miliciana* battalion, the Lina Odena,[16] the Communist party by the fall of 1936 contributed to the propaganda campaign to end women's military activism and return them to the rearguard: "Men to the front/ Women to the home front" or "to the workplace" was their slogan. The Communists sacrificed the revolution for the immediate objective of winning the war. The only way to involve the middle class was to empty propaganda of revolutionary content. The much-admired Dolores Ibárruri—*La Pasionaria*—stressed moderation and the necessity of vigilance against extremism and Trotskyism. She called for cooperation between Republicans and anarchists—something rarely ever achieved. At the end of the war, emancipation would be the goal.

After the October 1936 military reorganization, women were decidedly unwelcome at the front for a number of reasons including the traditional paternalistic views toward protecting them. Soldiers reacted like Spanish *caballeros* or Don Quixote, running to a woman's rescue whenever they thought she might be wounded or killed. These attitudes only served to cause more deaths. There also existed unfair and still unfounded accusations against women as carriers of sexually transmitted diseases. The novelty of the female soldier motivated photographers to capture their new visibility and over-represent them, but by December 1936, posters

Dolores Ibárruri, *La Pasionaria*. Photographs by Gerda Taro. From Robert Capa's notebooks. "La Pasionaria. . . . It was she who made the phrase of the war, 'Better to die on one's feet than to live on one's knees.'"
—From *Death in the Making*, Robert Capa (RC).

and propaganda depicting the *milicianas* as heroines had disappeared. The *milicianas* were no longer evoked as heroines but as disreputable figures who impeded the correct development of the war effort.[17] Women who wore the practical workman's blue overalls were criticized as coquettish and frivolous and were charged with confusing the war with a carnival. For men, the blue overalls were a symbol of political identification; but, as Spanish women had never worn masculine attire, donning these overalls represented a subversion of traditional gender roles as well as the political order. Rosa the Dynamiter, for example, who attended the 1989 Salamanca conference, said, "We women wore overalls like the men. They criticized us a lot for that, when overalls cover you up more than anything! Women went to jail after the war for having worn overalls and having carried a gun. You didn't have to have used it, just carried it."[18]

In the fall of 1936 the Minister of War, Largo Caballero, began to organize the Popular Front army and urged women to return to the rearguard in order to achieve a more efficient and disciplined army. As the military situation deteriorated, the government increasingly centralized control of the war effort in the face of the opposition of many unions and, primarily, anarchists. After March of 1937, women were forbidden from participating at the front and from wearing uniforms, unless they were nurse's uniforms. By 1938 women had returned to a strictly auxiliary role in the rearguard.

A NEW MODEL OF WOMAN: SYMBOL VS. REALITY

Throughout the civil war, women were cultural agitators, teaching illiterate men on the front and their sisters in the rearguard. They formed literacy and cultural brigades and carried out pedagogical missions similar in spirit to the Republican *La Barraca*, an effort directed by Federico García Lorca in the early thirties to bring classical Spanish theater to villages. The writers Maria Teresa León, Rosario del Olmo, Rosa Chacel, and Maria Zambrano worked in the Antifascist Alliance of Intellectuals and Writers and wrote for the publication *El Mono Azul*.[19] Female intellectuals received military training in the first months of the war.

During these three intensive years, the press, women's magazines,[20] and political party propaganda promoted a new and positive image of the antifascist Spanish woman. This new image was used as a symbol of strength, balancing out the predominant image of woman as victim of military action and rearguard repression. Spanish and foreign propaganda and posters portraying *milicianas* with or without arms were not designed to recruit women for the front. Rather, the *miliciana* icon was used to inspire men to serve their patriotic duty. Whereas the *miliciana* was portrayed symbolically on posters, photographs documented the reality of the situation of women's military participation.

Besides the *miliciana*, who was more a symbol of Republican resistance than a prototype of it, there were abundant references to the mother/son image (daughters were less visible as they were not eligible for the draft).

This new model of womanhood—exemplified by real people like Dolores Ibárruri who became a role model for the mature woman activist, even inspiring a communist publication named *La Pasionaria* after her—was based on actual achievements of empowerment and activism carried out by a minority of women.[21] Unfortunately, despite revealing gradual changes in attitudes towards women, the new model did not correspond to the social reality of the majority of Spanish women. There were some concrete gains, particularly for the proletarian female worker, but the revolution did not fundamentally alter traditional roles or customary inequalities. The general public continued to see women as men's helpers—not protagonists—despite the brash, revolutionary images on posters and in propaganda.

A new phenomenon at the time was the presence and influence of foreign women in Spain committed to the antifascist cause. Political activists, writers, and artists such as Joan Crawford, Lillian Hellman, and Maria Brunet worked for the antifascist cause outside of Spain, and journalists like Gerda Gropp, Martha Gellhorn, Sofía Blasco, and Gerda Taro worked from within Spain.

Gerda Taro, a member of the French Association of Revolutionary Writers and Artists, was among the many women writers,

intellectuals, journalists, and photographers who came to the Republic's aid.[22] Taro, a photographer known as *la pequeña rubia* or "the little blonde," became famous overnight when she was killed in an accident during the Battle of Brunete on July 25, 1937. She was twenty-six years old. Her antifascist commitment and her death serve as case studies for female role models—in Spain and around the world. Her example inspired fan clubs in the United States, France, and Germany, [23] where she was well-known thanks to the publication of her photographs outside of Spain.

Like Robert Capa, Gerda Taro (born Gerta Pohorylle in Stuttgart, June 1, 1910) was Jewish. She left her native Germany in 1933 due to incipient anti-Semitism and Nazi fascism. Politically active, she was jailed for her political beliefs in 1931, having been a member of the Socialist Students Club, part of the German Communist Party (KPD), whose leader was Ernst Thälmann. She and Capa met in Paris in September 1934. Convinced of his talent as a photographer, Taro acted as his promoter, and suggested that he change his name from André Friedman to Robert Capa. He, in turn, taught her photographic techniques. Together they traveled to Spain in August 1936, where they demonstrated a professional and life commitment to Republican Spain.

When they arrived in Spain, they first gravitated towards the familiar and contacted the German Communist unit in Aragon, the Thälmann Battalion, later spending time with other International Brigades battalions throughout Spain. An emancipated woman, Taro was in contact with the anarchist Free Women group. She wore pants and a beret and lived in the Intellectual Alliance House (Casa de Alianza Intelectual) in Madrid. She participated in the intellectual circles frequented by Pablo Neruda, Ernest Hemingway, Rafael Alberti, and Jose Bergamin. She and Capa worked together in February of 1937 photographing the front and rearguard for French publications, occasionally using the byline "Reportage Capa and Taro."

The Argentinean Cordova Iturburu, present at Taro's well-attended funeral in Paris, wrote: "She was beautiful and she was young and courageous. She was triply beautiful, in fact." Maria Teresa Leon, Rosa the Dynamiter, and Lola the Riojana, according to Iturburu, embroidered the tri-colored flag that covered Taro's casket.[24] Robert Capa dedicated his book *Death in the Making* to her: "For Gerda Taro, who spent one year at the Spanish front and who stayed on."[25]

Despite the existing evidence we have in numerous photographs, Capa's among them, contemporary historians have chosen either to ignore or underestimate women's participation in public life in this brief five-year period, and in the civil war itself. Gerda Taro's story is only one of many stories that illustrates women's active opposition to fascism. Unfortunately, many other women, such as Victoria Kent, Margarita Nelken, Campoamor, Alvarez Resano, de la Torre, Martinez Sierra and other figures visible during the war disappeared into oblivion after 1939. They died in exile and their reputations have been only slowly revived, in particular since the 1989 congress in Salamanca. Those Republican women who remained in Spain were considered "infected by the Marxist virus,"[20] mentally ill, and treated as such.

Spanish women were exposed to extraordinary change in eight years (1931–39), and gained a new awareness of their potential, through what we today term consciousness raising, a remarkable achievement considering the weight of Spanish tradition. With the Nationalist victory, women who fought for democratic and personal freedom were two-time losers: not only did they lose the war, but also their newly acquired identity, their new conception of self. In Capa's photographs of the "new women," their exemplary sacrifices and their history remain alive. What was perceived as an insignificant piece of data in one period can now be reinterpreted within a new historical context. Robert Capa offers us a pretext for reexamining issues which have been heretofore submerged.

Women, heroic women of the people! . . .
Soldiers, sons of the people! . . .
Workers of all kinds . . .
Let no one hesitate! Everybody ready for action. Every worker,
everyone against fascism should see himself as a soldier-in-arms.
Peoples of Catalonia, Galicia and Basque Country! People of Spain!
Let's defend the democratic Republic, let's consolidate the victory
obtained by the people on the 16th of February.
The Communist Party calls you up. It calls you in particular, work-
ers, peasants, intellectuals, in order to fight and squash at once the ene-
mies of the Republic and of the popular rights. Hurrah for the Popular
Front! Hurrah for the union against fascism! Hurrah for the Republic
of the people! We won't let fascism win! We won't let them win!

DOLORES IBÁRRURI
July 19, 1936

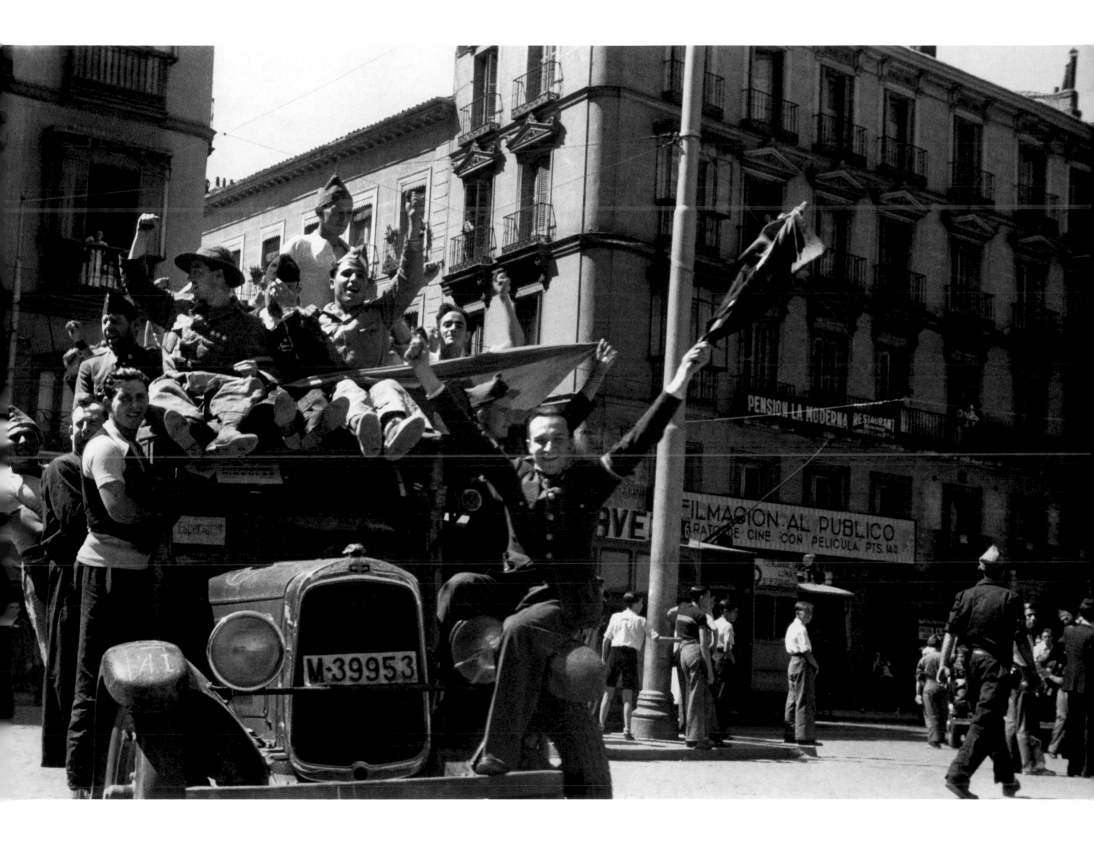

Madrid, August–September 1936

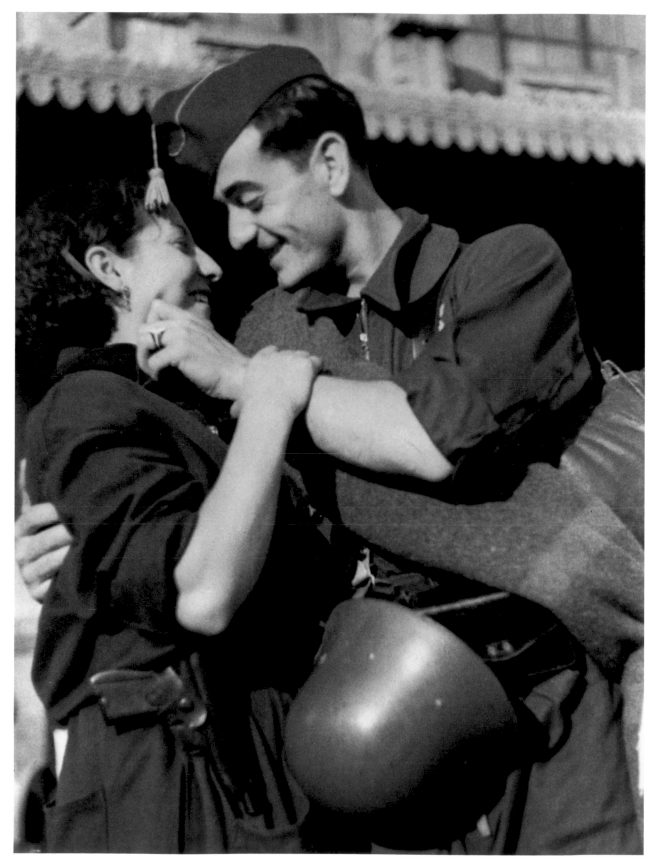

Barcelona, August 1936

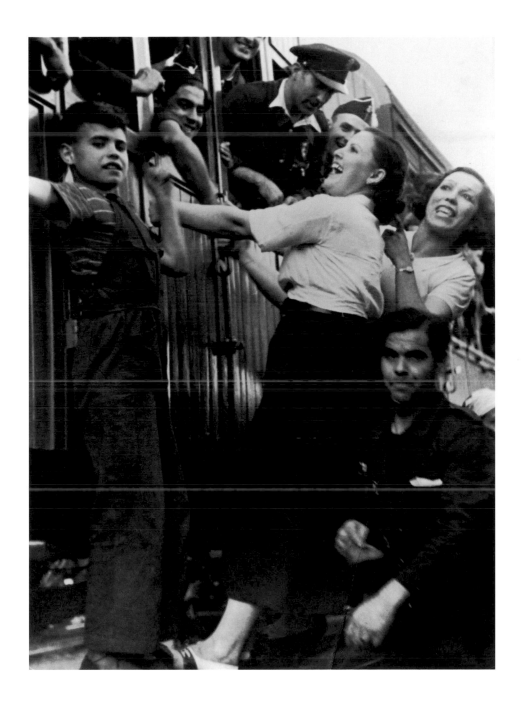
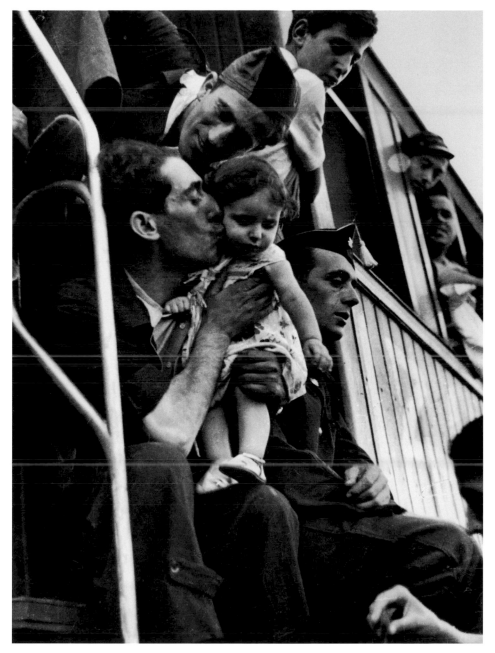

Barcelona, August 1936

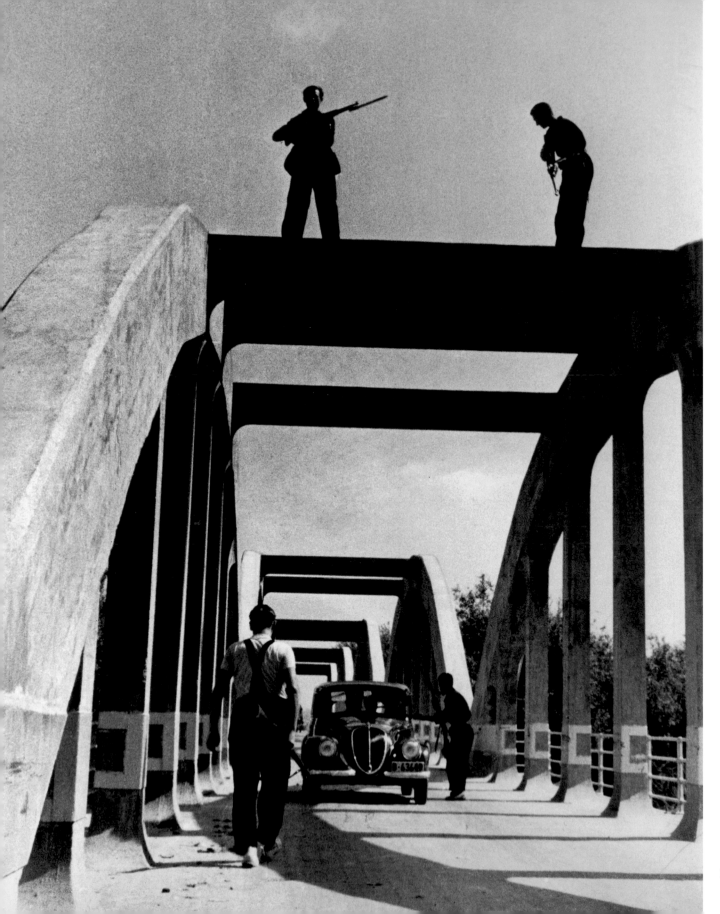

Near Barcelona, August–September 1936

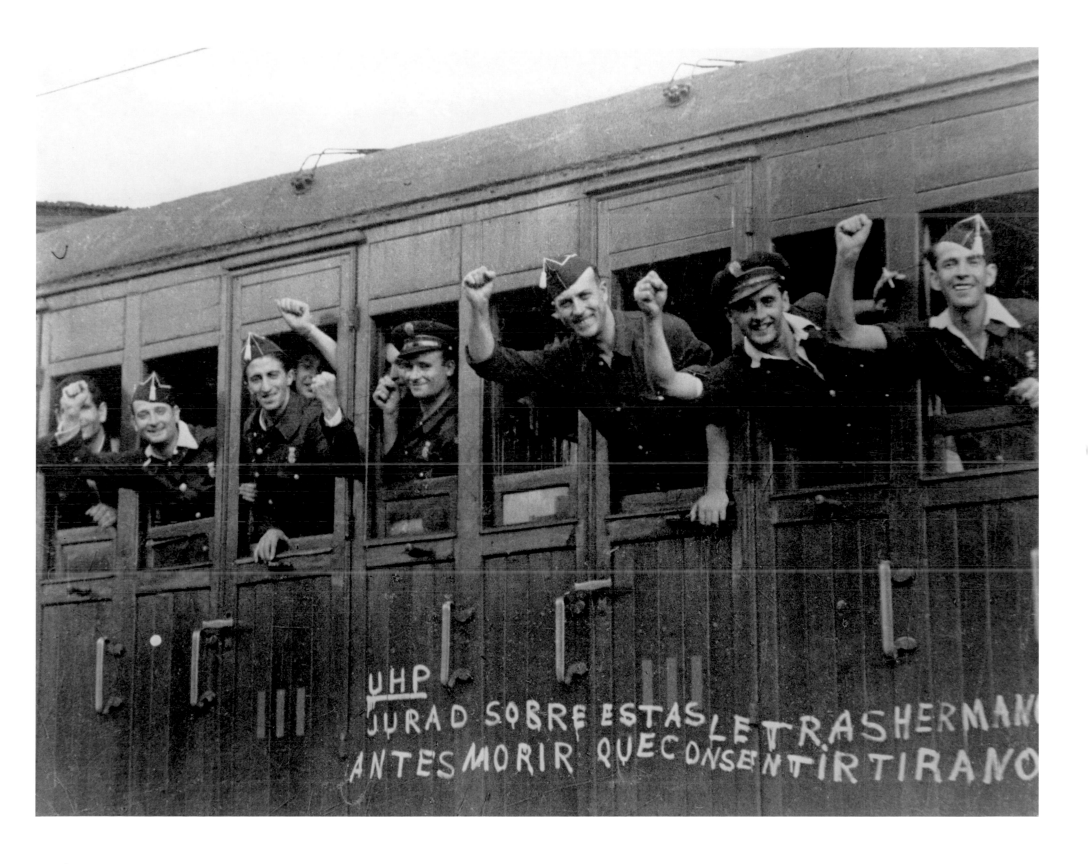

UHP
JURAD SOBRE ESTAS LETRAS HERMANO
ANTES MORIR QUE CONSENTIR TIRANO

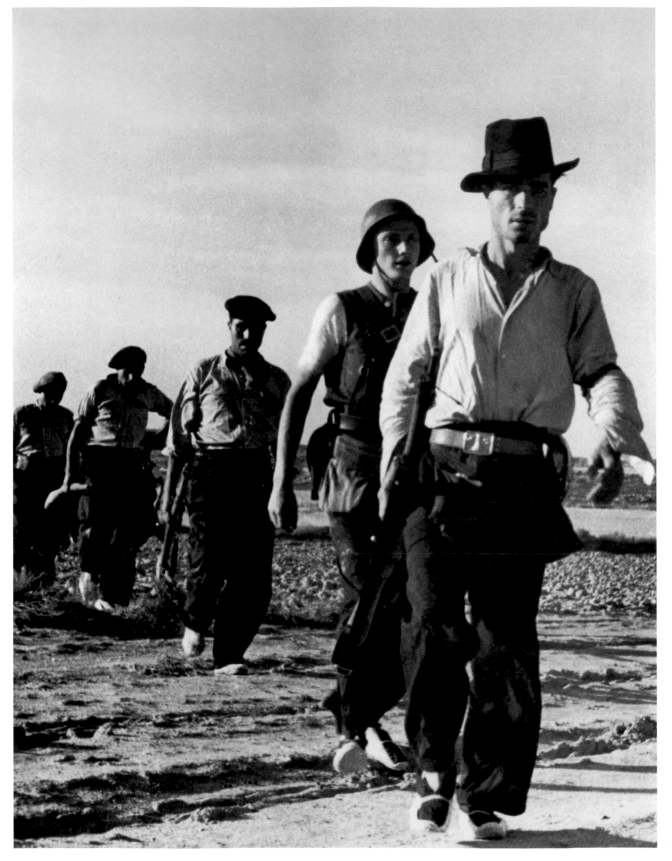

Near Barcelona, August 1936

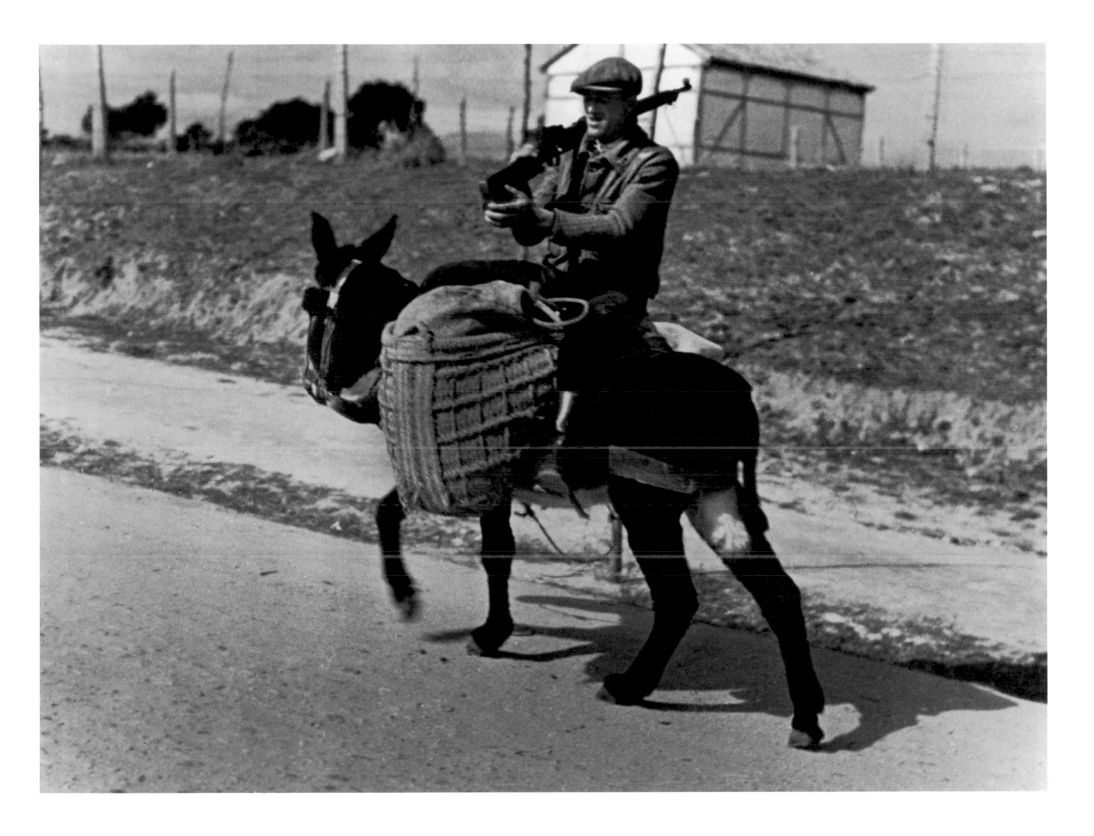

Near Madrid, November 1936

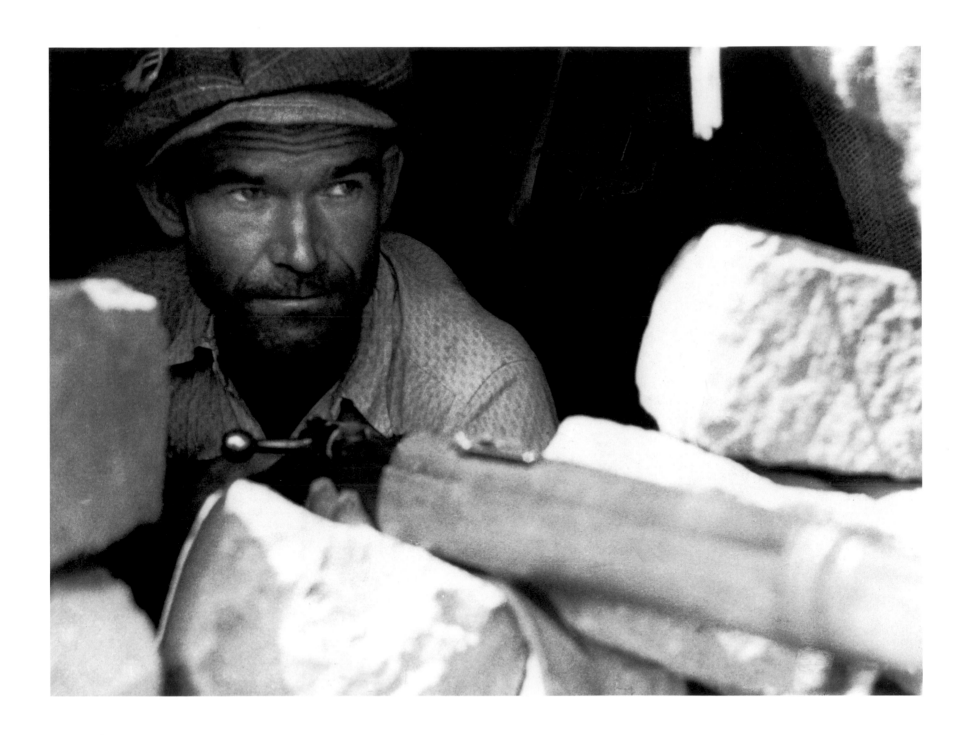

Barcelona or its vicinity, August 1936

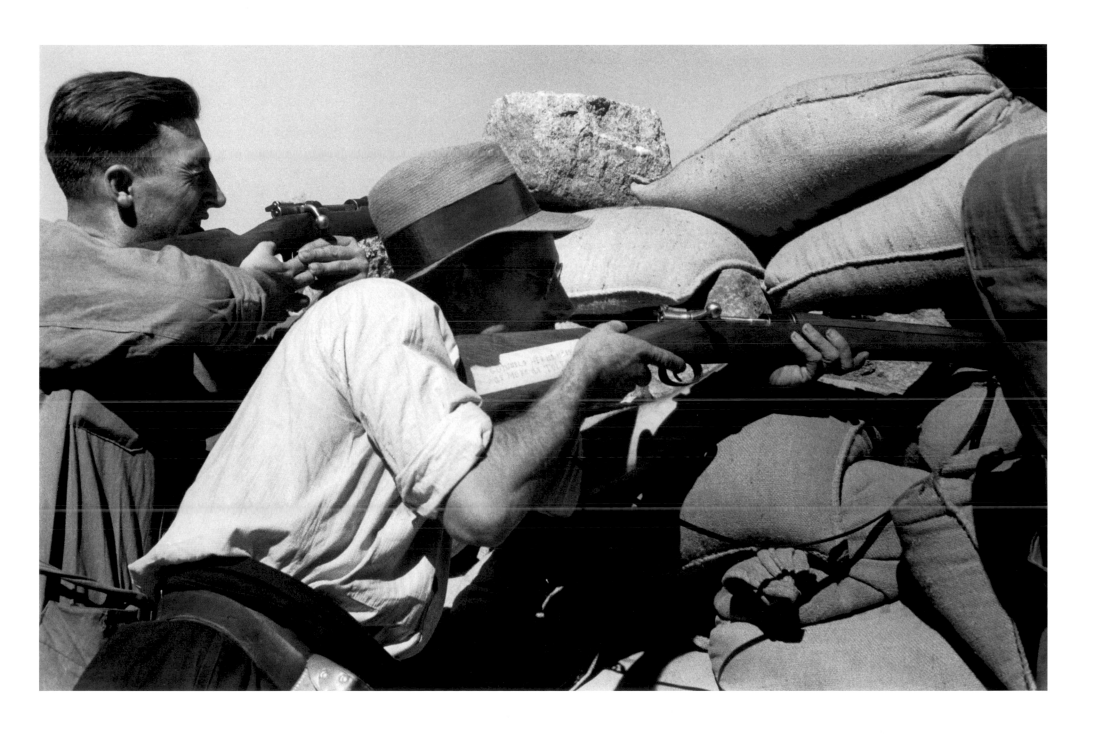

Barcelona or its vicinity, August 1936 61

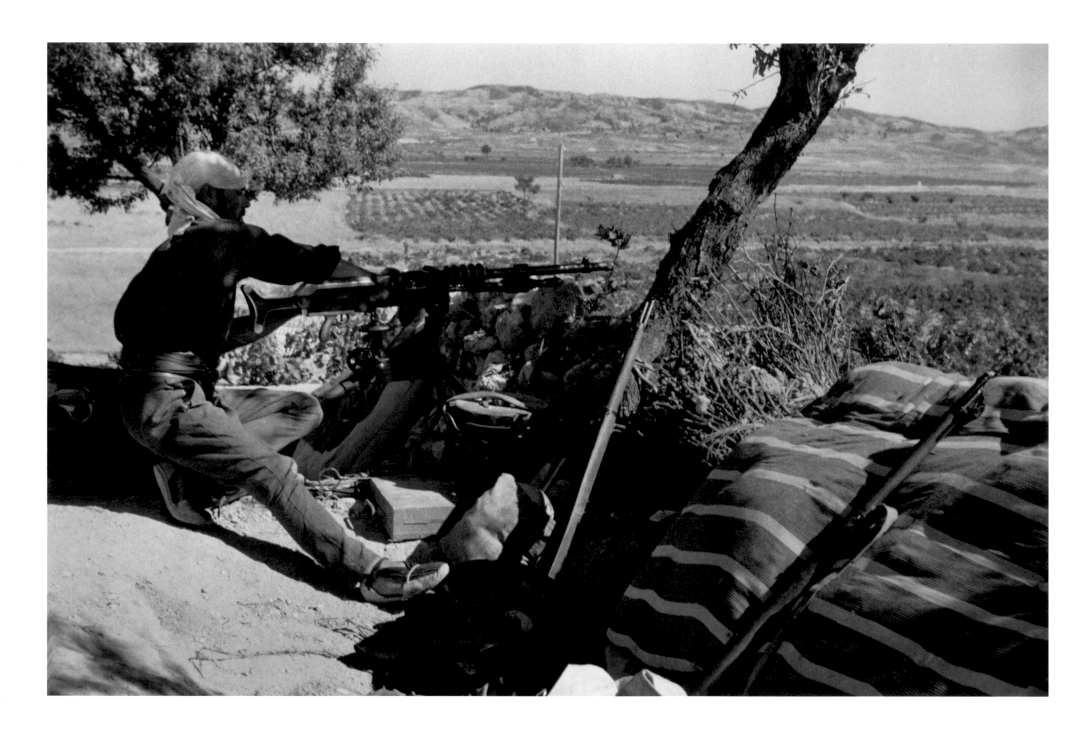

62 Near Huesca, Aragon front, August 1936

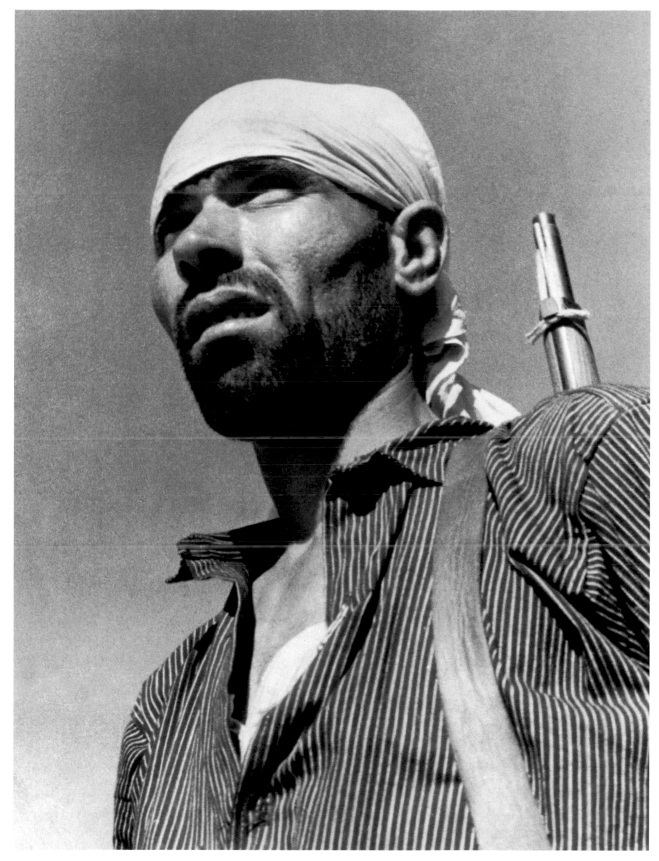

Near Huesca, Aragon front, August 1936

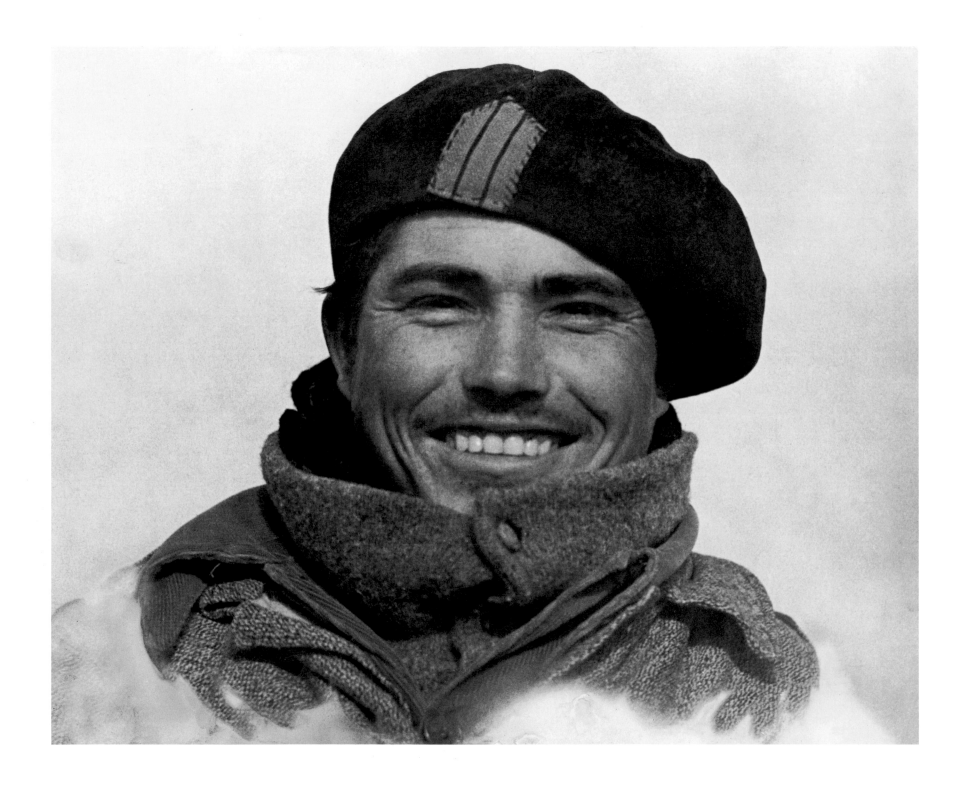

64 Madrid, November–December 1936

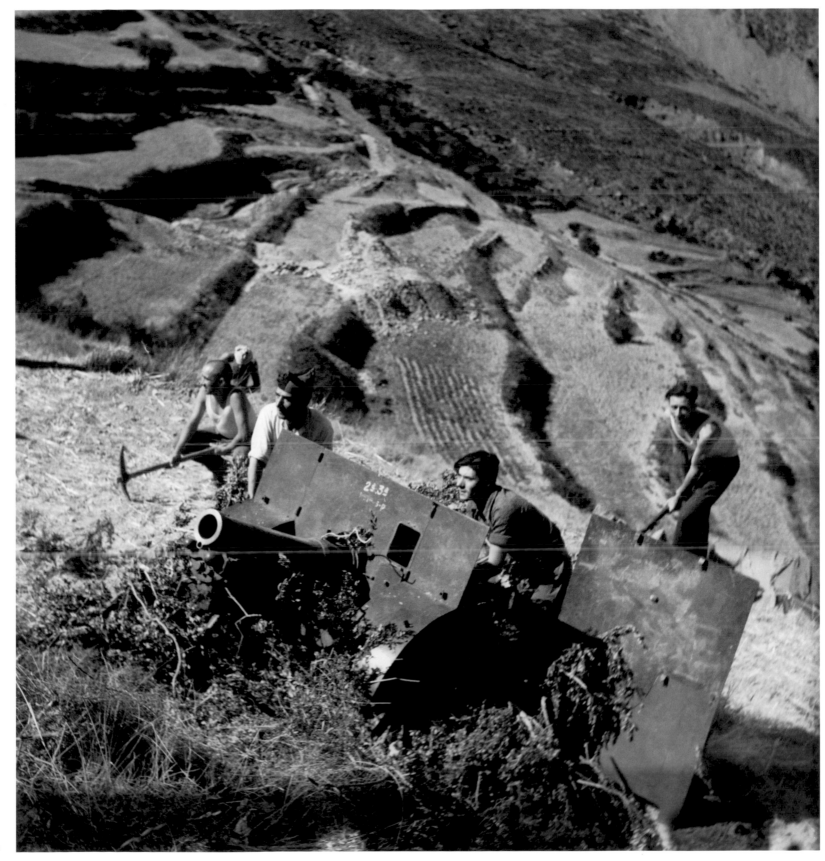

Near Huesca, Aragon front,
August 1936

Leciñena, Aragon front, August 1936
Aragon front, August 1936

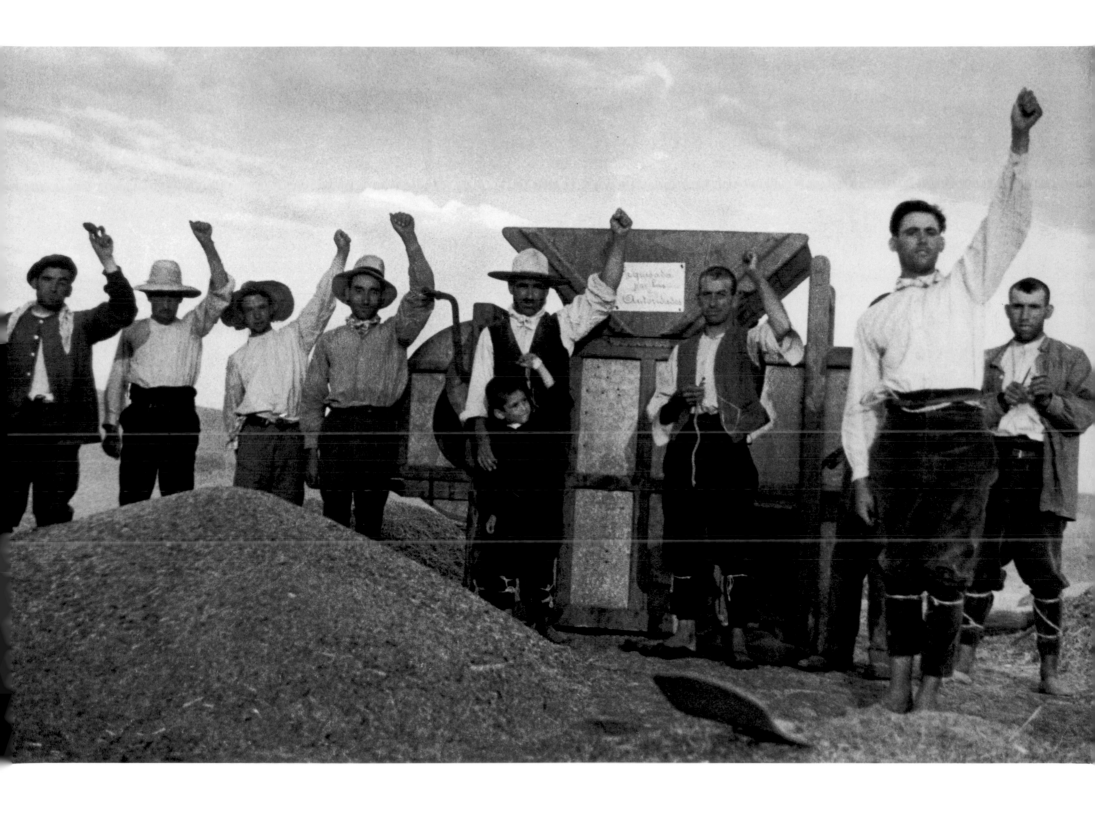

Aragon front, August 1936

Asturians of bravery
Basques of armored stone
Valencians of happiness
and Castilians of soul
worked over like the soil
and as airy as wings;
Andalusians of lightning,
born amidst guitars
and forged in torrential
anvils of tears;
Estremadurans of rye
Galicians of rain and tranquility
Catalans of firmness
Aragonese of caste
Murcians of dynamite
fruitfully propagated
men of Leon and Navarre, masters
of hunger, of sweat, and of axe,
kings of mining
gentle men of farming,
men who among roots,
like brave roots yourself,
you go from nothing to nothing

.

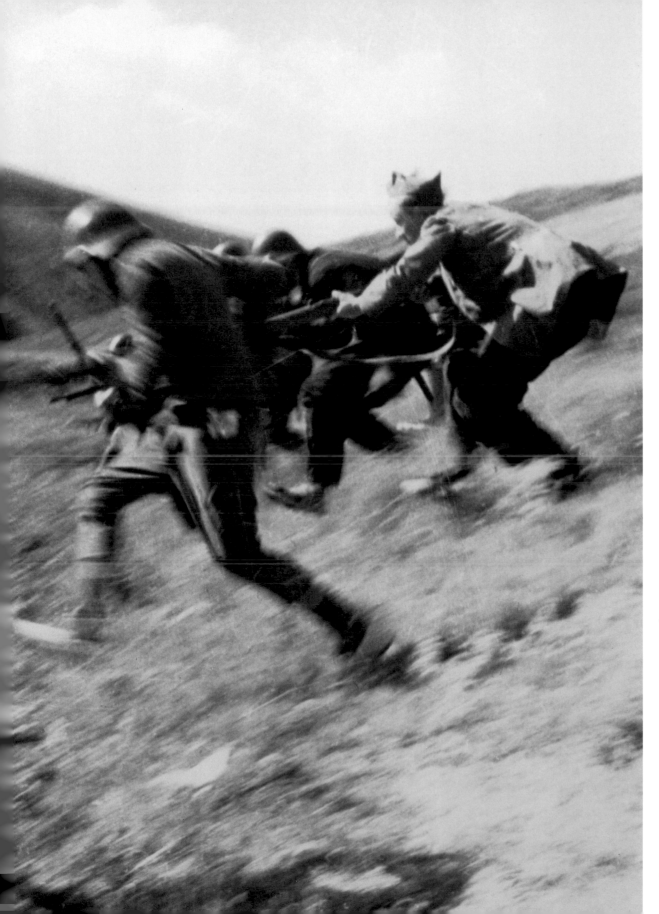

If I must die, let me die
with my head very high
Dead and twenty times dead,
my mouth against the grass,
I shall have my teeth clenched
and my chin firm.

Singing I await death,
for there are nightingales that sing
above the bugles
and in the midst of battles

 MIGUEL HERNANDEZ
 "Vientos del pueblo me llevan"
 (The winds of my people carry me)

Santa Eulalia, Aragon front,
August 1936

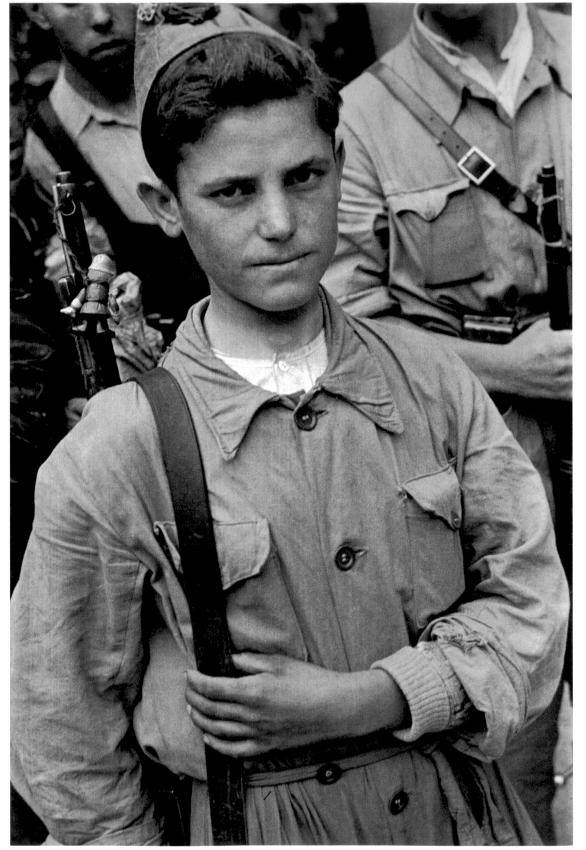

Madrid, late August or early
September 1936

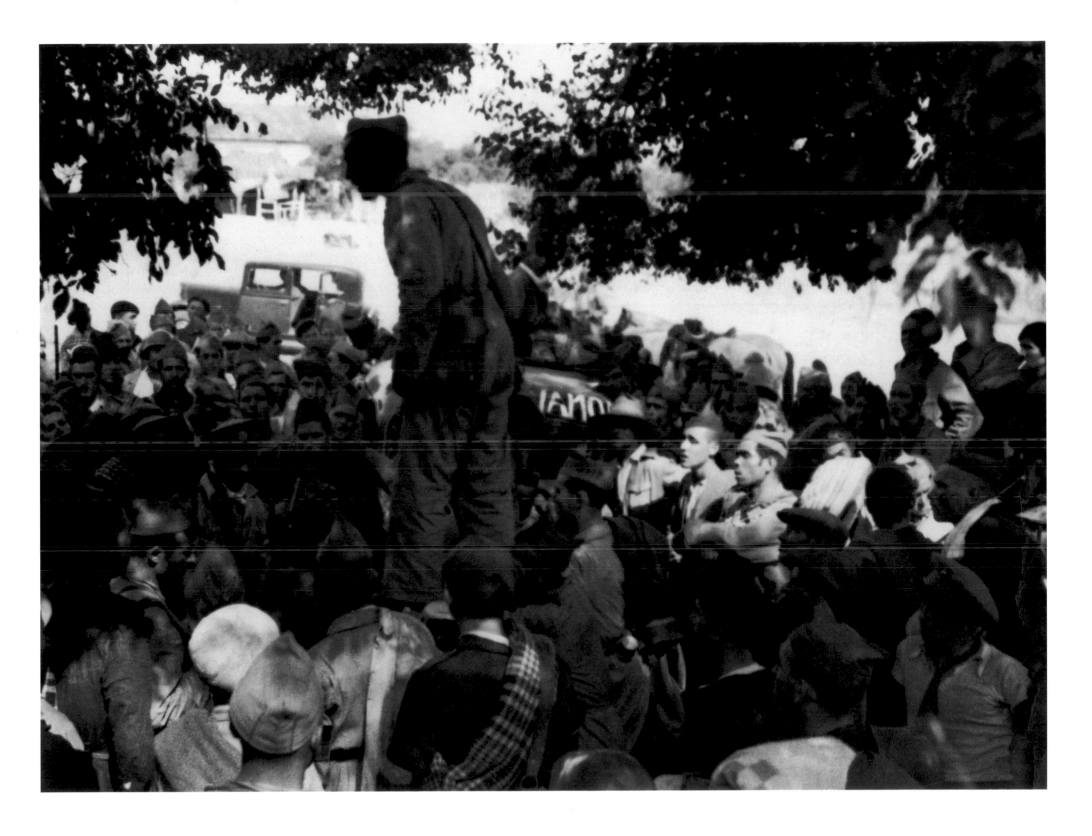

Córdoba front, September 1936

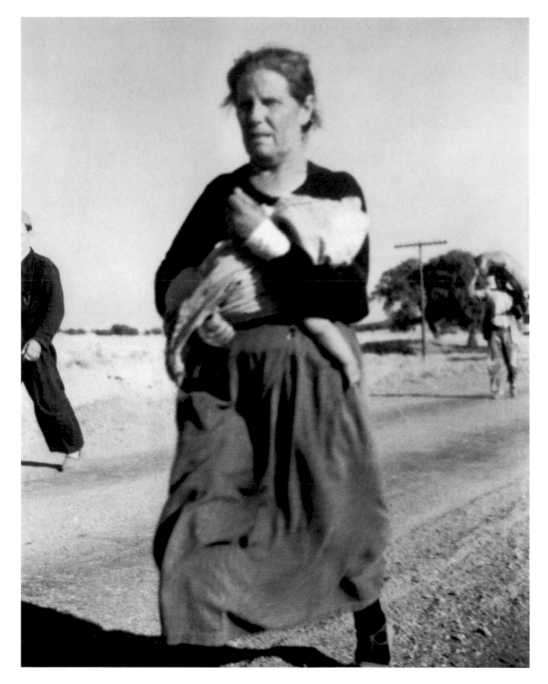

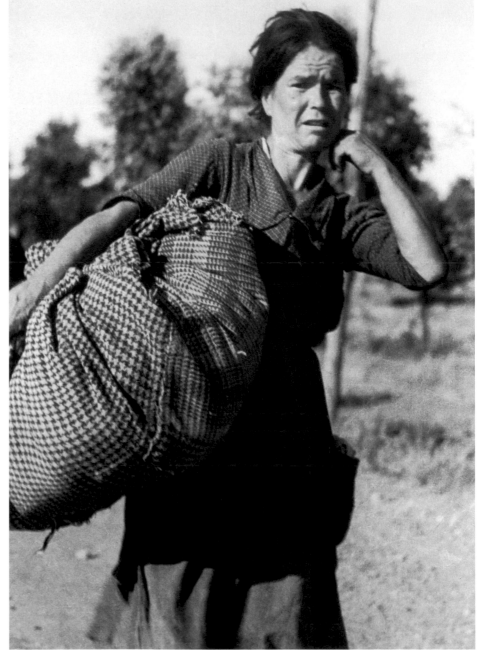

Cerro Muriano, Córdoba front, September 5, 1936

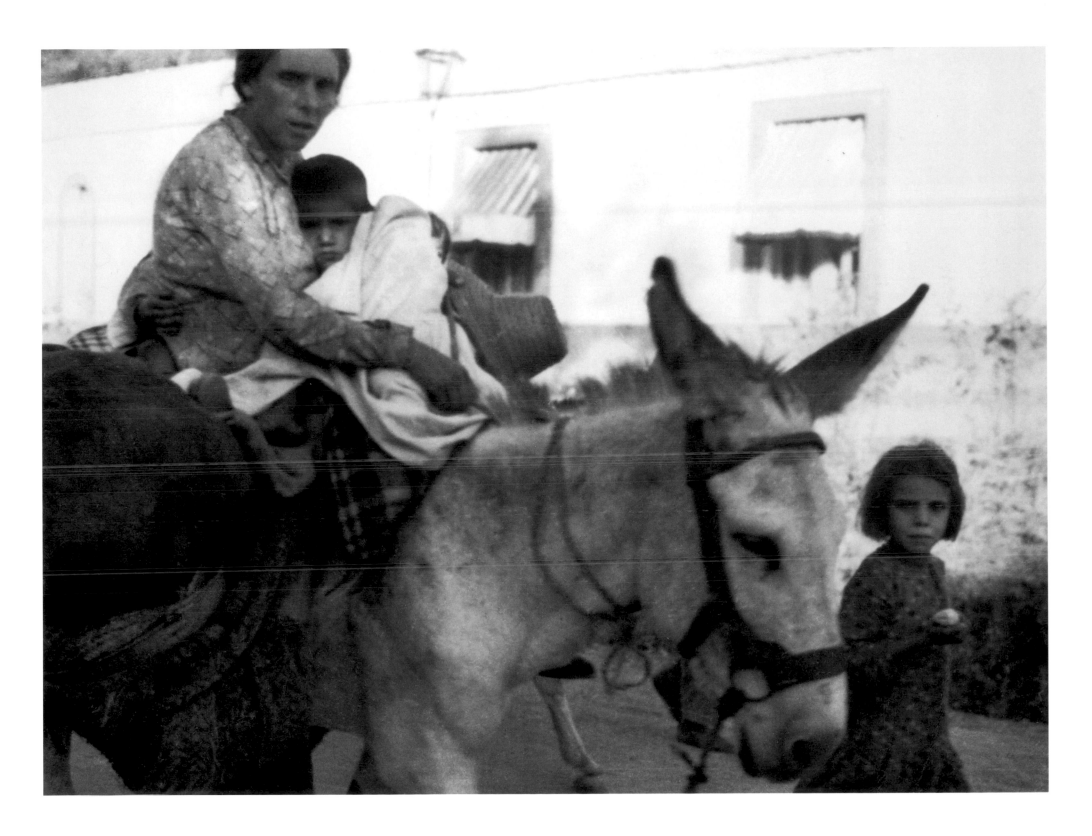

Cerro Muriano, Córdoba front, September 5, 1936

Eight of Robert Capa's notebooks were rediscovered during the 1980s in the Archives Nationales, in Paris. These notebooks contain about twenty-five hundred contact prints of Capa's 35 mm film, as well as many images attributed to Gerda Taro and David Seymour ("Chim"). Pages from these notebooks are reproduced throughout this volume, and are accompanied by excerpts from Capa's caption sheets and selections from *Death in the Making* (1938), a collaborative book project with photographs by Robert Capa and Gerda Taro, a preface by Jay Allen, and layout by André Kertész.

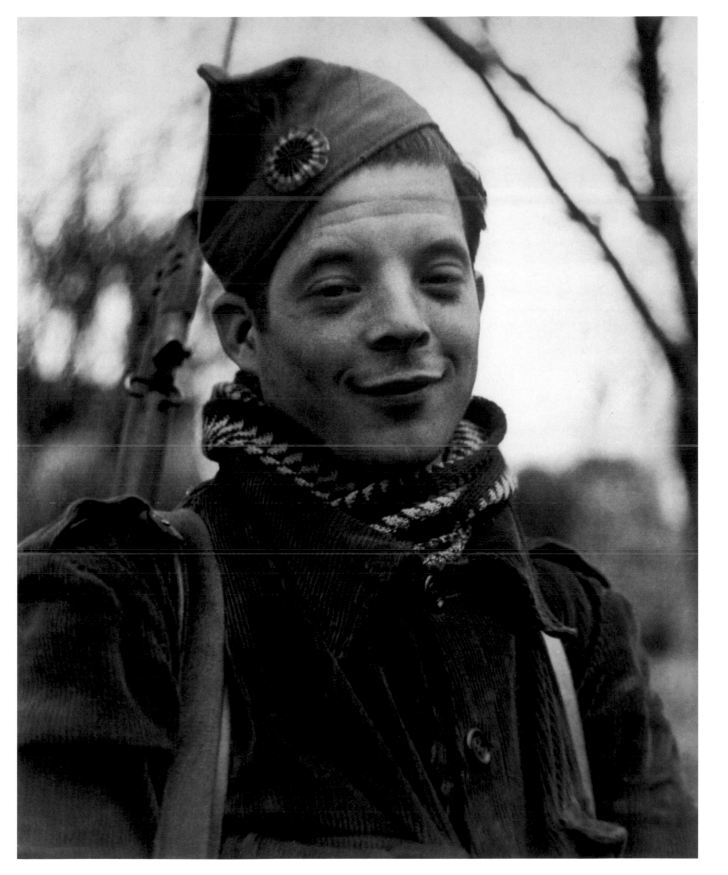

Madrid, November–
December 1936

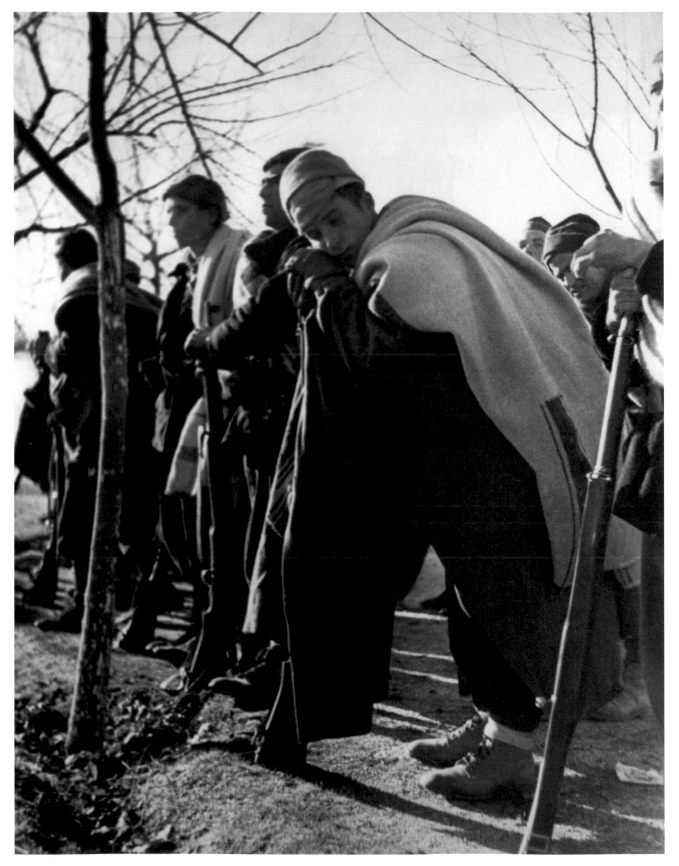

Madrid, November–
December 1936

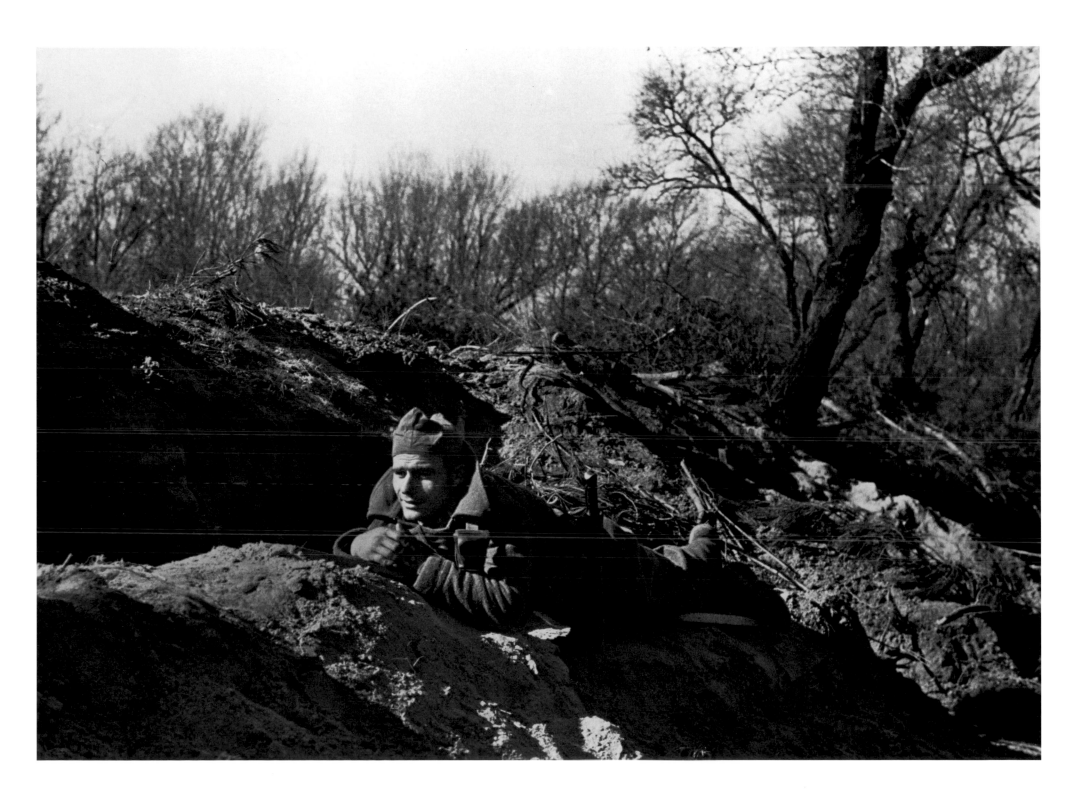

Madrid, November–December 1936 77

Sometimes the shelling lags, the enemy rests on his haunches, and on such mornings the defenders take the sun, read, play chess, write letters home which, when they arrive, will be no guarantee that the sender is still alive. The war had become routine; the abnormal, as always, had become normal. —From *Death in the Making*, RC

Madrid, November–December 1936

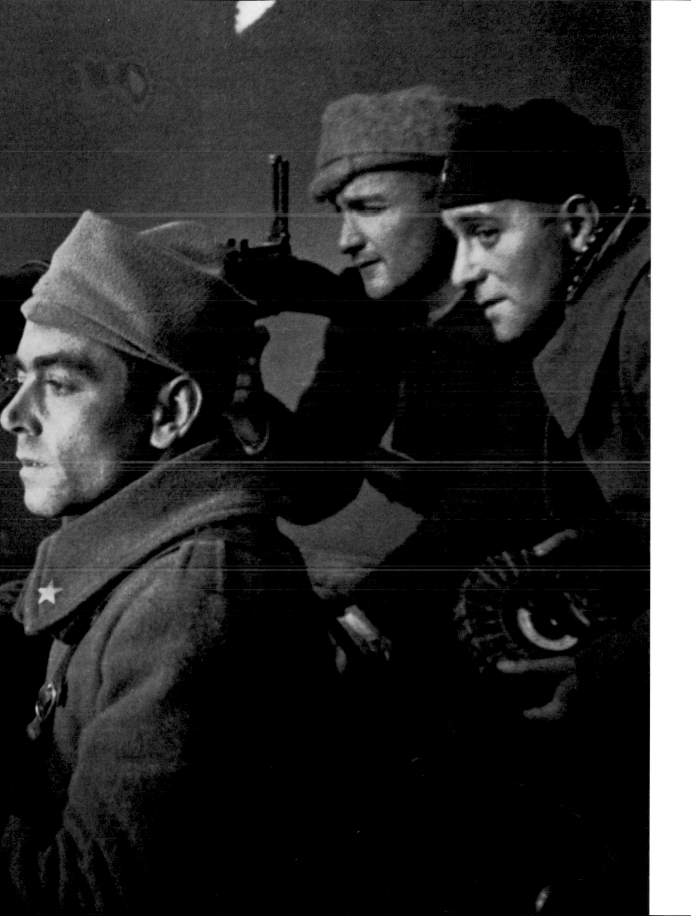

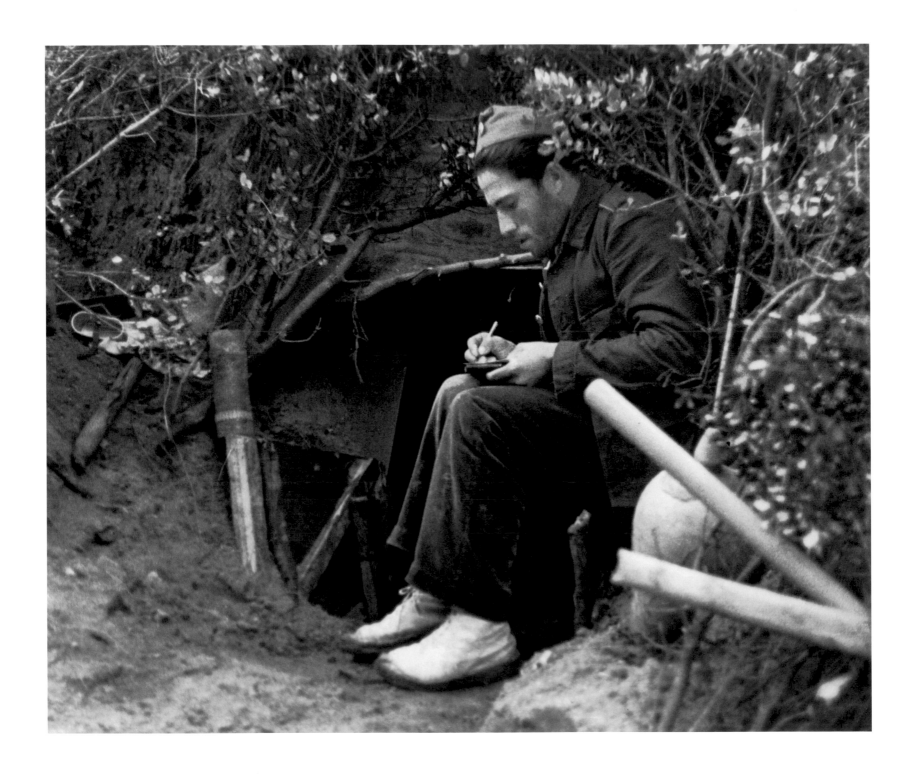

Madrid, November–December 1936

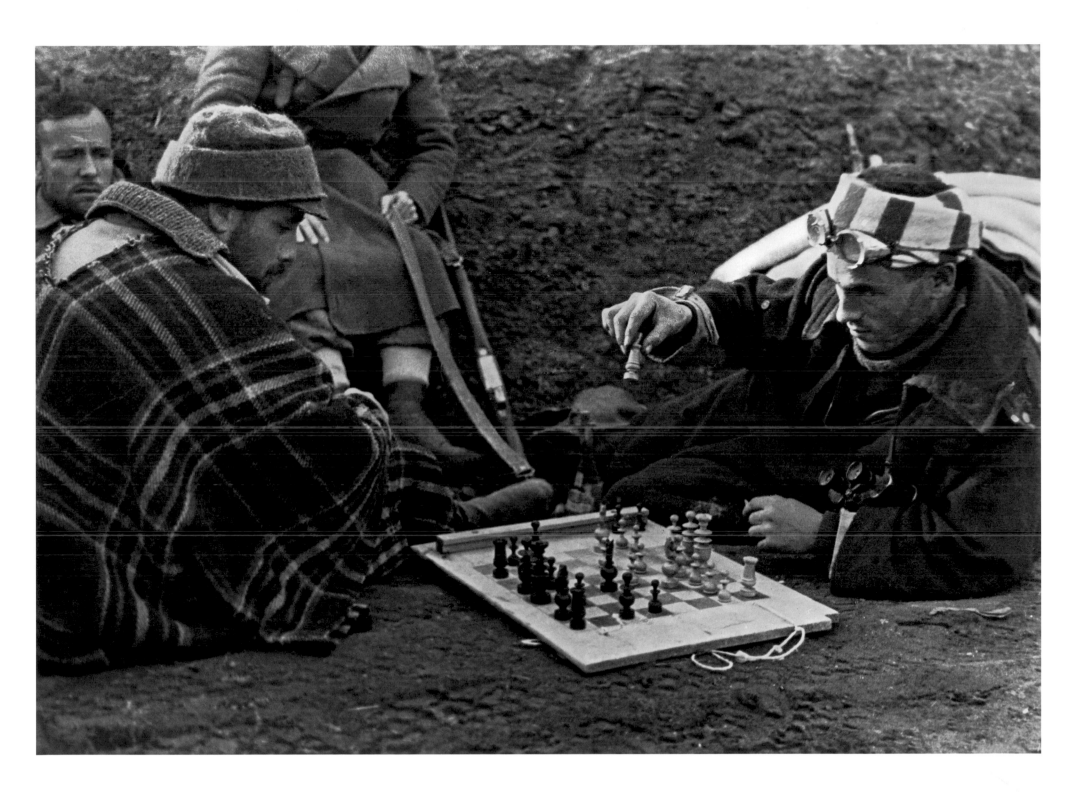

Madrid, November–December 1936

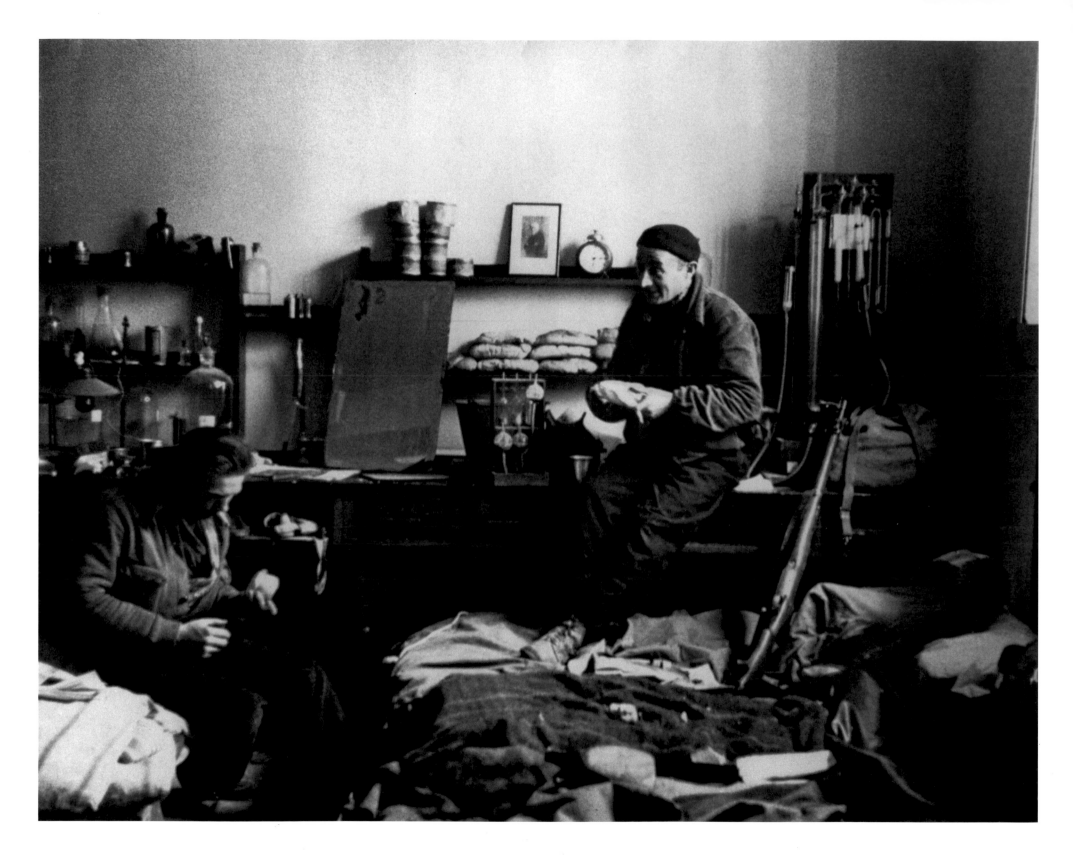

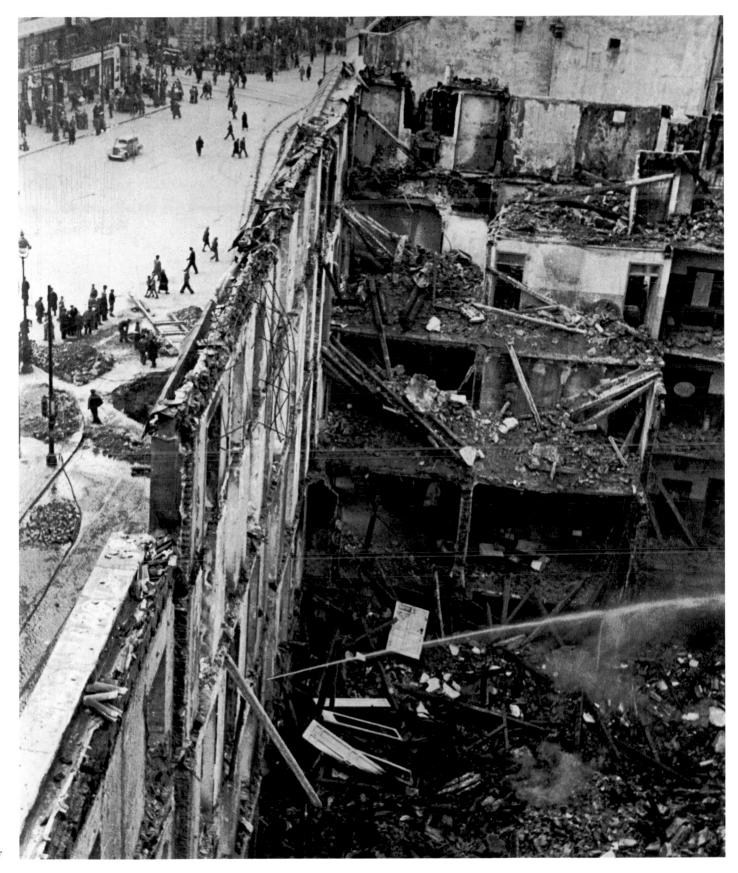

Madrid, winter 1936–37

I have shut my balcony door
because I don't want to hear the sobbing,
but from behind the grayish walls
nothing else comes out but sobbing.

Very few angels are singing,
very few dogs are barking,
a thousand violins fit into the palm of my hand.

But the sobbing is a gigantic dog,
the sobbing is a gigantic angel,
the sobbing is a gigantic violin,
tears close the wind's jaws,
all there is to hear is sobbing.

FEDERICO GARCÍA LORCA
"Casida of Sobbing" from *Divan del Tamrit*

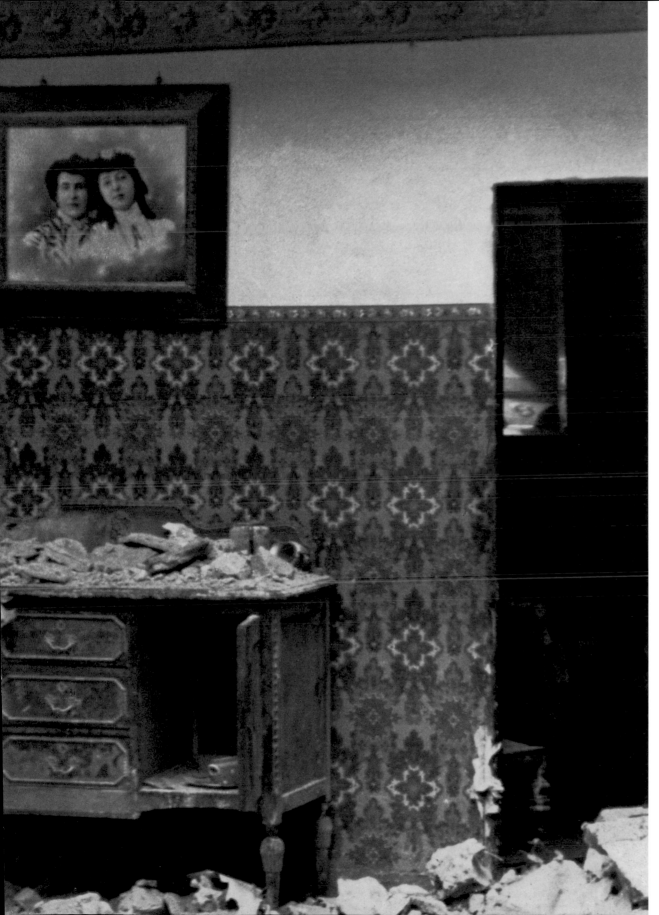

Madrid, winter 1936–37 85

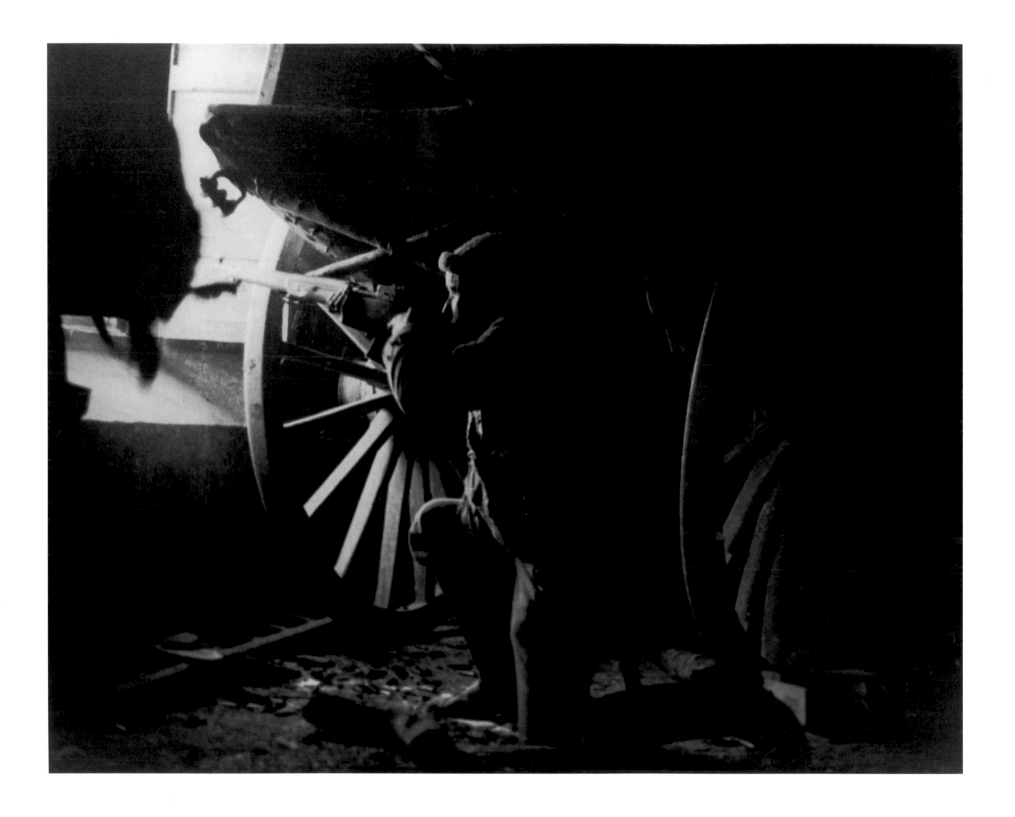

Above and opposite: Madrid, November–December 1936

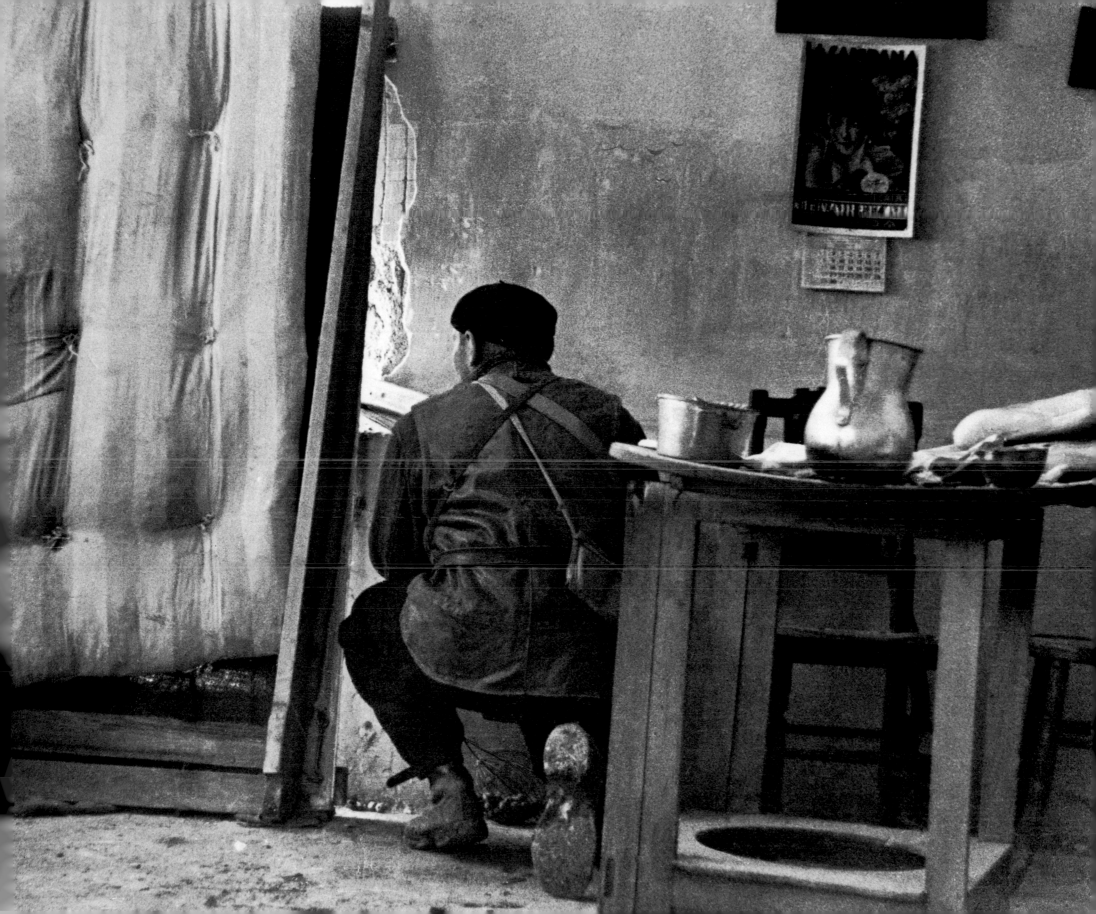

There is no rest or peace in all this land,
Along this bitter, this hard-trodden road,
And in these hearts.
Listen, road-menders, shepherds,
Workers of Paris, London and the world;
There is no rest or peace in all this land!

Men, workers like yourselves, they too
With bullocks yoked to plough just like
 your own,
With lathes like yours,
Or dusty flocks smelling of rosemary,
Under the same sky, in the same factories,
Trudging and working, and never resting.

Men, workers like yourselves, they too
With children just as lovely
And sheets as poor on beds just like your own,
And with fresh bread that smells as good
 as yours,
Fight on and triumph under olive trees
And in yellow cornfields,
And on the eternal snow that sleeps beneath
 the pines.

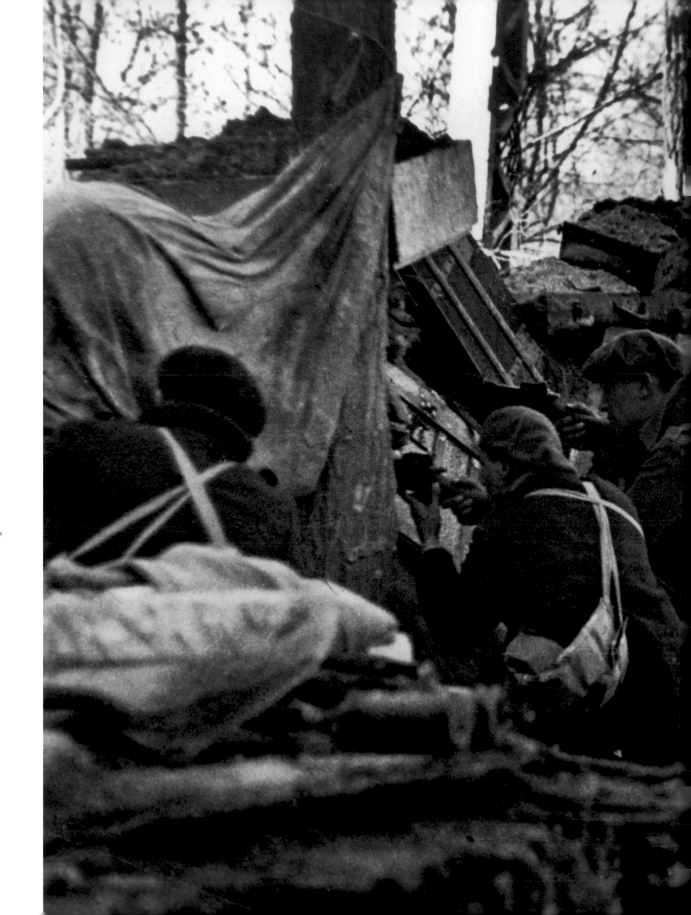

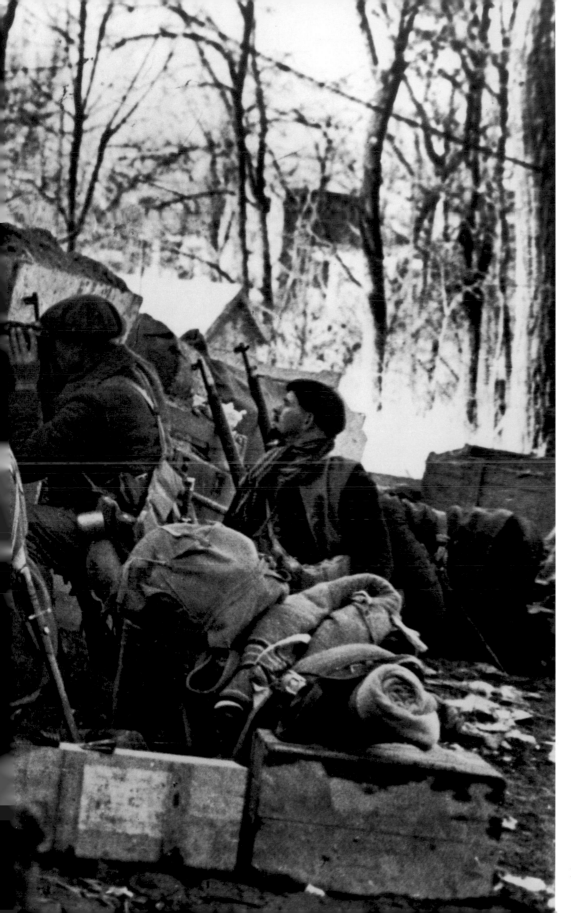

Under a manly sky, men among men,
Strong and glad as you are strong and glad,
Leave in forgetfulness
Their blazing houses and their old folk crippled.
There is no rest or peace in all this land
Which shall forever bear the name of Spain!—
Because we are and shall be the only masters of the day,
Masters of all our cities, and the real masters of our fields.

The men from the mines,
The herdsmen and the men from up the hills,
The men who make the bread and those who grow
 the wheat,
The poets, blacksmiths, woodworkers,
Defending here a people's name and life
On the baked soil out with advance posts,
And in the factories.

There is no rest or peace in all this land!
But only flowers growing in earthen pots.
Letters and artillery finished.
And men who do not rest,
Are ever watchful, like our chestnut trees,
And stand on guard, waiting for victory's fruits.

LORENZO VARELA, "A Poem"

(Translated from the Spanish by A.M. Elliot)

Madrid, November–December, 1936

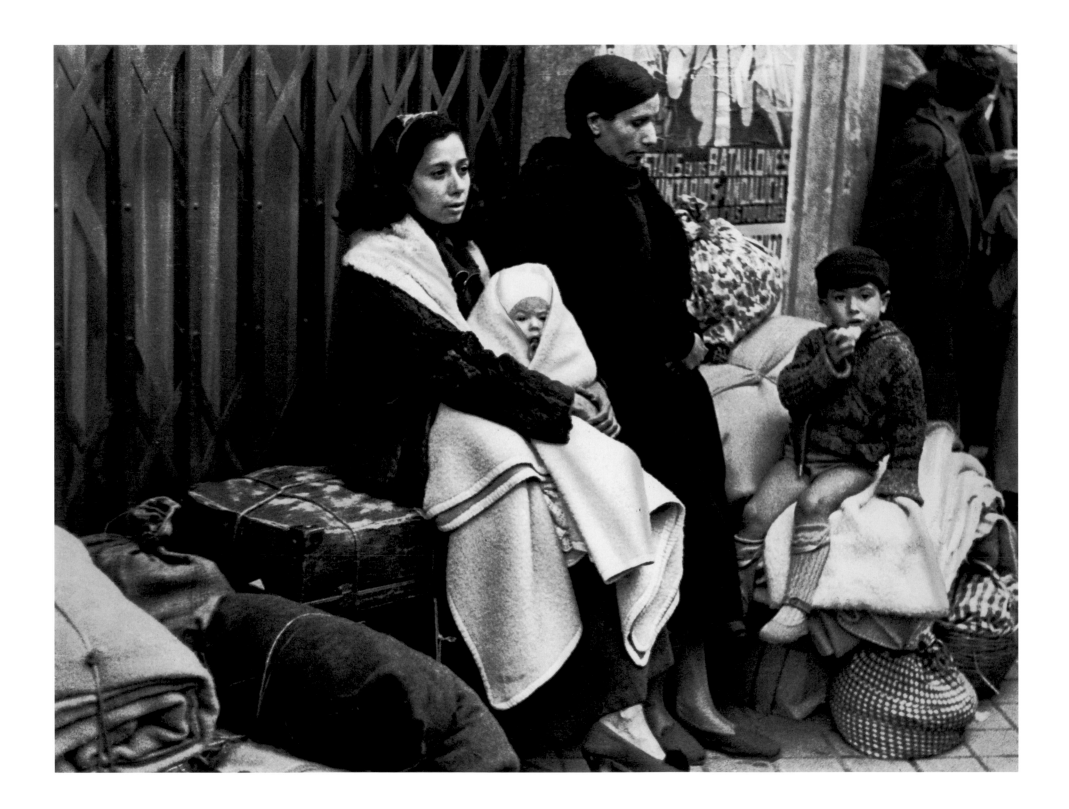

90 Madrid, November–December 1936

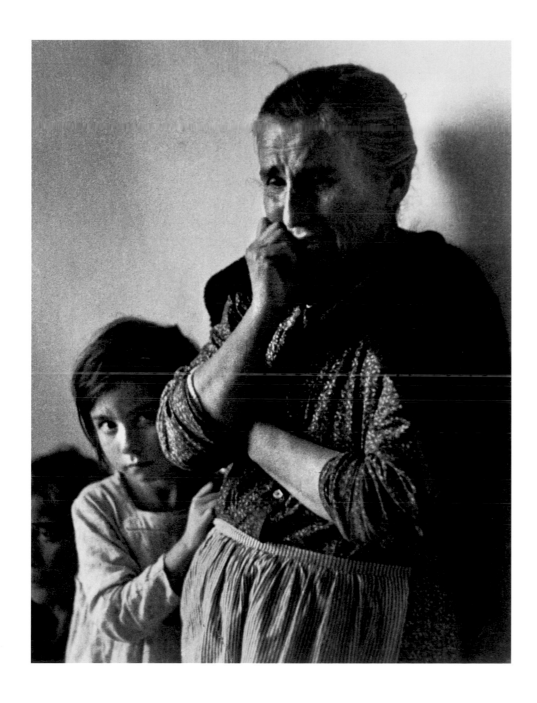
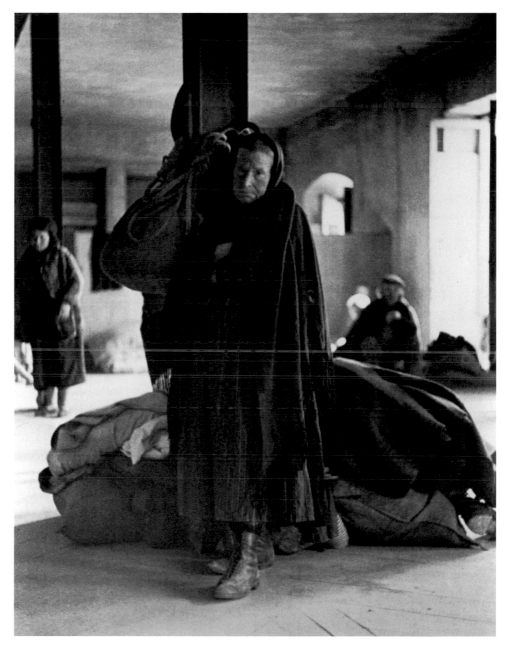

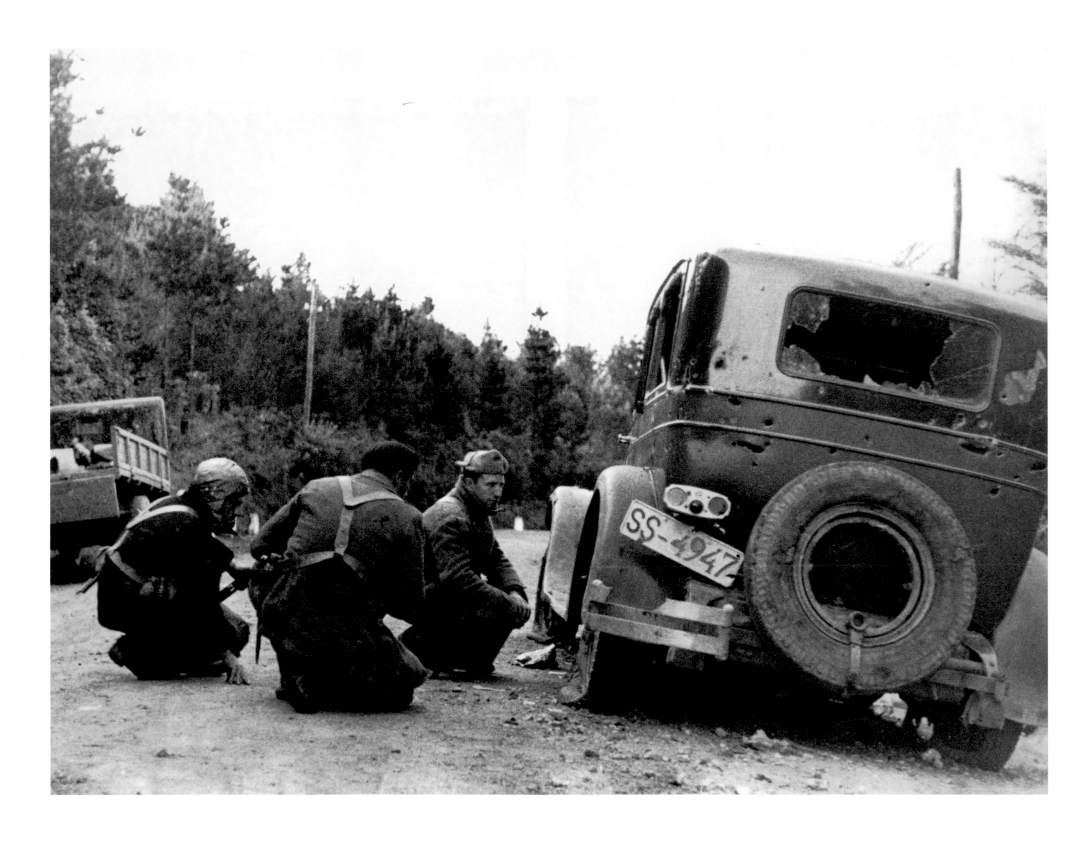

Mount Sollube, Bilbao front, May 7, 1937

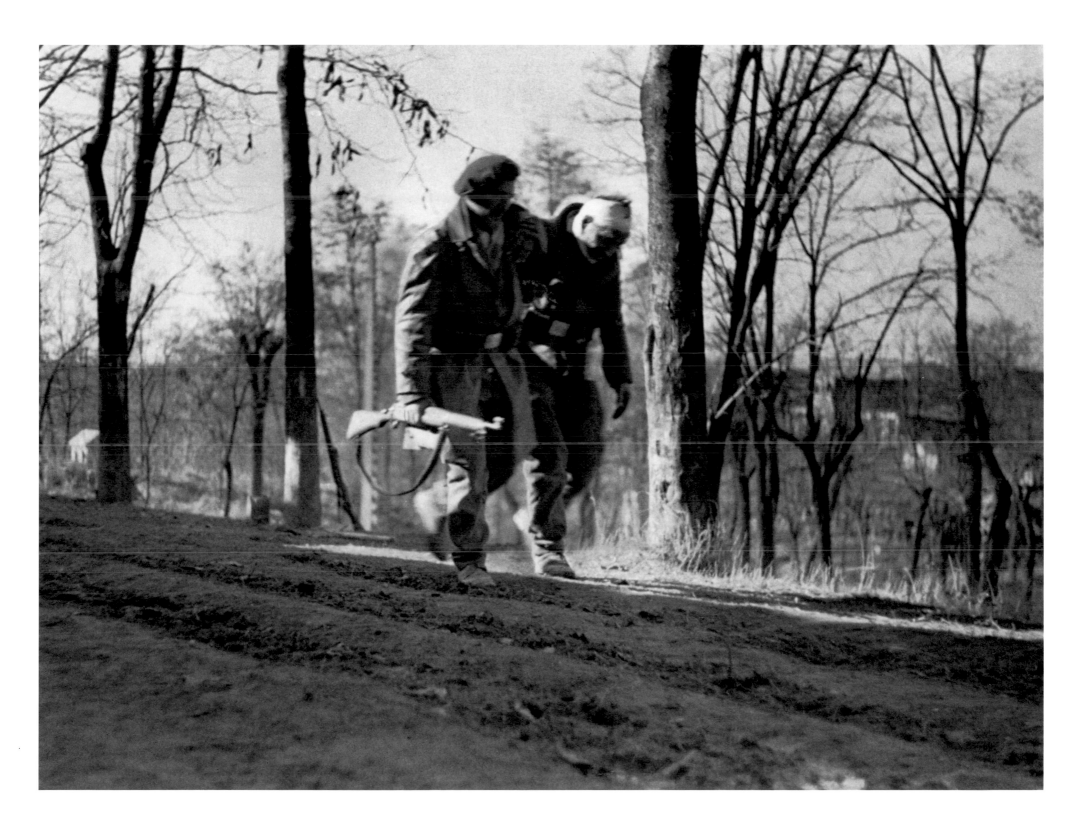

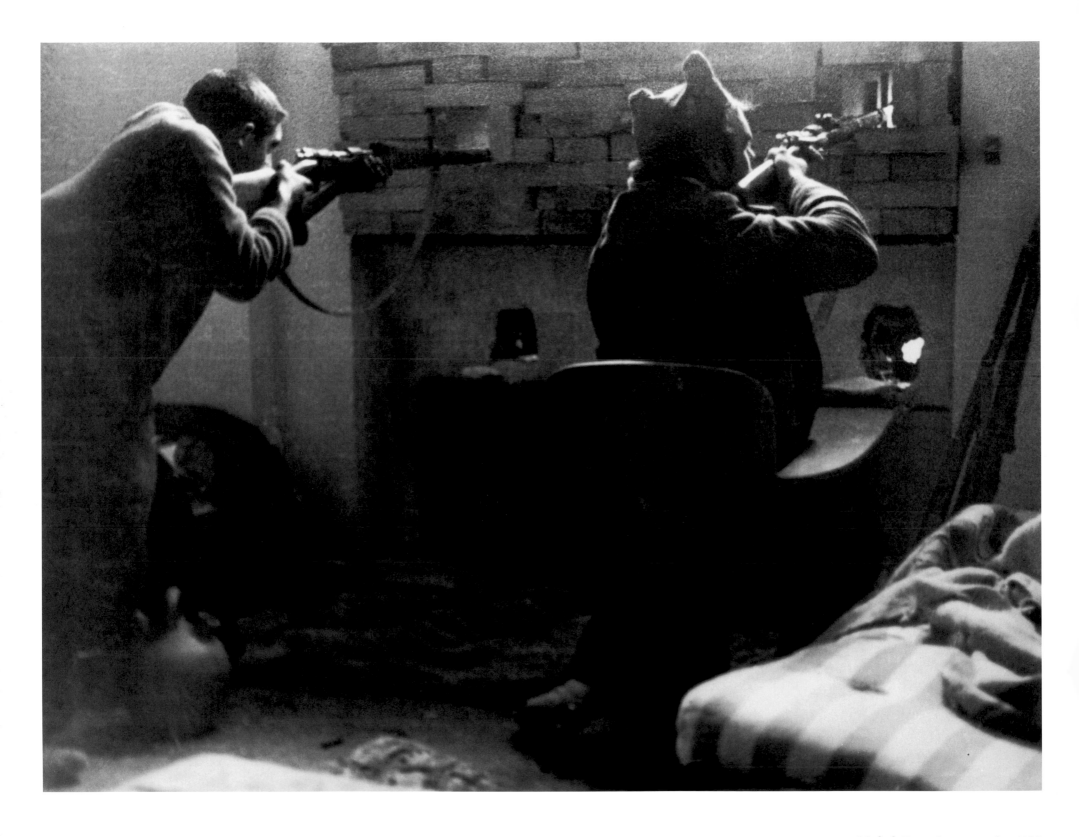

Madrid, November–December 1936
Madrid, February 1937

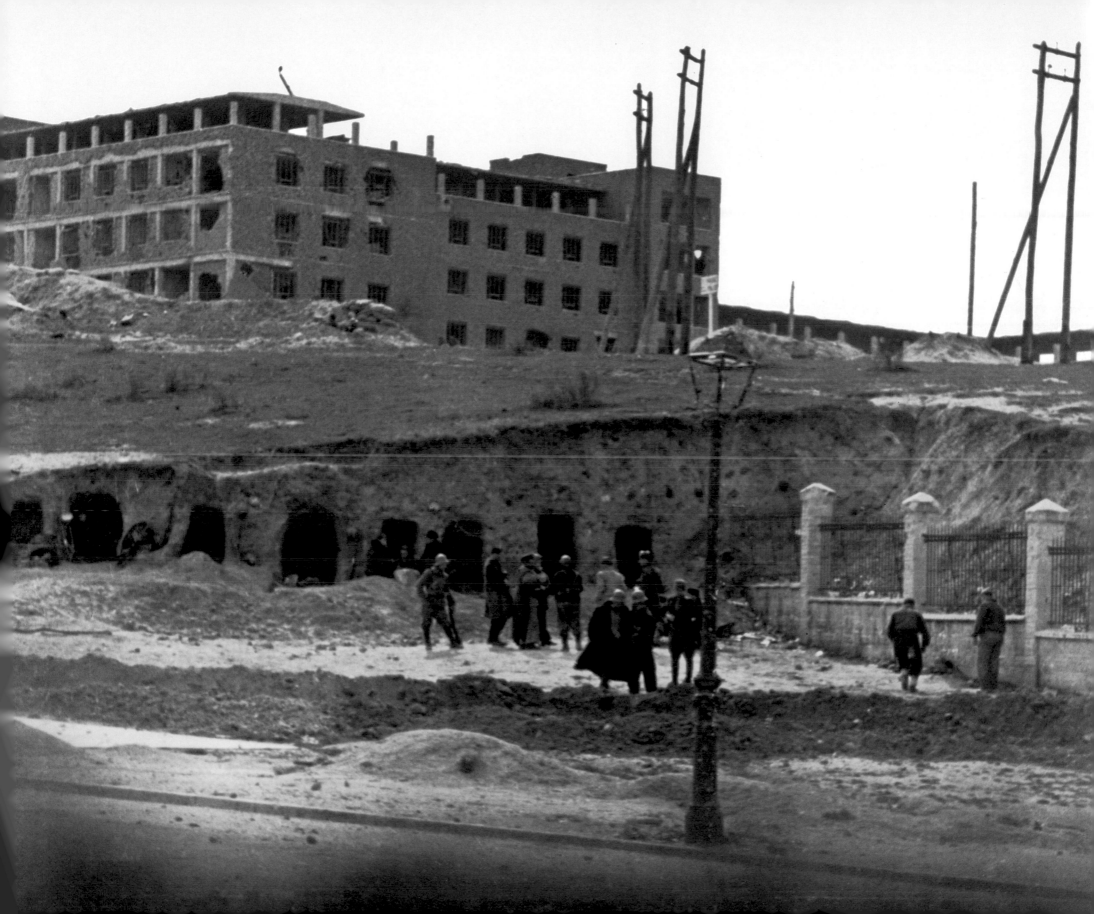

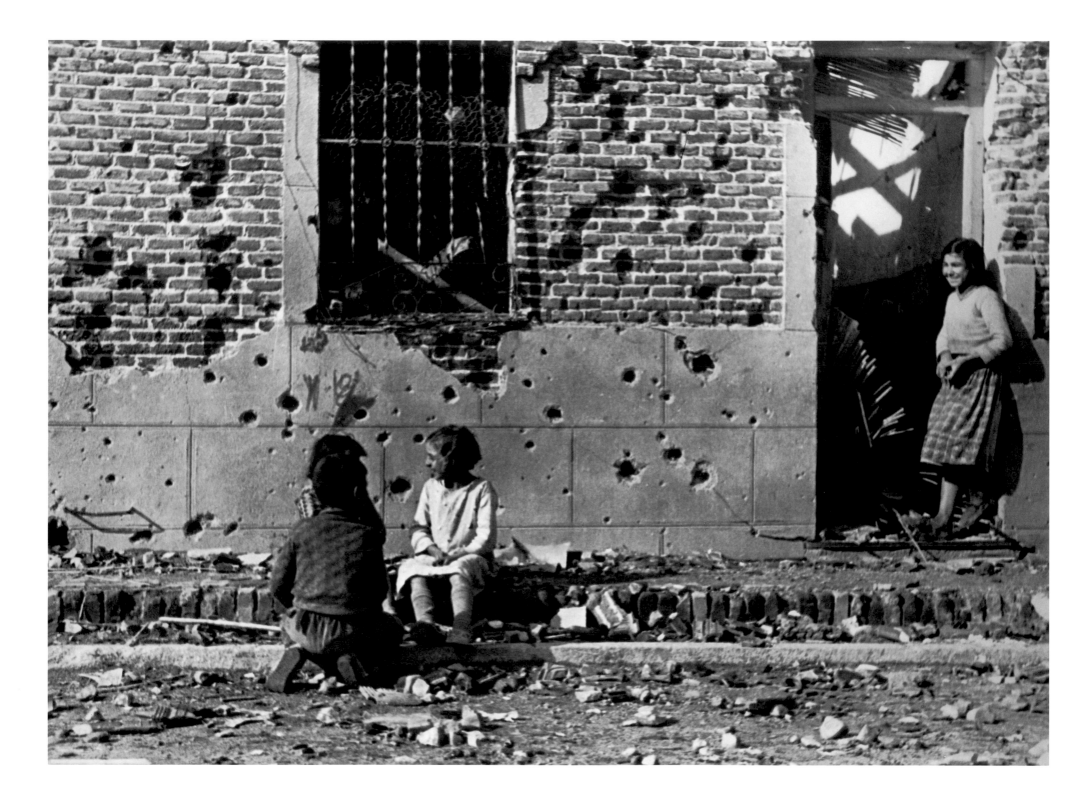

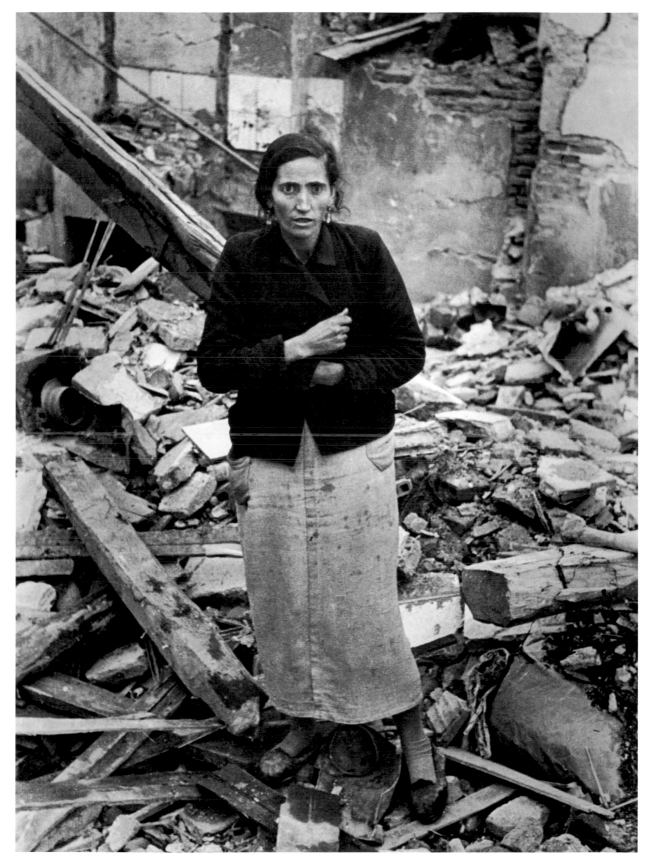

The Madrid district of Vallecas,
Winter 1936–37

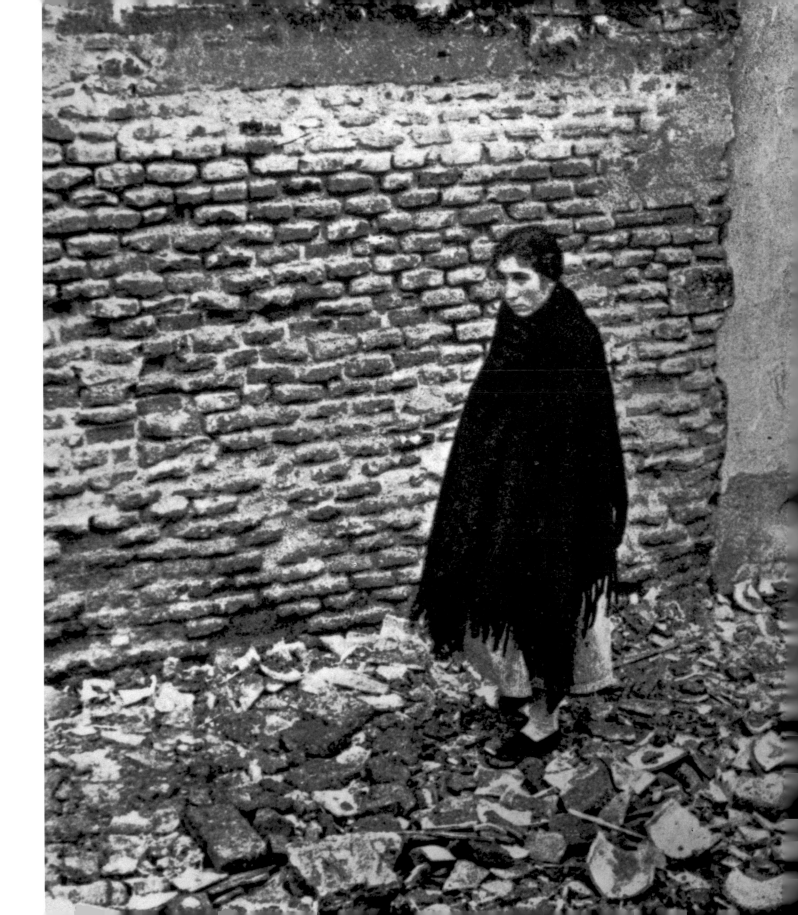

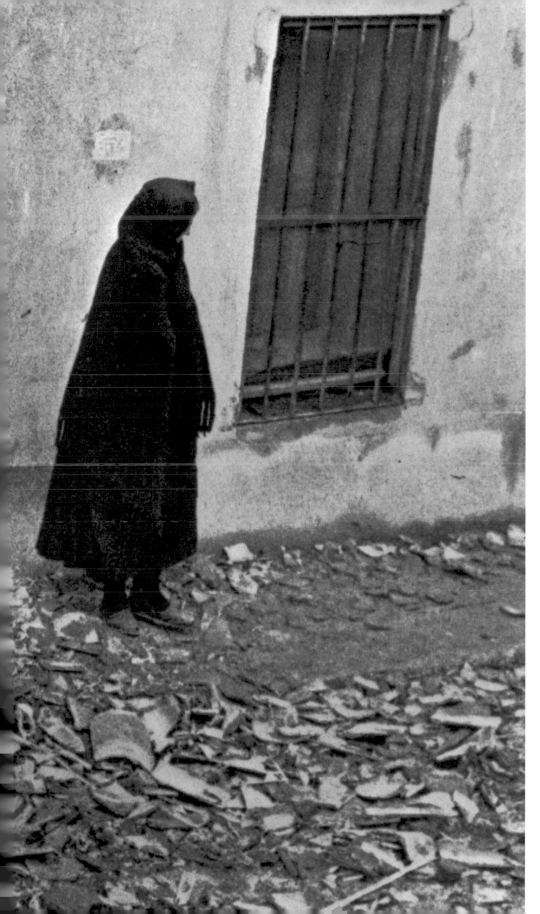

Regions submerged
in ceaseless martyrdom, through endless
silence, throbbing
of bees and exterminated rock;
you, lands, that instead of wheat
 and clover
wear the mark of dried blood and crime
· ·
Furor, flight of sorrow
and death and anger,
until the tears and grief now gathered,
until the words and fainting and ire
are but a heap of bones in the road
and a stone buried in the dust.

It is so much, so much
tomb, so much martyrdom, so much
galloping of beasts on the star!
Nothing, not the victory
will erase the terrible bloody hole:
nothing, not the sea, not the passage
of sand and time, not the geranium ablaze
on the grave.

PABLO NERUDA
from "Offended Lands"

The Madrid district of Vallecas,
winter 1936–37

99

Black afternoon, rain and mud,
streetcars and militiamen.
The avenue a tangle
of carts without horses,
mules packed with the villagers'
paltry household wares.
Lusterless faces of those who flee
Toledo's countryside;
children and the old,
women who were somebody,
once the village rose,
now a withered garland.
Nothing is spoken. All of them,
all of us headed
to war, for war,
rushing onward, or drifting
by the thousands, like leaves
in golden autumn.
Vehicles of war and rows
of militiamen storm
through zones of cease-fire,
through rain and mud.

The front of automobiles
flicker with red pennants
in a frenzy, threadbare,
like harbingers of victory
while women stand waiting
in line for milk, garbanzos,
charcoal, lentils, bread.
The ground is sown
with glass, and buildings
that gleamed with bright, clear eyes
now stare from gelid caverns,
tragic cavities.
There are streetcar tracks
like upraised horns,
streets cordoned off
where smoke now rises in tufts,
stone barricades
where we would sit
and watch the gossamer sky
of an unsuspecting Madrid
open to all breezes
and human sentiments.

Troubled, like a fish
encased in water, I efface
my footsteps through the streets.
I walk up, I walk down
into a metro station. The bundled sacks
of homeless families sleeping there.
The stench is thick;
it's hard to breathe.
I come up, I leave
returning to the clouded
afternoon. I feel encircled
by Madrid, now an island,
alone beneath the asphalt sky,
where ravens soar across
in search of children and the old.
Black afternoon; rain, rain,
streetcars and militiamen.

JOSÉ MORENO VILLA
"Madrid Front"
(Translated from the Spanish
by Roberto Tejada)

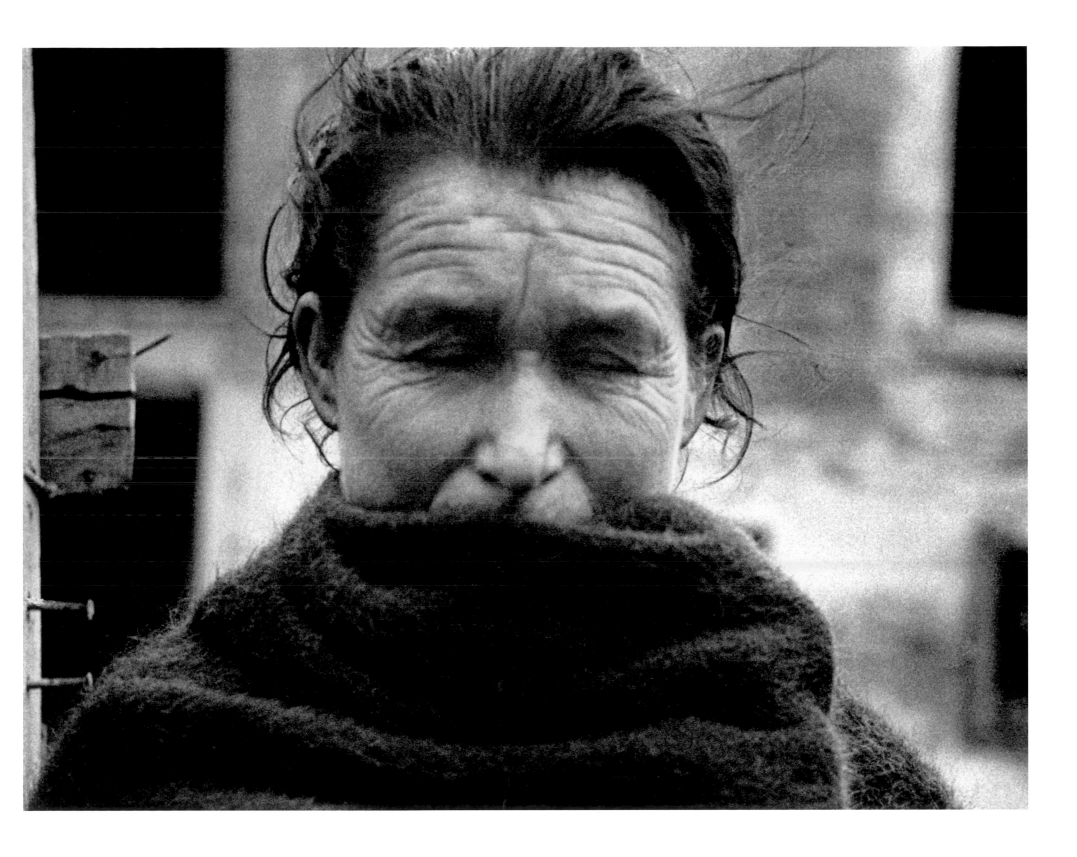

The Madrid district of Vallecas, winter 1936–37

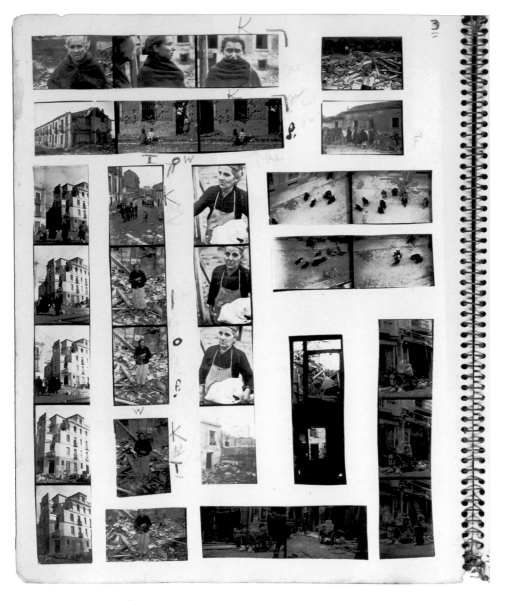

Nowhere is there safety for anyone in this war. The women stay behind, but the death, the ingenious death from the skies finds them out. In their homes. The men in the lines watch the bombers go over the lines with anguish, for in this war there are no non-combatants.
—From *Death in the Making*, RC

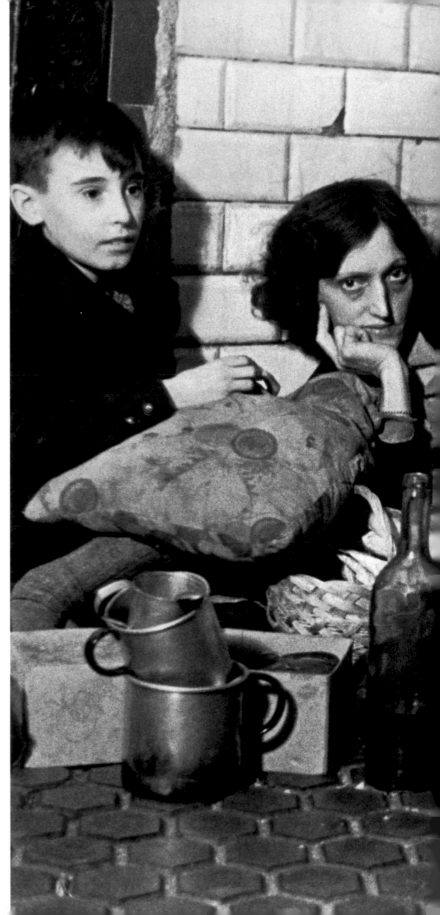

Madrid, November–
December 1936

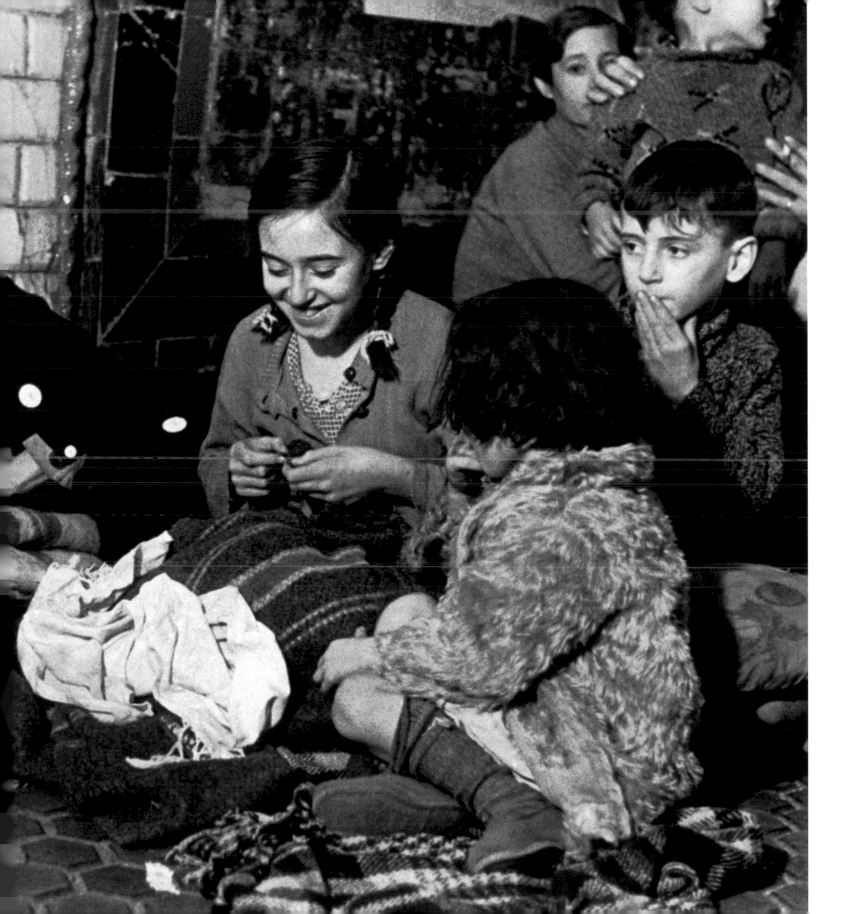

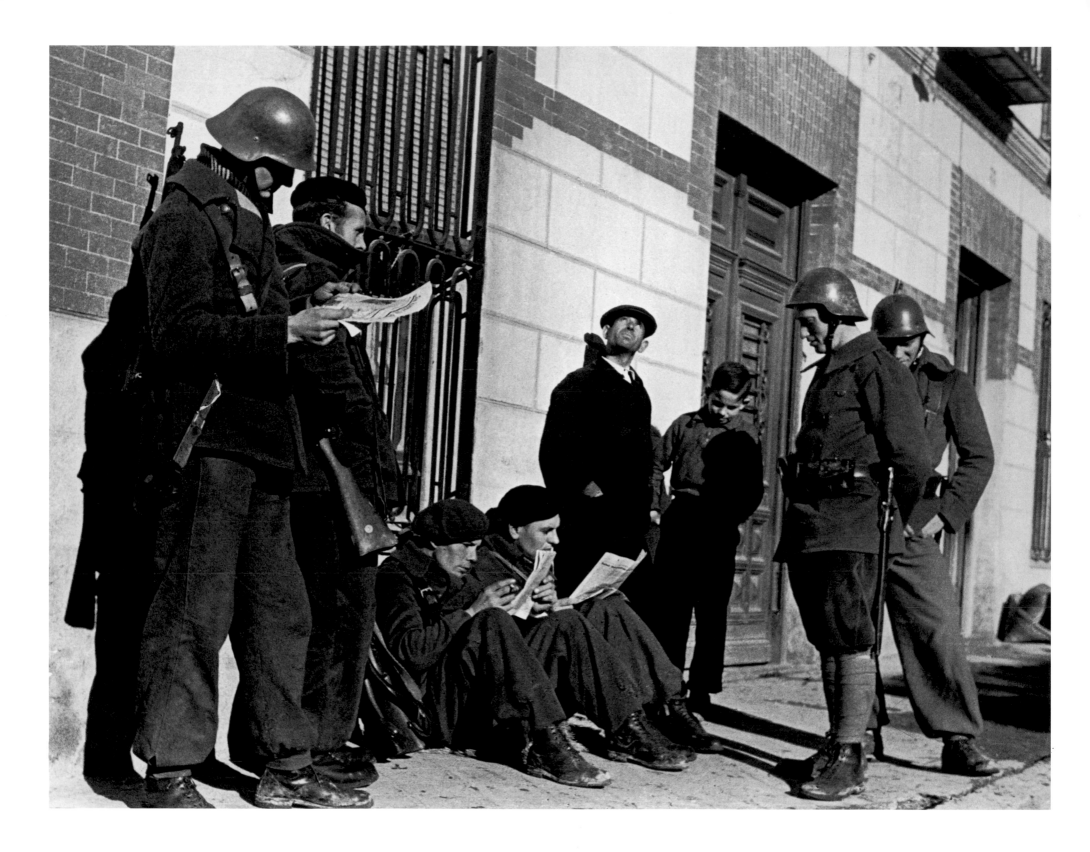

104 Madrid, November–December 1936

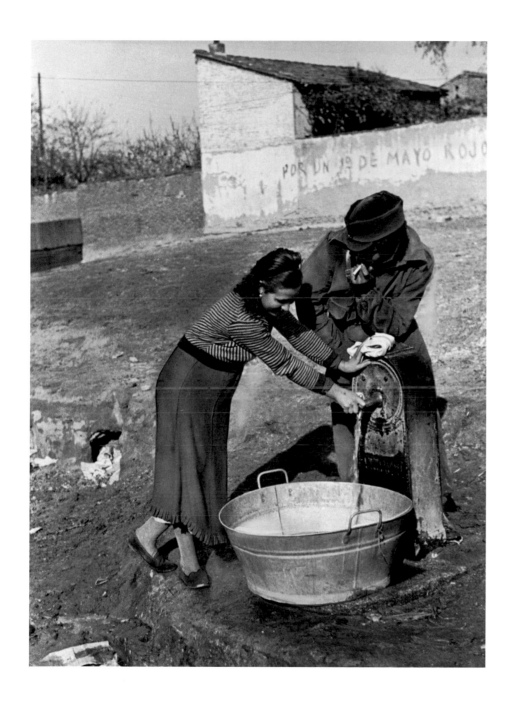

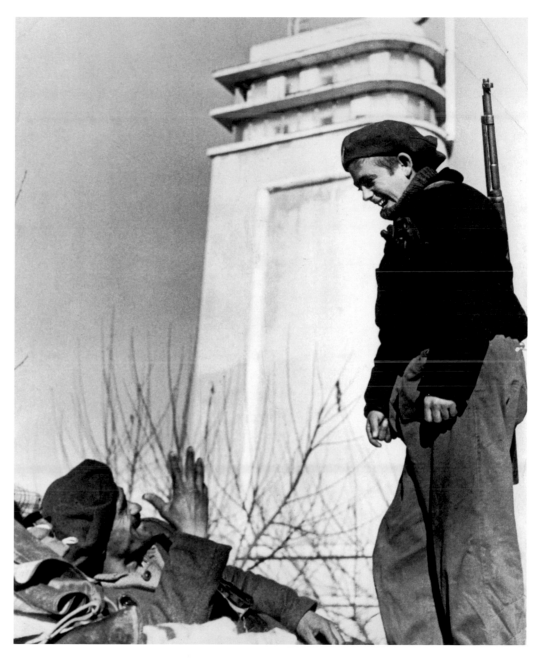

Madrid, November–December 1936

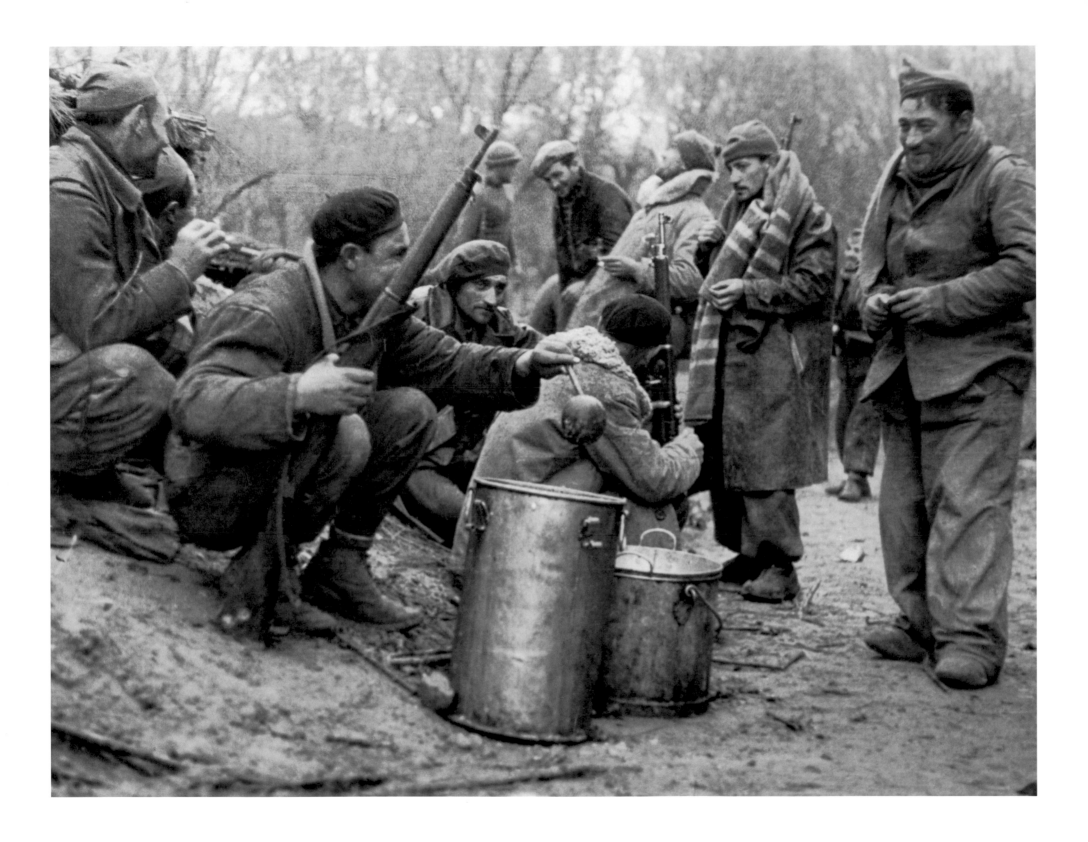

106 Madrid, November–December 1936

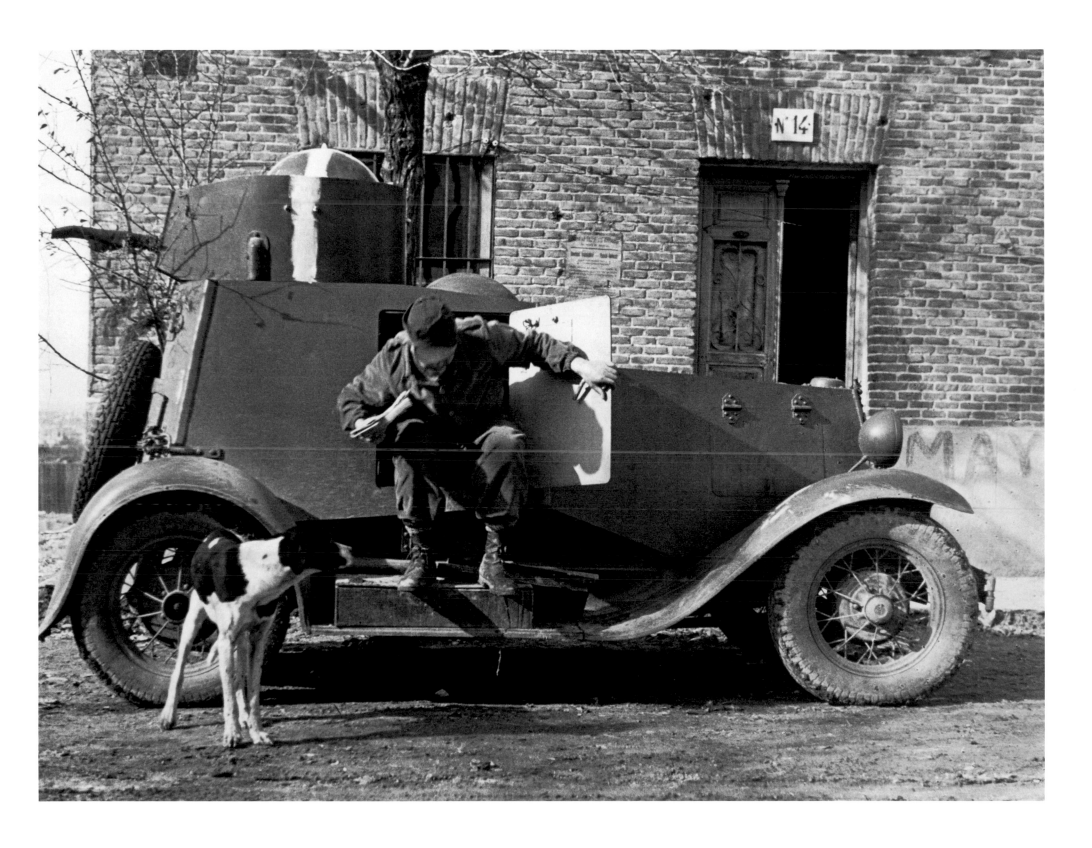

Madrid, November–December 1936

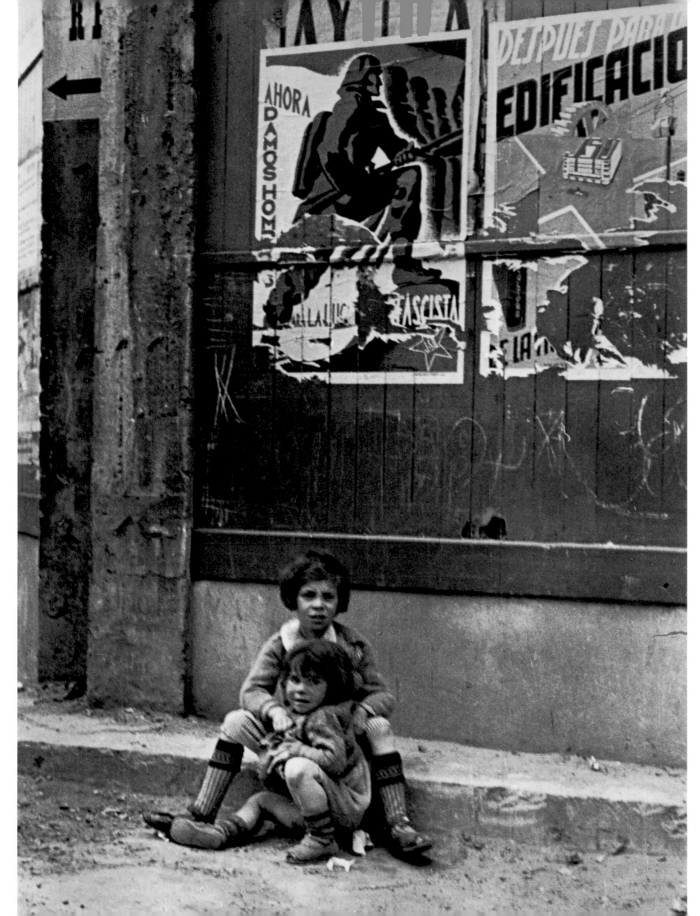

Bilbao, May 1937

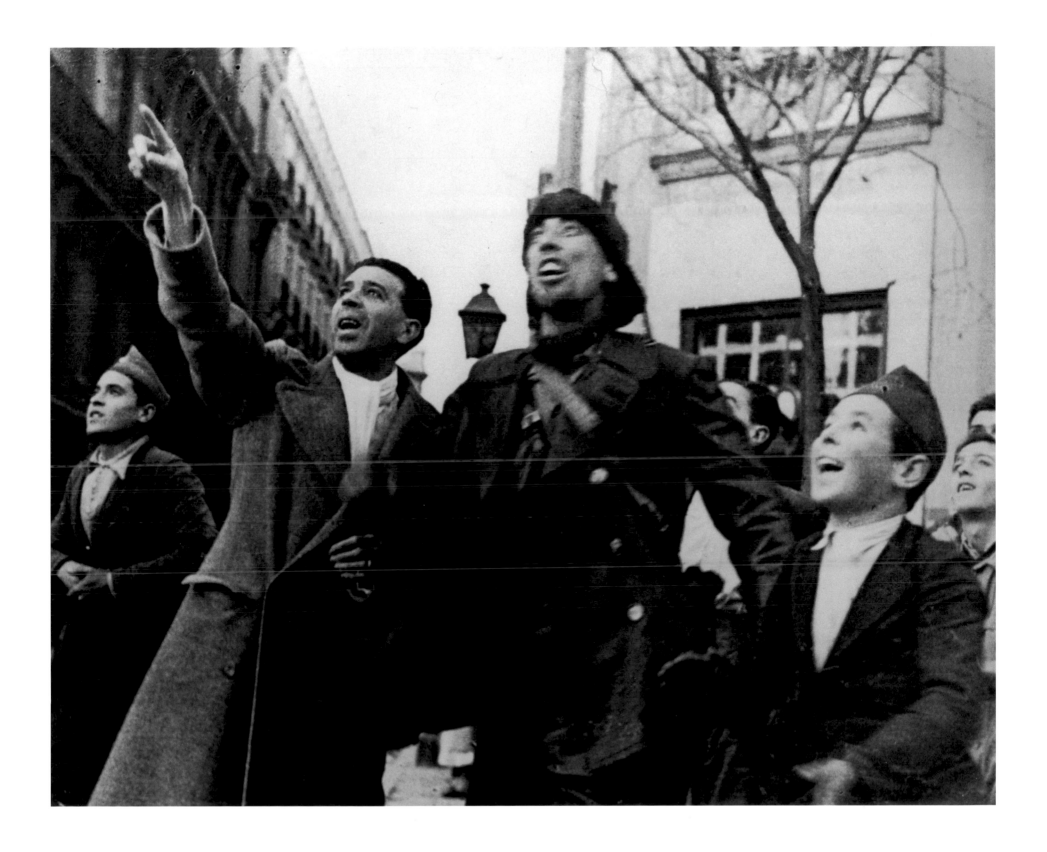

Madrid, November–December 1936

There is little protection in the cities. The bombs break through the shelters. In Valencia, in Madrid there is a daily toll. . . . Always the same, the sirens, the panic rush, the fracas of the bombs and then, as the dust settles, people go off to the morgue, to wait, to see if by chance the son, the father, the mother who did not come home is on the lists. . . .
—From *Death in the Making*, RC

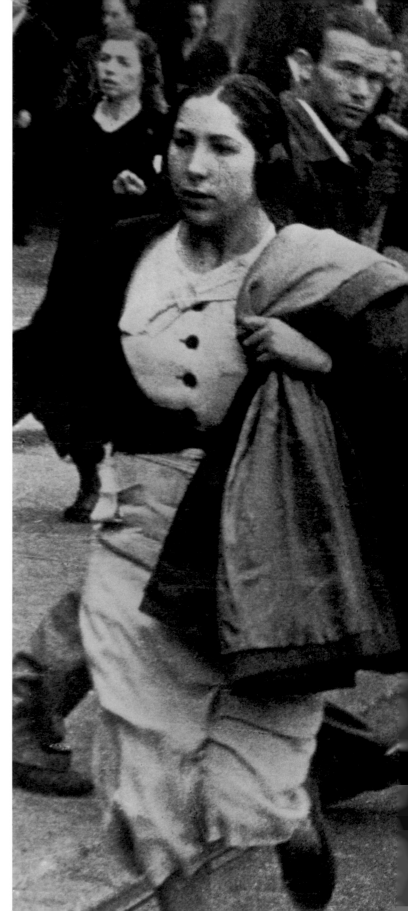

Bilbao, May 1937

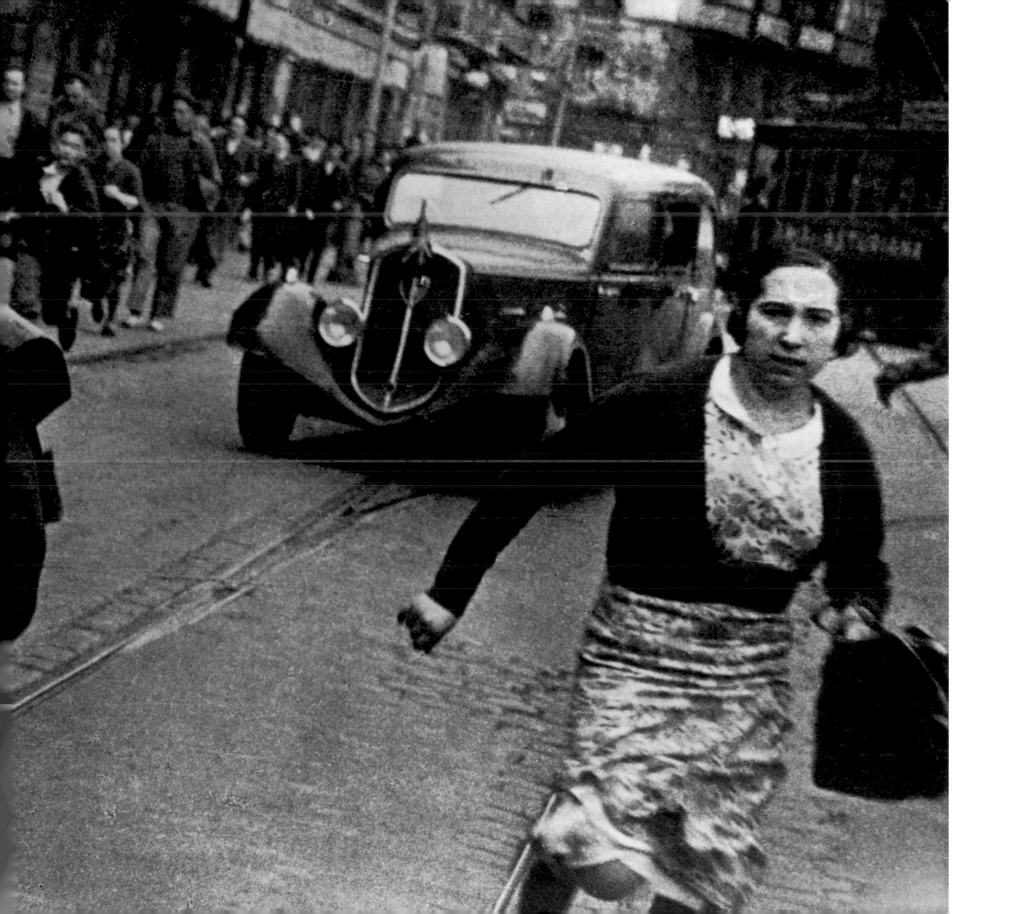

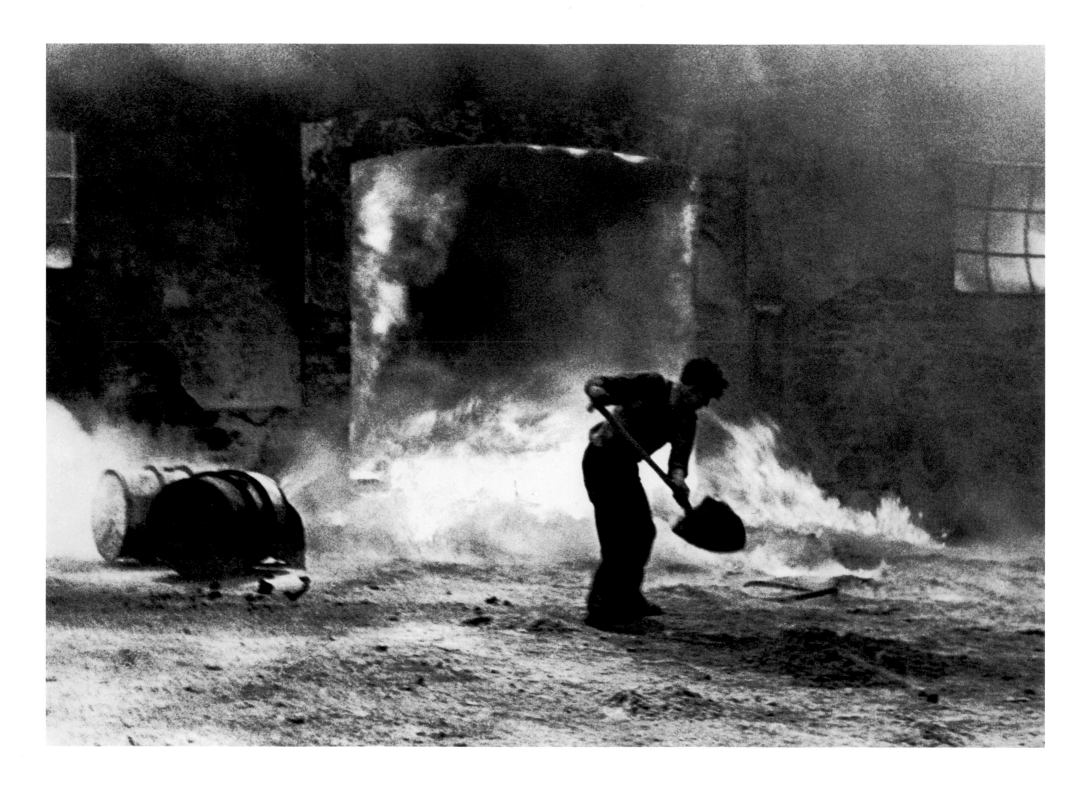

112 Bilbao, May 1937

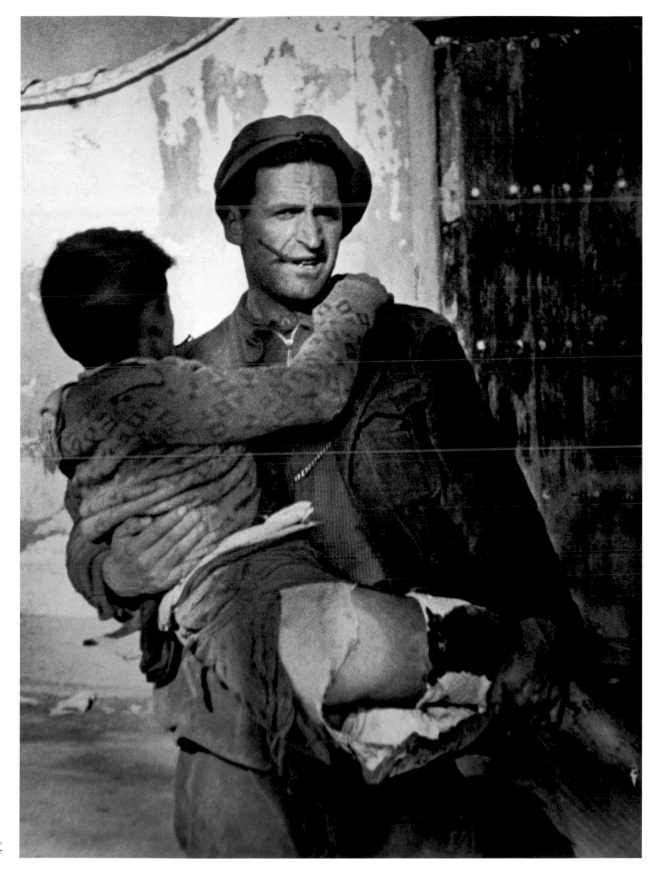

Teruel, Aragon front,
December 21, 1937

All the posters on the walls,
All the leaflets in the streets
Are mutilated, destroyed, or run in rain,
Their words blotted out with tears,
Skins peeling from their bodies
In the victorious hurricane.

.

All the lessons learned, unlearnt;
The young, who learned to read, now blind
Their eyes with the archaic film;
The peasant relapses to a stumbling tune
Following the donkey's bray;
These only remember to forget.

But somewhere some word presses
In the high door of a skull, and in some corner
Of an irrefrangible eye
Some old man's memory jumps to a child—
Spark from the days of liberty.
And the child hoards it like a bitter toy.

STEPHEN SPENDER
from "Fall of a City"

Bilbao, May 1937

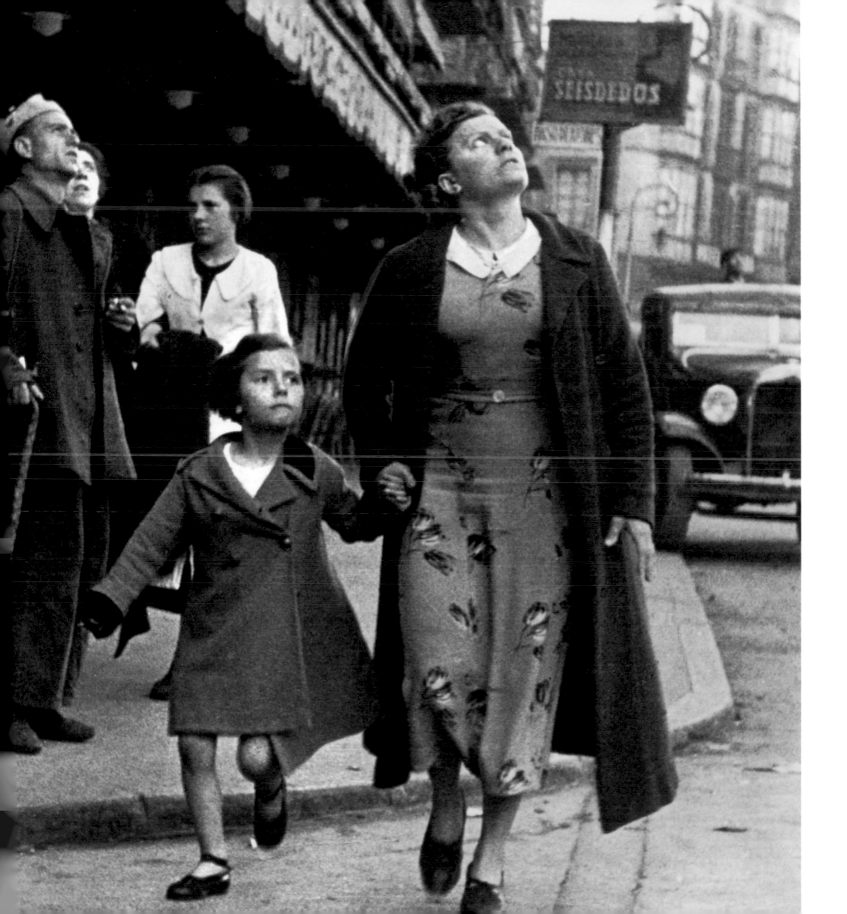

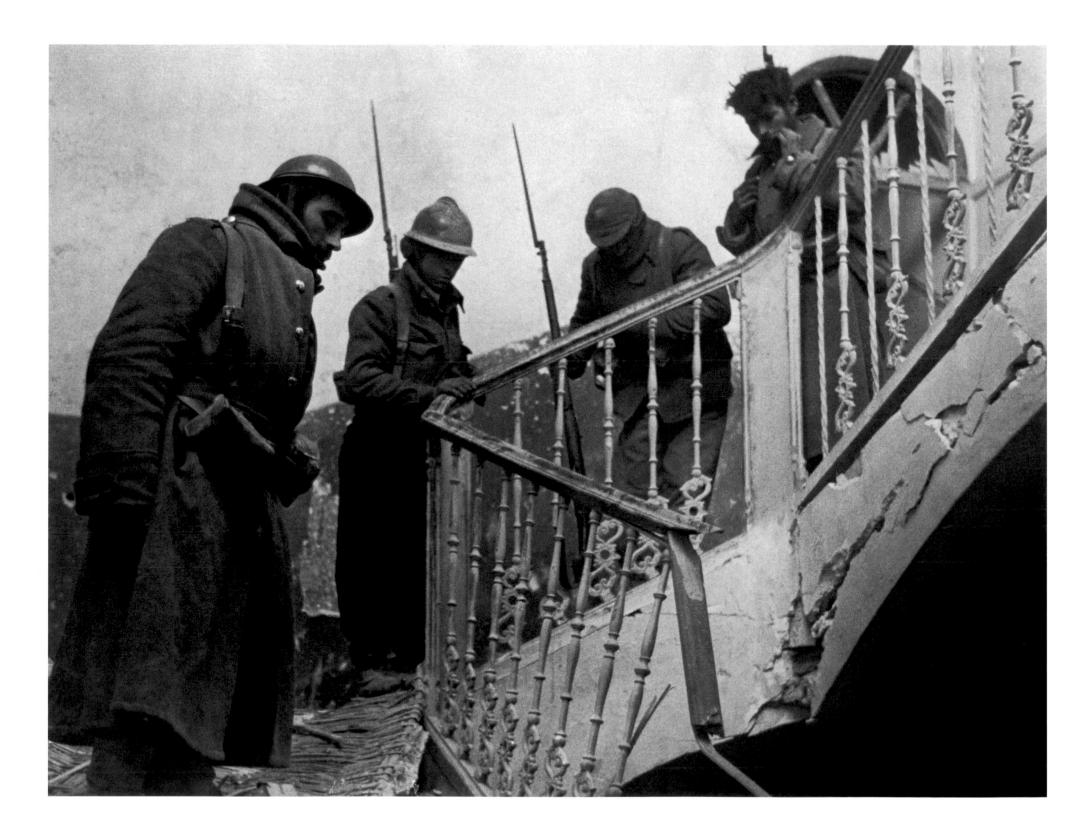

116 Teruel, Aragon front, January 3, 1938

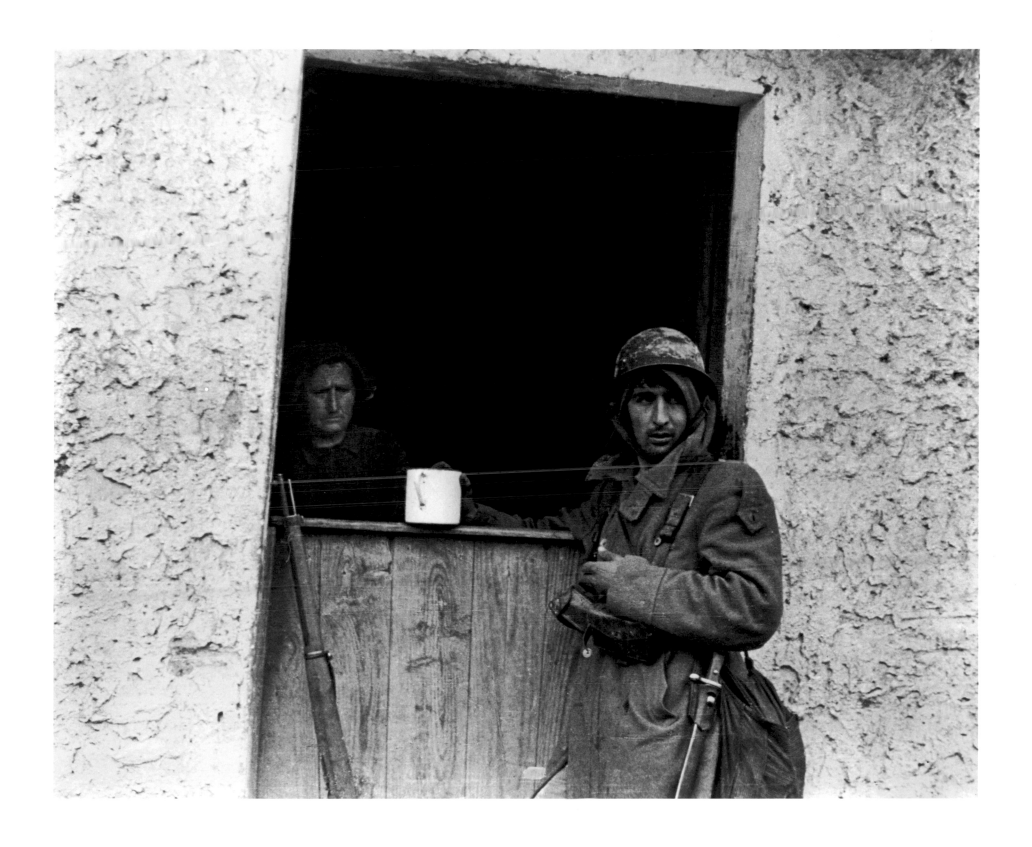

Mount Sollube, Bilbao front, May 7, 1937

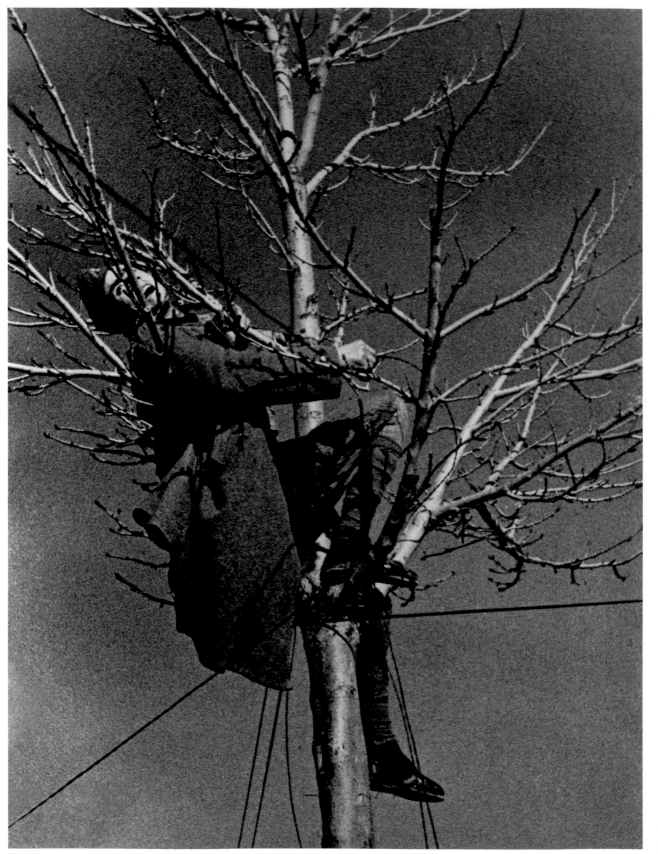

Teruel, Aragon front,
December 21–24, 1937

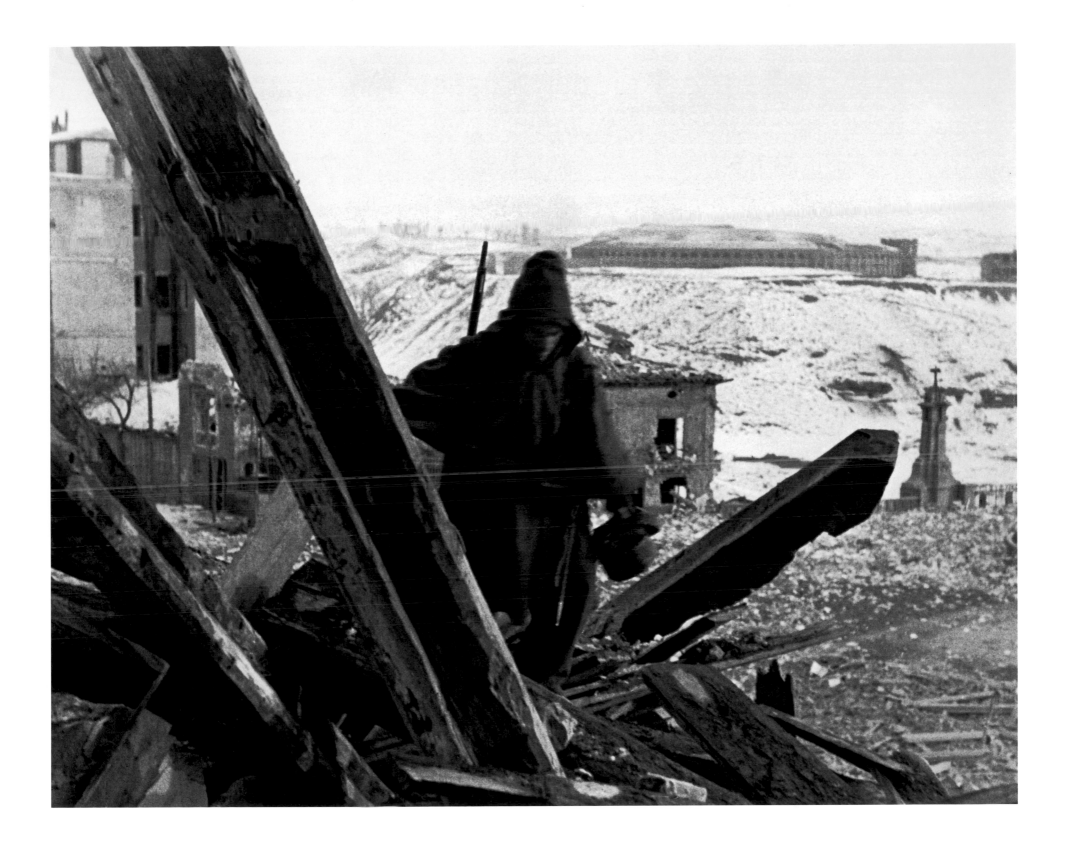

Teruel, Aragon front, December 1937–January 1938

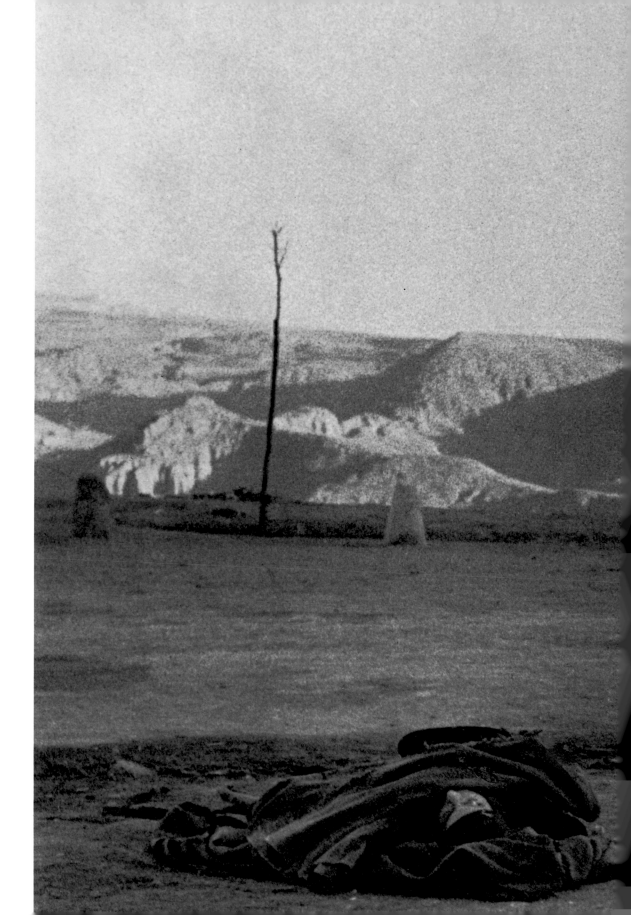

The fiery palm tree in front of me,
that the setting sun is just now leaving
this late and silent afternoon
inside our peaceful garden,
while flowery old Valencia
drinks the Guadalaviar water—
Valencia of delicate towers,
in the joyful sky of Ausias March,
her river turns entirely to roses
before it arrives at the sea—
I think of the war. The war
is like a tornado moving
through the bleak foothills of the Duero,
through the plains of standing wheat,
from the farmlands of Extremadura
to these gardens of private lemons,
from the grey skies of the north
to these salty marshes full of light.
I think of Spain, all of it sold out,
river by river, mountain by mountain, sea to sea

Antonio Machado, "Today's Meditation"
(Translated from the Spanish by Robert Bly)

120

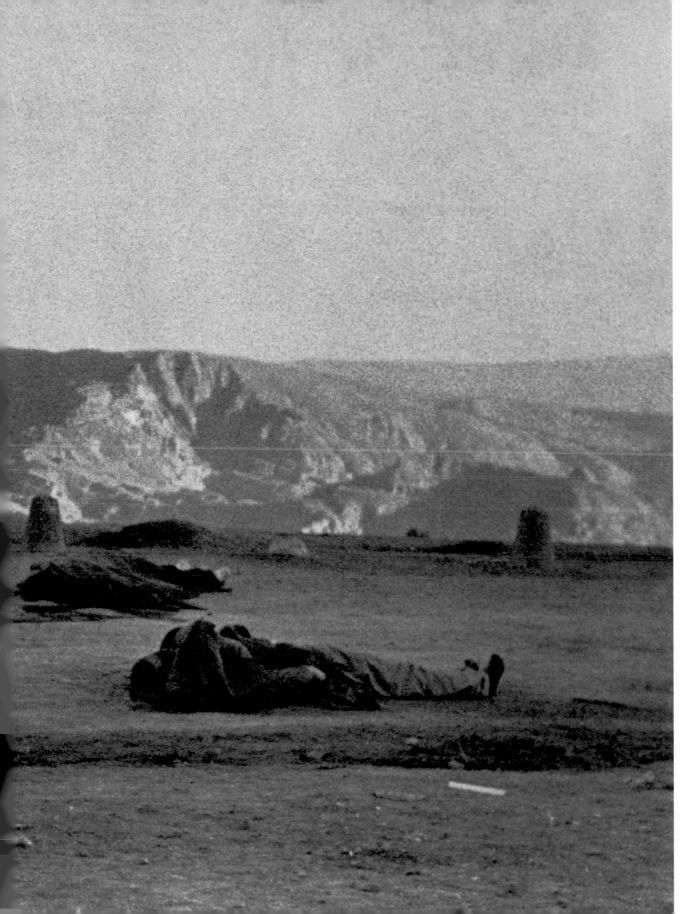

Teruel, Aragon front,
December 21, 1937

. . . When the years pass by and the wounds of the war are stanched; when the cloudy memory of the sorrowful, bloody days returns in a present of freedom, peace, and well-being; when the feelings of rancor die away and when pride in a free country is felt equally by all Spaniards, then speak to your children. Tell them of these men of the International Brigades.

Tell them how, coming over seas and mountains, crossing frontiers bristling with bayonets, watched for by raving dogs thirsting to tear at their flesh, these men reached our country as crusaders for freedom, to fight and die for Spain's liberty and independence, which were threatened by German and Italian fascism. They gave up everything: their loves, their countries, home and fortune; fathers, mothers, wives, brothers, sisters, and children, and they came and told us: "We are here. Your cause, Spain's cause, is ours—it is the cause of all advanced and progressive mankind."

Today they are going away. Many of them, thousands of them, are staying here with the Spanish earth for their shroud, and all Spaniards should remember them with the deepest feeling.

Comrades of the International Brigade . . . we shall not forget you, and when the olive tree of peace puts forth its leaves again, entwined with the laurels of the Spanish Republic's victory—come back! . . .

Come back to us. With us, those of you who have no country will find one, those of you who have to live deprived of friendship will find friends, and all of you will find the love and gratitude of the whole Spanish people who, now and in the future, will cry out will all their hearts:

"Long live the heroes of the International Brigades!"

DOLORES IBÁRRURI, from the farewell
speech to the International Brigades,
Barcelona, October 1938

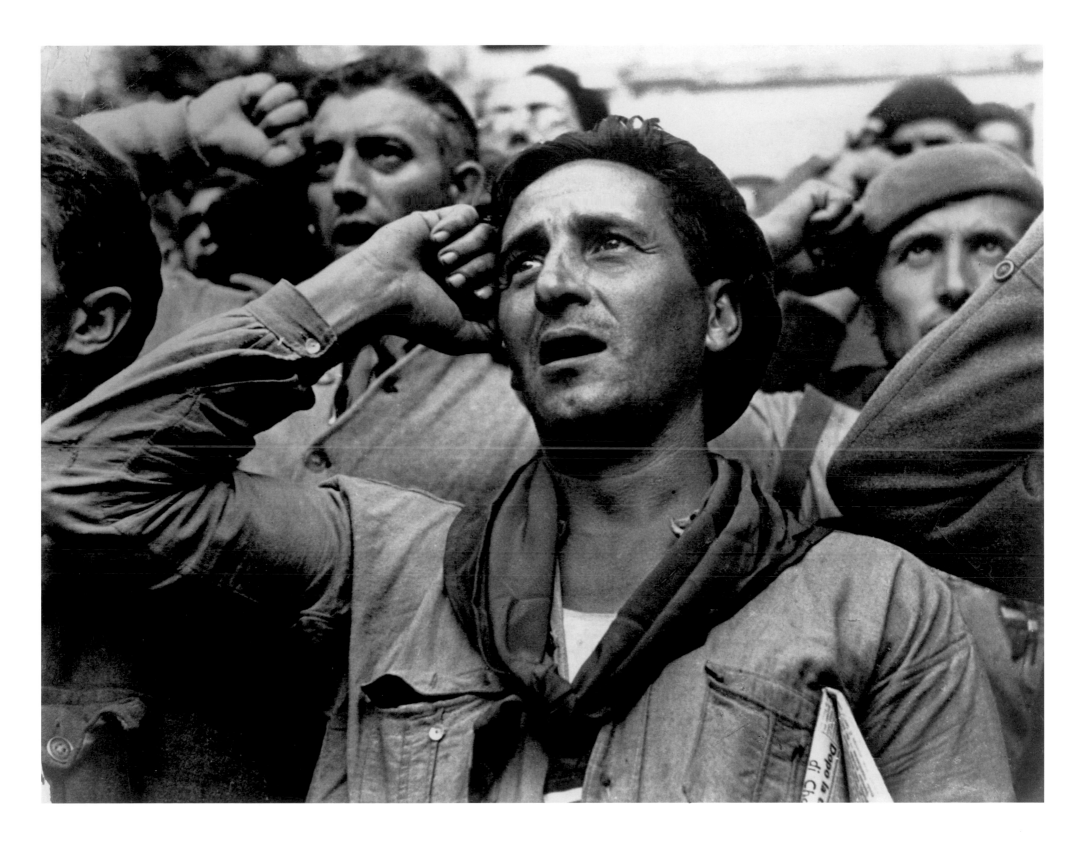

Montblanch (near Barcelona), October 25, 1938

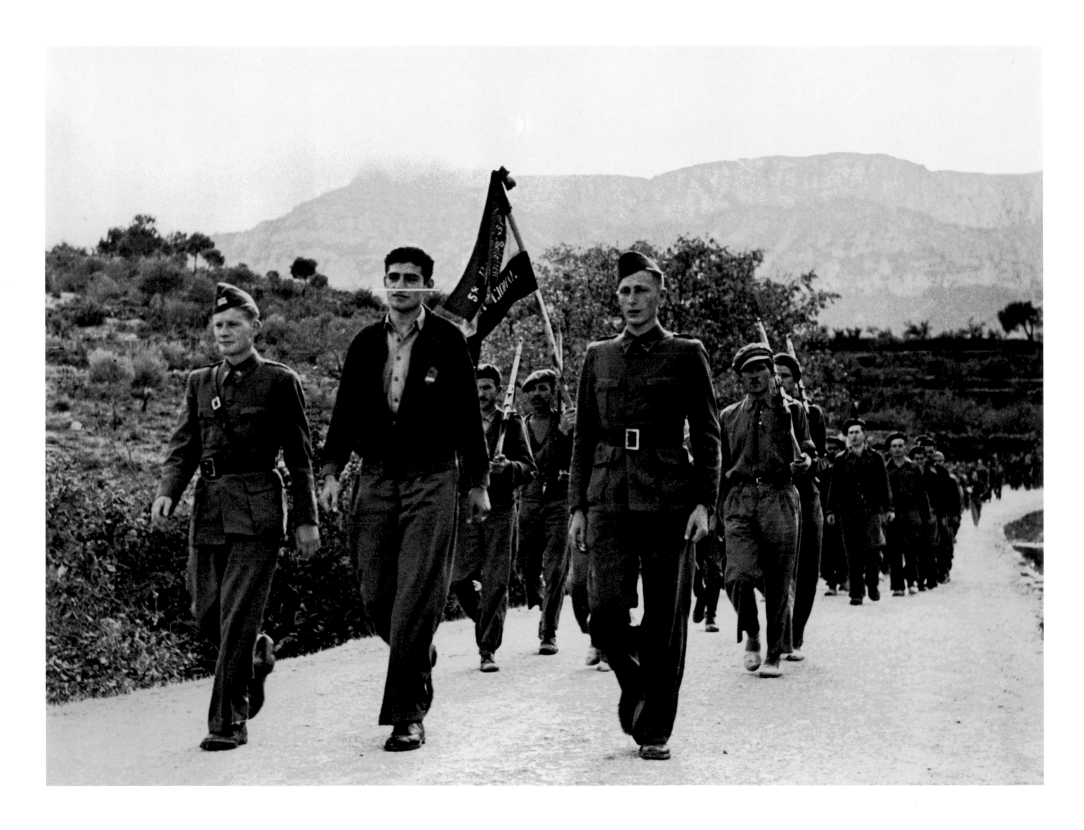

124 Falset (near Barcelona), October 16, 1938

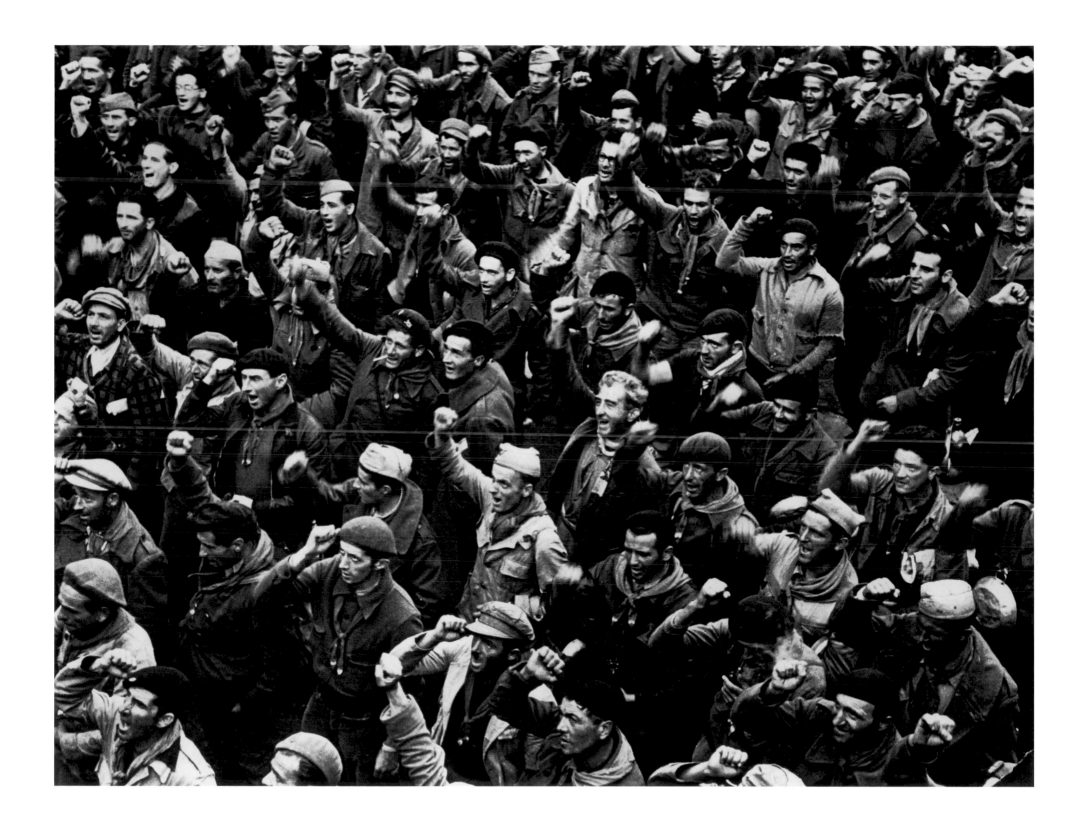

Montblanch (near Barcelona), October 25, 1938

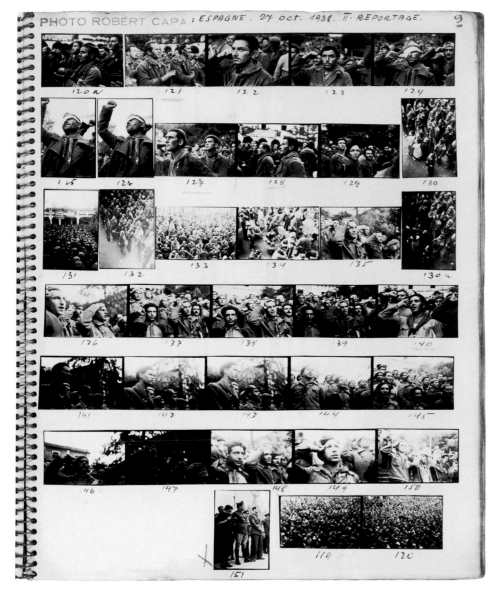

Photographs from the farewell rally held in honor of the International Brigades. In the preface to *Death in the Making*, Jay Allen wrote of the non-Spaniards experience, "Each man had to discover his Spain. There were Spains for us all."

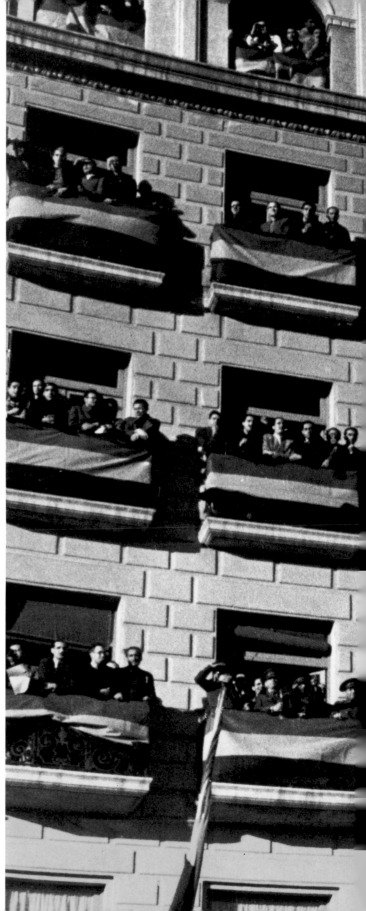

Barcelona,
October 29, 1938

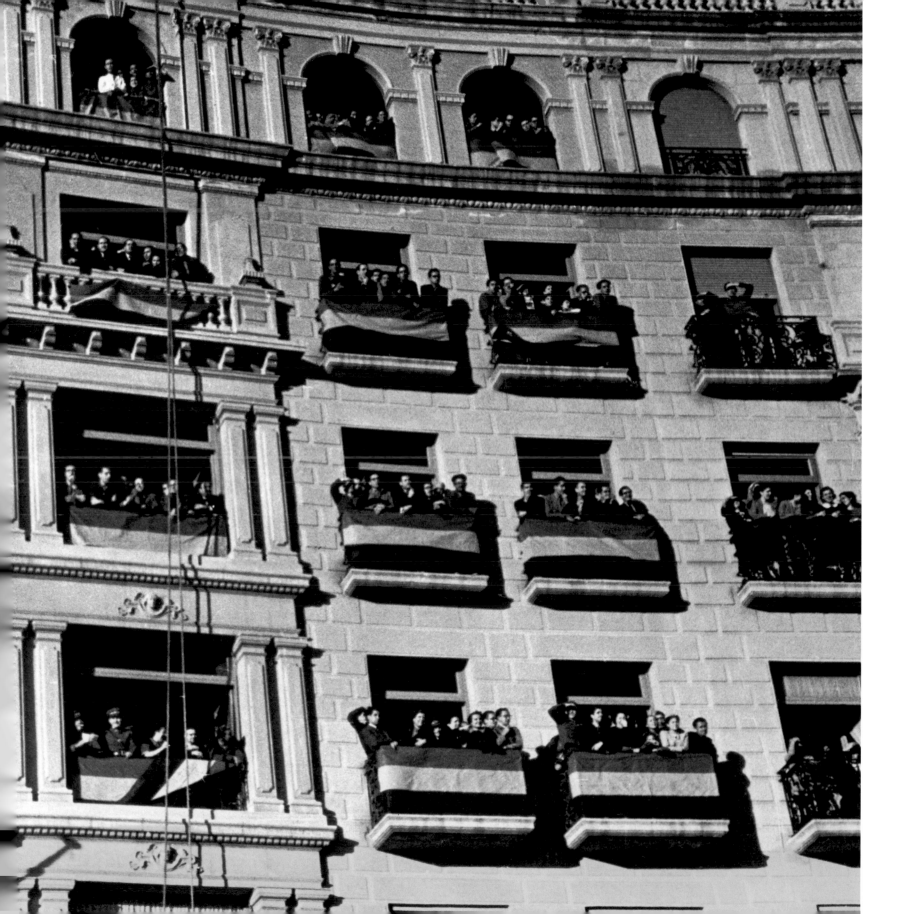

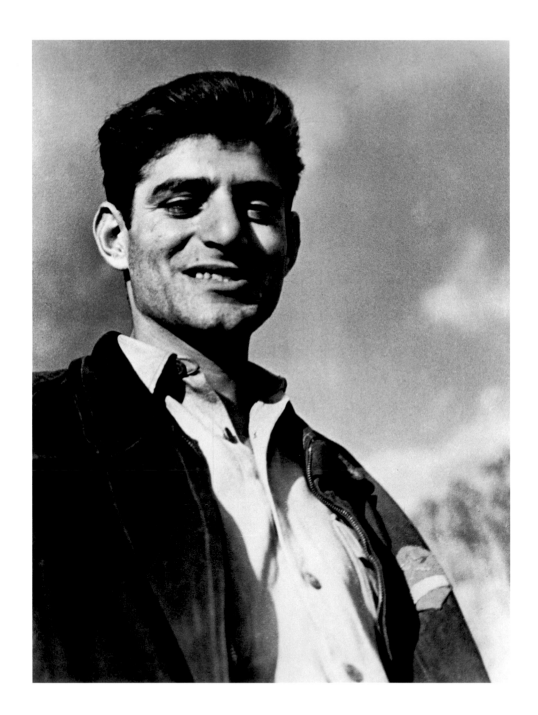

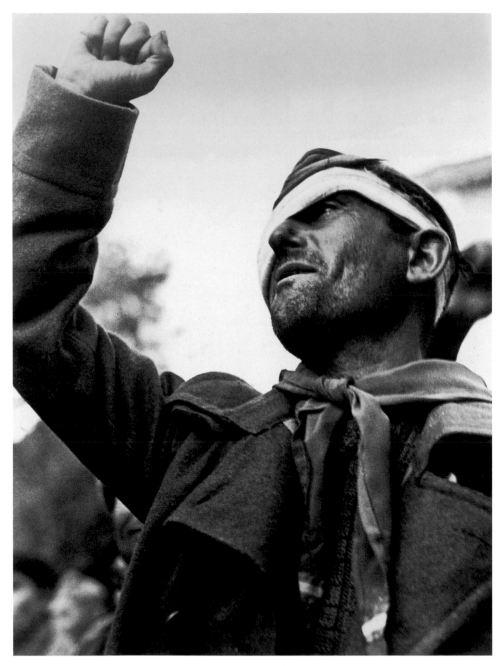

Falset (near Barcelona), October 16, 1938
Montblanch (near Barcelona), October 25, 1938

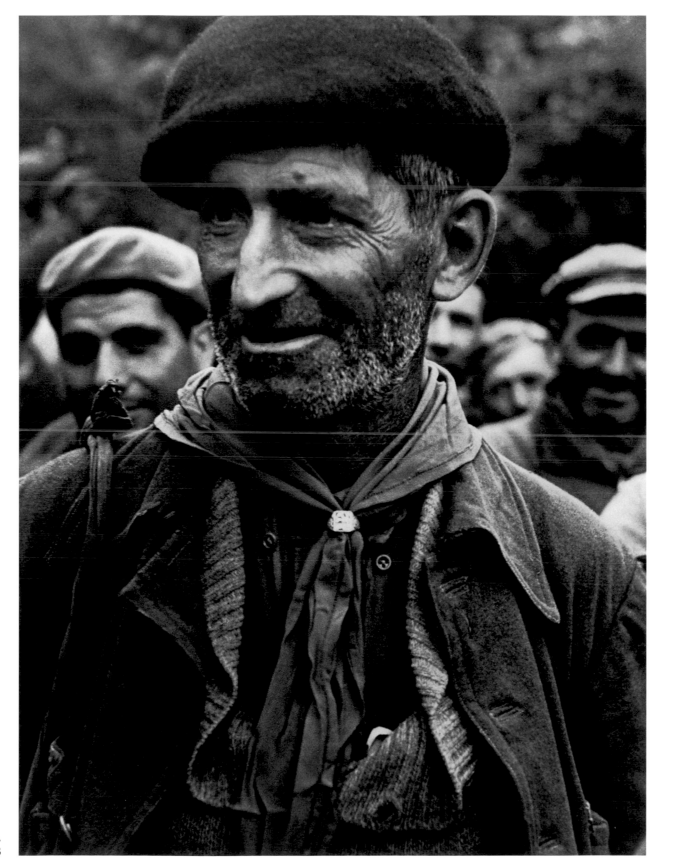

Montblanch (near Barcelona),
October 25, 1938

This is our moment.
You can hear us singing
Where the earth is brittle under the southern sun
Watch us marching in serried ranks to the death that is our homage
To the unbroken spirit of our dishonoured country.
For here we are showing the world our country's other face,
And the voice that for three years in Germany has been silenced
Utters its songs of freedom under an alien sun.

We were in Barcelona with the masses that stormed the Colon;
We left with the first militia for the Eastern Front;
Then we went to Madrid;
We were at Casa del Campo,
Guadalajara, Brunete, Belchite and Teruel,
Putting to rout the Italians in the name of Thälmann.

Here we have shown to the world our country's other face;
And not the face of the hangman with the sprouting forelock
But the face of the young men who march together singing
Through southern plains where the clay is brittle under the sun.

AILEEN PALMER
"Thälmann Battalion"

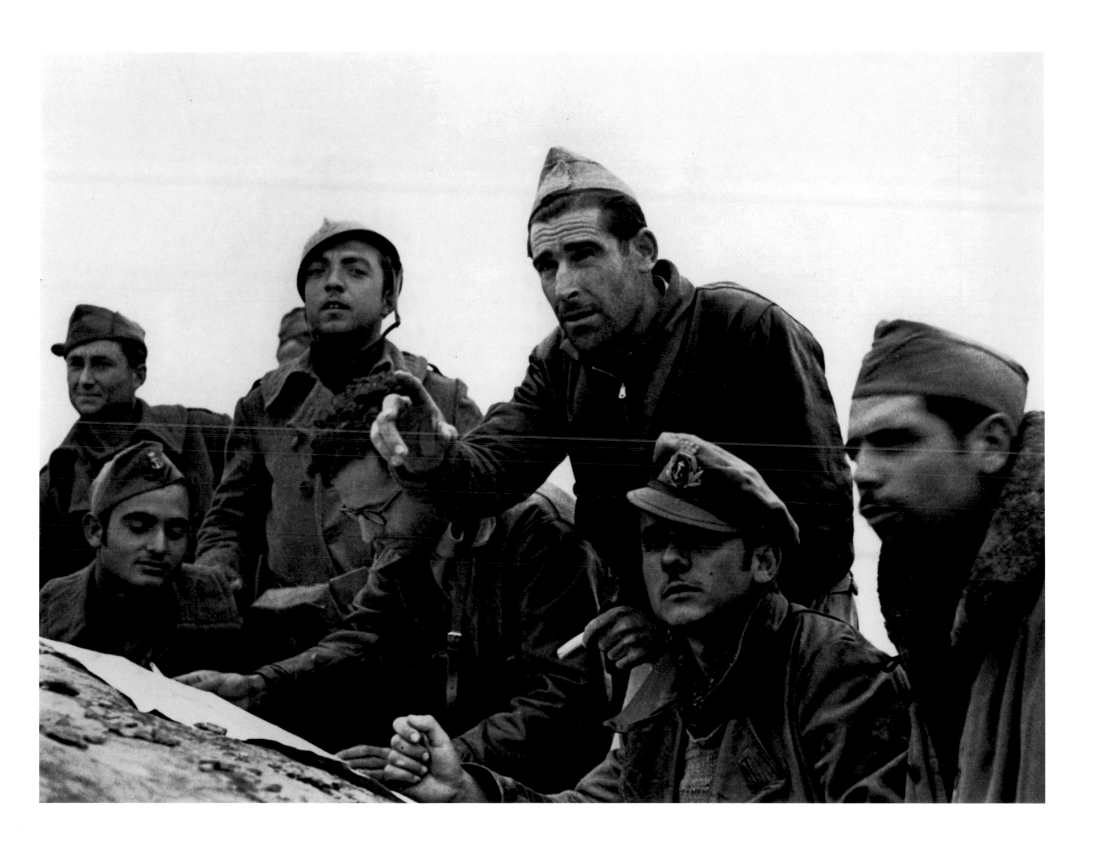

Rio Segre, Aragon front (near Fraga), November 7, 1938

131

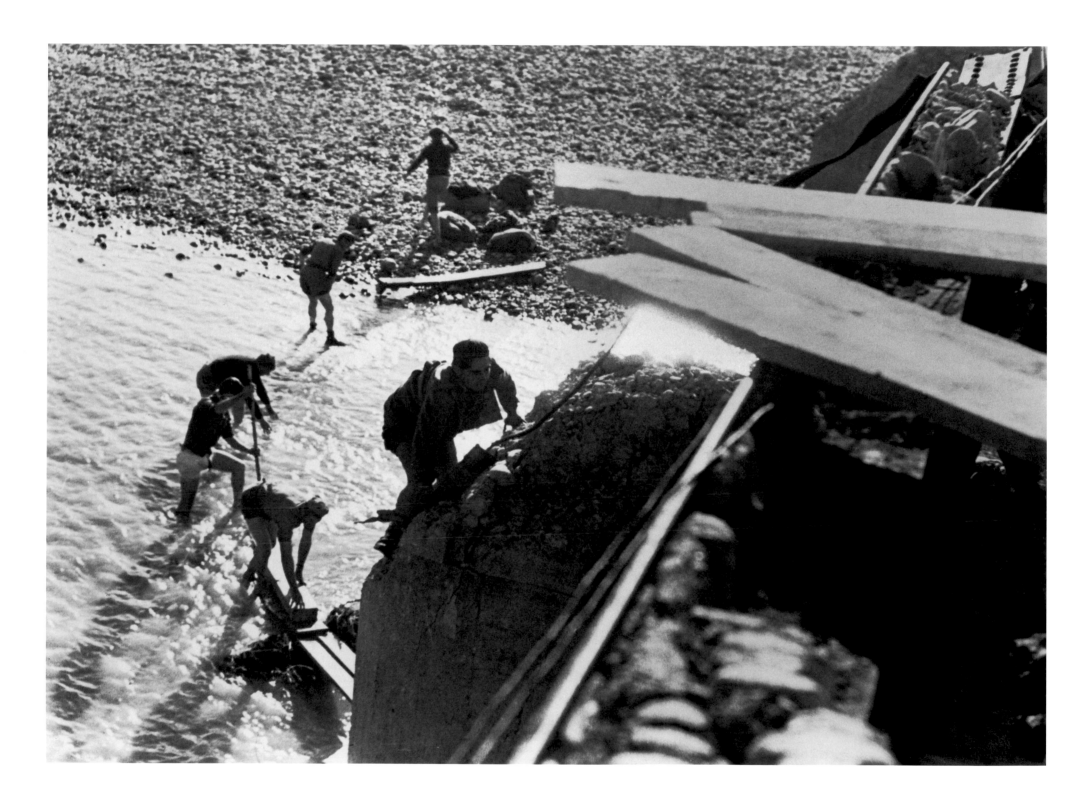

132 Mora de Ebro, Aragon front, November 5, 1938

Rio Segre, Aragon front (near Fraga), November 7, 1938

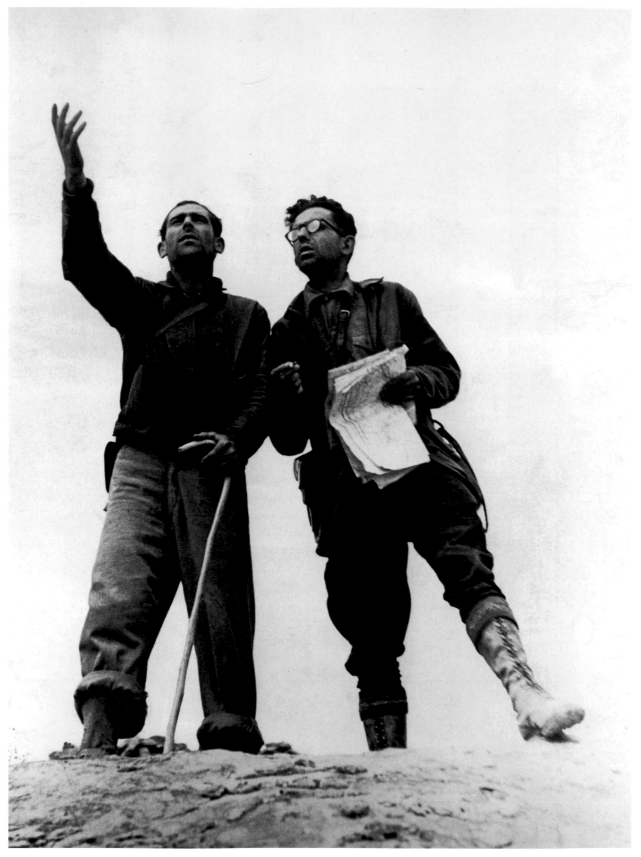

Left and opposite: Rio Segre, Aragon front
(near Fraga), November 7, 1938

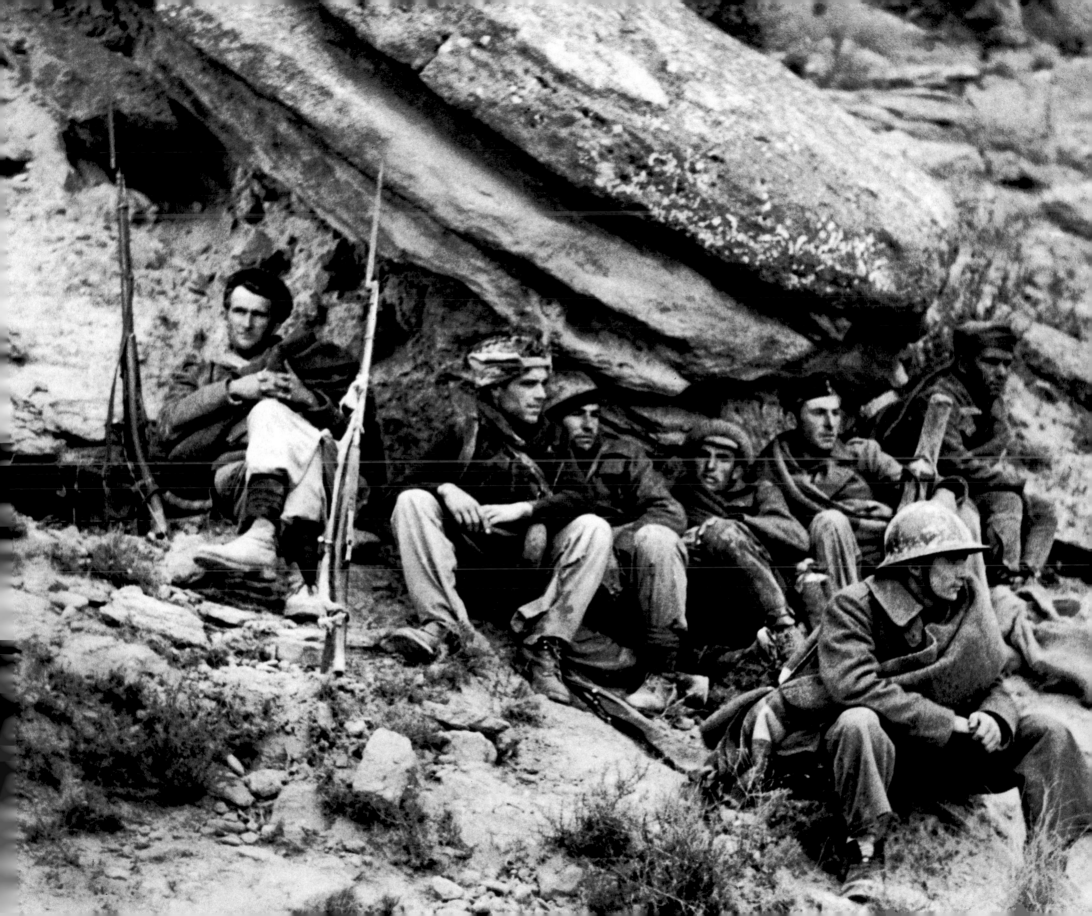

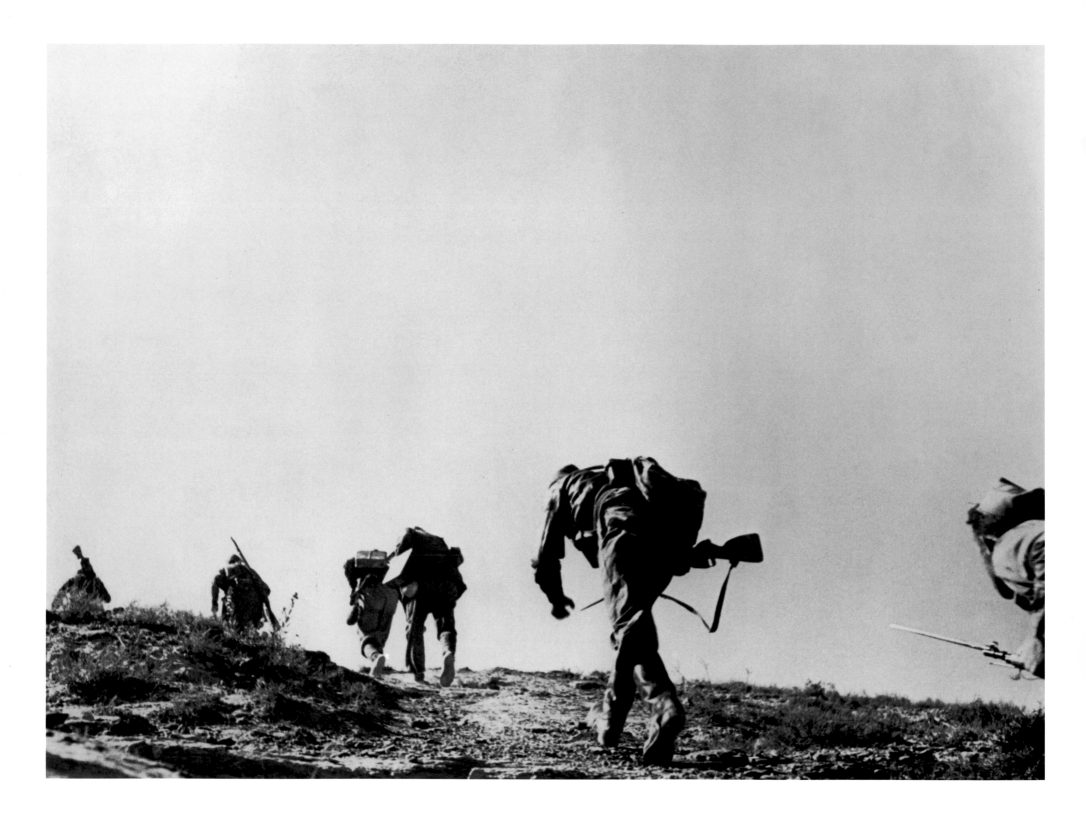

Pages 136–39: Rio Segre, Aragon front (near Fraga), November 7, 1938

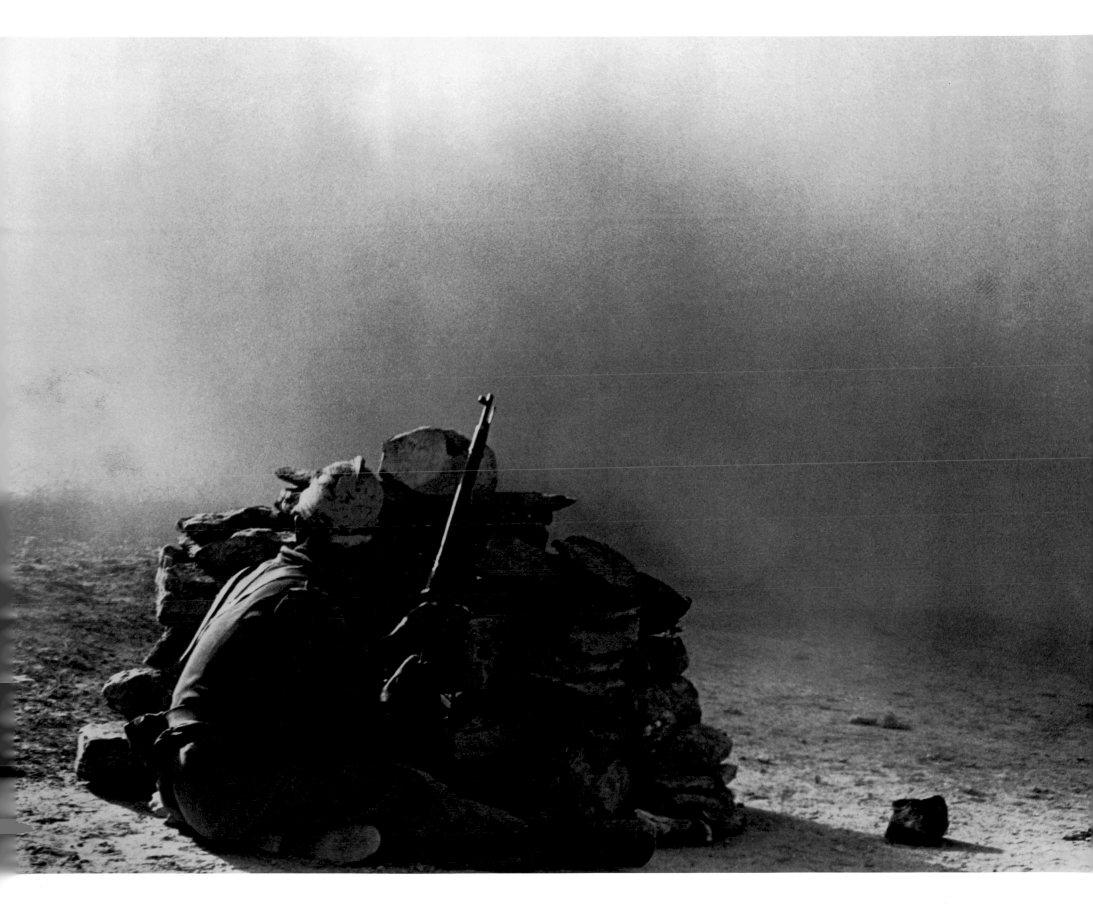

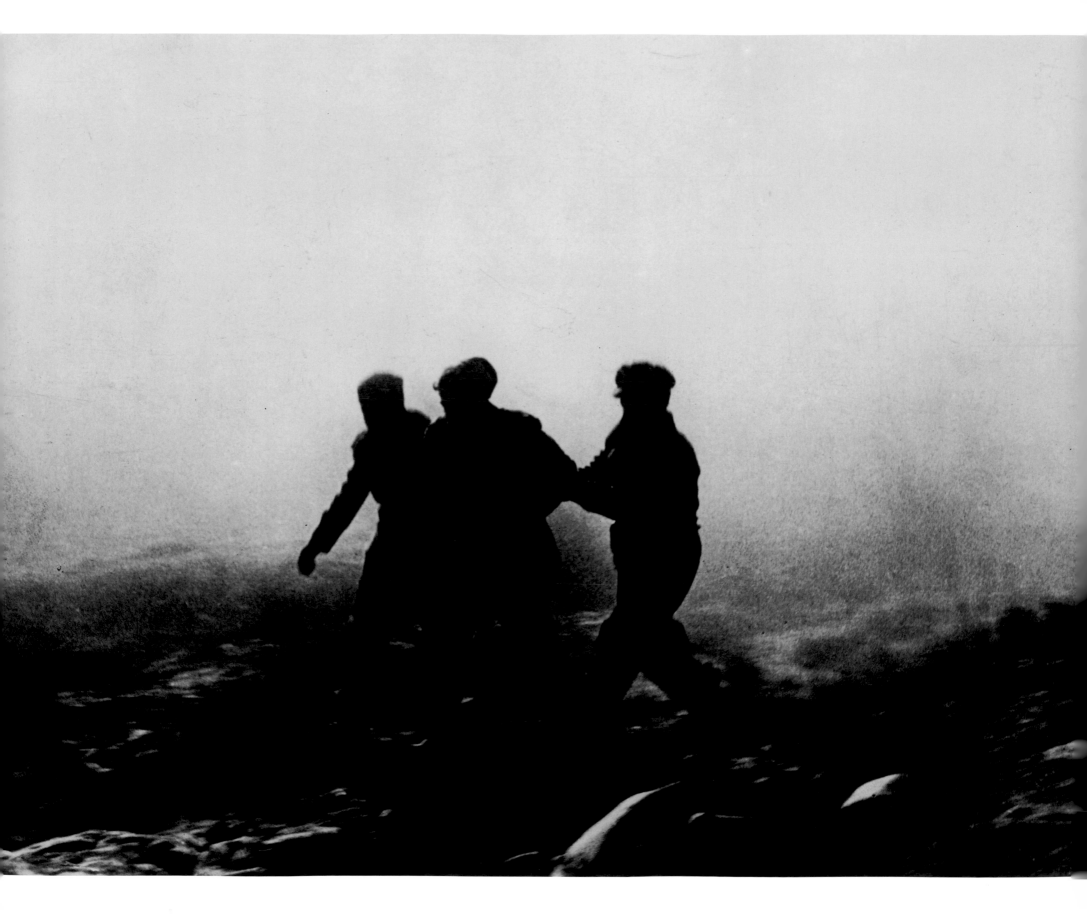

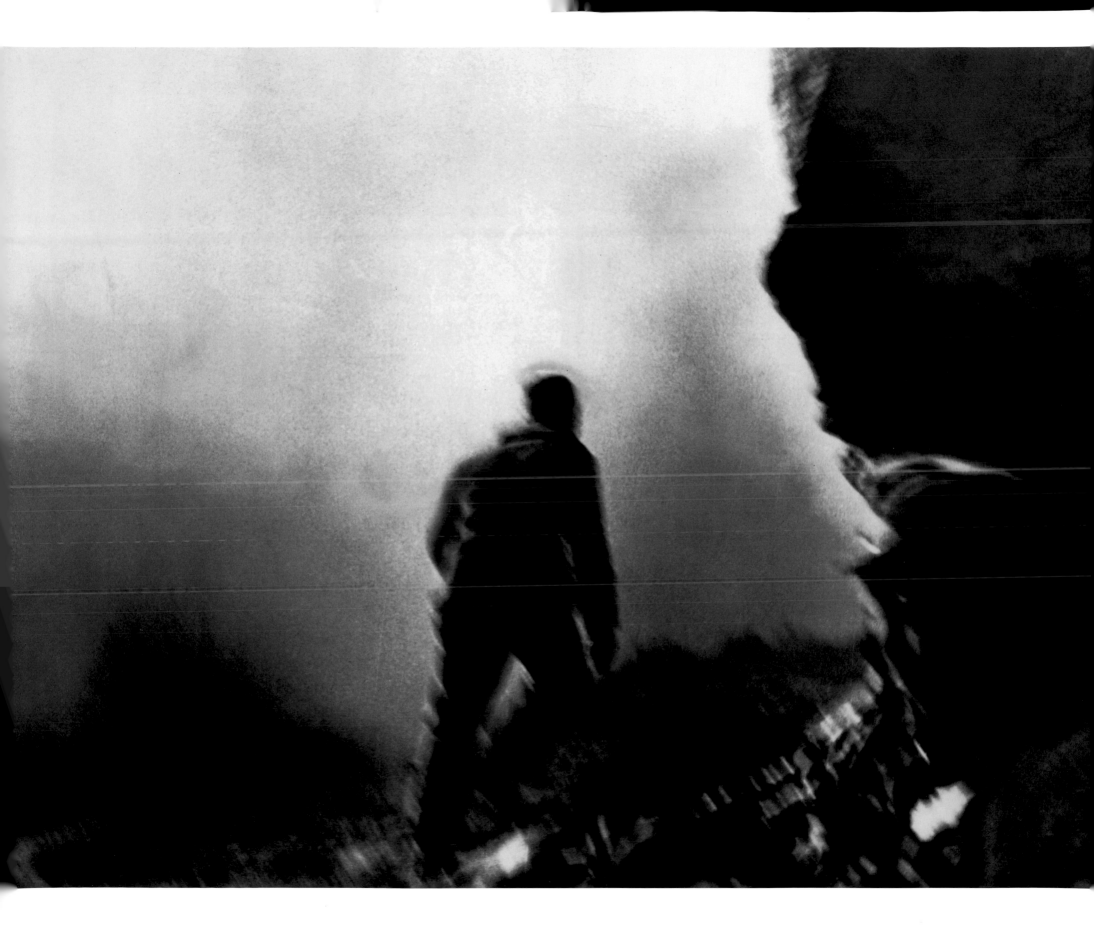

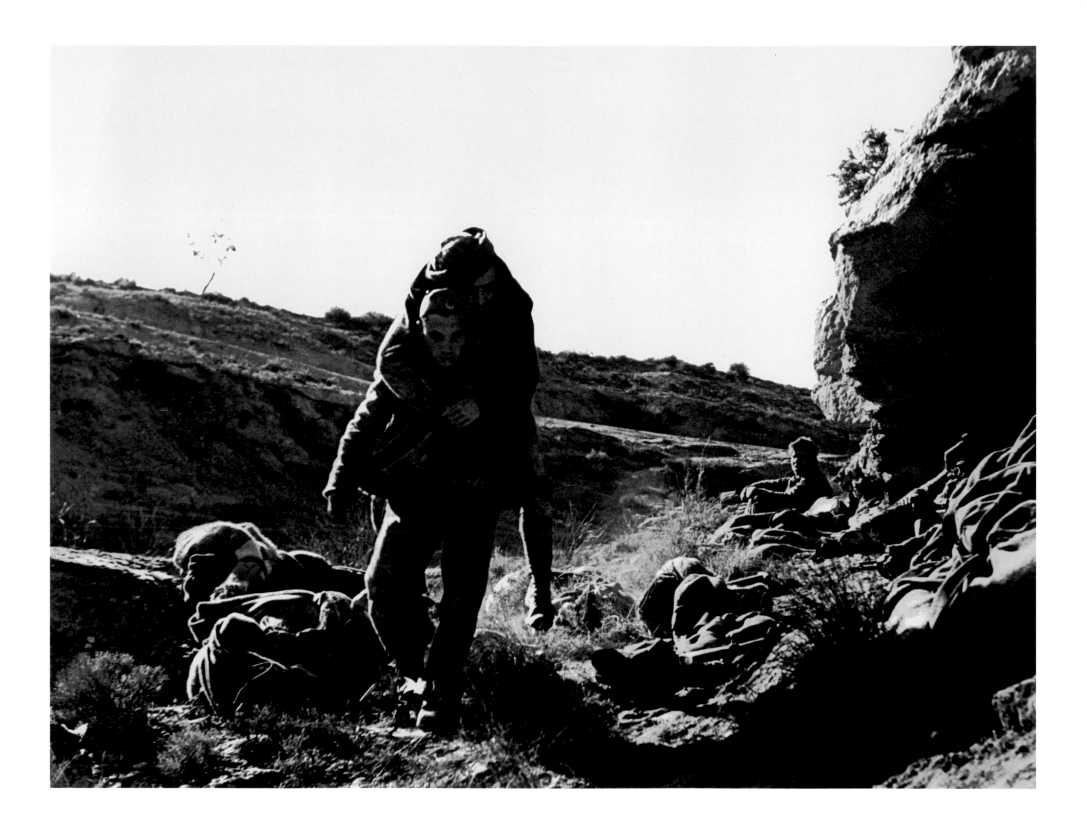

140 Rio Segre, Aragon front (near Fraga), November 7, 1938

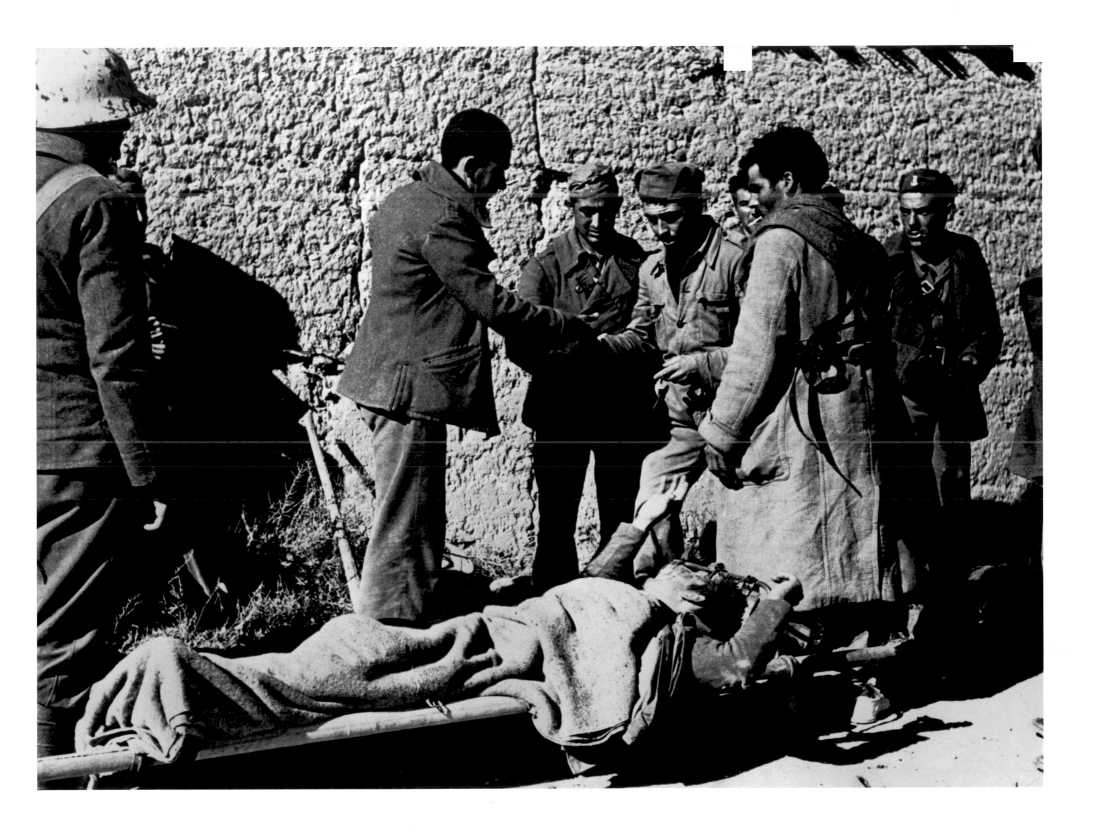

Rio Segre, Aragon front (near Fraga), November 7, 1938

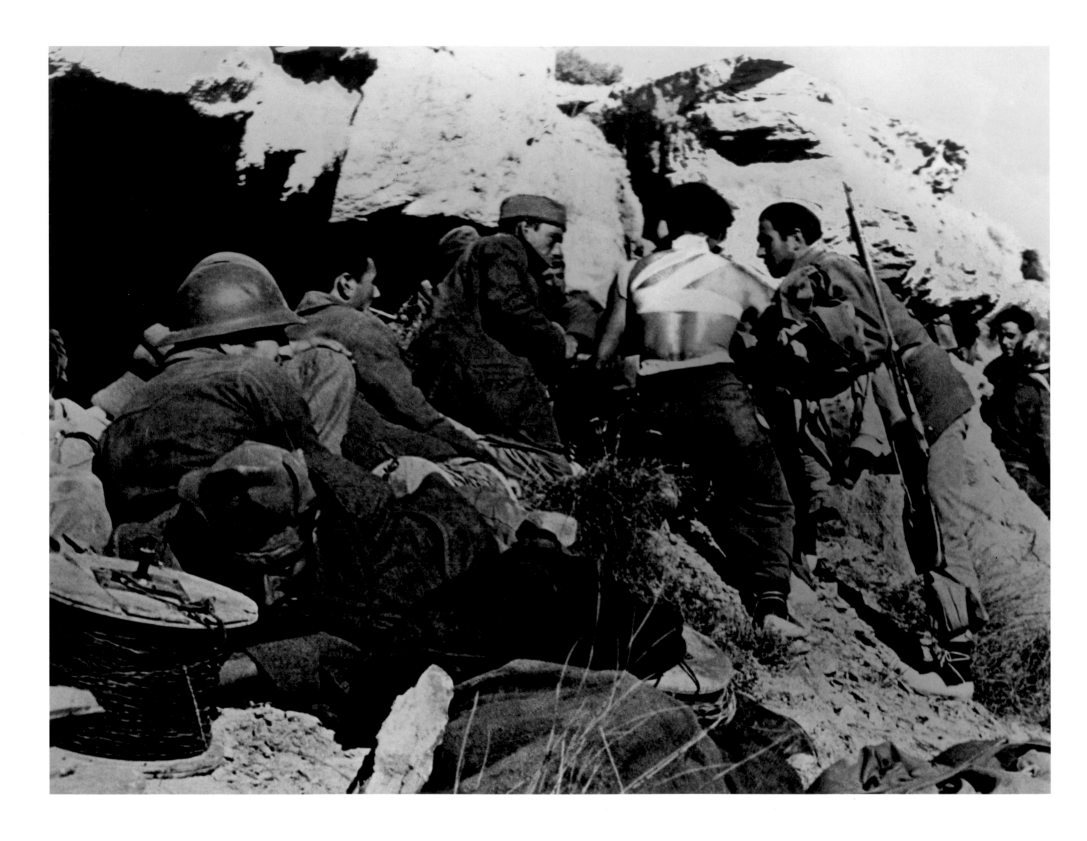

142 Rio Segre, Aragon front (near Fraga), November 7, 1938

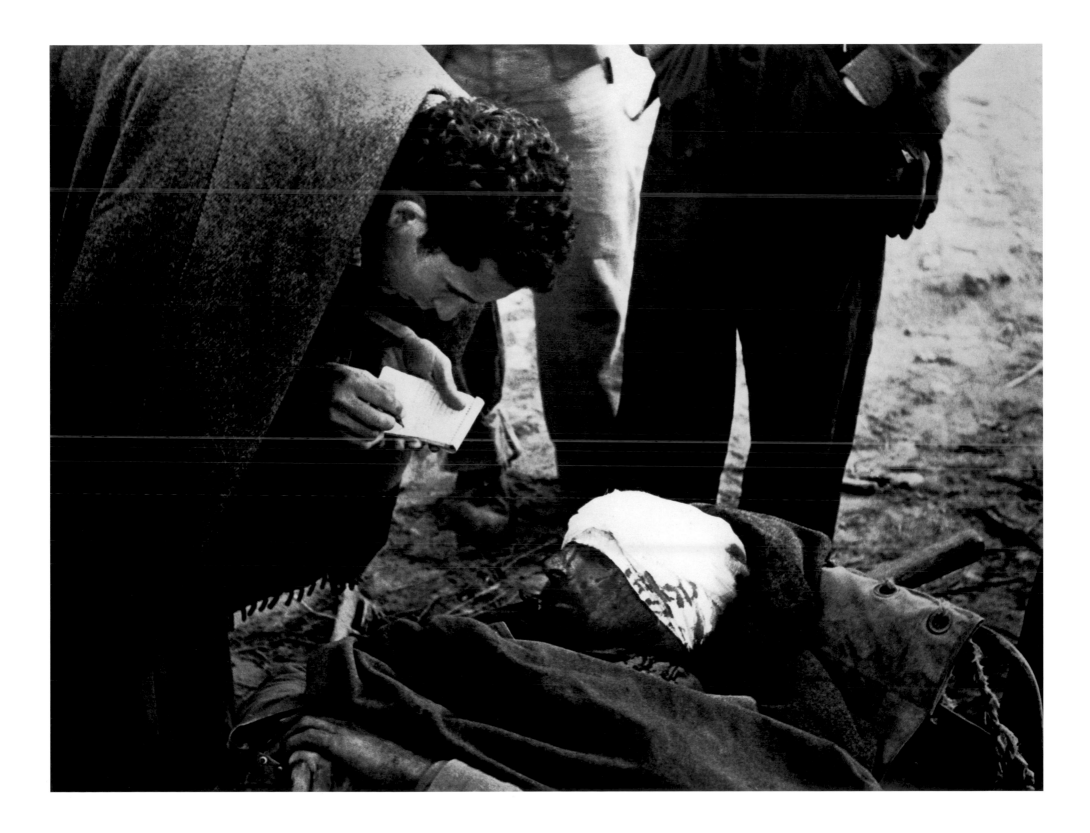

Rio Segre, Aragon front (near Fraga), November 7, 1938 143

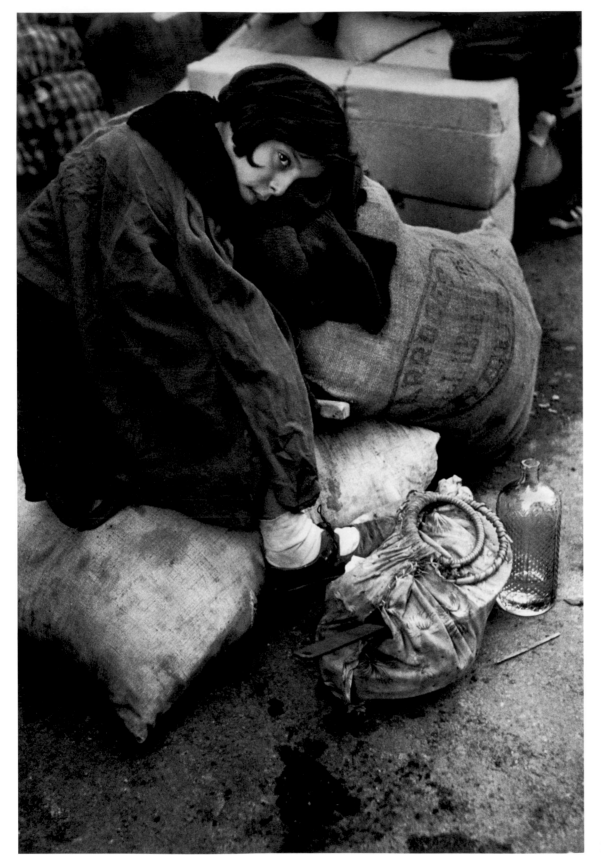

Barcelona, January 1939

Barcelona, January 1939

. . . When the planes were sighted, the church bells rang a warning to the villages. . . .
In Bilbao the sirens screamed their warning. A long blast when the raiders of the air were sighted. Three short blasts when they were straight overhead. Sometimes there were fifteen to twenty raids a morning. You couldn't run downstairs every time to the shelter in the basement which wasn't a shelter, or to the place under the bridge that wasn't much good either, or to the tunnel that was best, fifteen to twenty times a morning with the kids. So you took your knitting and sat on the sandbags outside the quite good shelter in the vaults of banks, a paper hat to hold the sun.

ROBERT CAPA
from *Death in the Making*

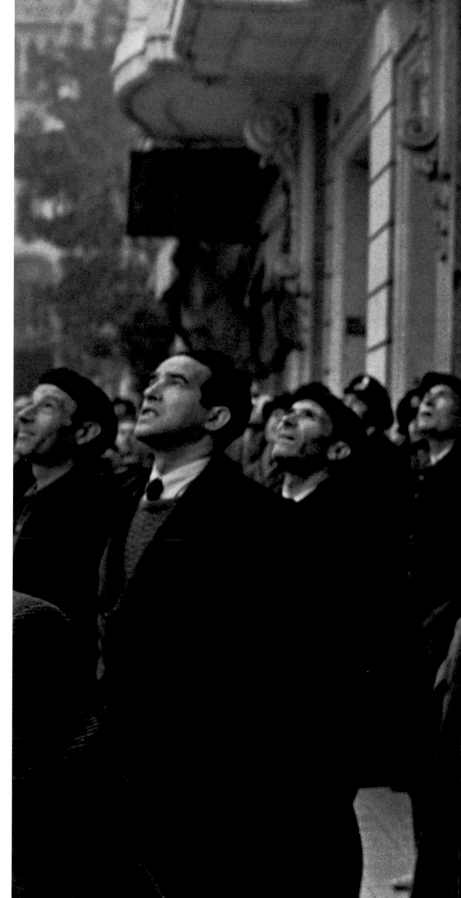

Bilbao, May 1937 (formerly identified as
Barcelona, January 1939)

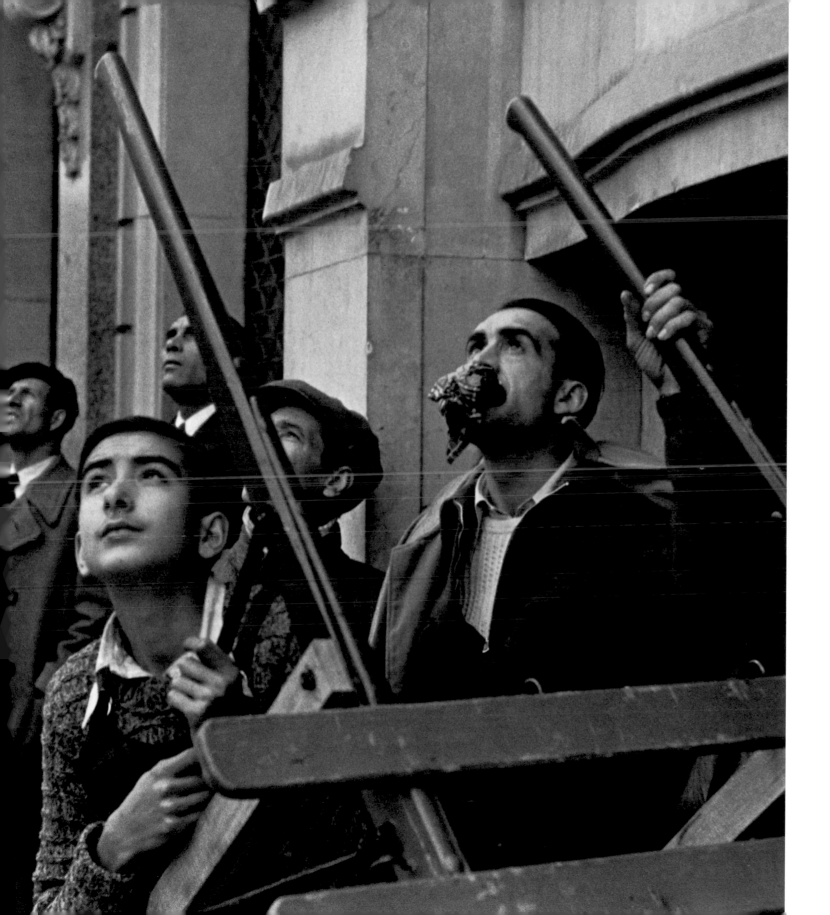

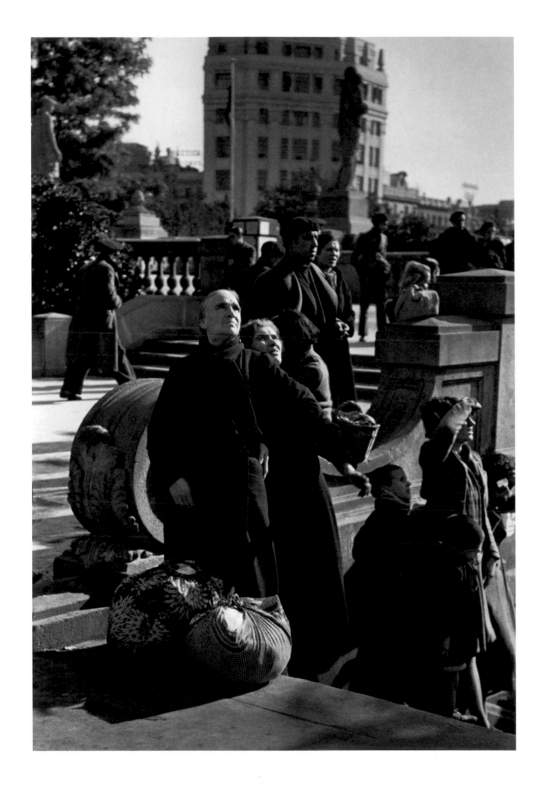

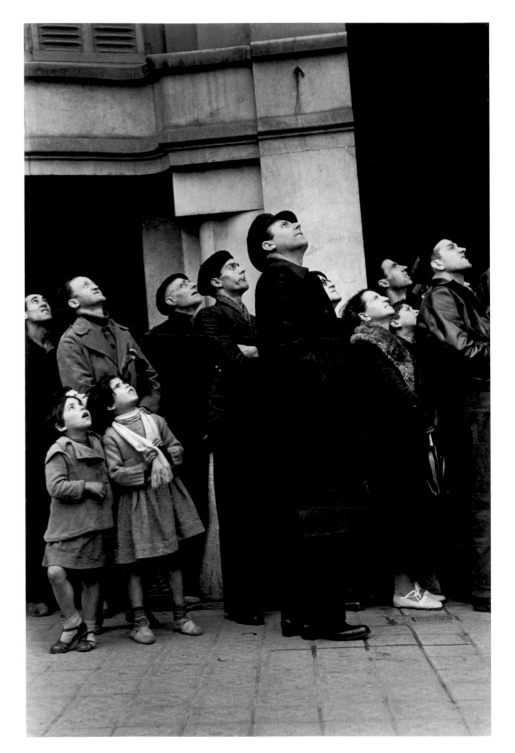

Barcelona, January 1939

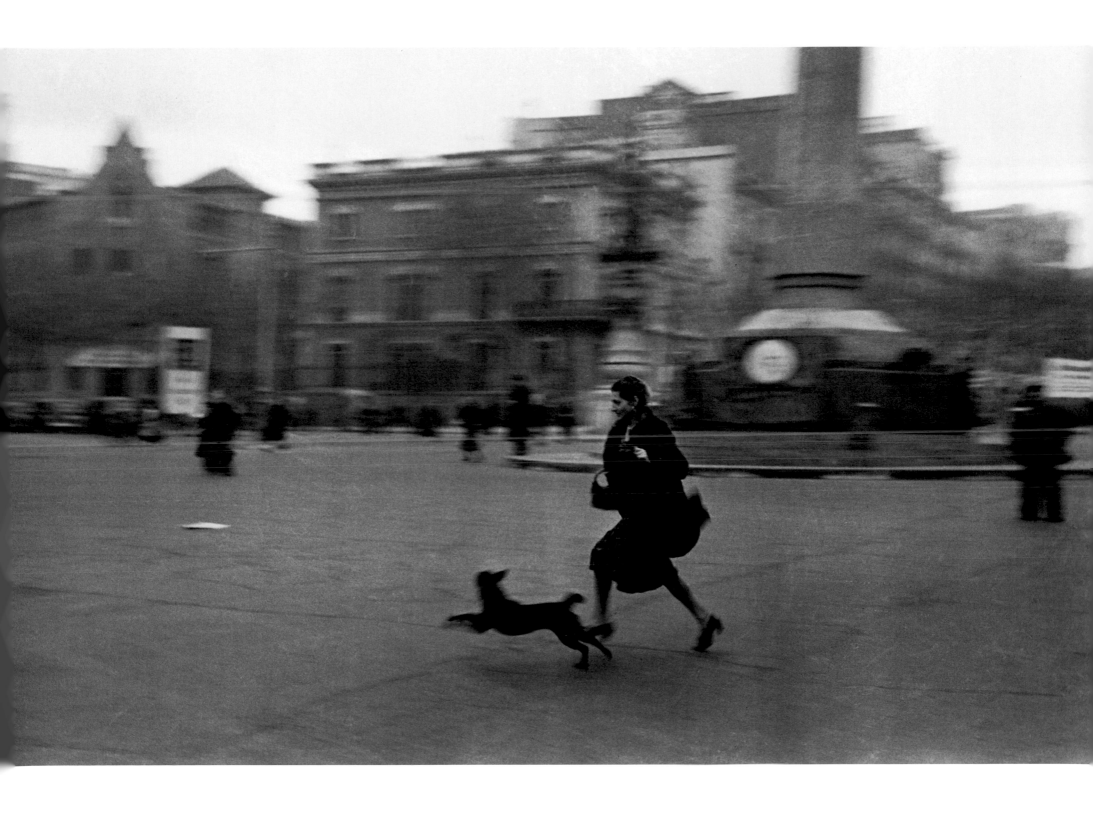

Barcelona, January 1939

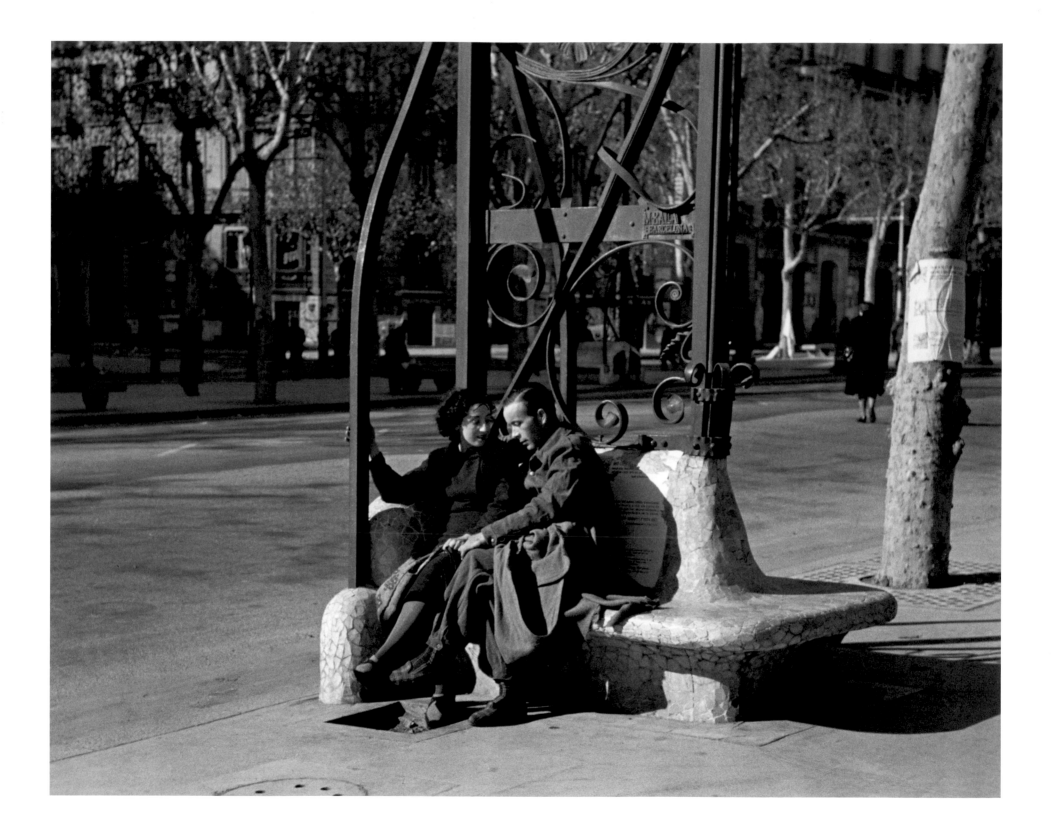

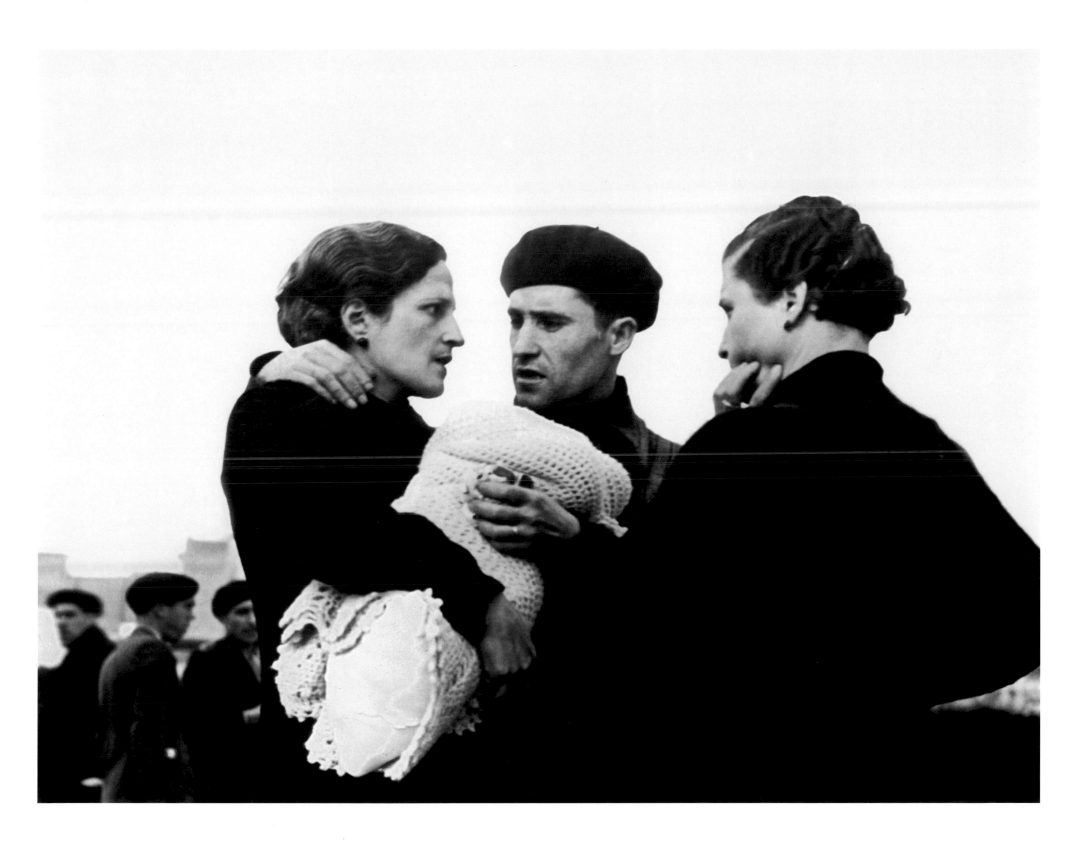

Barcelona, January 13, 1939 151

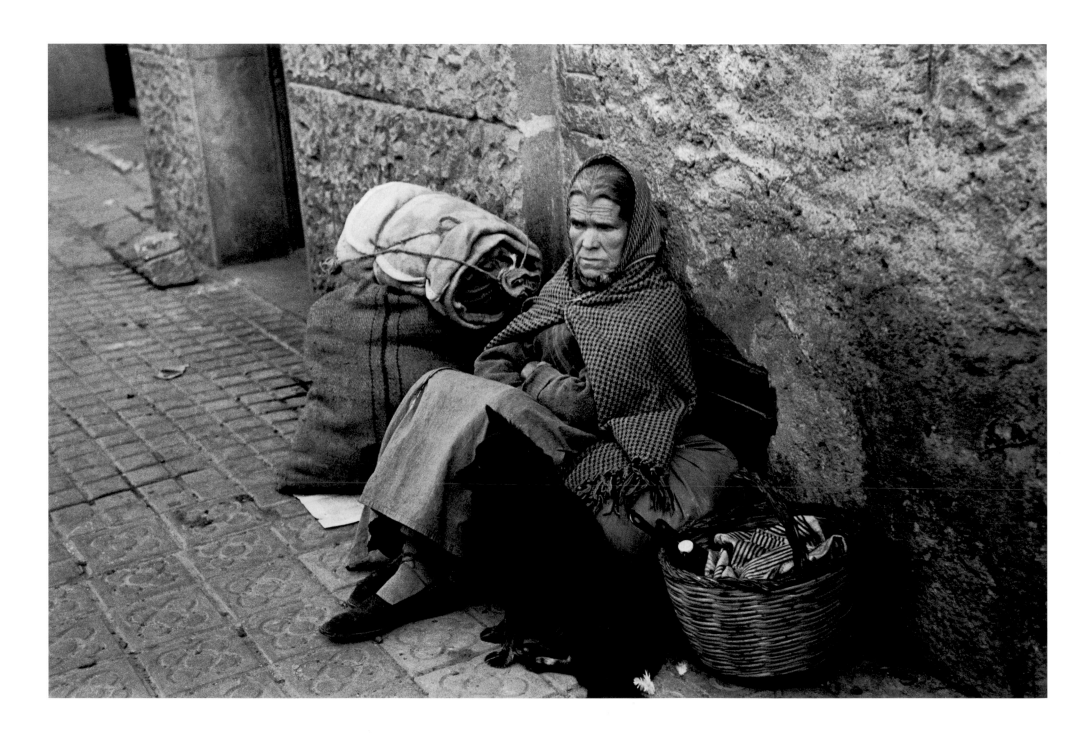

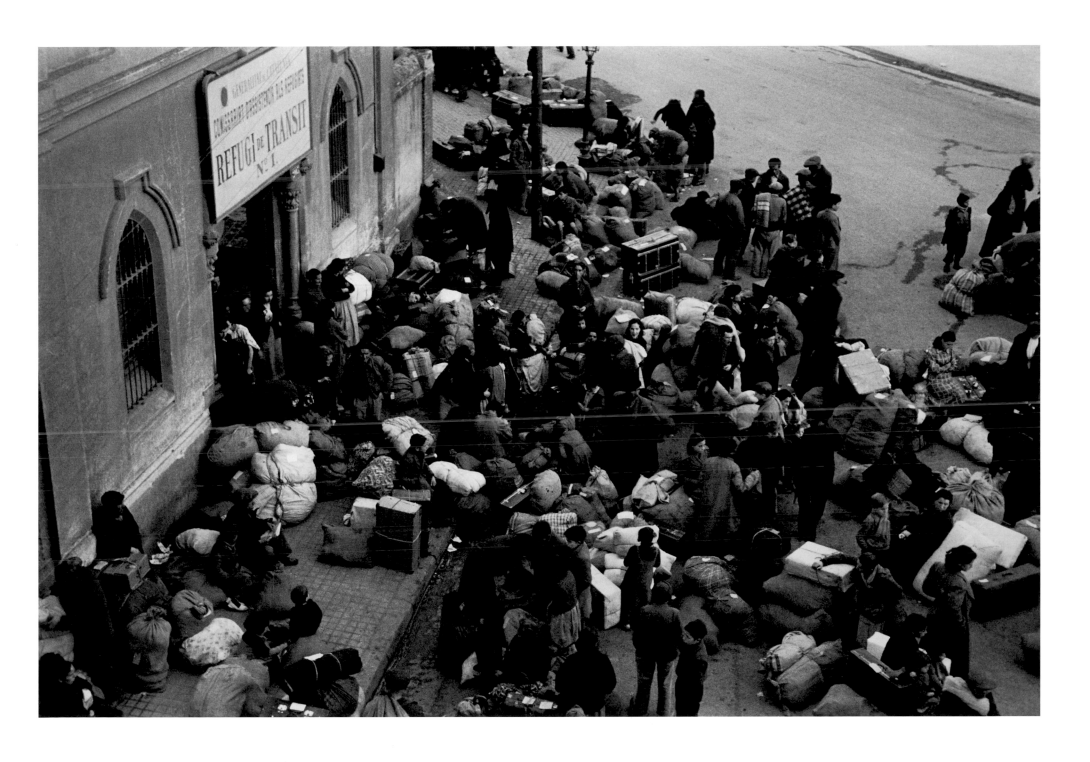

Barcelona, January 1939

In a caption sheet that accompanied this series of photographs, Capa wrote of the exodus: "There were people on foot, groups of neighbors and small families, some with handcarts; many women carried market satchels or baskets, perhaps a jug of oil or wine, on their heads. . . . A few days ago these were not poor people. And among the others who passed by, many certainly had memories of prosperity; but such distinctions disappear quickly. What remains is a common fate."

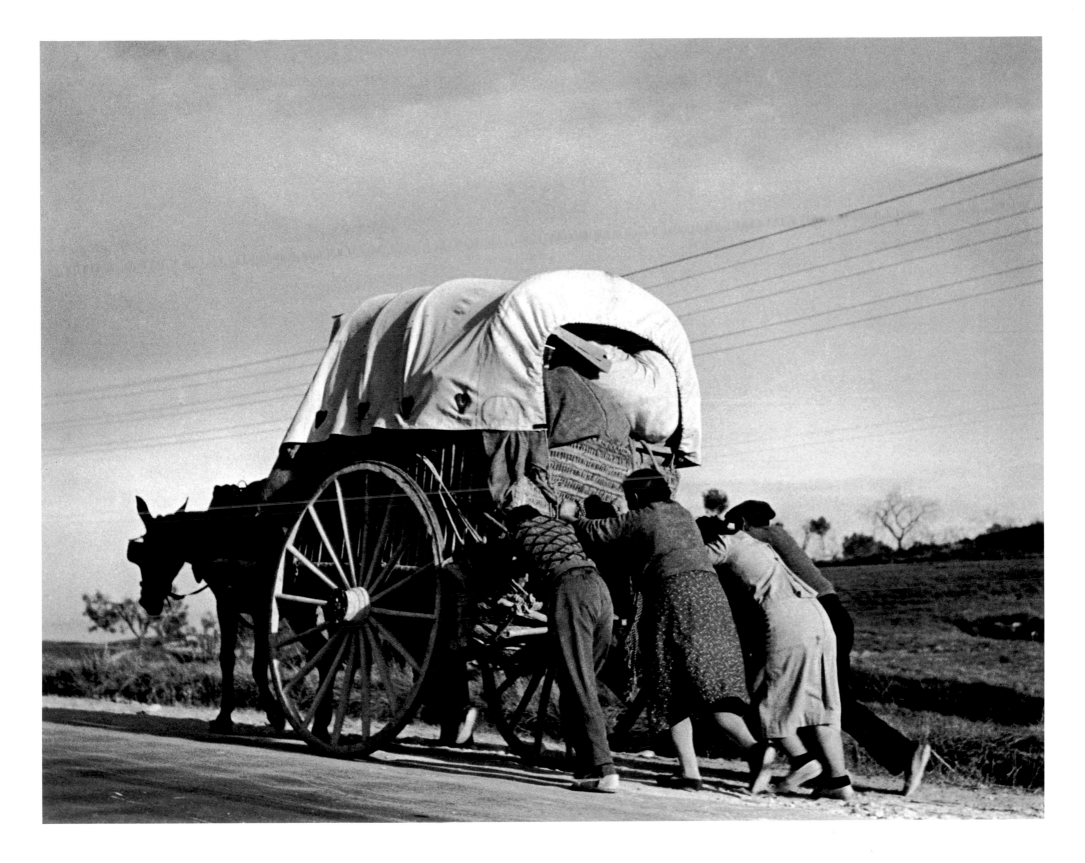

On the road from Tarragona to Barcelona, January 15, 1939

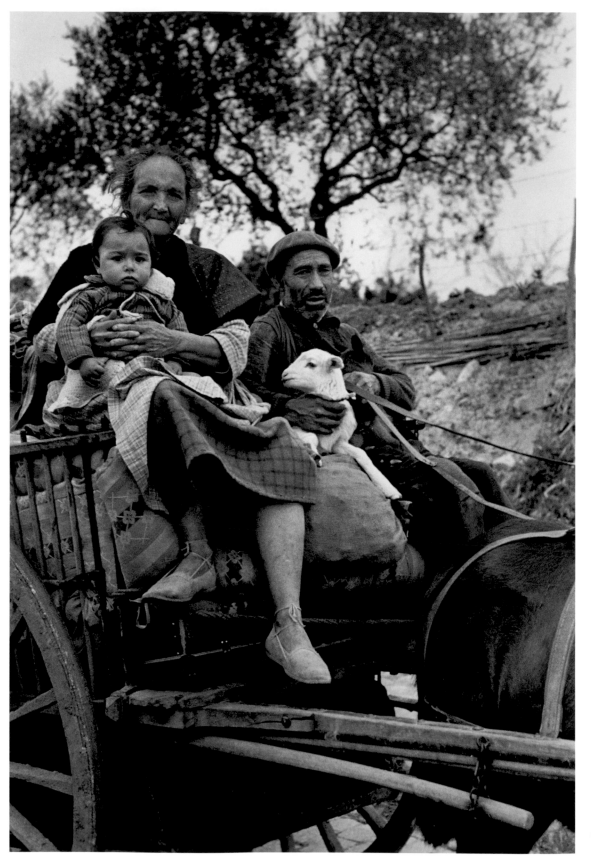

On the road from Tarragona to
Barcelona, January 15, 1939

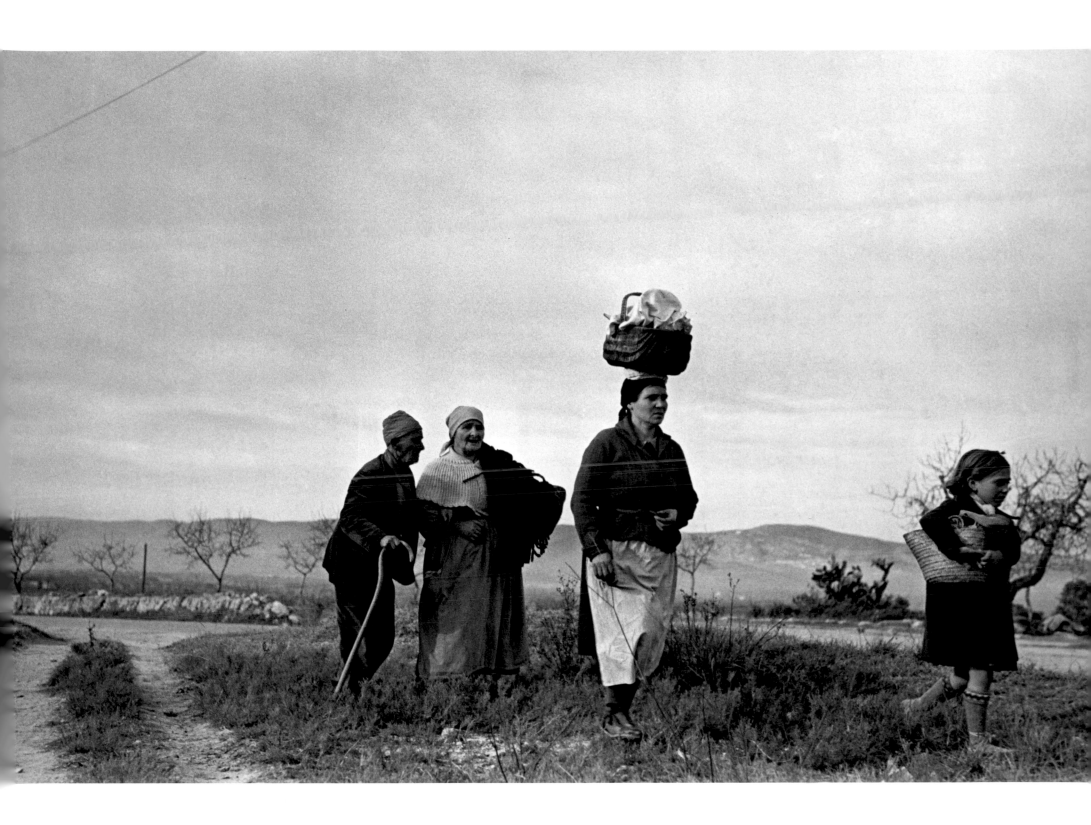

On the road from Tarragona to Barcelona, January 15, 1939

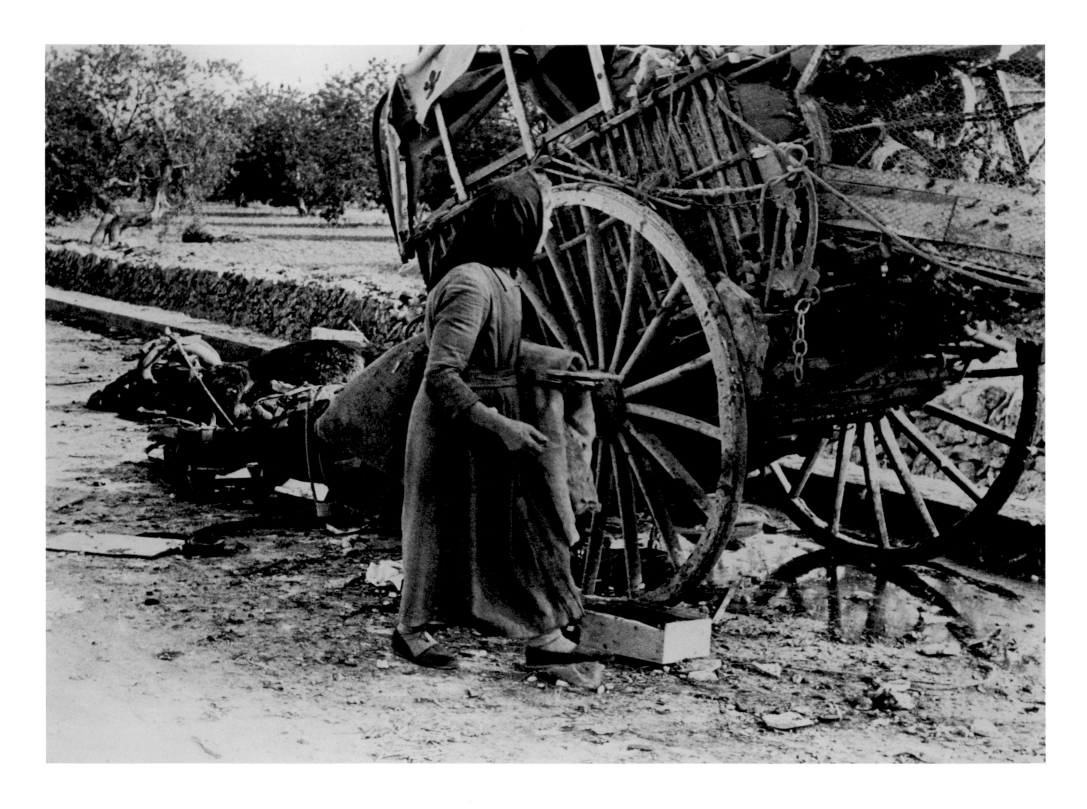

158 On the road from Tarragona to Barcelona, January 15, 1939

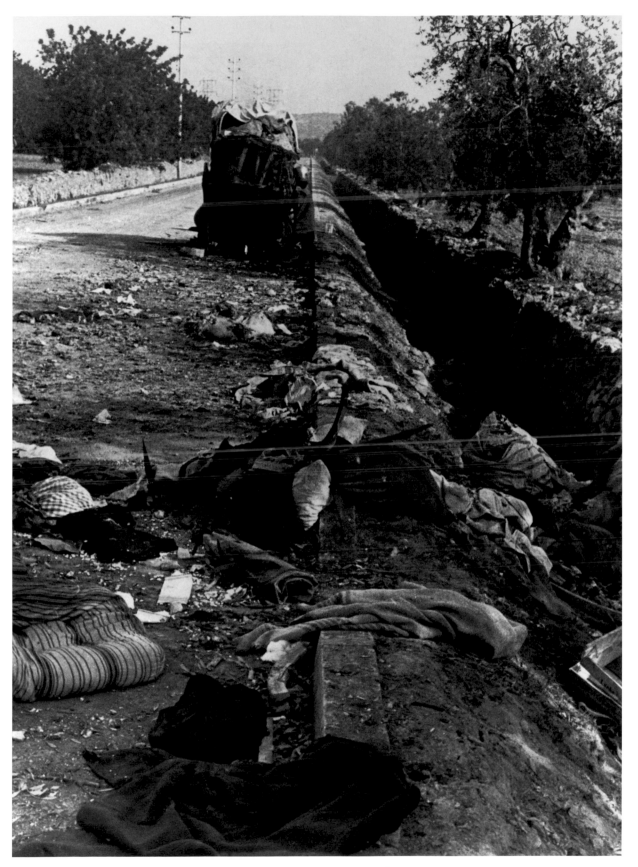

On the road from Tarragona to
Barcelona, January 15, 1939

The truth is this: Barcelona falls silently. The matron, milked dry, collapses exhausted, to await the enemies of her freedom, of her language, of her flag. The tie is broken. Some journalists still launch a few mottoes of resistance, when everyone already is obsessed with the border, an obsession that they exhibit without any consideration; and as if they were insane, they argue over a place in the trucks that are going to Gerona and Figueras. . . .

At 8:00 P.M. I found myself without means of transportation to get home. . . . I have gone along the solitary and dark highway on foot, thinking about him at that front that changes each morning. Since my feet hurt, I took off my shoes after three kilometers, and the rest of the way I walked digging my feet into the cold asphalt. My nails painted red stand out against the dirty gray cement. All around me is silence and abandonment. Not one policeman. The windows without light, closed like a mole's eyes. Behind them must in some cases be the silence of emptiness; in others, the tearful goodbye or the piles where books, letters, and papers that mean a lifetime for someone are thrown. . . .

In a sort of family council, and while I ate the last of the lentils, it was decided I would leave the next day. Mother is packing my suitcases, gathering up the trifles that I like: books, fans, tapestries, paintings, and knickknacks. Father is looking for a rope to tie up a sack. Neither is crying, but their words keep getting caught in their throats.

This is my last night in my parents' home. It is 2:00 A.M. and I am still wandering about the house as if I were saying goodbye to all the things that are part of it. Me, who fought so much against the family regimen, I feel now such a terrible, profound pain.

Will I return someday?

SILVIA MISTRAL, from *Exodo*

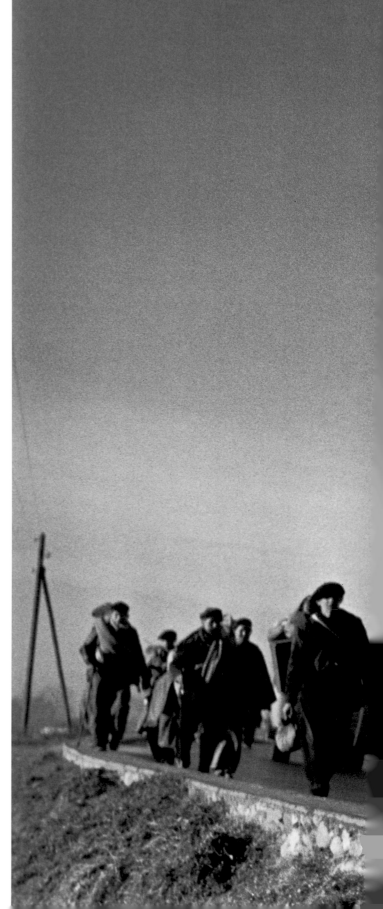

On the road from Barcelona to the French border, January 25–27, 1939

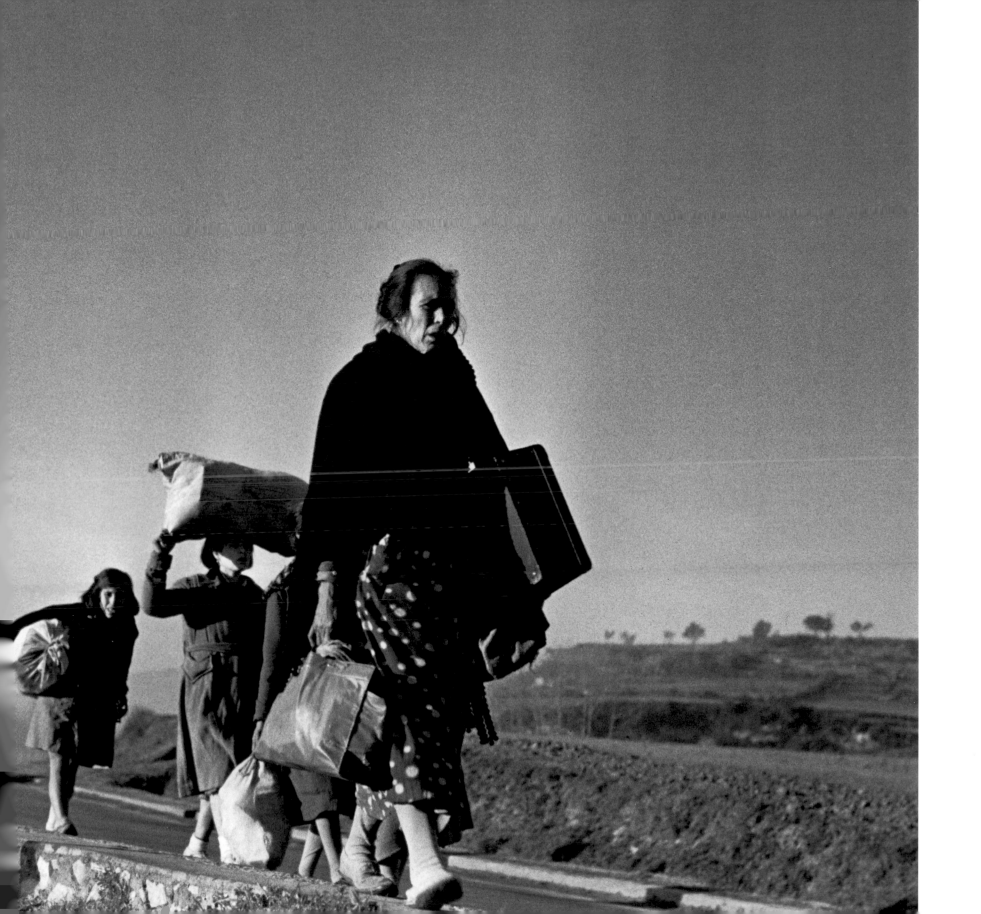

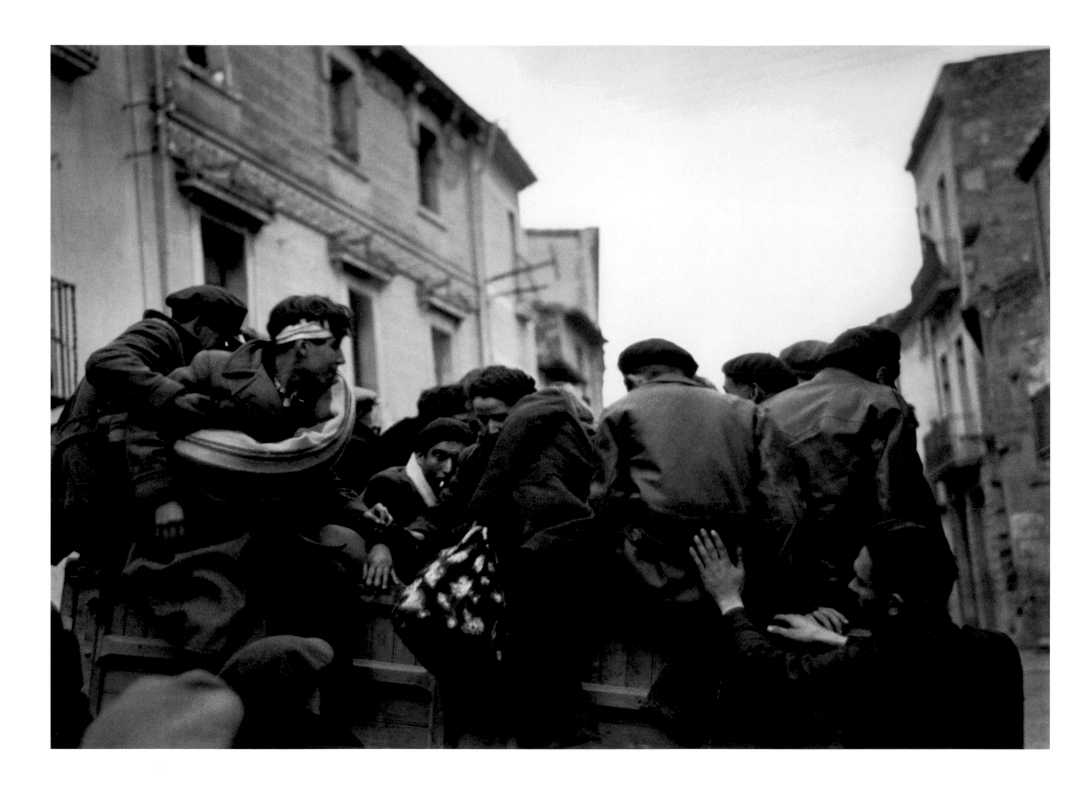

162　　On the road from Barcelona to the French border, January 25–27, 1939

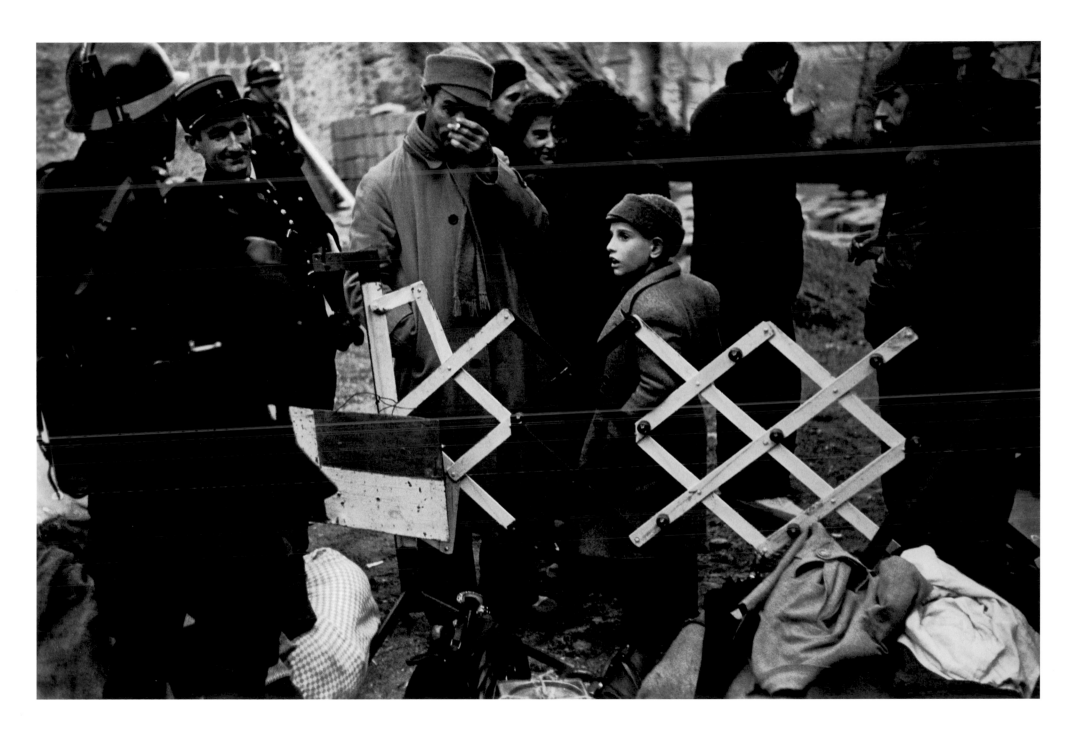

At the French border, north of Barcelona, January 28, 1939

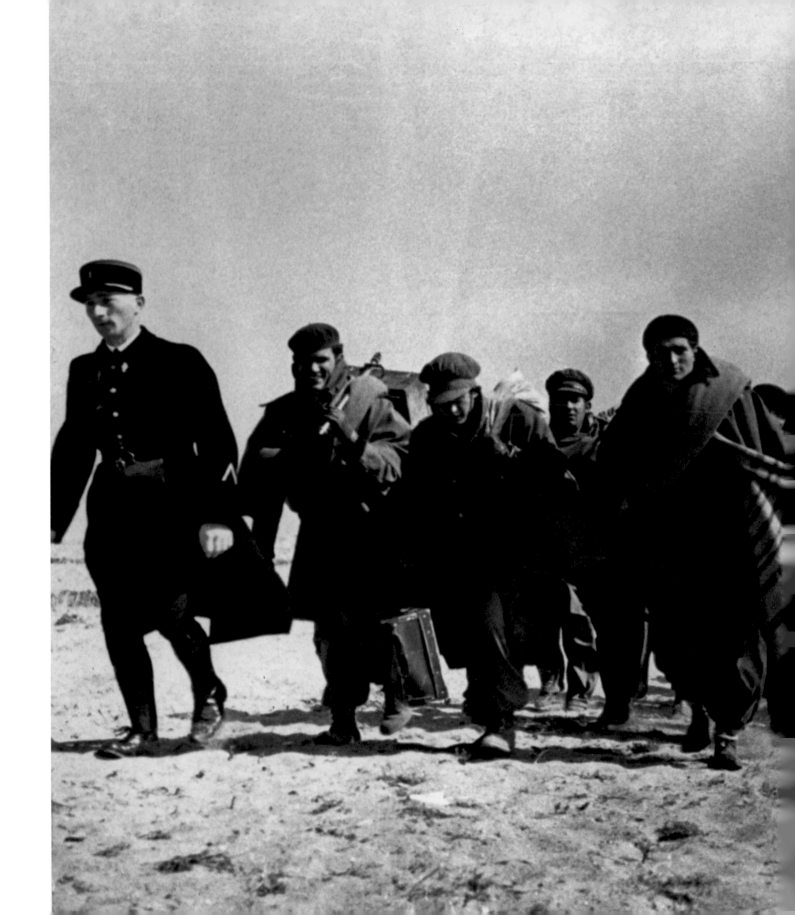

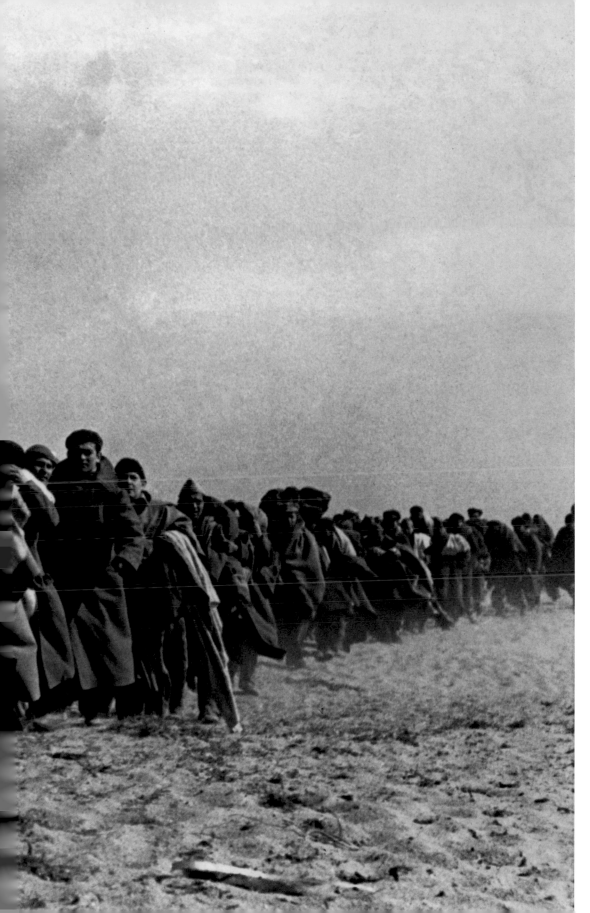

Behind the Spanish refugees were two years of a fierce and heartbreaking war, and most of them left their families locked inside their own country. . . . After the desperate years of their own war, . . . these people remain intact in spirit. They are armed with a transcendent faith; they have never won, and yet they have never accepted defeat. Theirs is the great faith that makes miracles and changes history. You can sit in a basement restaurant in Toulouse and listen to men who have uncomplainingly lost every safety and comfort in life, talking of their republic; and you can believe quite simply that, since they are what they are, there will be a republic across the mountains and that they will live to return to it.

MARTHA GELLHORN
"The Undefeated"

Between Argelès-sur-Mer and
Le Barcarès, France, March 1939

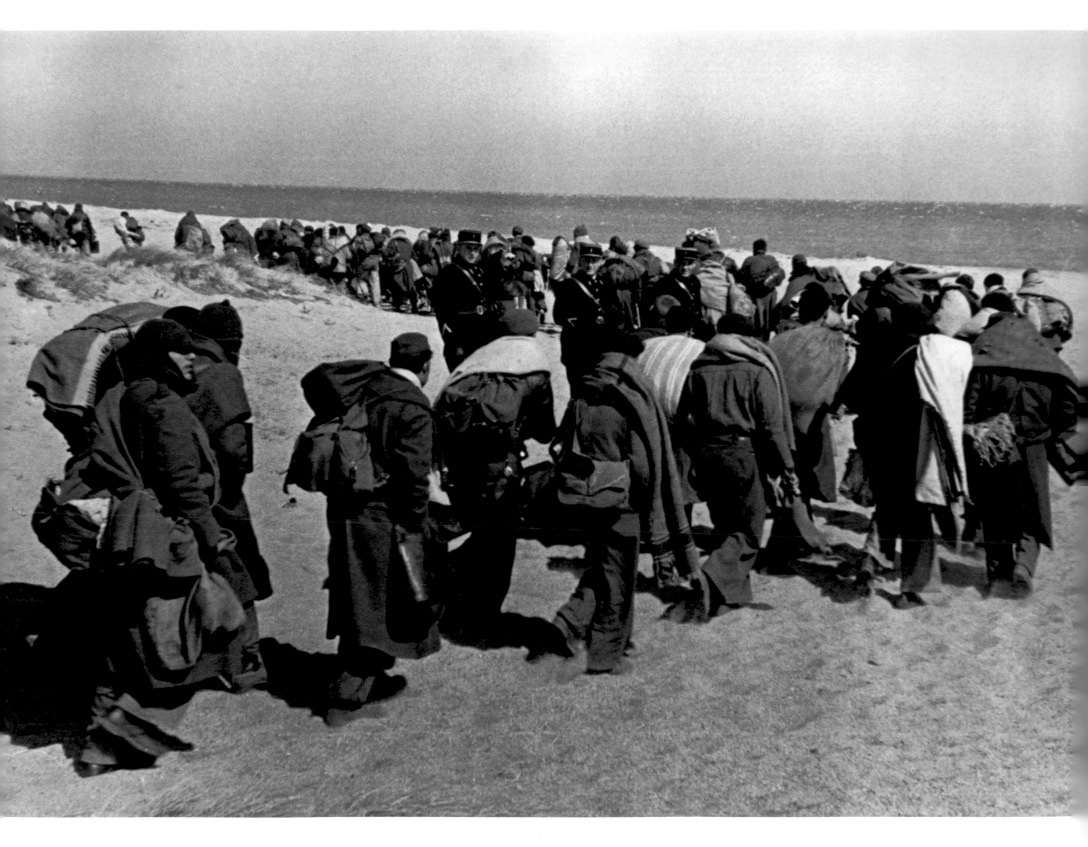

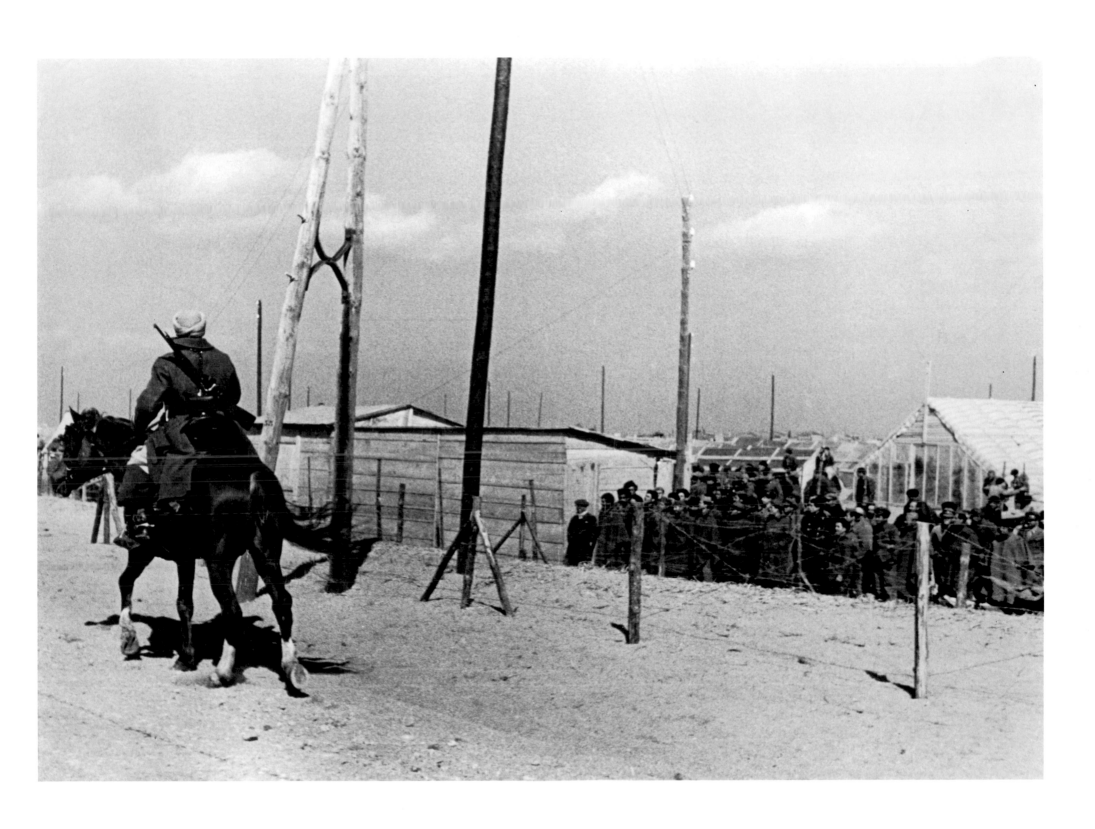

Between Argelès-sur-Mer and Le Barcarès, France, March 1939
Opposite: Argelès-sur-Mer or Le Barcarès, France, March 1939

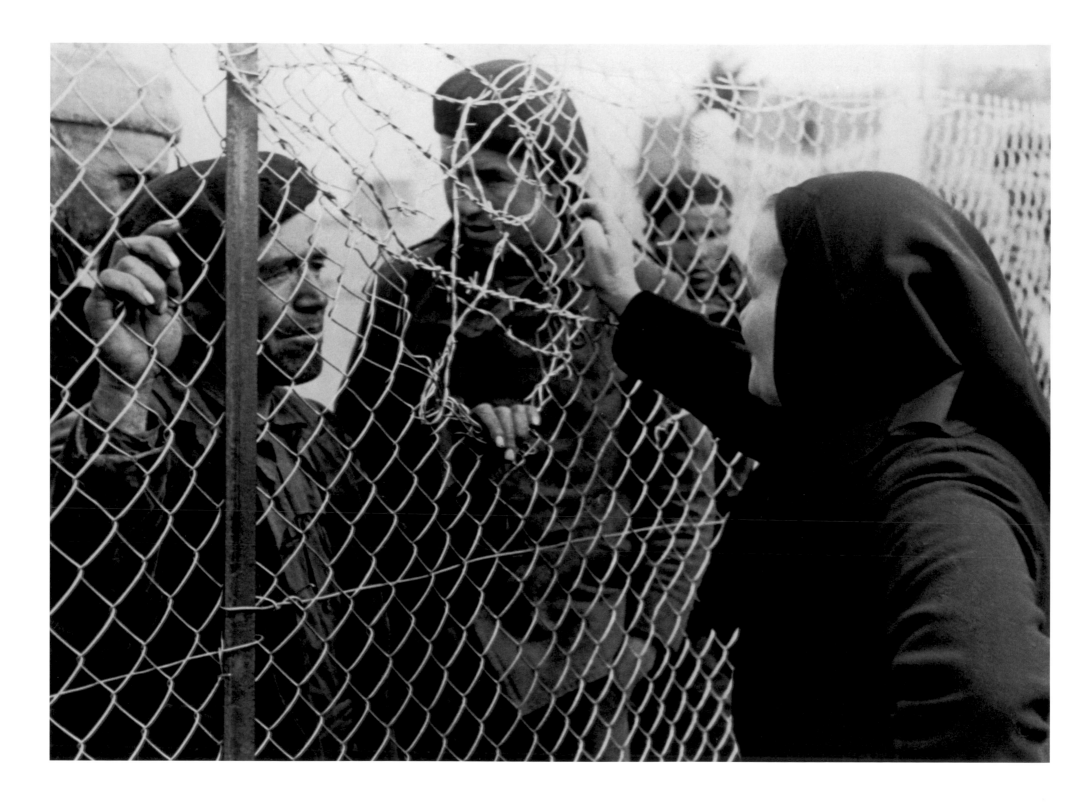

168 Argelès-sur-Mer, France, March 1939

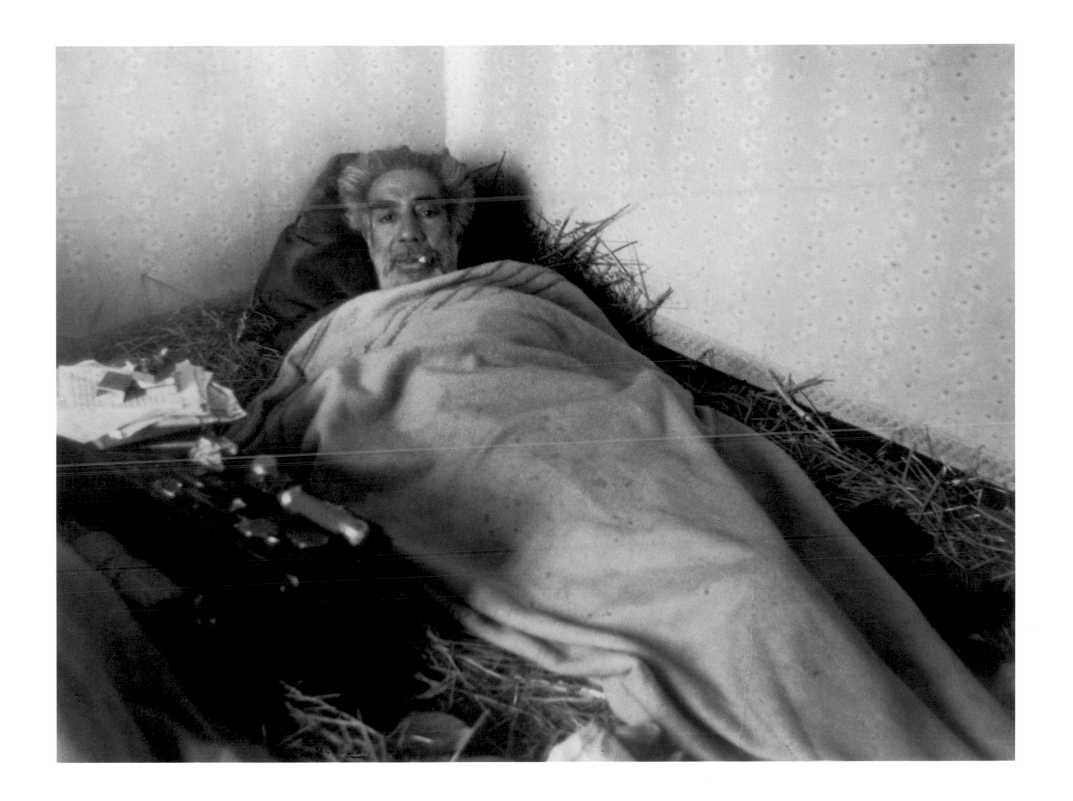

Argelès-sur-Mer or Le Barcarès, France, March 1939

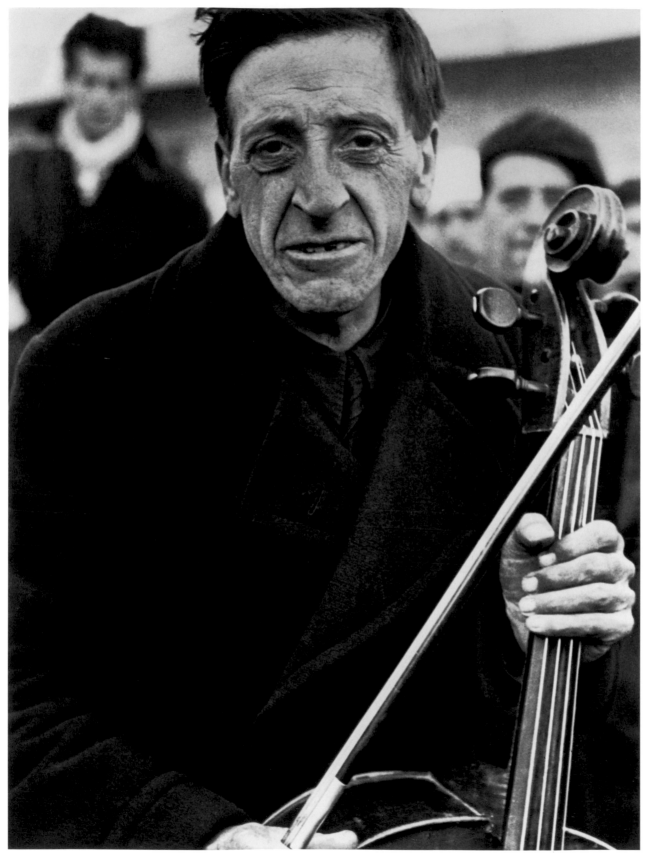

Argelès-sur-Mer or Le Barcarès,
France, March 1939

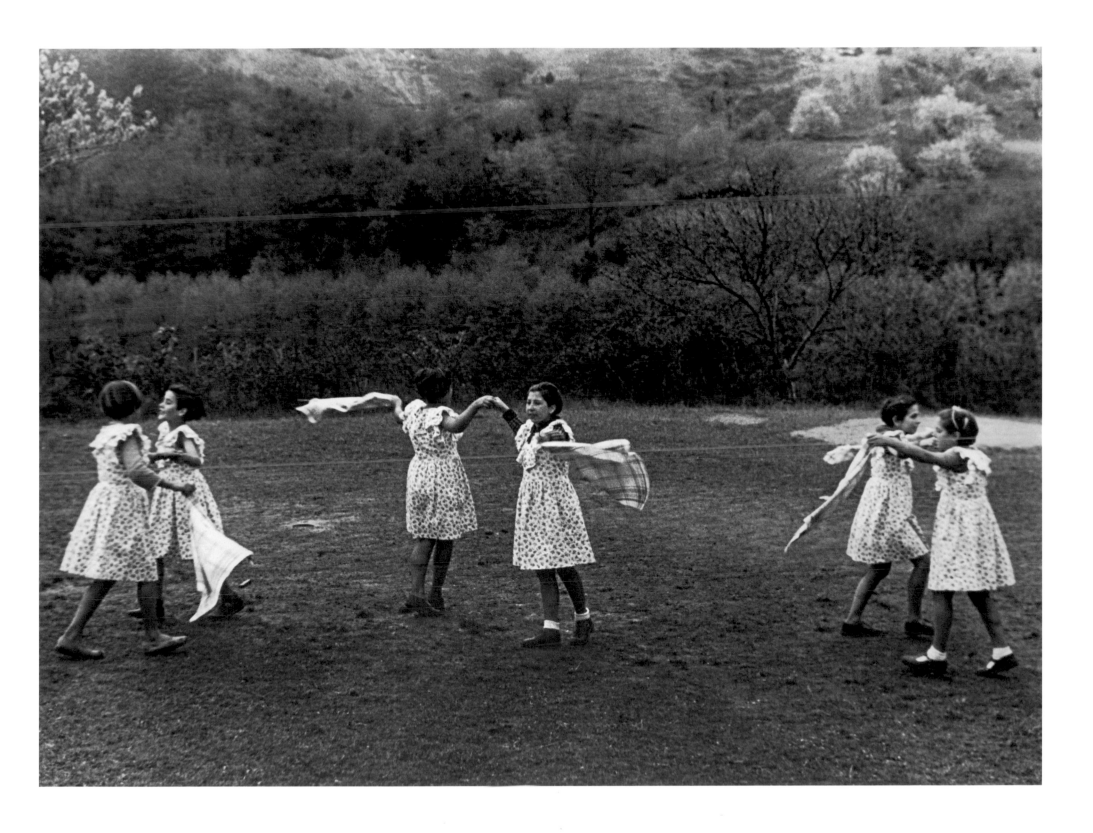

Near Biarritz, France, May 1939

FOOTNOTES

THE CULTURE OF ANTIFASCISM
JUAN P. FUSI AIZPÚRUA

1. Stephen Spender, *The Thirties and After: Poetry, Politics, People 1933–1970* (New York: Random House, 1978), p. 13.

2. Samuel Hynes, *The Auden Generation: Literature and Politics in the 1930s* (Princeton, New Jersey: Princeton University Press, 1976); Peter Stansky and William Abrahams, *Journey to the Frontier: Two Roads to the Spanish Civil War* (Palo Alto, California: Stanford University Press, 1966).

3. Such clubs were named after John Reed, the radical journalist who founded the American Communist Party and who died in Russia in 1920.

4. On 1930s political culture in the United States, see Richard H. Pells, *Radical Visions and American Dreams* (Hanover, New Hampshire: Wesleyan University Press, 1973). On the impact of the civil war in that country, see Marta Rey García, *Stars for Spain: La guerra civil española en los Estados Unidos* (Sada: A Coruna Ediciosole Castro, 1997).

5. The modern classic on that decade's French intellectuals is: Herbert Lottman, *The Left Bank: Writers, Artists, and Politics from the Popular Front to the Cold War* (Boston: Houghton Mifflin, 1982).

6. A good introduction to that period in German culture is still: Peter Gay, *Weimar Culture* (New York: HarperCollins Publishers, 1974).

7. On the Spanish case, see Andrés Trapiello, *Las armas y las letras: Literatura de la guerra civil* (Barcelona: Planeta, 1994); and H. Escolar, *La cultura durante la guerra civil* (Madrid: Alhambra, 1987).

8. The bibliography on the Spanish Civil War is immense. Those indispensable are: Hugh Thomas, *The Spanish Civil War* (Bellevue, Washington: S & S Trade, 1966); Gabriel Jackson, *The Spanish Republic and Civil War* (Princeton, New Jersey: Princeton University Press, 1965); Raymond Carr, *The Spanish Tragedy: the Civil War in Perspective* (London: Weidenfeld & Nicholson, 1986); and E. Malefakis, ed., *La guerra de España* (1996).

9. On Azaña, see Santos Juliá, *Manuel Azaña: Una biografía política* (Madrid: Alianza, 1990).

10. The classic on this topic is B. Bolloten, *The Grand Camouflage: The Communist Conspiracy in the Spanish Civil War* (1971).

11. Paul Preston, *Franco: A Biography* (New York: Basic Books, 1994).

12. S. Orwell and I. Angus, eds., *My Country Right or Left 1940–1943: The Collected Essays, Journalism, and Letters of George Orwell.* (Orlando, Florida: Harcourt Brace, 1968).

ROBERT CAPA IN SPAIN
BY RICHARD WHELAN

1. *Picture Post*, December 3, 1938, pp. 13–24.

2. *Vu*, June 5, 1935, pp. 755–757; *Berliner Illustrirte Zeitung*, June 20, 1935, pp. 897 (cover), 898 and 937.

3. *Weekly Illustrated* (London), April 14, 1936, pp. 18–19.

4. *Vu* (special Spanish Civil War issue), August 29, 1936, pp. 22–23, 26, 28, 30–31, 34–35, 42–43, 46, and 48.

5. Franz Borkenau, *The Spanish Cockpit; An Eye-Witness Account of the Political and Social Conflicts of the Spanish Civil War* (London: Faber and Faber, 1937), pp. 137–165.

6. *Vu*, September 23, 1936, pp. 1106–1107.

7. Phillip Knightley, *The First Casualty: From the Crimea to Vietnam; The War Correspondent as Hero, Propagandist, and Myth Maker* (New York and London: Harcourt Brace Jovanovich, 1975), p. 212.

8. Jorge Lewinski, *The Camera at War: A History of War Photography from 1848 to the Present Day* (New York: Simon and Schuster, 1978), p. 88.

9. Mario Brotóns Jordá: *Retazos de una época de inquietudes.* 2nd edition. (Alcoy: the author, 1995), pp. 128–135 and inserted sheet: "La Fotografía de la Guerra Civil Española Mundialmente Más Difundida: La Muerte de un Alcoyano."

10. *Death in the Making* (New York: Covici, Friede, 1938), unpaginated. Photographs by Robert Capa and Gerda Taro [and Chim]. Captions by Robert Capa, translated by Jay Allen. Preface by Jay Allen. Arrangement [i.e., layout] by André Kertész.

11. *New York World-Telegram*, September 2, 1937.

12. Gustav Regler, *The Owl of Minerva* (London: R. Hart-Davis, 1959).

13. *Regards*, December 10, 1936, cover & pp. 11–14; December 17, cover & pp. 6–17; December 24, cover & pp. 8–11; December 31, pp. 12–13.

14. *Ce Soir*, May 14, 1937, p. 1; May 15, p. 1.

15. *Ce Soir*, June 18, 1937, p. 10; June 20, p. 10.

16. Alfred Kantorowicz, *Spanisches Tagebuch* (Berlin: Aufbau-Verlag, 1949).

17. *Ce Soir*, July 9, 1937, p. 10; July 10, p. 8; July 14, p. 1; July 16, p. 8; August 10, p. 8. *Regards*, July 22, 1937, pp. 12–13 & back cover; August 5, pp. 8–9.

18. Herbert Matthews, *The Education of a Correspondent* (New York: Harcourt Brace, 1946). *Ce Soir*, December 30, 1937, p. 8; January 1, 1938, p. 10; January 8, pp. 1, 5 (text by Capa), & 10. *Regards*, January 6, 1938, pp. 11–13 & back cover; January 13, pp. 8–9. *Life*, January 24, 1938, pp. 9–13.

19. *Regards*, October 27, 1938, pp. 6–7 & back cover; November 10, pp. 12–13; November 17, p. 9. *Ce Soir*, October 29, 1938, p. 8; November 15, p. 8; *Picture Post*, November 12, 1938, pp. 34–37.

20. Herbert Matthews, op. cit.

21. *Regards*, November 24, 1938, pp. 11–15 & back cover. *Picture Post*, December 3, 1938, pp. 13–24. *Life*, December 12, 1938, pp. 28–9.

22. *Ce Soir*, January 22, 1939, p. 8. *Picture Post*, February 4, 1939, pp. 13–19.

23. Original typescript in German. Capa Archives, International Center of Photography, New York.

24. Original typescript in German. Capa Archives, International Center of Photography, New York.

25. Herbert Matthews, op. cit. *Ce Soir*, January 29, 1939, pp. 1 & 8; January 30, pp. 1 & 8; January 31, p. 8. *Regards*, February 2, 1939, pp. 9–13. *Match*, February 2, 1939, pp. 9–14. *Collier's*, February 4, 1939, pp. 12–13.

26. *Picture Post*, April 15, 1939, pp. 13–20.

27. *Ce Soir*, May 5, 1939, pp. 1, 8.

28. Capa's account of this episode in his book *Slightly Out of Focus* (New York: Henry Holt, 1947), 189–195, is completely fictionalized. For his unembroidered account, see *Life*, December 25, 1944, p. 4.

WOMEN IN THE SPANISH CIVIL WAR
CATHERINE COLEMAN

1. Richard Whelan, *Robert Capa: A Biography* (New York: Knopf, 1985).

2. Shirley Mangini, *Memories of Resistance, Women's Voices from the Spanish Civil War* (New Haven and London: Yale University Press, 1995). Federica Montseny (1905–1994) joined the Republican government as Minister of Health in November 1936, contrary to the anarchist mistrust of formal government.

3. Victoria Kent was the first female lawyer in Spain and held the post of General Director of Prisons during the Second Republic; Clara Campoamor, Doctorate of Law, was Director of Public Welfare; Margarita Nelken was the only woman elected three times to Parliament with the Socialist Party, in 1931, '33 and '36. In 1937 she joined the Communist Party.

4. Rosa María Capel Martínez, *El sufragio femenino en la Segunda República Española* (Madrid: Dirección General de la Mujer, Ministerio de Cultura, 1992), p. 93.

5. The majority of the left, correctly or not, blamed women for the 1933 conservative victory at the polls. However, their argument that women were not politically or ideologically prepared cannot explain the Popular Front victory in February of 1936.

6. Julio Álvarez del Vayo, *Freedom's Battle*. Trans. Eileen E. Brooke (New York: Hill and Wang, 1971), pp. 184–185.

7. To be exact: 4,654,116 votes for the Popular Front over 4,503,505 votes for the Right Coalition. From Rosa María Capel, *El sufragio femenino*. Capel quotes Javier Tusell, *Las elecciones del frente popular*, Vol. 2 (Madrid: 1971), p. 13.

8. For example, the Fuero de Trabajo legislation, which, among other restrictions, prohibited married women from taking jobs other than domestic service, was reinstated and lasted until 1975.

9. For example, their heads were shaved, or in the worst cases, they were given as "war booty" to the Moors. Yannick Ripa, "La violence nationaliste contre les femmes pendant la guerre civil espagnole: un enjeo politique," *La place des femmes: Les enjea de l'identite et de l'egalite au regards des science socials* (Paris: la Découverte, 1995), p. 483.

10. Martha Ackelsberg, *Free Women of Spain: Anarchism and Struggle for Emancipation of Women* (Bloomington: Indiana University Press, 1991), pp. 115–142.

11. Mary Nash, "*Milicianas* and Homefront Heroines. Images of Women in Revolutionary Spain, 1935–39," *History of European Ideas II* (London: Pergamon Press, 1989), p. 238. Nash deserves credit for groundbreaking work in the field of women's history in Spain. See also: Mary Nash, *Las mujeres en la Guerra Civil* (Madrid: Minister of Culture, 1989). Exhibition catalog.

12. A series of conferences was recently held in Salamanca to celebrate the fiftieth anniversary of the civil war and to address the female role in the struggle. It is the first time the subject of the *milicianas* was openly dealt with. See: *Las mujeres y la Guerra Civil Española* (Madrid: Ministerio de Asuntos Sociales/Instituto de la Mujer and Ministerio de Cultura/Dir. Gral. de los Archivos Estatales, 1991).

13. Anthony Beevor, *The Spanish Civil War* (New York: Peter Bedrick Books, 1982). Quoted in Mangini, op. cit.

14. II. E. Kaminski, *Los de Barcelona* (Barcelona: Ediciones del Cotal, 1976), 209–210. Quoted in Mangini, op. cit.

15. Mika Etchebéhère, *Mi Guêrra de España* (Barcelona: Plaza and Janes, 1976), pp. 56–57.

16. Captured in Granada, Lina Odena became a heroic figure when she committed suicide to avoid being given over to the North African legionnaires.

17. Nash, op. cit., p. 238. As English journalist Henry Buckely wrote in 1940: "There was a good deal of criticism already of the women in the militia. Obviously some of them were prostitutes of the lowest scale who had just been caught up in the whirl of excitement and had gone off with friends to the front. . . . But the majority of the girls came along to cook and care for the men. It must be remembered that these hastily flung together units had not cooks or kitchens or first aid men or anything like that. The maid in the next flat to that in which I live in Madrid went off to the Somosierra front to look after her two brothers. Several weeks later she returned, giving the matter no importance, putting away her overalls and serving lunch as efficiently as ever. Her brothers need looking after—and one had to help the Republic." *Life and Death of the Spanish Republic* (London: Hamish Hilton, 1940), p. 227.

18. Mangini, op. cit., footnote 54.

19. *El Mono Azul* (The blue overalls) was published by the Alianza de Intelectuales Antifascistas para la Defensa de Cultura, Spanish section of the International Spanish Alliance of Antifascist Writers, founded in 1935. The magazine published from August 1936 to February 1939, releasing forty-seven issues in all.

20. Among them: *Companya* (Unión de la Dones); *Emancipación* (POUM); *Muchachas* (Union de Muchachas); *Mujeres y La Pasionaria* (Agrupación Mujeres Antifascistas); *Mujeres Libres* (CNT/FAI); *Trabajadores* (Communist Party); and *Noies Muchachas* (Alianza Nacional de la Dona Jove). See also: Juilo Pérez Serrano, "La mujer y la imagen de la mujer en la resistencia antifascista española. *El Mono Azul* (1936–39)," *Jornadas de Investigación Interdisciplinaria*. (Madrid: Mujeres y Hombres en la Formación del Pensamiento Intelectual, Universidad Autónoma, 1989), pp. 353–65.

21. Ackelsberg, op. cit., p. 115.

22. Irme Schaber, *Gerta Taro. Fotoreporterin in spanischen Bürgerkreig eine Biografie* (Marburg: Jonas Verlag, 1995). Introduction by Ute Eskildsen. All information on Taro is from this source.

23. In addition, the street Tarostrasse was named after her in Leipzig (then East Berlin) in 1970, with the plaque "Gerta Taro. Young Communist, cofounder of the International Brigade. Fallen in 1937 in the fight against fascism in Spain." She lived in Leipzig from 1929 to 1932, where a memorial to her is in the city's cemetery. Playing cards portraying her life were printed in Philadelphia in 1938. She is buried in the Père Lachaise cemetery in Paris. A Giacometti sculpture was placed on the tomb.

24. Cordova Iturburu. *España bajo el comando del pueblo*. (Buenos Aires, n.d.), p. 178. First published as "Adiós to Gerda Taro" in *El Mono Azul*.

25. Robert Capa, *Death in the Making* (New York: Covici Friede, 1937). Photographs by Robert Capa and Gerda Taro. Preface by Jay Allen. Design by André Kertész.

26. Yannick, op.cit., p. 483.

CATALOGUE RAISONNÉ

Between 1990 and 1992, Cornell Capa and Richard Whelan meticulously reexamined all of Robert Capa's contact sheets. From the approximately 70,000 negatives that he exposed during his lifetime, they chose 937 images to constitute an in-depth survey of his finest work. Under their close supervision an edition strictly limited to three identical sets of 937 gelatin-silver prints on paper measuring 16-by-20-inches was produced by master printers Igor Bakht and Teresa Engle Moreno. The Tokyo Fuji Art Museum acquired one set, and one set was donated to the permanent collection of the International Center of Photography, in New York.

The 205 prints donated by Cornell Capa to the Museo Nacional Centro de Arte Reina Sofía (MNCARS) constitute a specially produced set of the Spanish Civil War section of the 937 images. The MNCARS set is composed of 205 gelatin-silver prints made on paper trimmed to 15½-by-19½ inches. Each of the prints is distinguished by an embossed seal which reads "Robert Capa" in the lower margin. The first number that appears with each image is the accession number assigned by the MNCARS. The second number, assigned by the International Center of Photography, New York, corresponds to the Spanish Civil War section of the master set of 937 images (numbers 112 / 001–316 / 205).

Unless otherwise noted, all captions and commentary are by Richard Whelan

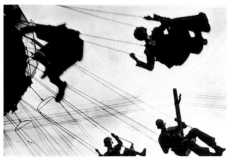

AD 687 112 / 001
Seville, April 1935.
Feria, the annual spring fair.

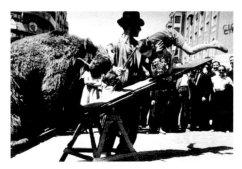

AD 688 113 / 002
Madrid, August–September 1936.
Street performer with a tame bear.

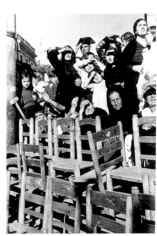

AD 689 114 / 003
Seville, April 1935.
Spectators at a Holy Week procession.

AD 690 115 / 004
Seville, April 1935.
A young participant in a Holy Week procession. Throughout Capa's work, his photographs of children provide a microcosmic view of the adult world around them, a view that often revealingly exaggerates both the follies and the virtues of their elders.

AD 691 116 / 005
San Sebastián, April 1935.
A shoeshine boy.

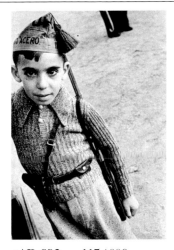

•AD 692 117 / 006
(page 2)
Barcelona, August–September 1936.
The boy is wearing a cap of the Steel Battalions of the Union de Hermanos Proletarios (Union of Proletarian Brothers), one of the anarchistic militias.

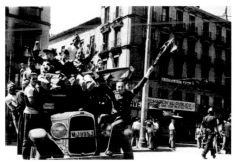

•AD 694 118 / 007
(page 53)
Madrid, August–September 1936.

•**AD 701** 119 / 008
(page 56)
Near Barcelona, August–September 1936.

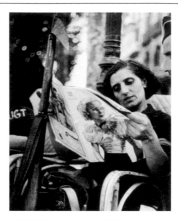

AD 693 121 / 010
Barcelona, August 1936.
A Loyalist militiawoman. Among the most radical innovations in the early days of the war were the women's militias.

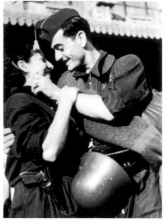

•**AD 697** 123 / 012
(page 54)
Barcelona, August 1936.
Capa's photographs of the departure of a troop train from Barcelona are devoid of the sad farewells that normally characterize such scenes. Instead we see only ebullient optimism, the joy and confidence on the part of the soldiers and their families that all would be well—that these men and women would easily defeat the fascist menace and return safely home.

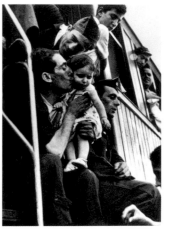

•**AD 699** 125 / 014
(page 55)
Barcelona, August 1936.

AD 695 120 / 009
Madrid, August–September 1936.
A fascist officer or policeman being questioned by a Loyalist officer.

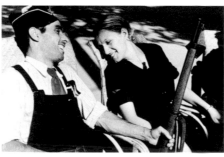

•**AD 696** 122 / 011
(page 14–15)
Barcelona, August 1936.
A Loyalist militiaman and militiawoman.

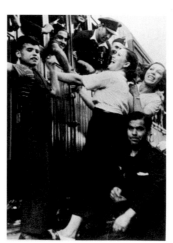

•**AD 698** 124 / 013
(page 55)
Barcelona, August 1936.

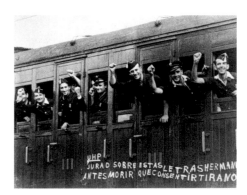

•**AD 700** 126 / 015
(page 57)
Barcelona, August 1936.
The slogan painted on the side of the railroad car translates, "UHP [Union de Hermanos Proletarios] Swear upon these fraternal letters that you will sooner die than consent to tyranny."

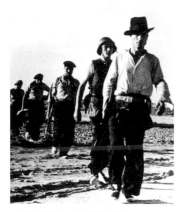

•AD 702 127 / 016
(page 58)
Near Barcelona, August 1936.
Loyalist militiamen. Many of the hastily assembled militias that rallied to resist Franco's well-trained armies were ragtag and ill-equipped bands of anarchistic workers who refused to wear uniforms or to submit to military hierarchy or discipline. What they lacked in training they often made up for in enthusiasm and bravery.

•AD 703 128 / 017
(page 59)
Near Madrid, November 1936.

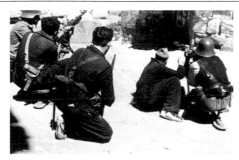

AD 704 129 / 018
Barcelona, August 1936.
Training militiamen.

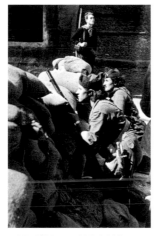

•AD 708 130 / 019
(page 42)
Barcelona, August 1936.
Militiawomen guarding a barricade across a street.

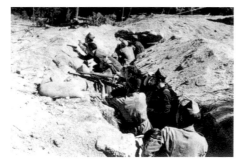

AD 711 131 / 020
Aragon front, August 1936.
Loyalist militiamen.

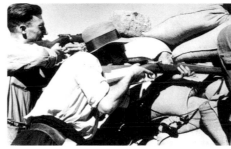

•AD 707 132 / 021
(page 61)
Barcelona or its vicinity, August 1936.
Loyalist militiamen. It is rather surprising to see a militiaman wearing a felt hat, for in the eyes of the most fanatic anarchists in Barcelona wearing such a quintessentially bourgeois accoutrement could be grounds for execution.

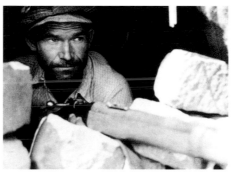

•AD 705 133 / 022
(page 60)
Barcelona or its vicinity, August 1936.
Loyalist militiaman.

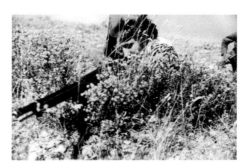

AD 706 134 / 023
Aragon front, August 1936.
Loyalist militiawoman.

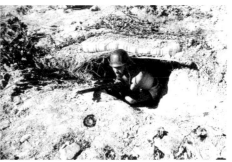

AD 710 135 / 024
Aragon front, August 1936.
Loyalist militiaman.

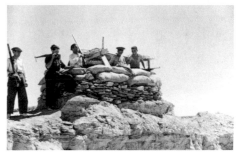

AD 709 136 / 025
Near Huesca, Aragon front, August 1936.
Loyalist militiamen.

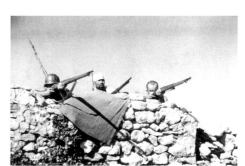

AD 713 137 / 026
Near Huesca, Aragon front, August 1936.
Loyalist militiamen.

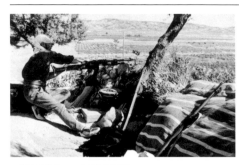

•AD 714 138 / 027
(page 62)
Near Huesca, Aragon front, August 1936.
Loyalist militiaman.

•AD 712 140 / 029
(page 65)
Near Huesca, Aragon front, August 1936.
Loyalist militiamen.

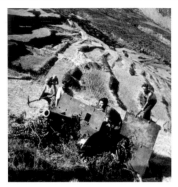

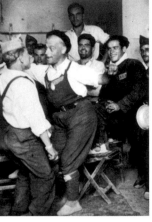

•AD 716 142 / 031
(page 66)
Aragon front, August 1936.
Loyalist militiamen.

•AD 719 144 / 033
(page 66)
Leciñena, Aragon front, August 1936.
Members of the semi-Trotskyite POUM (Partido Obrero de Unificación Marxista) militia.

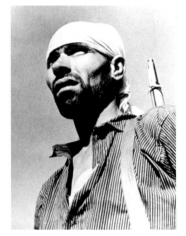

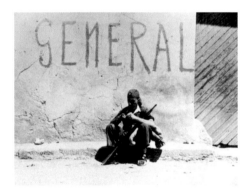

•AD 715 139 / 028
(page 63)
Near Huesca, Aragon front, August 1936.
Loyalist militiaman.

AD 718 141 / 030
Aragon front, August 1936.
Loyalist militiaman outside the local general headquarters.

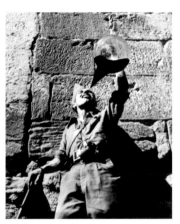

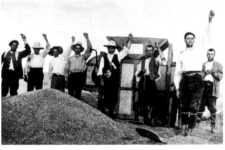

AD 717 143 / 032
Aragon front, August 1936.
Loyalist militiaman.

•AD 721 145 / 034
(page 67)
Aragon front, August 1936.

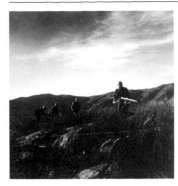

AD 722 146 / 035

Santa Eulalia, Aragon front, August 1936.
Capa wrote in his book Death in the Making *that he and Taro first encountered fighting near an Aragonian village called Santa Eulalia. "The enemy was out of sight across a ravine. The defenders of the village, soldiers, peasants, young professional men, here and there a woman, lay in the cornfields without protection; the art of building trenches was unknown in this country without a military tradition. . . Bullets sang past, but the enemy keeps out of sight. The republican line moves forward to a better spot."*

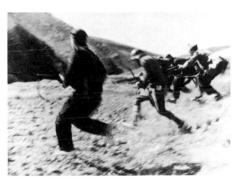

•AD 723 147 / 036
(page 68–69)
Santa Eulalia, Aragon front, August 1936.

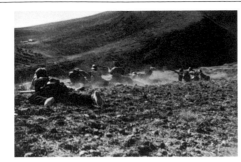

AD 724 148 / 037
Santa Eulalia, Aragon front, August 1936.

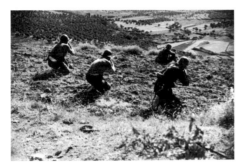

AD 725 149 / 038
Santa Eulalia, Aragon front, August 1936.

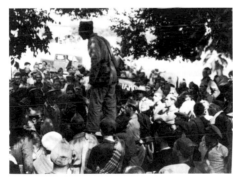

•AD 720 150 / 039
(page 71)
Córdoba front, September 1936.
Officer addressing militia members before an attack.

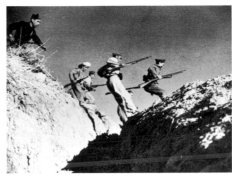

•AD 727 151 / 040
(page 32)
Cerro Muriano, Córdoba front,
September 5, 1936.
Loyalist militia.

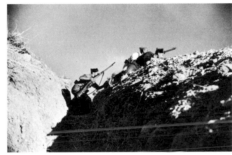

•AD 728 152 / 041
(page 32)
Cerro Muriano, Córdoba front,
September 5, 1936.
Loyalist militia.

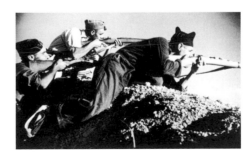

•AD 726 153 / 042
(page 32)
Cerro Muriano, Córdoba front,
September 5, 1936.
Loyalist militia.

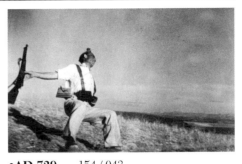

•AD 729 154 / 043
(page 26)
Cerro Muriano, Córdoba front,
September 5, 1936.
The death of a Loyalist militiaman. The man has been recently identified as Federico Borrell Garcia, a member of the militia regiment from the village of Alcoy, near Alicante.

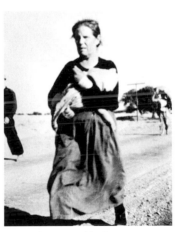

•AD 731 155 / 044
(page 72)
Cerro Muriano, Córdoba front,
September 5, 1936.
This and the following four photographs show the terror-stricken inhabitants of Cerro Muriano fleeing from a Nationalist air raid.

AD 730 156 / 045
Cerro Muriano, Córdoba front,
September 5, 1936.

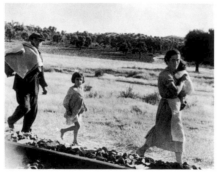

AD 733 158 / 047
Cerro Muriano, Córdoba front,
September 5, 1936.

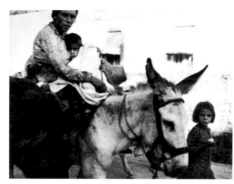

•**AD 732** 159 / 048
(page 73)
Cerro Muriano, Córdoba front,
September 5, 1936.

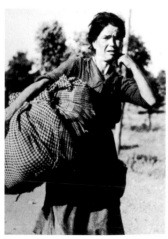

•**AD 734** 157 / 046
(page 72)
Cerro Muriano, Córdoba front,
September 5, 1936.

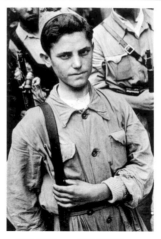

•**AD 739** 160 / 049
(page 70)
Madrid, late August or early September 1936.
*Capa's extraordinary rapport with all sorts of
people comes through very clearly in his close-
ups of faces. Some years later, when he was
asked if he had any advice for aspiring pho-
tographers, he replied that his own secret was
simply to "like people and let them know it."
Indeed, in whatever company or conditions
he found himself, he was always able to put
people at ease and even to make them laugh.
Among his most engaging photographs from
the Spanish Civil War are his impromptu por-
traits of members of Loyalist militias and of
the International Brigades.*

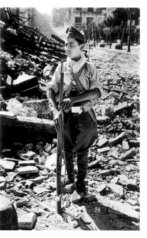

AD 740 161 / 050
Location unknown, August–September 1936.
Loyalist soldier.

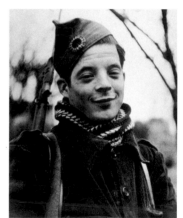

•**AD 738** 162 / 051
(page 75)
Madrid, November–December 1936.

•AD 737 163 / 052
(page 64)
Madrid, November–December 1936.

AD 742 166 / 055
Madrid, November–December 1936.
Capa was deeply moved by the diversity of the Loyalist forces, composed of many unlikely soldiers from various backgrounds. He seems to have found the disruptive transformation of ordinary civilians into soldiers quite poignant, and many of his photographs emphasize the incompleteness of the transformation. He often caught the sadness, the fear, the confusion, or the boredom of these reluctant soldiers.

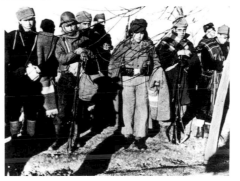

AD 741 168 / 057
Madrid, November–December 1936.

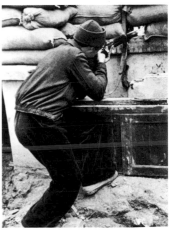

AD 745 170 / 059
Madrid, November–December 1936.

AD 736 164 / 053
Madrid, November–December 1936.

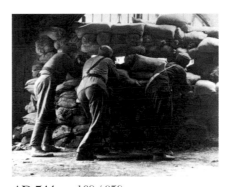

AD 744 169 / 058
Madrid, November–December 1936.
On November 6, 1936, Nationalist troops arrived at the western outskirts of Madrid, where some of the fiercest battles of the entire civil war would take place over the course of the next few weeks. This fighting was especially concentrated in and around the University City and the nearby slaughterhouses. Day after day Capa, like many militiamen, would take a trolley from downtown Madrid out to the front.

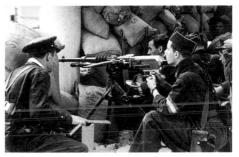

AD 747 171 / 060
Madrid, November–December 1936.

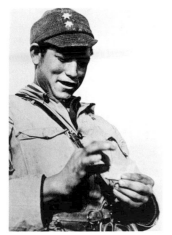

AD 735 165 / 054
Madrid, November–December 1936.

•AD 743 167 / 056
(page 76)
Madrid, November–December 1936.

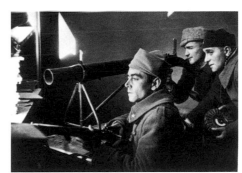

•AD 746 172 / 061
(page 78–79)
Madrid, November–December 1936.

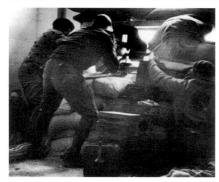

AD 748 173 / 062
Madrid, November–December 1936.

AD 749 174 / 063
Madrid, November–December 1936.

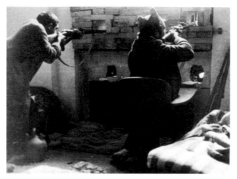

•AD 750 175 / 064
(page 94)
Madrid, November–December 1936.
*Capa spent several days with the men of the
Commune de Paris battalion of the Interna-
tional Brigades in the Medical School build-
ing of the University City. In his book* Death
in the Making, *Capa wrote of this and the fol-
lowing three photographs, "The word no longer
dominates in the University of Madrid; lead
from rifles, from machine guns, from field
artillery is master now. Soldiers, spraying [with
bullets] the grounds where students dodged
the strong sun of Castile, sit in the armchairs
from which professors retailed the wisdom of
the ages. On a library table an anti-tank can-
non stands in readiness, just in case. . . . In a
chemical laboratory, sheltered from rebel fire,
the defenders sleep and eat."*

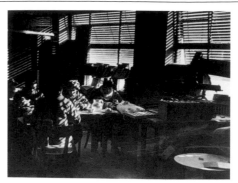

AD 760 177 / 066
Madrid, November–December 1936.

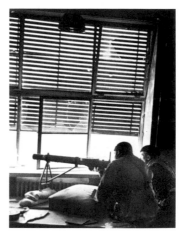

AD 762 178 / 067
Madrid, November–December 1936

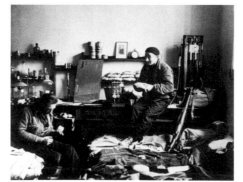

•AD 761 176 / 065
(page 82)
Madrid, November–December 1936.

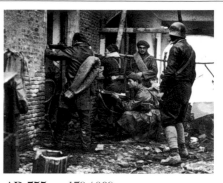

AD 755 179 / 068
Madrid, November–December 1936.
*Capa accompanied men of various Interna-
tional Brigade units in house-to-house fight-
ing and reconnaissance missions. At least some
of the men in this photograph and the follow-
ing were members of the Twelfth Brigade's
Thälmann Battalion, composed of anti-fascist
German volunteers.*

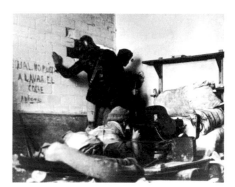

AD 754 180 / 069
Madrid, November–December 1936.

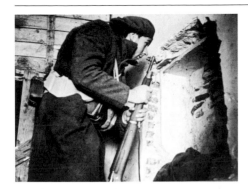

AD 752 181 / 070
Madrid, November–December 1936.

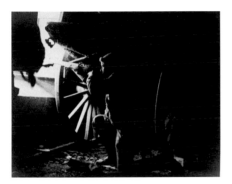

•**AD 753** 182 / 071
(page 86)
Madrid, November–December 1936.

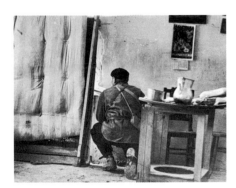

•**AD 751** 183 / 072
(page 87)
Madrid, November–December 1936.
Along the bottom of the calendar poster hang-
ing on the wall may be read the name "Mála-
ga," but Capa almost certainly made this
photograph in Madrid.

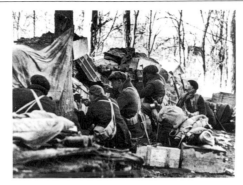

•**AD 756** 184 / 073
(page 88–89)
Madrid, November–December
A Loyalist barricade made of suitcases that
had been removed from the baggage room of
the Estación del Norte (the nearby railway sta-
tion) and filled with dirt.

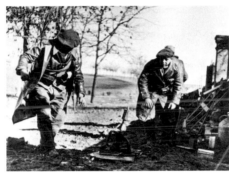

AD 757 185 / 074
Madrid, November–December 1936.
Asturian dinamiteros.

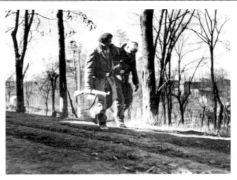

•**AD 758** 186 / 075
(page 93)
Madrid, November–December 1936.

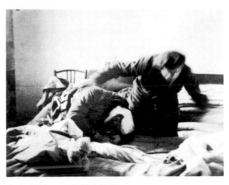

AD 759 187 / 076
Madrid, November–December 1936.

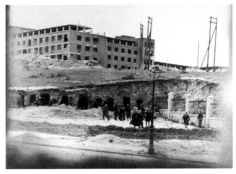

•**AD 763** 188 / 077
(page 95)
Madrid, February 1937.
In February 1937 Capa and Taro photo-
graphed the elaborate system of trenches, tun-
nels, and caves that the Loyalists had dug
around the University City's Clinical Hospi-
tal, one of the principal bastions of the Nation-
alists. There was no serious fighting at that
time, only sniper fire and endless watching and
waiting in the cold and damp weather.

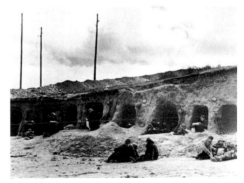

AD 764 189 / 078
Madrid, February 1937.

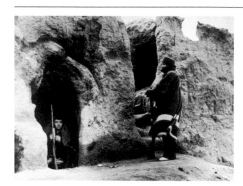

AD 766 190 / 079
Madrid, February 1937.

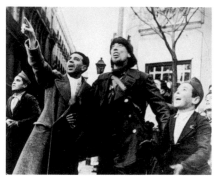

•**AD 767** 192 / 081
(page 109)
Madrid, November–December 1936.
Watching an air battle over the city.

•**AD 769** 194 / 083
(page 84–85)
Madrid, winter 1936–37.

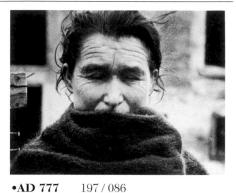

•**AD 777** 197 / 086
(page 101)
Vallecas, Madrid, winter 1936–37.
Capa's greatest images from the first months of the siege of Madrid are those that show people trying to live amid the ruins of Vallecas, a working-class neighborhood that had been hit especially hard. Surrounded by suffering and death, the people of Vallecas carried on stoically.

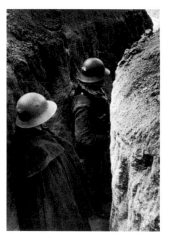

AD 765 191 / 080
Madrid, February 1937.

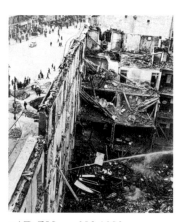

•**AD 768** 193 / 082
(page 83)
Madrid, winter 1936–37.
The business and residential districts of Madrid were under very heavy aerial and artillery bombardment, and Capa made an extensive documentation of the destruction.

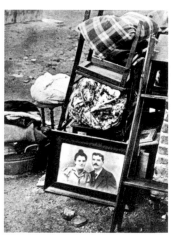

AD 770 195 / 084
Madrid, winter 1936–37.

AD 774 196 / 085
Madrid, winter 1936–37.

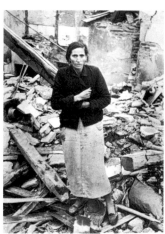

•**AD 778** 198 / 087
(page 97)
Vallecas, Madrid, winter 1936–37.

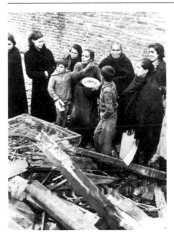

AD 779 199 / 088
Vallecas, Madrid, winter 1936–37.

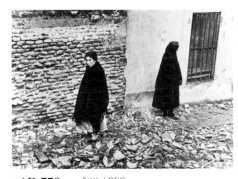

•**AD 776** 200 / 089
(page 98–99)
Vallecas, Madrid, winter 1936–37.

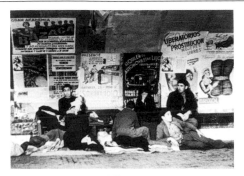

AD 780 201 / 090
Madrid, November–December 1936.
Many Madrileños whose homes had been destroyed in Nationalist air raids, as well as others seeking shelter from the bombing, lived for weeks and months on the platforms of subway stations. Capa photographed extensively in the Gran Vía station, in downtown Madrid, where undaunted children played and laughed as always, but the faces of their elders showed fear, grief, and boredom.

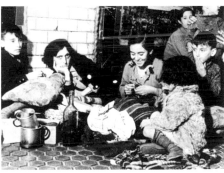

•**AD 781** 202 / 091
(page 102–103)
Madrid, November–December 1936.

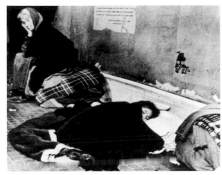

AD 782 203 / 092
Madrid, November–December 1936.

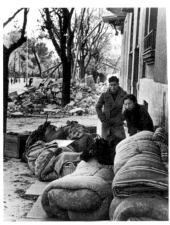

AD 771 204 / 093
Madrid, November–December 1936.
Capa chronicled the great exodus from the city, as thousands fled to safer locales.

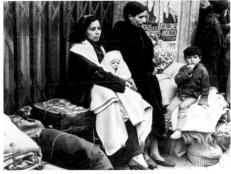

•**AD 772** 205 / 094
(page 90)
Madrid, November–December 1936.

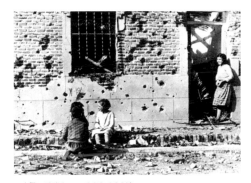

•**AD 775** 206 / 095
(page 96)
Madrid, November–December 1936.

•**AD 773** 207 / 096
(page 107)
Madrid, November–December 1936.
An armored car used by officers of the International Brigades.

•AD 784 208 / 097
(page 47)
Madrid, November–December 1936.
Capa loved the spirit of camaraderie that pre-
vailed among the Loyalists and the Interna-
tional Brigades. He and Taro were both pleased
to see men and women sharing tasks—such as
doing laundry—that would previously have
been unthinkable for a Spanish man with any
pride.

•AD 785 209 / 098
(page 105)
Madrid, November–December 1936.

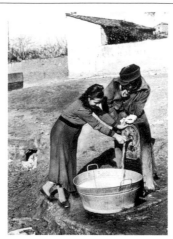

•AD 783 210 / 099
(page 105)
Madrid, November–December 1936.

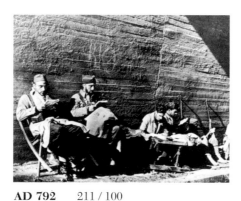

AD 792 211 / 100
Madrid, November–December 1936.
Capa understood that the truth about war was
to be found not only in the heat of battle but
also behind the lines, in the faces of soldiers
enduring cold, fatigue, and tedium. Many of
his greatest images of war are profoundly sym-
pathetic and compassionate studies of ordi-
nary men and women called upon to perform
extraordinary service for their country or for
a cause in which they passionately believed.

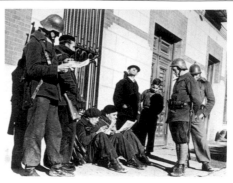

•AD 793 212 / 101
(page 104)
Madrid, November–December 1936.
German members of the International Bri-
gades.

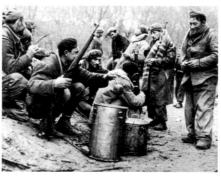

•AD 790 213 / 102
(page 106)
Madrid, November–December 1936.

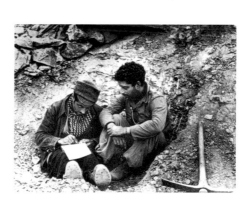

AD 786 214 / 103
Madrid, November–December 1936.

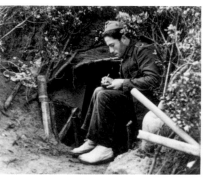

•AD 789 215 / 104
(page 80)
Madrid, November–December 1936

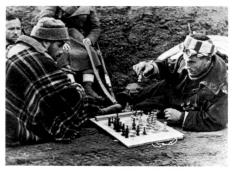

•AD 791 216 / 105
(page 81)
Madrid, November–December 1936.

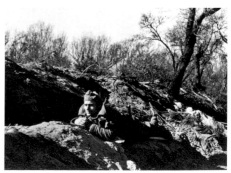

•AD 787 217 / 106
(page 77)
Madrid, November–December 1936.

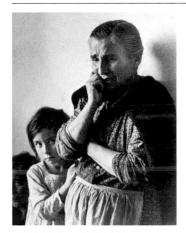

•**AD 795** 218 / 107
(page 91)
Almería or Murcia, February 1937.
Refugees from Málaga.When the Nationalists took the southern city of Málaga, on February 8, 1937, tens of thousands of the city's inhabitants fled along the coastal road to Almería, one hundred fifty miles to the east. Many of them were killed by Nationalist strafers or naval artillery; others collapsed from hunger and exhaustion. Finally, on the evening of February 12, when the streets of Almería were choked with sleeping refugees, Nationalist planes bombed the town. Capa and Taro photographed some of the surviving refugees in Almería as well as in the nearby town of Murcia.

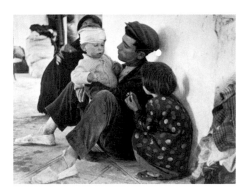

AD 788 219 / 108
Almería or Murcia, February 1937.
Refugees from Málaga

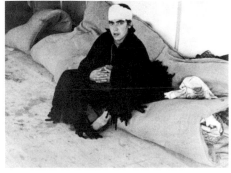

AD 796 220 / 109
Almería or Murcia, February 1937.
Refugees from Málaga.

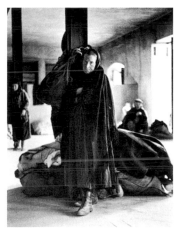

•**AD 794** 221 / 110
(page 91)
Almería or Murcia, February 1937.
Refugees from Málaga.

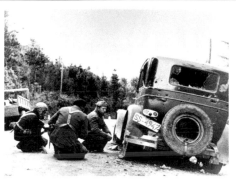

•**AD 797** 222 / 111
(page 92)
Mount Sollube, Bilbao front, May 7, 1937.
Early in May 1937 Nationalist troops were closing in on the great Basque city of Bilbao. On May 7 they attacked Mount Sollube, a strategic peak in the range of low mountains that served as the city's last natural line of defense. Capa covered this crucial and dramatic battle, which ended in a Loyalist victory that briefly stalled the Nationalist advance.

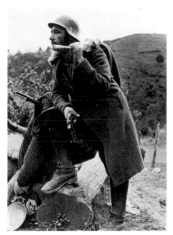

AD 798 223 / 112
Mount Sollube, Bilbao front, May 7, 1937.

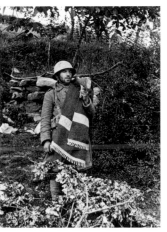

AD 800 224 / 113
Mount Sollube, Bilbao front, May 7, 1937.

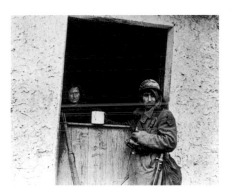

•**AD 801** 225 / 114
(page 117)
Mount Sollube, Bilbao front, May 7, 1937.

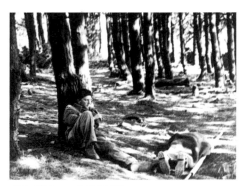

AD 799 226 / 115
Mount Sollube, Bilbao front, May 7, 1937.

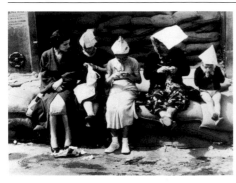

AD 803 227 / 116
Bilbao, May 1937.
Capa wrote of this and the following three pho-
tographs, "In Bilbao the sirens screamed their
warning. A long blast when the raiders of
the air were sighted. Three short blasts when
they were straight overhead. Sometimes there
were fifteen to twenty raids a morning. You
couldn't run downstairs every time to the shel-
ter in the basement which wasn't a shelter, or
to the place under the bridge that wasn't much
good either, or to the tunnel that was best,
fifteen to twenty times a morning with the
kids. So you took your knitting and sat on the
sandbags outside the quite good shelter in the
vaults of banks, a paper hat to hold back the
sun. When three blasts blew, three hysterical
blasts, the streets were cleared. The police fired
to hurry the laggards under ground."

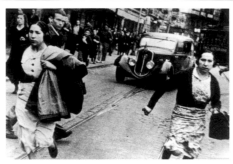

•**AD 806** 228 / 117
(page 110–111)
Bilbao, May 1937.

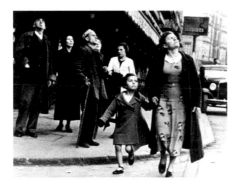

•**AD 807** 229 / 118
(page 114–115)
Bilbao, May 1937.
This is surely one of the most affecting pho-
tographs Capa ever made. The little girl—in
her frightened confusion—has misbuttoned
her coat. Capa had a genius for catching such
expressively revealing details.

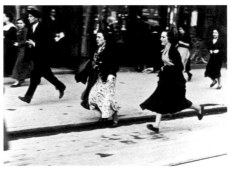

AD 805 230 / 119
Bilbao, May 1937.

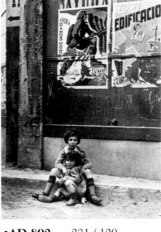

•**AD 802** 231 / 120
(page 108)
Bilbao, May 1937.

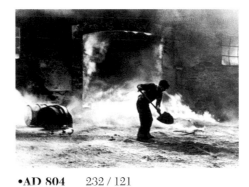

•**AD 804** 232 / 121
(page 112)
Bilbao, May 1937.
Fighting a fire ignited in a gasoline depot by
a Nationalist air raid.

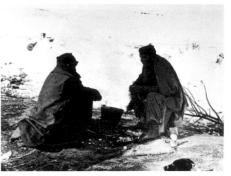

AD 811 233 / 122
Teruel, Aragon front, December 1937–
January 1938.
In December 1937 and January 1938, Capa
covered the crucial battle of Teruel, a strate-
gic town in northeastern Spain that had
been captured by Nationalist forces in Octo-
ber. Historian and novelist James Michener
has written that Teruel "had become the key-
stone of the Republican line running between
Valencia and Barcelona, and its retention
would determine who would win the war." For
twenty-four bitterly cold days the Loyalists
besieged the town until they finally managed
to retake it.

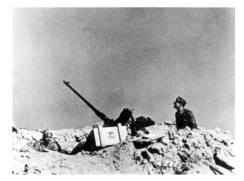

AD 810 234 / 123
Teruel, Aragon front, December 1937–
January 1938.

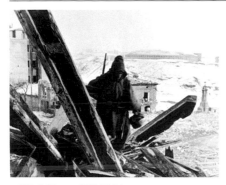

•AD 808　235 / 124
(page 119)
Teruel, Aragon front, December 1937–
January 1938.

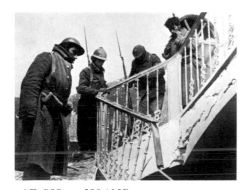

•AD 809　236 / 125
(page 116)
Teruel, Aragon front, January 3, 1938.
Inside the Governor's Palace, one of last
Nationalist bastions to hold out.

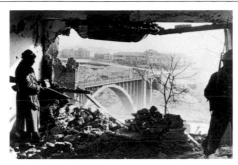

•AD 812　237 / 126
(page 4–5)
Teruel, Aragon front, January 3, 1938.
Inside the Governor's Palace, one of last
Nationalist bastions to hold out. Shortly before
Capa made this photograph, the Loyalists had
dynamited one of the outside walls.

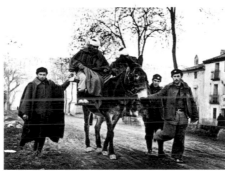

AD 813　238 / 127
Teruel, Aragon front, December 1937–
January 1938.

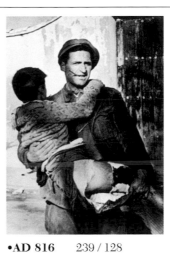

•AD 816　239 / 128
(page 113)
Teruel, Aragon front, December 21, 1937.
When they entered the besieged town with the
first Loyalist troops, Capa and his colleague
Herbert Matthews, of the New York Herald-
Tribune, *encountered this painful scene of*
father and son.

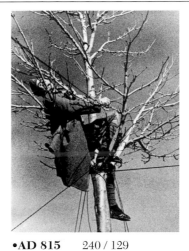

•AD 815　240 / 129
(page 118)
Teruel, Aragon front, December 21–24, 1937.
On January 4, 1938, Capa returned to Paris
with his rolls of film, on which were an extra-
ordinary number of great photographs. When
Life *published a selection of them, including*
this and the next, the text commented that "the
love of peace has no meaning or stamina unless
it is based on a knowledge of war's terrors."

　The man in this photograph was shot while
stringing telephone lines.

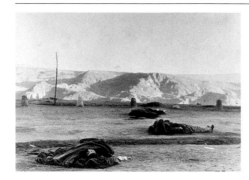

•**AD 814** 241 / 130
(page 120–121)
Teruel, Aragon front, December 21, 1937.
When Life *published this photograph on January 28, 1938, the editors were careful to contextualize this grim scene, admonishing their readers that "Dead men have indeed died in vain if live men refuse to look at them."*

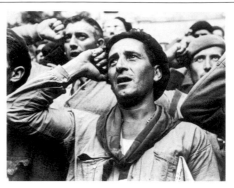

•**AD 824** 242 / 131
(page 125)
Montblanch (near Barcelona), October 25, 1938.
When Capa returned to Spain in the fall of 1938, after six months in China, the news was bad. As an overture of friendship toward Hitler, Stalin had forced the Spanish government to agree to disband the International Brigades, thereby more or less guaranteeing ultimate victory to Hitler's ally Franco. This and the following six photographs were made on the day the brigades gathered to be addressed by Prime Minister Juan Negrín, André Marty (commander of the International Brigades), and generals Rojo, Modesto, and Lister. Everyone then sat down to a farewell feast, at which (as some of Capa's photographs testify) at least some of the men were able to forget their sadness for a while.

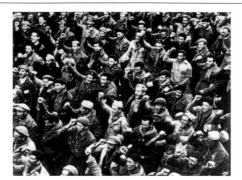

•**AD 818** 244 / 133
(page 123)
Montblanch (near Barcelona), October 25, 1938.

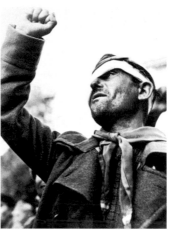

•**AD 819** 245 / 134
(page 128)
Montblanch (near Barcelona), October 25, 1938.

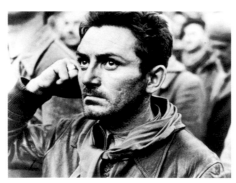

•**AD 817** 243 / 132
(page 16)
Montblanch (near Barcelona), October 25, 1938.

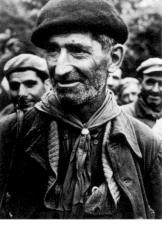

•**AD 820** 246 / 135
(page 129)
Montblanch (near Barcelona), October 25, 1938.

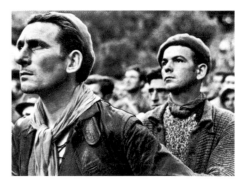

•**AD 822** 247 / 136
(page 12–13)
Montblanch (near Barcelona), October 25, 1938.

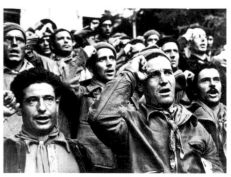

AD 821 248 / 137
Montblanch (near Barcelona), October 25, 1938.

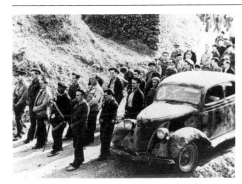

AD 826 249 / 138

Falset (near Barcelona), October 16, 1938.
*Men of the International Brigades passing in
their final review before a group of open trucks
(visible in other Capa photographs) that served
as reviewing stands.*

•AD 825 251 / 140
(page 128)
Falset (near Barcelona), October 16, 1938.
*Milt Wolff, commander of the Abraham Lin-
coln Battalion.*

AD 832 253 / 142
Mora de Ebro, Aragon front, November 5,
1938.
*Hoping to prevent the Loyalists from crossing
the Rio Ebro, the Nationalists had bombed
the bridge at Mora de Ebro and opened the
dams in the north. Capa, Ernest Hemingway,
and several other journalists drove out from
Barcelona to assess the situation. After a
nearly disastrous crossing of the treacherous
river in a small boat, the journalists visited
General Lister and his Fifth Army Corps,
which was barely holding out against a major
Nationalist offensive. Indeed, the day ended
in a massive Loyalist retreat.*

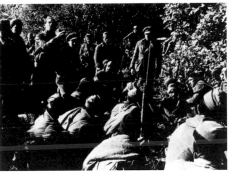

AD 834 255 / 144
Rio Segre, Aragon front (near Fraga),
November 7, 1938.
*On the night of November 6, in an effort to
divert the Nationalists from Mora de Ebro,
Loyalist troops launched an offensive near
Fraga, on the Rio Segre, about forty miles to
the north. When news of the offensive reached
Barcelona early on the morning of the seventh,
Capa rushed to the front. This and the fol-
lowing eighteen photographs belong to his cov-
erage of that futile battle.*

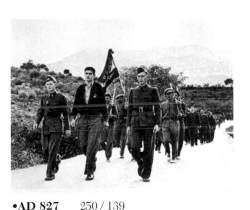

•AD 827 250 / 139
(page 124)
Falset (near Barcelona), October 16, 1938.
*Milt Wolff (front row center), commander of
the Abraham Lincoln Battalion (the American
unit of the International Brigades), leading his
men in their final review.*

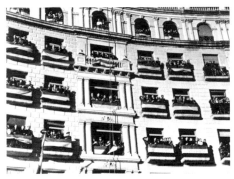

•AD 823 252 / 141
(page 126–127)
Barcelona, October 29, 1938.
*Spectators looking down at the farewell parade
for the International Brigades.*

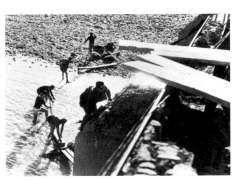

•AD 833 254 / 143
(page 132)
Mora de Ebro, Aragon front, November 5,
1938.

•AD 828 256 / 145
(page 134)
Rio Segre, Aragon front (near Fraga),
November 7, 1938.
Political commissar exhorting troops.

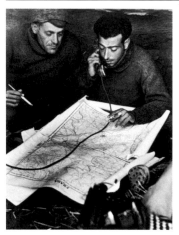

•AD 831 257 / 146
(page 133)
Rio Segre, Aragon front (near Fraga),
November 7, 1938.

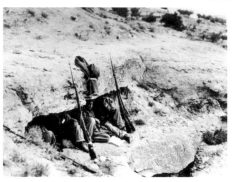

AD 835 259 / 148
Rio Segre, Aragon front (near Fraga),
November 7, 1938.

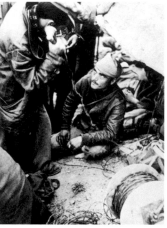

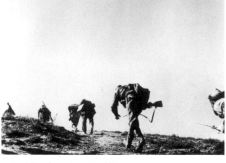

•AD 837 263 / 152
(page 136)
Rio Segre, Aragon front (near Fraga),
November 7, 1938.

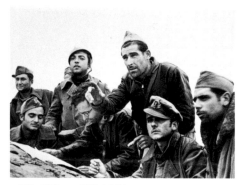

•AD 830 258 / 147
(page 131)
Rio Segre, Aragon front (near Fraga),
November 7, 1938.
*A field headquarters during the Loyalist offen-
sive along the Rio Segre.*

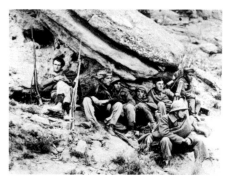

•AD 836 260 / 149
(page 135)
Rio Segre, Aragon front (near Fraga),
November 7, 1938.

•AD 829 261 / 150
(page 133)
Rio Segre, Aragon front (near Fraga),
November 7, 1938.

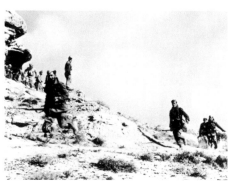

AD 838 262 / 151
Rio Segre, Aragon front (near Fraga),
November 7, 1938.

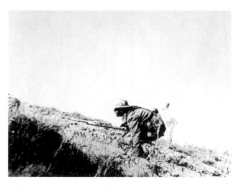

AD 839 264 / 153
Rio Segre, Aragon front (near Fraga),
November 7, 1938.

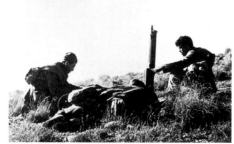

AD 840 265 / 154
Rio Segre, Aragon front (near Fraga),
November 7, 1938.

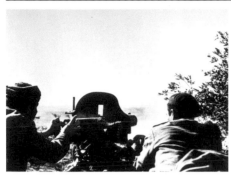

AD 841 266 / 155
Rio Segre, Aragon front (near Fraga),
November 7, 1938.

AD 847 269 / 158
Rio Segre, Aragon front (near Fraga),
November 7, 1938.

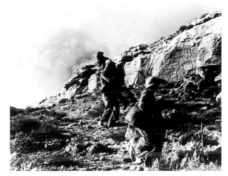

AD 848 272 / 161
Rio Segre, Aragon front (near Fraga),
November 7, 1938.

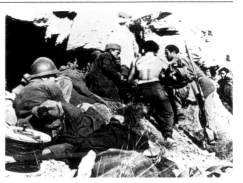

•**AD 851** 275 / 164
(page 142)
Rio Segre, Aragon front (near Fraga),
November 7, 1938.

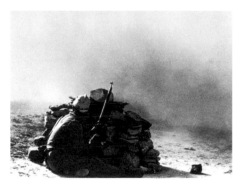

•**AD 842** 267 / 156
(page 137)
Rio Segre, Aragon front (near Fraga),
November 7, 1938.

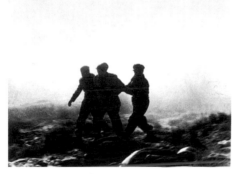

•**AD 844** 270 / 159
(page 138)
Rio Segre, Aragon front (near Fraga),
November 7, 1938.

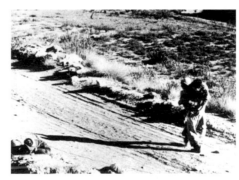

AD 849 273 / 162
Rio Segre, Aragon front (near Fraga),
November 7, 1938.

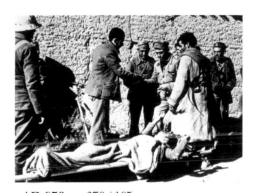

•**AD 850** 276 / 165
(page 141)
Rio Segre, Aragon front (near Fraga),
November 7, 1938.

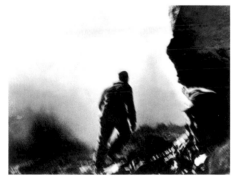

•**AD 843** 268 / 157
(page 139)
Rio Segre, Aragon front (near Fraga),
November 7, 1938.

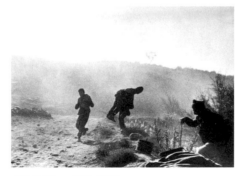

AD 845 271 / 160
Rio Segre, Aragon front (near Fraga),
November 7, 1938.

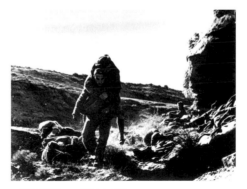

•**AD 846** 274 / 163
(page 140)
Rio Segre, Aragon front (near Fraga),
November 7, 1938.

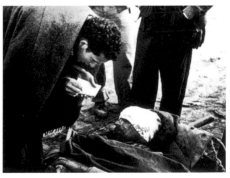

•**AD 852** 277 / 166
(page 143)
Rio Segre, Aragon front (near Fraga),
November 7, 1938.

•**AD 853** 278 / 167
(page 148)
Barcelona, January 1939.
Exhausted, Capa left heavily bombed Barcelona around December 10. After spending Christmas in Paris, he returned to Barcelona around January 10, 1939, as the Nationalists were closing in on the city. During the next two weeks he often photographed people running for shelter at the sound of the air raid alarms. When Loyalist fighter planes attacked the Nationalist bombers, some people couldn't resist remaining aboveground to watch the air battle.

•**AD 854** 279 / 168
(page 148)
Barcelona, January 1939.

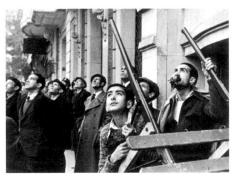

•**AD 855** 280 / 169
(page 146–147)
Bilbao, May 1937 (formerly identified as Barcelona, January 1939).

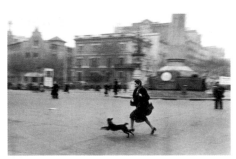

•**AD 858** 281 / 170
(page 149)
Barcelona, January 1939.

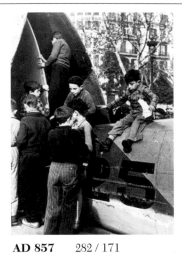

AD 857 282 / 171
Barcelona, January 1939.
One crippled Nationalist bomber (a German-made Heinkel) that managed to land outside the city was put on display in a downtown park, to the obvious delight of the boys who clambered all over it.

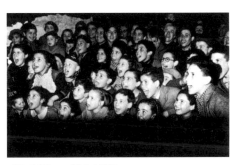

AD 856 283 / 172
Barcelona, January 1939.
These children were treated to a performance by clowns before being evacuated from the city.

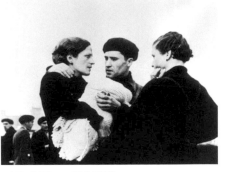

•**AD 867** 284 / 173
(page 151)
Barcelona, January 13, 1939.
In mid-January 1939, all able-bodied men up to the age of fifty were mobilized to resist the Nationalist troops that were rapidly approaching Barcelona.

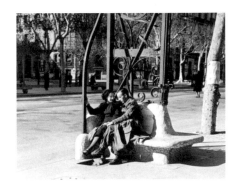

•**AD 868** 285 / 174
(page 150)
Barcelona, January 1939.

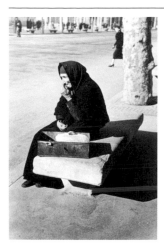

AD 871 286 / 175
Barcelona, January 1939.
By mid-January, a mass evacuation of the city was well under way. Thousands of women, children, and the elderly—many of them on foot—began their trek to the French border with what few possessions they could carry.

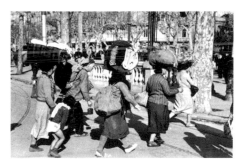

AD 869 287 / 176
Barcelona, January 1939.

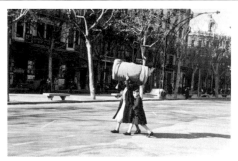

•AD 870 288 / 177
(page 145)
Barcelona, January 1939.

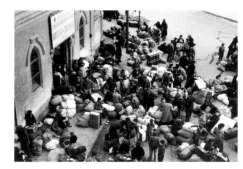

•AD 872 289 / 178
(page 153)
Barcelona, January 1939.
A refugee transit center.

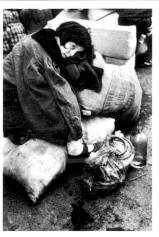

•AD 875 290 / 179
(page 144)
Barcelona, January 1939.
Writing about the refugee transit center in the previous photograph, Capa described the girl seen here (she appears near the bottom center of the overview) and then lamented, "It is not always easy to stand aside and be unable to do anything except record the sufferings around one."

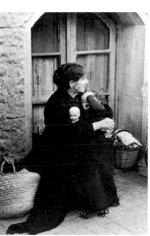

AD 874 291 / 180
Barcelona, January 1939.
At the refugee transit center seen in photograph 289.

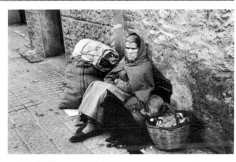

•AD 873 292 / 181
(page 152)
Barcelona, January 1939.
At the refugee transit center seen in photograph 289.

AD 876 293 / 182
Barcelona, January 1939.

AD 863 294 / 183
On the road from Tarragona to Barcelona, January 15, 1939.

•AD 859 295 / 184
(page 156)
On the road from Tarragona to Barcelona,
January 15, 1939.

•AD 860 297 / 186
(page 155)
On the road from Tarragona to Barcelona,
January 15, 1939.

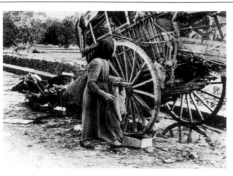

•AD 865 299 / 188
(page 158)
On the road from Tarragona to Barcelona,
January 15, 1939.

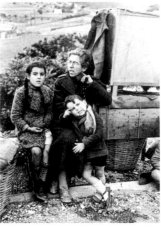

AD 861 301 / 190
On the road from Tarragona to Barcelona,
January 15, 1939.

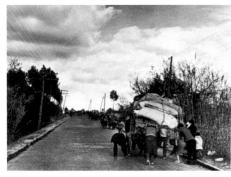

AD 878 296 / 185
On the road from Barcelona to the French
border, January 25–27, 1939.

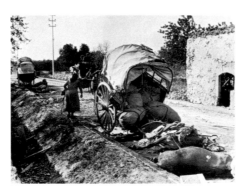

AD 864 298 / 187
On the road from Tarragona to Barcelona,
January 15, 1939.
*Before the refugees could reach their destina-
tion, Nationalist planes strafed them merci-
lessly, killing many and scattering their
belongings. Capa's photographs of this tragedy
(numbers 298, 299, and 300) show an elderly
woman who survived an attack that killed
everyone else in her group, including her dog
and her two mules. In a state of shock, she was
walking endlessly in circles around her cart.*

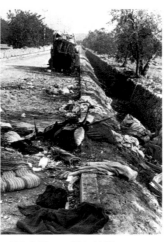

•AD 866 300 / 189
(page 159)
On the road from Tarragona to Barcelona,
January 15, 1939.

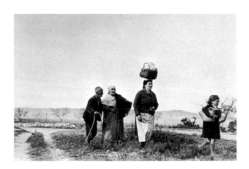

•AD 862 302 / 191
(page 157)
On the road from Tarragona to Barcelona,
January 15, 1939.

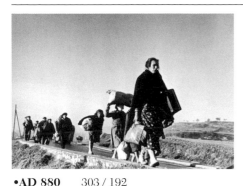

•AD 880 303 / 192
(page 160–161)
On the road from Barcelona to the French
border, January 25–27, 1939.
*With not only the fall of Barcelona but also
Nationalist rule over all of Spain clearly immi-
nent, many thousands of Spanish civilians
sought refuge and political asylum in France.
Early on the morning of January 25, 1939,
with the Nationalists only ten miles from
Barcelona, Capa left the city and headed north
on the coastal road toward the French border.
One journalist who accompanied him wrote
that as they drove, they "overtook thousands
and thousands of refugees, in carts, on mules,
afoot, begging rides in trucks and cars, and
always wearily struggling forward to that
inhospitable frontier which still remained
grimly closed to them." Capa remained in the
area of Figueras for three days to document
the hardships of the refugees on the road.*

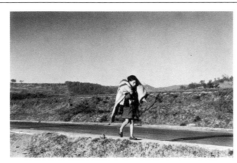

AD 879 304 / 193
On the road from Barcelona to the French
border, January 25–27, 1939.

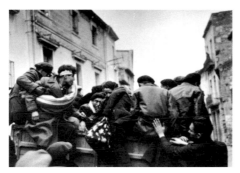

•AD 877 305 / 194
(page 162)
On the road from Barcelona to the French
border, January 25–27, 1939.

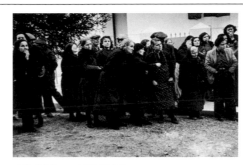

AD 881 306 / 195
Near the French border, north of Barcelona,
January 25–27, 1939.

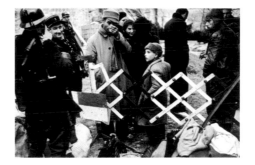

•AD 882 307 / 196
(page 163)
At the French border, north of Barcelona,
January 28, 1939.
*On January 28, the French government fin-
ally opened the border to the refugees, and the
first of some four hundred thousand Spanish
men, women, and children went into exile.*

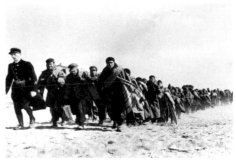

•AD 883 308 / 197
(page 164–165)
Between Argelès-sur-Mer and Le Barcarès,
France, March 1939.
*The Spanish Loyalist soldiers who crossed the
French border into exile found themselves
interned in vast and primitive camps, which
not even their close relatives were allowed to
enter for a visit. Argelès-sur-Mer, where some
seventy-five thousand men were interned. They
were living in appalling conditions, in impro-
vised tents and shacks without running water.
While there, Capa photographed the large
group of men seen in this and the next picture
being transferred from the camp to a slightly
more comfortable one at Le Barcarès, twenty
miles to the north.*

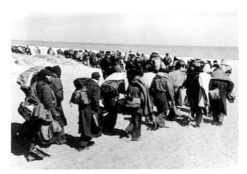

•AD 885 309 / 198
(page 166)
Between Argelès-sur-Mer and Le Barcarès,
France, March 1939.

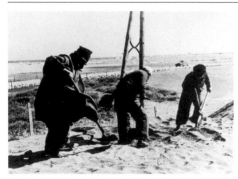

AD 888 310 / 199

Argelès-sur-Mer or Le Barcarès, France, March 1939.

•AD 886 313 / 202
(page 169)

Argelès-sur-Mer or Le Barcarès, France, March 1939.

AD 890 315 / 204

Near Biarritz, France, May 1939.

·During the first week of May 1939, Capa went to the French beach resort of Biarritz to do a story about a group of exceptionally pleasant orphanages run by the Foster Parents' Plan for Spanish Children, largely financed by contributions from Americans. Having photographed the horrifying conflict through which these children had lived, he was pleased to see that they were being well taken care of. Capa donated prints of his pictures to the sponsoring organization for use in its fundraising efforts.

PHOTOGRAPHS FROM THE COLLECTION OF THE ARCHIVO HISTÓRICO NACIONAL, SECCIÓN GUERRA CIVIL, SALAMANCA

Included in the 1999 exhibition, "Capa: Cara a Cara" (Capa: Face to Face), at the Museo Nacional Centro de Arte Reina Sofía, are twenty-two photographs by Robert Capa and one by Fred Stein from the collection of the Archivo Histórico Nacional, Sección Guerra Civil, Salamanca. The title of each print is hand-written in French on the back; all measure 18-by-24 centimeters. The titles with an asterisk are reproduced in this catalogue.

°Madrid, 1937; Sur le Front de Madrid; Madrid; Madrid après un bombardement, 1937; Ruines de Madrid, 1937; Madrid, 1937; Madrid, 1937; Madrid; Fortification de Madrid; Défense de Barcelone, 1936; Défense de Barcelone; Front de Guadarrama; Front de Huesca, 1936; Sur le front de Huesca; Héros inconnus; Tête de milicien; °Milicienne; Milicien; . . . École improvisée pour les analphabets; Rencontre; La vie collective chez les paysans espagnols; Fuite de la population; y Gerda Taro tuée sur le front de Brunete en 1937, de Fred Stein.

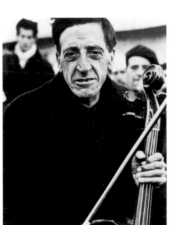

•AD 889 311 / 200
(page 167)

Argelès-sur-Mer or Le Barcarès, France, March 1939.

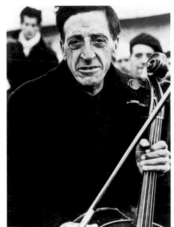

•AD 884 314 / 203
(page 170)

Argelès-sur-Mer or Le Barcarès, France, March 1939.

•AD 891 316 / 205
(page 171)

Near Biarritz, France, May 1939.

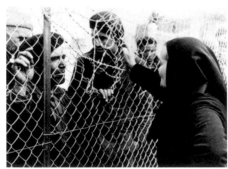

•AD 887 312 / 201
(page 168)

Argelès-sur-Mer, France, March 1939.

ACKNOWLEDGMENTS

MINISTRY OF EDUCATION AND CULTURE

Minister of Education and Culture
Esperanza Aguirre Gil de Biedma

State Secretary of Culture
Miguel Ángel Cortés Martín

**MUSEO NACIONAL CENTRO
DE ARTE REINA SOFÌA**

Director
José Guirao Cabrera

Deputy Director
Mercedes Morales Minero

Technical Advisor
Luis Jiménez-Clavería

Director of Communications
Janine Ronsmans

Director of Temporary Exhibitions
Marta González-Orbegozo

Director of the Permanent Collection
Paloma Esteban Leal

Curator of Photography
Catherine Coleman

Director of Publications
Cristina Torra

**EXHIBITION: MUSEO NACIONAL CENTRO DE ARTE
REINA SOFÍA, FEBRUARY 2–APRIL 5, 1999**

Curators: Catherine Coleman
 Richard Whelan

Administrative coordinator: Angel Serrano

Exhibition design: Manuel Martinez Muñiz

Installation: Alcoarte, S.A.

Insurance: Plus Ultra

Research: Laura Suárez-Galbán

Restoration: Pilar García, Manuela Gómez

Copyeditor: Sonia Álvarez

Translations: Entrelíneas

Registrar: Reyes Carretero

**ROYAL TRUSTEES OF THE MUSEO NACIONAL
CENTRO DE ARTE REINA SOFÍA**

President
Juan Manuel Urgoiti López-Ocaña

Vice-president
Eugenio Trías Sagnier

Trustees
Kosme María Barañano
Juan Manuel Bonet
Miguel Ángel Cortés
Álvaro Delgado Gal
José Antonio Fernández Ordóñez
José Guirao Cabrera
Antonio López Fernández Serra
Tomàs Llorens Serra
Luis Monreal
Mercedes Morales Minero
Benigno Pendás
Claude Picasso
María Elvira Rodríguez Herrer
Juan Torres Piñón
Julián Trincado
José Luis Yuste

Secretary
Concha Vela

FOR THEIR ASSISTANCE on the exhibition and catalog, the MNCARS would like to thank the following:

IBERIA

Ramón Buckley
George Buckley
Edie Capa
María Blanca Desantes Fernández
Thomas Eintwhistle
Gabriela Matthes
Maria José Salazar
Laura Suárez-Galbán
Rosalind Williams, *Photo Projects*
*Dirección General del Libro, Archivos y
 Bibliotecas*
*Subdirección General de Archivos Estatales,
 Archivo Histórico Nacional, Sección
 Guerra Civil, Salamanca*

MY MOST SINCERE THANKS go to the many members of the staff of the International Center of Photography, which has the world's largest collection of Robert Capa material, without whose generous assistance and invaluable expertise this book could never have been produced. I also wish to express my warm gratitude to photographic printer Teresa Engle Moreno, who made the master prints for the Museo Nacional Centro de Arte Reina Sofía. I would like to thank everyone at Aperture who has participated in the production of this book, especially executive director Michael E. Hoffman, editor Lesley Martin, designer Wendy Byrne, and production director Stevan Baron

As in any Robert Capa project, the support of Magnum Photos, Inc., of which Bob was a founding member, is gratefully acknowledged.

Above all, I give my loving thanks to my wonderful wife, Edie, who has cared for the Robert Capa Archive with extraordinary ability and dedication for many decades.

CORNELL CAPA

CREDITS

The publisher gratefully acknowledges permission to reprint the following:

"Vientos del pueblo me llevan" by Miguel Hernandez. Translated from the Spanish by Marilyn Rosenthal. Reprinted by permission of the publisher, from *Poetry of the Spanish Civil War*. Buenos Aires: Editorial Losada, © 1975.

"Casida of Sobbing" by Ferderico García Lorca. Translated from the Spanish by Robert Bly © 1967. Reprinted by permission of the translator, from *Lorca & Jiménez: Selected Poems*. Boston: Beacon Press, © 1997.

"Spanish Folk Song of the War," Anonymous. Translated from the Spanish by Langston Hughes. Reprinted by permission of the editor, from *The Penguin Book of Spanish Civil War Verse*. Valentine Cunningham, ed., London: Penguin Books, Ltd., © 1980.

An excerpt from *The Labyrinth of Solitude*, by Octavio Paz. Translated from the Spanish by Lysander Kemp. Reprinted by permission of the publisher. New York: Grove/Atlantic, Inc. © 1985.

"A Poem" by Lorenzo Varela. Translated from the Spanish by A. M. Elliot. Reprinted by permission of the editor, from *The Penguin Book of Spanish Civil War Verse*. Valentine Cunningham, ed., London: Penguin Books, Ltd. ©1980.

"Offended Lands" by Pablo Neruda. Translated from the Spanish by Richard Shaaf. Reprinted by permission of the publisher from *Spain in the Heart: Hymn to the Glories of the People at War*. Falls Church, Virginia: Azul Editions, © 1993.

"Madrid Front" by José Moreno Villa. Translated from the Spanish by Roberto Tejada. Reprinted by permission of José E. Moreno Nieto, from *Antología poética*, Seville: Biblioteca de Cultura Andaluza, © 1993.

"Fall of a City" by Stephen Spender. Reprinted by permission of Lady Spender, from *The Penguin Book of Spanish Civil War Verse*. London: Penguin Books, Ltd., © 1980.

"Today's Meditation" by Antonio Machado. Translated from the Spanish by Robert Bly © 1983. Reprinted by permission of the translator, from *Times Alone: Selected Poems of Antonio Machado*. Hanover, New Hampshire: Weslyan University Press, © 1983.

"Thälmann Battalion" by Aileen Palmer. Reprinted by permission of the editor, from *The Penguin Book of Spanish Civil War Verse*. Valentine Cunningham, ed., London: Penguin Books, Ltd., © 1980.

An excerpt from *Exodo* by Silvia Mistral. Reprinted by permission of the publisher from *Memories of Resistance: Women's Voices from the Spanish Civil War*. Shirley Mangini, ed. New Haven, Connecticut: Yale University Press, © 1995.

An excerpt from "The Undefeated" by Martha Gellhorn as it appears in *Women's Voices of the Spanish Civil War*, London: Lawrence & Wishart, © 1991. Reprinted by permission of the publisher.

Illustrations: All pages from Robert Capa's notebooks appear courtesy the Archives Nationales, Paris, copyright © 1999 by Cornell Capa; pp. 20, 48, courtesy the Archivo Histórico Nacional, Sección Guerra Civil, Salamanca; p. 25, courtesy Lawrence & Wishart, London; p. 32 courtesy the Bridgeman Art Library, New York, and the Prado Museum, Madrid; all other illustrations courtesy International Center of Photography, New York.

NOTES ON THE AUTHORS

CATHERINE COLEMAN was born in Westfield, New Jersey. She has a BA from Wells College (New York) and a PhD in art history from the Complutense University (Madrid). She is a member of the Cuerpo de Conservadores de Museos in Spain and Curator of Photography at the Museo Nacional Centro de Arte Reina Sofía. She has lived in Madrid since 1971.

Born in San Sebastián, Spain, in 1945, JUAN P. FUSI AIZPÚRUA received his PhD from Oxford University in 1974. From 1986 to 1990, he served as the Director of the National Library, Madrid. A Professor of Contemporary History at the Complutense University, Madrid since 1990, Fusi is the author of *Franco: Authoritarianism and Personal Power* (1995), *Spain: Dictatorship to Democracy* (1979), with Sir Raymond Carr, and *España 1808–1996 el desafío de la modernidad* (1997), with José Palavox.

RICHARD WHELAN is an independent cultural historian who writes extensively about photography. As Robert Capa's biographer, he serves as the Consulting Curator of the Robert Capa Archive at the International Center of Photography, New York. He has organized numerous exhibitions and has edited several books of Capa's photographs. Among his other books are a political history of the Korean War and a biography of Alfred Stieglitz.

Library of Congress Catalog Card Number: 98-85809
Paperback ISBN· 1-931788 02-2
Spanish language catalog ISBN. 84-80-26-117-X

Design by Wendy Byrne
Printed by Sing Cheong Printing Co. Ltd., Hong Kong
Separations by Robert Hennessey, U.S.A., and Sele Offset, Turin Italy

The Staff at Aperture for *Heart of Spain* is:
Michael E. Hoffman, *Executive Director*
Stevan A. Baron, *Production Director*
Lesley A. Martin, *Editor*
Eileen Max, *Associate Production Director*
Nell Elizabeth Farrell
Phyllis Thompson Reid, *Assistant Editors*
Jacquie Byrnes
Jorge Del Olmo, *Production Assistants*
Jane Goldberg, *Editorial Work-Scholar*

Aperture Foundation publishes a magazine, books, and portfolios of fine photography and presents world-class exhibitions to communicate with serious photographers and creative people everywhere. A complete catalog is available upon request.

Aperture Customer Service: 20 East 23rd Street, New York, New York 10010. Phone: (212) 598-4205. Fax: (212) 598-4015. Toll-free: (800) 929-2323. E-mail: customerservice@aperture.org

Aperture Foundation, including Book Center and Burden Gallery: 20 East 23rd Street, New York, New York 10010. Phone: (212) 505-5555, ext. 300. Fax: (212) 979-7759. E-mail: info@aperture.org

Aperture Millerton Book Center: Route 22 North, Millerton, New York, 12546. Phone: (518) 789-9003.

Visit Aperture's website: www.aperture.org

Aperture Foundation books are distributed internationally through:

CANADA: General/Irwin Publishing Co., Ltd., 895 Don Mills Road, 400-2 Park Centre, Toronto, Ontario, M3C 1W3, Canada. Fax: +1 (416) 213-1917.

UNITED KINGDOM, EIRE, SOUTH AFRICA: Aperture c/o Robert Hale, Ltd., Clerkenwell House, 45-47 Clerkenwell Green, London, United Kingdom, EC1R OHT. Fax: +44 (207) 490-4958. E-mail: enquire@hale-books.com

WESTERN EUROPE, SCANDINAVIA: Nilsson & Lamm, BV, Pampuslaan 212-214, P.O. Box 195, 1382 JS Weesp, Netherlands. Fax: ¡31 (29) 441-5054. E-mail: info@nilsson-lamm.nl

AUSTRALIA: Tower Books Pty. Ltd., Unit 9/19 Rodborough Road, Frenchs Forest, Sydney, New South Wales, Australia. Fax: +61 (29) 975-5599. E-mail: towerbks@zipworld.com.au

NEW ZEALAND: Southern Publishers Group, 22 Burleigh Street, Grafton, Auckland, New Zealand. Fax: +64 (9) 309-6170. E-mail: hub@spg.co.nz

INDIA: TBI Publishers, 46 Housing Society, South Extension Part-I, New Delhi 110049, India. Fax: +91 (11) 461-0576. E-mail: tbi@del3vsmp.net.in

To subscribe to the magazine *Aperture* write Aperture, P.O. Box 3000, Denville, New Jersey 07834, or call toll-free: (866) 457-4603. One year: $40.00. Two years: $66.00. International subscriptions: (973) 627-2427. Add $10.00 per year.

First Paperback Edition
10 9 8 7 6 5 4 3 2 1